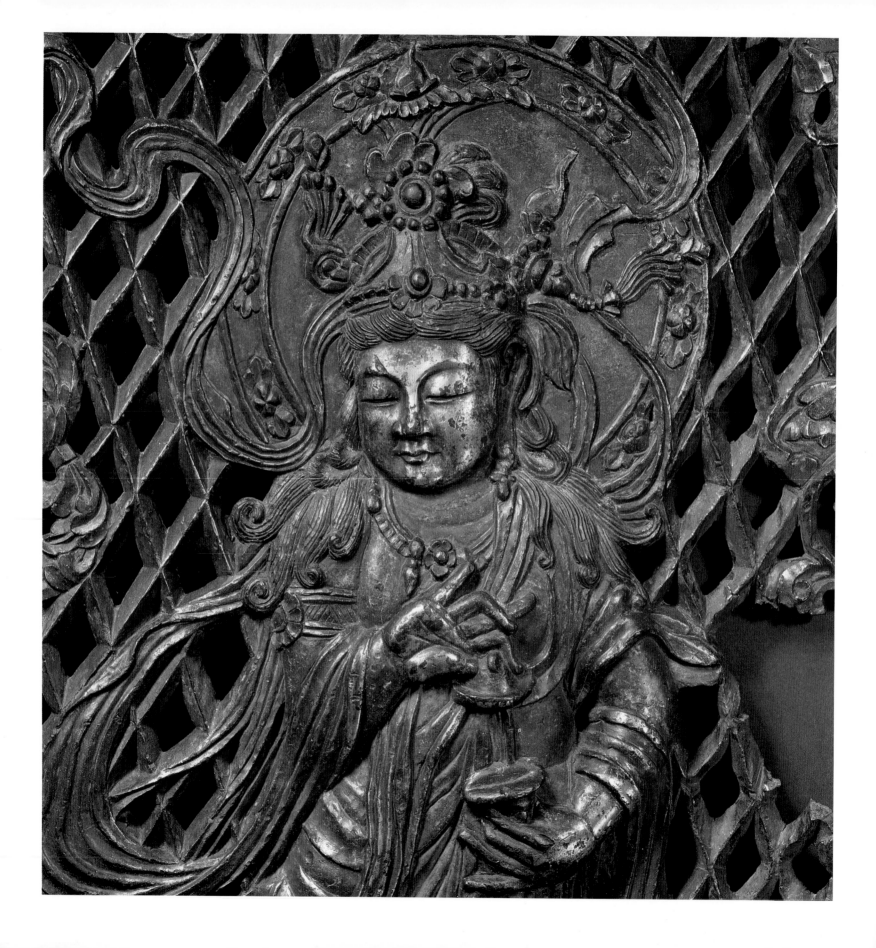

The Great Eastern Temple

TREASURES OF JAPANESE BUDDHIST ART FROM TŌDAI-JI

Organized by Yutaka Mino

WITH CONTRIBUTIONS FROM JOHN M. ROSENFIELD,

WILLIAM H. COALDRAKE, SAMUEL C. MORSE, AND

CHRISTINE M. E. GUTH

The Art Institute of Chicago
IN ASSOCIATION WITH INDIANA UNIVERSITY PRESS

This exhibition and its accompanying catalogue were made possible through the co-sponsorship of Tōdai-ji and the Asahi Shimbun.
We wish to thank the Japanese Agency for Cultural Affairs for allowing the exhibition to travel to the United States.

Special support for this unique venture between Japan and the United States was provided by:

In Japan
IDEMITSU KOSAN COMPANY
THE NOMURA SECURITIES CO.
NIPPON EXPRESS CO.
TOYOTA MOTOR CORPORATION
TOPPAN PRINTING CO. (AMERICA), INC.
JAPAN FOUNDATION

In the United States
EPSON AMERICA INC.
UNITED AIRLINES
THE ALLSTATE FOUNDATION
NATIONAL ENDOWMENT FOR THE ARTS

An indemnity has been granted by the Federal Council on the Arts and Humanities.

Additional support was provided by the John D. and Catherine T. MacArthur Foundation Special Exhibitions Grant.

The exhibition that this catalogue accompanies was held at The Art Institute of Chicago from June 28 to September 7, 1986.

Translated by:
CYNTHEA J. BOGEL (CJB)
CHRISTINE M. E. GUTH (CMEG)
LAWRENCE E. MARCEAU (LEM)
ANNE NISHIMURA MORSE (ANM)
SAMUEL C. MORSE (SCM)
JOSEPH D. PARKER (JDP)
JOHN M. ROSENFIELD (JMR)
WILLIAM SAMONIDES (WS)
T. B. M. SCREECH (TS)

Executive Director of Publications:
Susan F. Rossen

Edited by Naomi Noble Richard

Designed by Betty Binns Graphics, New York

Typeset in Bembo by Trufont Typographers, Hicksville, New York

Printed and bound by Dai Nippon Printing Co., Ltd. Tokyo

Distributed by Indiana University Press, Bloomington, Indiana 47405.

© 1986 by The Art Institute of Chicago. All rights reserved.

Library of Congress Catalog Card Number: 86-045044

ISBN-0-253-20390-2 (paperback)
ISBN-0-253-32634-6 (clothbound)

COVER ILLUSTRATION: *High Priest Rōben* (Number 27); calligraphy by Kitagawara Koten, Chief Abbot of Tōdai-ji

FRONTISPIECE: Panel from fire chamber of octagonal lantern (Number 62)

Library of Congress Cataloging-in-Publication Data
The Great Eastern temple.
 1. Art, Buddhist—Japan—Nara-shi—Exhibitions. 2. Art, Japanese—To 1868—Exhibitions. 3. Art, Japanese—Japan—Nara-shi—Exhibitions. 4. Tōdai-ji (Nara-shi, Japan)
 5. Nara-shi (Japan)—Buildings, structures, etc.—Exhibitions. I. Mino, Yutaka. II. Art Institute of Chicago.
N7357.N3G74 1986 704.9′48943′0952184
86-45044
ISBN 0-253-32634-6
ISBN 0-253-20390-2 (pbk.)

Contents

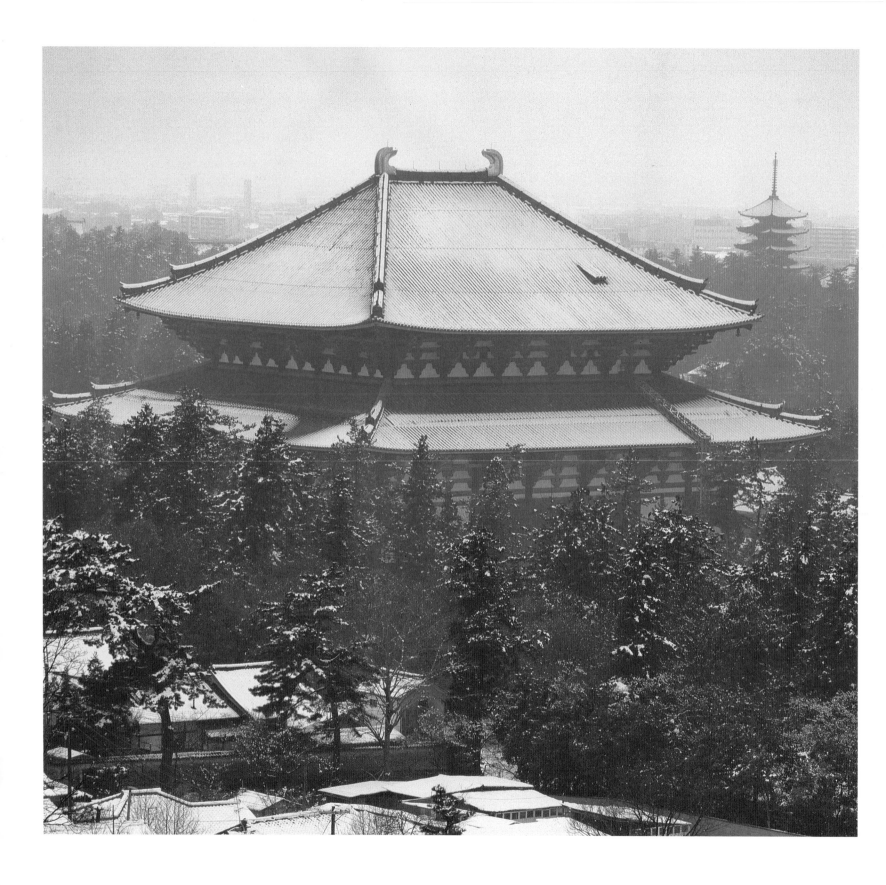

THE Tōdai-ji was originally an official temple founded by the leaders of the day, as a necessary part of the apparatus of the state, in order to pray for peace and prosperity. Today, however, politics and religion are separate, and the state no longer has any say in the Tōdai-ji's affairs.

Among the traditional rites of the temple, most widely known among the Japanese people is a ceremony known as *Omizutori*, or "water-drawing." In February, during the season of bitterest cold, monks of the Tōdai-ji shut themselves up for two weeks in one of the temple's buildings to devote themselves to praying for the spiritual and material wellbeing of all creatures. Just once during this period they emerge from their retreat, in order to draw water at a holy well nearby for offering to the Buddha. This "water-drawing," from which the rite takes its name, has been observed annually without a single interruption for the more than 1,200 years that have passed since the consecration of the *Great Buddha* that is the temple's focal object of worship.

The same continuity of spiritual tradition may be observed in the approximately 150 cultural treasures on display in this exhibition. They are all expressions of the spirit of outstanding Japanese who, in a succession of widely differing ages, were associated with the Tōdai-ji; yet at the same time, I feel, they also embody something basic that continues to underlie Japanese culture even today.

To ensure that the twenty-first century is a century of hope in which cooperation and a sense of unity form the true bases of international society, we must first establish relations of understanding and trust between individual peoples. It is for this reason that the expansion of international exchanges in cultural and other spheres is so necessary; and it is here—in the opportunity it affords to increase understanding of Japanese culture—that the great significance of this exhibition lies.

Yasuhiro Nakasone

YASUHIRO NAKASONE
Prime Minister of Japan

I'M delighted to learn that Americans will have an opportunity to see the magnificent exhibition "The Great Eastern Temple: Treasures of Japanese Buddhist Art from Tōdai-ji." And I congratulate The Art Institute of Chicago on hosting this exhibition. I understand it will be the only showing in the United States, and I commend you and your colleagues for taking the initiative.

Our Ambassador to Japan, Mike Mansfield, has put it very well: "Despite many decades of study by visiting foreign scholars, the true depth of Japan's contribution to world art history through its ancient Buddhist treasures has yet to be fully appreciated abroad." The exhibition should help remedy that.

I am extremely grateful to my friend Prime Minister Nakasone and to everyone in Japan who has helped make this exhibition possible. It will certainly serve to bring our two friendly countries still closer together.

Ronald Reagan

RONALD REAGAN
President of the United States

Figure 1 Daibutsu-den, Tōdai-ji, in snow, with distant view of Kōfuku-ji

IT is most significant that the treasures of the Tōdai-ji, which rank among Japan's most precious cultural assets, are to be exhibited at The Art Institute of Chicago. My respectful gratitude goes to the Art Institute and to all those concerned in both the United States and Japan for making it possible, in spite of all difficulties, to realize this project within the short space of little more than one year.

The Tōdai-ji, with its history of 1,200 years, was established by command of the Emperor Shōmu in order to pray for the peace of the state and the happiness of its people. Calling on each of his subjects to contribute what he could, "be it no more than a blade of grass or a handful of soil," he rallied the resources of the whole nation to help in constructing the temple.

The figure of the Great Buddha that is the principal object of worship is a gilt-bronze statue, fifteen meters in height, that required casting in eight separate stages—a difficult operation that took three years in all. It was erected in the Hall of the Great Buddha, a huge wooden building. At the opening ceremony in 752 some 10,000 monks were invited to witness the "eye-opening" of the *Great Buddha*. The original building, however, was burnt down during subsequent civil strife; the present building is a second reconstruction completed some 300 years ago and further restored in the Meiji (1868–1912) and Showa (1926–) eras. On each occasion the structure's phoenix-like re-emergence was made possible through the cooperation of the nation as a whole.

In the course of its long history, the Tōdai-ji has experienced repeated catastrophes, in which it has lost a large number of cultural treasures. In spite of this, it not only has maintained its ancient traditions of Buddhist ceremony, but has preserved more than 140 objects designated as national treasures and 1,300 designated as important cultural properties; when those not so designated or not yet submitted for consideration are included, the total amounts to several thousand. The number of visitors to the Tōdai-ji is three million every year.

One small part of this great cultural heritage, a selection embracing sculpture, painting, handicrafts, and calligraphy, is now being placed on exhibit at The Art Institute of Chicago. It is a message from the Tōdai-ji to the American people, a token of the friendly relationship between the peoples of Japan and the United States, and it is my sincerest hope that the American public will respond to the gesture in the spirit in which it is offered, and make the exhibition a resounding success.

KITAGAWARA KOTEN
Chief Abbot, Tōdai-ji

THE city of Nara, in which the Tōdai-ji stands, flourished in the eighth century as one of the earliest capitals of the Japanese state. The temples, paintings, sculpture, decorative art, and other cultural treasures still preserved there are among Japan's most irreplaceable national assets. The city as a whole, moreover, with its innumerable temples, still suggests the atmosphere of the ancient capital, constituting in itself a great cultural complex that, along with the other ancient capital of Kyoto, forms one of the "spiritual homes" of the Japanese people.

Standing at the heart of this complex, the Tōdai-ji was first founded more than 1,200 years ago. In 1180 and again in 1567 its buildings were razed by fire as a result of civil strife, but on both occasions they were rebuilt. The objects being shown at The Art Institute of Chicago are survivors of this repeated destruction; superb specimens of Japanese

Buddhist art, they include many jealously guarded treasures that have never before been allowed outside the temple.

Japan and the United States share sad memories of the war that brought them into conflict some forty-odd years ago. Toward the close of the four years of fighting that ended in Japan's defeat, almost all Japan's cities were devastated in the B29 bombing raids. Yet despite this, Nara and Kyoto were spared any serious damage—an almost miraculous outcome in those days of total warfare.

Following the end of the war, the reason for this miracle became known in Japan. Dr. Langdon Warner, an expert in Japanese art who had lectured on Japanese art at Harvard, had joined with colleagues in strongly urging the U.S. government to remove the two cities from the list of targets. Dr. Warner—himself influenced by Tenshin Okakura, former head of the Oriental Department of the Museum of Fine Arts, Boston—had a profound understanding of Japanese history and culture, and I share with the Japanese people as a whole a deep sense of gratitude toward him and the others who acted with him at that time.

For the individual to love the culture of his own nation while harboring understanding and respect for that of others is, I am convinced, one of the best ways of ensuring world peace. It is in this spirit that we at the Asahi Shimbun have worked over the years to introduce various aspects of American culture to the Japanese people. And now, the realization of this exhibition of treasures from the Tōdai-ji will, I feel pleased to think, serve to deepen still further the understanding between our peoples.

The exhibition has been made possible by contributions from a number of well-wishers in both the United States and Japan. Our heartfelt thanks go to them and to The Art Institute of Chicago and the Tōdai-ji for cooperating in the realization of the project, as well as to the governments of the two countries, the National Museum of Nara, and all the many others concerned.

T. Hitotsuyanagi

TOICHIRO HITOTSUYANAGI
President, The Asahi Shimbun

9

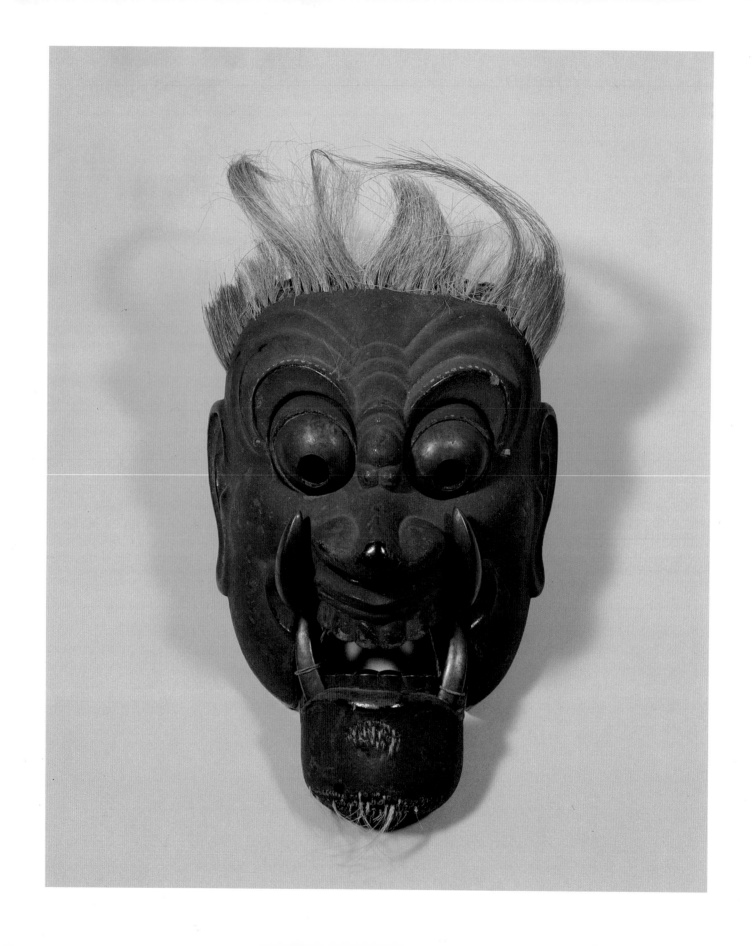

Foreword

"THE GREAT EASTERN TEMPLE" is the name for Japan's popular and most important monument to the spiritual and political impact of Buddhism on the nation's history and culture. In all of Asia, Tōdai-ji alone among the great centers of state Buddhism survives as a living sanctuary and active institution with an unbroken tradition stretching back 1,200 years. No single repository could better convey the quality and range of Japanese Buddhist art and architecture.

Chief among the temple's cultural properties are the objects once stored in the famous Shōsō-in treasure house. Primarily the personal possessions of the Emperor Shōmu (701–56), they were given to the temple at the time of his death. Objects from the Shōsō-in have never left Japan and until recent times they were not even placed on public display. In addition to these sequestered treasures, Tōdai-ji maintains one of Asia's and Japan's richest collections of traditional art and architecture. Its buildings range in date from the time of its founding to the present. Its superb Buddhist and Shinto sculptures are representative of the main creative periods in the history of Japanese sculpture, and the paintings and liturgical objects included here are a rich reflection of the history of Japanese arts and crafts.

An exhibition such as this would have been unthinkable without the full support of the Tōdai-ji authorities and the Japanese government. We are honored to have received the encouragement of Kitagawara Koten, Chief Abbot of Tōdai-ji, and are deeply grateful as well to Kosai Moriya, his Chief Administrator. The Japanese government, through the Agency for Cultural Affairs, has been a critical partner from the outset, and Ambassador Nobuo Matsunaga has been generous with his support. Similarly, our Ambassador, Michael Mansfield, has been essential in guaranteeing the exhibition's success. From their proposal of the initial concept to its final realization, the cooperation of the Asahi Shimbun has been the determining factor in assuring that planning for the exhibition proceeded efficiently and that the financial support required was raised in a very short amount of time. The earliest and most substantial financial contribution for the exhibition came from a grant from Epson America Inc./Seiko-Epson Corporation, allowing the project to proceed with confidence from the outset. We are particularly grateful to Ichirō Hattori, President, for his support of the project. In addition, I would like to thank former Ambassador Robert Ingersoll for his encouragement and efforts in developing American support for the exhibition, which is being generously provided by the Allstate Foundation and United Airlines. We are most grateful for their contributions in support of this exhibition.

The possibility of presenting an exhibition of this magnitude was suggested only two years ago. At that time, it was a dream with little chance of realization. While many individuals have made essential contributions, there is one without whom the American half of this partnership could not

Figure 2 **Bugaku dance mask. Number 33B**

have succeeded. Dr. Yutaka Mino, the Art Institute's Curator of Chinese and Japanese Art, brought to this project his wide knowledge of the field and skillful diplomacy, as well as a contagious conviction that no obstacle in the way of the exhibition's realization could not be overcome. The determination he brought to the tasks of organizing the exhibition appropriately recalls the perseverance of the Chinese monk Ganjin, who was invited by Emperor Shōmu to Tōdai-ji in the eighth century to supervise the training and ordination of Japanese monks and who, despite repeated shipwrecks and interceptions by pirates, arrived to play an essential role in the temple's history! Facing severe time limitations, Dr. Mino nonetheless was able to assemble leading scholars in the field to produce a publication that becomes the definitive work in English on the subject. John M. Rosenfield, Abby Aldrich Rockefeller Professor of Oriental Art at Harvard University, responded to our request for support with his characteristic generosity and enthusiasm. His guiding intelligence has been essential in determining the final form of both the exhibition and publication.

Nara and Chicago are literally at different ends of the world, and yet the history of Tōdai-ji includes events that are familiar to our much younger city. As William Coaldrake points out in his essay, the pair of pagodas constructed at Tōdai-ji in the eighth century were equivalent in height to a thirty-story office block today, placing them among the tallest wooden structures erected before the invention of steel-frame construction and distant ancestors of the buildings that have given Chicago its architectural identity. Similarly, when Tōdai-ji was nearly totally destroyed in the conflagration of the twelfth century, the entire nation responded to the call for its reconstruction, and the disaster, not unlike the great Chicago fire, was followed by a period of extraordinary renewal and artistic creativity.

In his introduction for the Western layman to the ideals and aesthetics of the East, *The Book of Tea*, Okakura Kakuzo observed: "Strangely enough, humanity has so far met in the teacup. It is the only Asiatic ceremonial which commands universal esteem. The white man has scoffed at our religion and our morals but has accepted the brown beverage without hesitation." American receptivity to and knowledge of Japan have changed drastically since these words were written in 1906. The twentieth century has seen us in the roles of protagonists, competitors, and partners; and still we have only begun to appreciate the richness and mutual dependence of our respective cultures. Thanks to the generosity of Tōdai-ji and the Japanese cultural authorities, this exhibition is uniquely suited to furthering Western understanding of the East.

JAMES N. WOOD
Director, The Art Institute of Chicago

Acknowledgments

As someone who has loved and studied Japanese art for twenty-five years, I feel both deep personal pride and professional satisfaction to have been involved in an unprecedented loan of works of art from one of Japan's greatest repositories of Buddhist art and architecture. The exhibition "The Great Eastern Temple: Treasures of Japanese Buddhist Art from Tōdai-ji" brings to the West for the first time a group of spectacular and important sacred objects—sculptures, paintings, calligraphy, decorative arts—spanning over 1,200 years. It marks the first time that such a large number of ancient Buddhist treasures, many of which are usually inaccessible to the public in Japan, have left the country. We hope that this outstanding selection will provide the American audience with a new understanding of Japan's rich spiritual and cultural heritage as well as its extraordinary artistic achievements.

The cooperation and aid of many institutions and individuals have enabled us to realize this long-standing dream. In his foreword, James N. Wood, Director of The Art Institute of Chicago, has acknowledged the major sources of our support. I want to add a special note of appreciation to the Idemitsu Kosan Company, the Nomura Securities Company, Nippon Express Company, Toyota Motor Corporation, Toppan Printing Company (America), Inc., and Japan Foundation, whose generous contributions allowed us to proceed with the exhibition. I should like in addition to thank by name those who were instrumental in bringing this exhibition about. I am immensely grateful to the officials of Tōdai-ji, who generously agreed to lend their invaluable works of art so that Westerners might learn more about Japanese art and culture. The Japanese Agency for Cultural Affairs gave official approval to the loan and was instrumental in the conservation of the objects and in securing materials for the catalogue. At the Agency, I would particularly like to thank Shumon Miura, Minister; Kakichi Suzuki, Counselor, Cultural Properties; Kenjiro Nakamura, Director-General, Cultural Properties; and Nobuyoshi Yamamoto, Director, Fine Arts Division. Takashi Hamada, Director of the National Museum of Nara, and his staff contributed their considerable skills and time to the physical preparation of the objects for travel.

Without the backing of one of Japan's great newspaper and communications companies, the Asahi Shimbun, Tokyo, the exhibition would never have been realized. I am particularly grateful to Asahi's Cultural Project Department: Managing Director Makio Itoh, Director-General Shoji Wakui, Director Kazuo Yoshida, Consultant Yasuo Akiyama, and Head of the Tōdai-ji Project Yoiichiro Nakagawa. I deeply appreciate the long working relationship I have enjoyed with this fine group, to whom much of the credit for the exhibition belongs. Over the years, their coopera-

tion, advice, and friendship have been very gratifying. Finally, acknowledgment of the help we received in Japan would not be complete without mention of Ichiko Ishihara, Representative Director of the Takashimaya Department Store, who helped us make proper contacts and gave us the benefit of her experience and wisdom. I am grateful, too, to Hirokazu Arai, Consul General of Japan in Chicago, and Mitsunori Namba, Consul, for their assistance. Warren Obluck, cultural attaché of the United States Embassy in Japan, was also very helpful.

The organization and production of a major catalogue in English in a very short time was a kind of miracle, accomplished through the cooperative efforts of a hard-working, talented group of people. Less than a year before the exhibition was scheduled to open in Chicago, Professor John M. Rosenfield, Abby Aldrich Rockefeller Professor of Oriental Art at Harvard University, agreed to coordinate the project. I am deeply indebted to Dr. Rosenfield, not only for his extraordinary efforts on behalf of the catalogue, but also for his wonderfully enthusiastic and supportive attitude throughout all stages of planning for the exhibition. In addition to the fine introductory essay he contributed to the catalogue, we were able to include three other essays on the Tōdai-ji complex: for their work, we are very grateful to William H. Coaldrake, Instructor of Japanese Art and Architecture at Harvard University; Samuel C. Morse, Assistant Professor of Fine Arts, Amherst College; and Christine M. E. Guth, Adjunct Assistant Professor of Japanese Art, Institute of Fine Arts, New York University. Professors Guth, Morse, and Rosenfield also prepared certain of the catalogue entries. A team of Harvard University graduate students in Fine Arts and East Asian Studies was instrumental in preparing the catalogue entries. (For the most part, these were translated, adapted, and substantially expanded from those in an exhibition catalogue written in Japanese and published in 1980. Entries for numbers 10, 16, and 26 were written expressly for the American catalogue.) We would like especially to single out Cynthea Bogel, who diligently directed the translators, listed by name on page 4. Kyoko Anderson assisted in the translating, and Christopher Cleary helped with matters of Buddhist doctrine and terminology.

The catalogue was expanded, refined, and further shaped by editor Naomi Noble Richard, whose knowledge of the field and consummate editorial skills greatly benefited the project. The index was prepared by Elinor Goettel. Manuscript typing was provided by Cris Ligenza and Holly Stec Dankert of the Art Institute's Publications Department. That department's Executive Director, Susan F. Rossen, oversaw the preparation and production of the book. The responsiveness of Alan Newman, the museum's Executive Director of Photography, and his staff to the photographic needs of the book is also appreciated. The elegant design of the book is the work of Betty Binns. The exhibition's design was provided by Sherman O'Hare and Clifford Abrams.

I am indebted to many more individuals at the Art Institute than can be named here. First, I wish to express my deep thanks to Director James N. Wood, who has been a totally supportive and insightful partner throughout this venture. Vice-President for Development Larry Ter Molen was instrumental in securing the funding needed for such an ambitious project. The complex financial and contractual arrangements were handled expertly by Robert Mars, Vice-President for Administration. I am very grateful to Dorothy Schroeder, Assistant to the Director, for her careful attention to the many organizational details. I also wish to thank Katharine Lee, Assistant Director, and, in my department, Cheryl Williams, Secretary. Finally, this extraordinary undertaking would never have been possible without the support of the Art Institute's Board of Trustees. To them, to the Officers, and to the entire museum staff, I extend my heartfelt thanks.

YUTAKA MINO
Curator of Chinese and Japanese Art
The Art Institute of Chicago

Editor's Notes

All Japanese and Chinese personal names are in traditional style, with surname preceding given name.

In the names of Japanese sanctuaries the suffixes *-ji* and *-dera* indicate a Buddhist monastery-temple; *-in* refers to a subtemple; *-dō* and *-den* are individual buildings within a temple or subtemple compound. The word *shrine* (J: *jinja*) denotes a Shinto sanctuary.

Parenthetic *J:*, *C:*, and *S:* stand for Japanese, Chinese, and Sanskrit, respectively.

In the measurement of sculptures, the height given is that of the figure alone (not including pedestal, base, or halo).

Unless otherwise noted, *left* and *right* mean proper left and right when referring to sculptures, viewer's left and right when referring to paintings.

All premodern Japanese dates are according to the lunar calendar, in which New Year occurs about a month later than in the solar calendar.

Historical Periods Referred to in Text

JAPAN

Protohistoric Era

Tumulus (J: *kofun*)	c. 250–552

Early Historical Era (J: *kodai*)

Asuka	552–645
Early Nara	645–710
Late Nara	710–784
(capital at Nagaoka)	784–794
Early Heian	794–898
Late Heian	898–1185

Medieval Era (J: *chūsei*)

Kamakura	1185–1333
Nambokuchō	1333–1392
Muromachi	1392–1568
Sengoku (Age of the Country at War)	1467–1568

Early Modern Era (J: *kinsei*)

Momoyama	1568–1603
Edo	1603–1868

CHINA

Han	206 B.C.–A.D. 220
Period of Disunity	220–589
Wu	222–280
Eastern Jin	317–420
Northern Wei	386–535
Sui	581–618
Tang	618–907
Five Dynasties	907–960
Song	960–1279
Northern Song	960–1127
Southern Song	1127–1279
Yuan	1271–1368
Ming	1368–1644
Qing	1644–1911

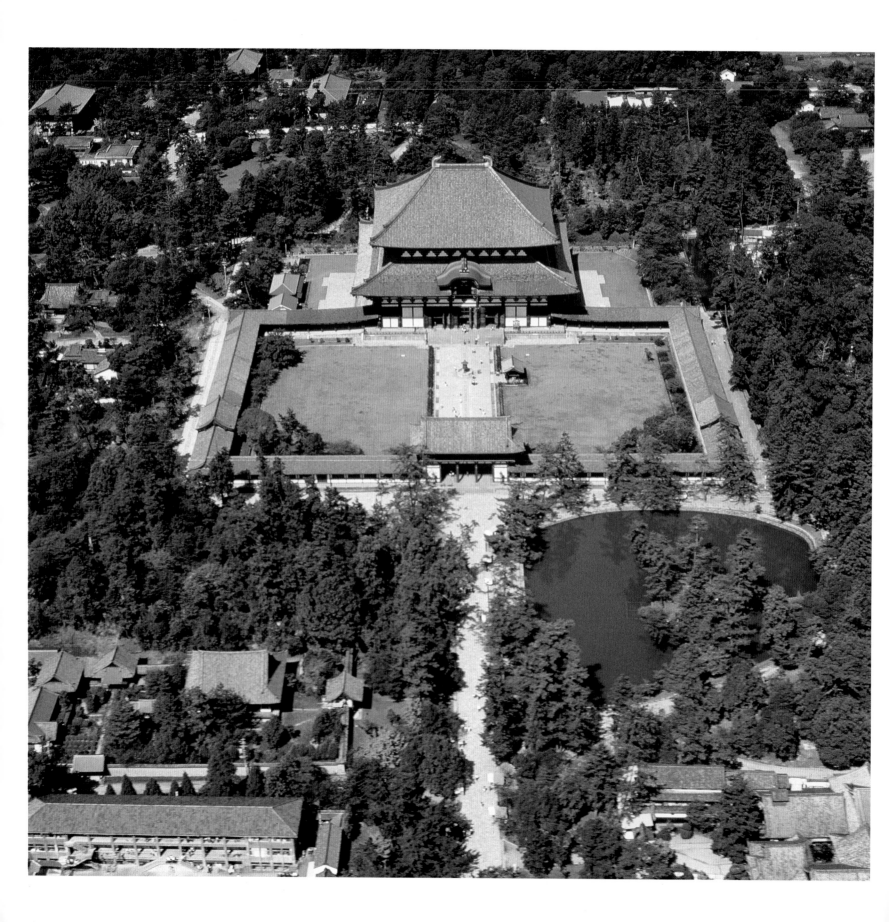

Introduction: Tōdai-ji in Japanese history and art

JOHN M. ROSENFIELD

Tōdai-ji, the Great Eastern Temple, is a Buddhist monastery on the eastern edge of Nara, capital of Japan during the eighth century A.D. Today, nestling against the gentle slopes of Mt. Wakakusa, Tōdai-ji consists of dozens of buildings which serve as gateways, votive halls, dormitories, storehouses, and offices. The main structure houses a colossal bronze statue depicting the deity now called in Japanese Dainichi, or Great Illumination. The statue itself is known as the *Daibutsu*, or *Great Buddha*. It is enshrined in what is said to be the largest wooden building in the world, the Daibutsu-den, or Hall of the Great Buddha (figs. 3, 4).

Made at a time when the linkage between the Japanese state and the Buddhist church was unusually close, Tōdai-ji's huge votive halls and religious art reflect the wealth and power of the throne and express the immensely complex theological concepts that inspired the temple's founders. In its fusion of political and spiritual values Tōdai-ji may be compared, for example, with London's Westminster Abbey, where the British monarch is crowned, or to St. Denis near Paris, where the kings of France were buried, or to the domed cathedral of Hagia Sophia in Istanbul, in which the emperor Justinian (483–565) symbolized his leadership of both the Holy Roman Empire and the Catholic Church. None of these comparisons is entirely accurate, however, because Japanese society and the Buddhist faith differ in fundamental ways from their Western counterparts.

Damaged in civil wars and earthquakes but always repaired, Tōdai-ji has survived for twelve hundred years as the nation's most prominent monument to the political and spiritual importance of the Buddhist faith. Ironically, however, the socio-religious ideals which inspired the building of Tōdai-ji were honored in Japan for only two generations. In fact, the transfer of the capital away from Nara in 784 was prompted largely by a rebellion against the fanatical application of those ideals, but the temple's symbolic role had already been indelibly imprinted on the nation's consciousness. Today, thronged with tourists, its religious life is only a pale reflection of its once vital role at the center of national polity; yet it is still an active sanctuary, well maintained by priests who are determined to adapt it to the modern world. Its counterparts elsewhere in Asia have almost all been abandoned or neglected.

State Buddhism

Built at a time when the spirit of internationalism in Buddhist Asia was at its peak, Tōdai-ji is the easternmost of a series of sanctuaries that express the union of kingship and faith. Even its name signifies this union—not the popular name, Tōdai-ji, which means simply "Great Eastern Temple," but its formal name, Temple for the Protection of the Nation by the Golden Radiant Four Divine Kings (J: Konkōmyō Shitennō Gokoku-ji); and Tōdai-ji played a prominent role in early Japanese

Figure 3 Aerial view of Tōdai-ji complex, showing Daibutsu-den

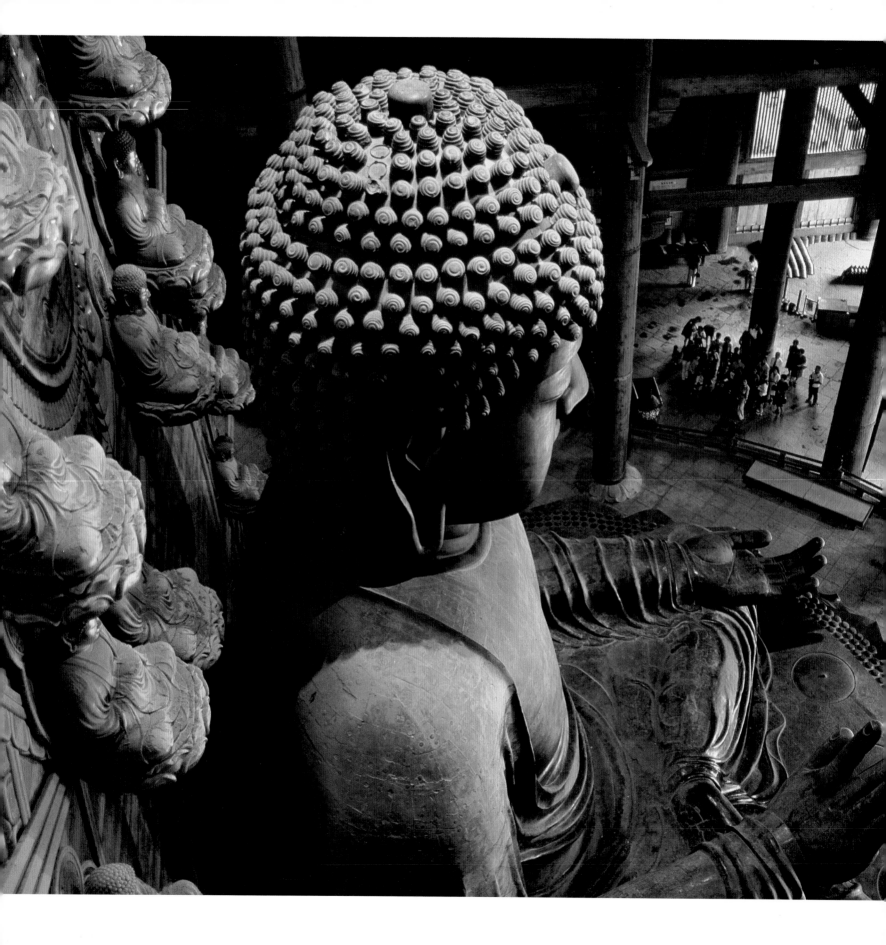

history as one of the instruments by which the imperial family created a unified state out of a loose federation of quarreling clans. Other monuments of State Buddhism in Asia are Bamiyan in Afghanistan, with its giant rock-cut standing images; the temple complex of Angkor Thom in Kampuchea; the cave sanctuaries of Yungang and Longmen in northern China; and Pulkuk-sa monastery and the man-made grotto of Sokkuram near the old Korean capital of Kyongju. Many other such monuments have been lost: the giant pagoda built by the Kushan emperor Kanishka near Peshawar in Pakistan, for example, or the great bronze statue commissioned by Empress Wu Zetian in the year 700 in the Tang capital of Changan, the modern Xi-an.

Underlying all of these sanctuaries is the concept that Buddhist deities, vast in number and limitless in power, will protect a kingdom and its ruling families—provided, of course, that the rulers generously support the church and the congregations of monks. By attracting state resources to support the faith, this concept played a major role in the expansion of Buddhism in Asia. It was not, however, one of the original ideals on which the faith had been founded in the late sixth century B.C. On the contrary, State Buddhism belonged to the religious system known as the Greater Vehicle (S: Mahāyāna), which had evolved in India during the first two centuries of the Christian era and eventually became the dominant form of Buddhism in East Asia.[1]

The linking of church with state seems almost heretical when compared with the earliest known Buddhist doctrines, propounded by Gautama Siddhārtha—usually called Shaka in Japanese, from his Sanskrit epithet Sākyamuni (Sage of the Sākya Clan). Born the heir-apparent of a small kingdom in northern India, he had renounced his family and his throne in order to seek personal salvation. By doing so Sākyamuni established one of the most basic sociological features of early Buddhism: personal spiritual goals were given precedence over the needs of the family or the state.

Early Buddhism was a creed of monks withdrawn from the world in pursuit of spiritual Enlightenment. Enlightenment was possible only to those who entered monastic life. Laymen gained merit by supporting the monastic communities, and they reached nirvana—the desired goal of all Buddhists—only through reincarnation at successively higher levels of existence until they too could lead a hermetic life. In this scheme of things a monk was given higher status than a king.

By the beginning of the Christian era, however, the Buddhist faith had developed the more popular doctrines of Mahāyāna. The path to Enlightenment was broadened to include laymen, who might attain salvation through faith alone. A huge pantheon of benevolent deities was created to offer protection in this life and salvation in the next; laymen could attain nirvana by entrusting their fate to deities who generously placed their divine powers at the service of all living beings. Prominent among these deities were the bodhisattvas (enlightenment beings), who worked ceaselessly for the safety and prosperity of the true believer.

The Buddhist pantheon protected not only individual believers but nations and their rulers. In China certain emperors of the Northern Wei dynasty (386–534) were thought to be under the special protection of the Buddhas, and at the cave-monastery complex of Yungang five colossal Buddhist images were carved in the late fifth century specifically to commemorate five of the Northern Wei rulers. Some Chinese rulers even thought of themselves as incarnations of the divine; the Tang empress Wu Zetian believed that she was Maitreya, the Buddha of the Future.

The Kegon school. One of the most influential schools of Mahāyāna Buddhist doctrine is based on an exceedingly long scripture called the *Flower Garland* (S: *Avatamsaka-sūtra*; C: *Hua-yan-jing*; J: *Kegon-kyō*), devoted to philosophy, rules of meditation, and ethics.[2] Composed in India and translated into Chinese as early as the second century A.D., the *Avatamsaka-sūtra* was continuously revised and retranslated in China, where it reached an apogee of influence in the seventh and eighth centuries and then found enthusiastic reception in Korea and Japan. The founders of Tōdai-ji were much inspired by this sutra, and that temple eventually became the Japanese headquarters of the Kegon

Figure 4 *Daibutsu* **and interior of Daibutsu-den, Tōdai-ji**

sect, which survives as a network of some fifty-one temples with over five hundred priests and fifty thousand believers.

The political aspirations of East Asian Buddhist rulers found much reinforcement in the Avatamsaka doctrine of the fundamental unity that pervades both the spiritual and physical realms, and modern scholars assume that the ruler's authority was likened to that of the Buddha-principle which animates all things. The source and center of creation was symbolized by the deity named in Sanskrit Vairocana, Great Sun or Illumination—a highly abstract god far different from the historical founder of the faith, Sākyamuni, whose personal life with its struggles and suffering was familiar to all Buddhists. At Tōdai-ji the giant bronze statue of Vairocana is the dominant symbol; its monumentality and connotations echo the large stone statue of this deity commissioned in the 670s by the Tang court at Feng-xian Si, one of the Longmen cave-temples near the capital city of Luoyang (fig. 5).

The founding of Tōdai-ji

The construction of Tōdai-ji was so costly an enterprise that it drained the resources of the Japanese nation and aroused serious opposition. The nobles and clergy who founded it, however, were endowed with such extraordinary strength of conviction and character that they overcame all resistance. In many ways the monastery is a monument to its founders, and it has honored them with commemorative portraits and ceremonies; it has similarly honored their successors who maintained and rebuilt the temple. A major part of this exhibition consists of portraits of key figures in Tōdai-ji's long history. The portrait imagery does not include women, however, even though their patronage was of vital importance—a telling commentary on the dominance of males in traditional East Asian society.

Foremost among the temple's patrons was the emperor Shōmu (r. 724–49), prominently depicted in catalogue numbers 38 and 39. Japan's forty-fifth sovereign, Shōmu consolidated the authority of the throne at a time when it was still threatened by rivals and barely reached the outlying provinces. His aspirations for unity were expressed in the era-name *Tempyō* (Heavenly Peace) that he and his successor used to designate the years from 729 to

766. *Tempyō* is now often used by historians to refer to this era of national unification and the flowering of Tang-style court and religious culture.

A devout Buddhist, Shōmu began planning in the 730s to establish a sanctuary that would serve as headquarters of a unified Buddhist church and chief seminary for training monks. In 743 he issued a proclamation that he wished to spread the Buddha's Law throughout the nation and to construct an image of Vairocana in gold and copper to be housed in a great edifice. He also bombastically proclaimed his own vast power and authority ("It is We who possess the wealth of the land; it is We who possess all power in the land. With this wealth and power at Our command, We have resolved to create this venerable object of worship . . .").[3] Finally, to promote in his divided and turbulent realm the unity that a common enterprise can engender, Shōmu called for each citizen to contribute to the project, even if it were no more than a twig or a handful of dirt.

Shōmu's immediate family shared his religious zeal. He and his consort, Kōmyō, commissioned the copying of thousands of scrolls of Buddhist scripture and the making of countless statues and paintings, and they sponsored elaborate vegetarian feasts for congregations of monks. In 749 they jointly abdicated the throne to devote themselves more completely to religious tasks, and their daughter, the empress Kōken (718–70), sought to convert Japan into a theocracy by abdicating in favor of the monk Dōkyō (?–772). Traditionalists opposed this step as well as the diversion of state resources into the church, and they eventually transferred the capital to Kyoto—out from under the influence of Tōdai-ji and the other Nara temples.

Shōmu's main religious adviser was the monk Rōben (689–773), whose small Nara hermitage, the Konshō-ji (Temple of the Golden Bell), became part of Tōdai-ji when that temple was built. Honored at Tōdai-ji by a splendid portrait statue (no. 27) and painting (no. 40), Rōben was credited with having secured the gold used to cover the bronze *Daibutsu*, for it was believed that his prayers had resulted in the finding of new supplies of gold in the Mutsu region of northern Honshu. Rōben's chief contribution, however, was the spreading of Avatamsaka doctrines. In 740 he invited the Korean monk Sim-Pyong to lecture on the *Ava-*

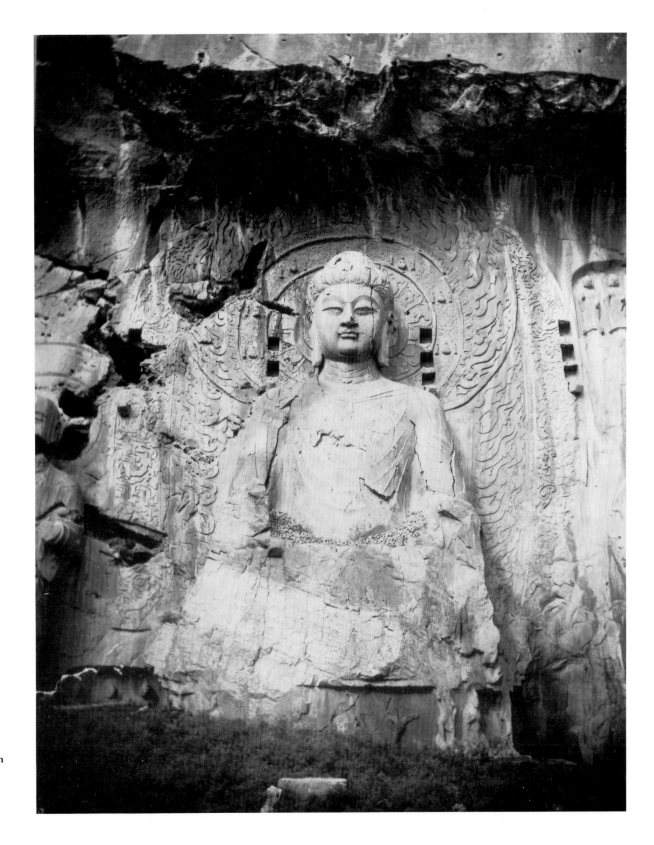

Figure 5 *Vairocana*. Tang
dynasty, late 7th century.
Limestone; h. 13.37 m. with
pedestal. Feng-xian Si,
Longmen cave-temples
(near Luoyang), Henan
Province, China

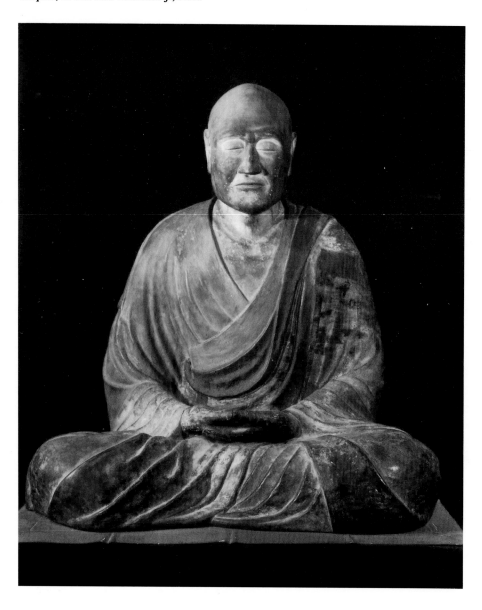

Figure 6 *Monk Jian Zhen* (J: *Ganjin*).
Late Nara period, c. 763. Hollow dry
lacquer; h. 80.1 cm. Tōshōdai-ji, Nara

tamsaka-sūtra; Rōben himself mastered the texts and
instructed large groups of Nara monks as well as
the emperor himself. He was appointed to several
distinguished positions; he was *bettō* (intendant, or
official in charge) of Tōdai-ji from 752 to 761, the
first to serve in that rank, and he was later given
the rank of high priest (J: *sōjō*).

Another of the emperor's advisers was the aged
monk Gyōki (668–749), called a living bodhisattva
for his charitable work among peasants and the
poor: constructing public baths, medical dispens-
aries, and irrigation projects. Enlisted by Shōmu
for the *Daibutsu* project, he was the first of many
men over the centuries to serve as chief solicitor (J:
kanjin shoku) of Tōdai-ji, touring the countryside
seeking money for the monastery; he was also the
first to be appointed senior high priest (J: *dai sōjō*).
Moreover, according to legend, he was sent to the
Ise Grand Shrine when Shōmu and his advisers
wished to reconcile the foreign creed of Buddhism
with the native Shinto. At the Ise Shrine, dedicated
to the sun goddess, Gyōki spent seven days and
seven nights reciting the *Sutra of the Greater
Perfection of Wisdom* (S: *Mahāprajnā-pāramitā-sūtra*),
and the shrine oracle proclaimed the compatibility
of the goddess and Vairocana. Gyōki, along with
Shōmu and Rōben and the Indian monk Bodhisena
(704–60), is one of the Four Saintly Founders of
Tōdai-ji depicted in a commemorative painting
included here (no. 38). Bodhisena is the only
Indian known to have reached premodern Japan,
arriving in 735. A master of Avatamsaka texts, he
worked closely with Gyōki and later with Rōben
and was frequently invited to lecture at the
imperial court.

Gyōki was often depicted in portrait statues;
the example in this exhibition (no. 30) is an
eighteenth-century replica of a much older one that
was installed at his mortuary shrine near Nara. A
similar sculpture (no. 31) reproduces the famous
eighth-century portrait statue of the Chinese monk
Jian Zhen (J: Ganjin; 689–763) (fig. 6), who had
been invited by Shōmu to Tōdai-ji to supervise the
training and ordination of Japanese monks.

Emperor Shōmu proclaimed in 741 that each of
the nation's sixty-seven provinces should build
both a nunnery and a monastery with a seven-
storied pagoda, and that each province should
possess ten copies of the *Lotus Sutra* (J: *Hokke-kyō*)
and ten of the *Sutra of the Golden Radiant All-*

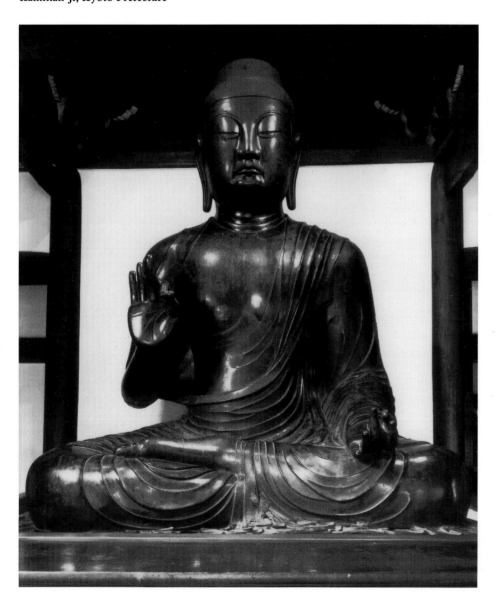

Figure 7 *Seated Buddha.* **Late Nara period, late 740s. Bronze; h. 240.3 cm. Kaniman-ji, Kyoto Prefecture**

Victorious Kings (J: *Konkōmyō-saishō-ō-kyō*), whose study promotes the well-being of the state. These sanctuaries were designated Provincial Monasteries or Nunneries (J: *kokubun-ji* or *-niji*) for the Protection of the Realm. Tōdai-ji eventually became the *kokubun-ji* headquarters, where all monks were to be trained and ordained; the chief nunnery was Hokke-ji, a small cloister adjacent to the Nara imperial palace. The system remained active even after the capital was moved to Kyoto, the throne continuing to issue a stream of instructions to the provincial temples about lands deeded for their support, ceremonies to prevent earthquake or famine, statues to be installed, and texts to be copied and studied. A system very similar to this had been established in China during the previous century, but in neither country was the throne able to sustain its operation permanently. In Japan the *kokubun-ji* system had weakened by the end of the ninth century and died out completely by the end of the twelfth, even though a few of the *kokubun-ji* temples have managed to survive independently to the present day.

Shōmu had first tried to build his headquarters temple in 744 near a palace at Shigaraki in the mountains north of Nara. In the following year, however, he decided to relocate it and to expand for that purpose Rōben's small hermitage in the hills just east of the Nara capital, the Konshō-ji. By midsummer of 745 the massive undertaking was under way, and as Essays 1 and 2 relate in detail, the small nation committed a prodigious amount of resources to gather the giant timbers, thousands of clay roof tiles, tons of copper, and several hundred pounds of gold for this project. Criticism was raised by conservative monks, fearful that the emphasis on the giant bronze statue overshadowed the individual spiritual goals of the faith. Conservative courtiers complained that ancient Japanese principles of kingship were being neglected in favor of imported ones. Shōmu and his consort Kōmyō pressed ahead, and to devote themselves more fully to their Buddhist goals, they both abdicated the throne in 749 in favor of their daughter, Kōken, who shared their intense piety.

In 752, on the ninth day of the fourth month, the dedication ceremony of the bronze *Daibutsu* (see no. 47) was held, even though the hall to enclose the statue was not yet finished. Ten thousand monks were assembled along with courtiers and

military officials. Troupes of dancers and musicians, dressed in lavish brocaded robes, performed the ancient *gigaku* dances of Chinese and Central Asian origin; surviving today are some of the exotic wooden masks used at the ceremony (see no. 32). With the Indian monk Bodhisena presiding, the ex-emperor and his consort attended the "eye-opening (J: *kaigen*) ceremony," wherein Bodhisena, standing on a scaffold, drew in the irises of the eyes of the *Daibutsu* with a giant brush connected by strings to the emperor's hands.

The Tempyō-period *Daibutsu* was badly damaged in 1180. Repaired soon thereafter, it was damaged again in 1567, and today only parts of the lotus petals on the statue's pedestal survive from the original. One can, however, gain a general idea of the appearance of the *Daibutsu* by studying contemporary images. A splendid statue now kept at Kaniman-ji, between Kyoto and Nara, is said to have been the main object of devotion for the *kokubun-ji* temple of the region built in the late 740s (fig. 7). Strongly Chinese in style, this statue is imbued with a sense of imperious presence that is appropriate to the symbolic content of the *Daibutsu*. The engraved Buddha-images on the surviving parts of the pedestal of the original *Daibutsu* must also be close in style to the statue that once towered above them. These engravings are also a precious relic of the Indian cosmology that inspired Shōmu, who saw the throne as source of the authority of provincial governors and court ministers, just as Vairocana was the source of the Buddhist realms shown on his lotus-pedestal. The engravings depict Mt. Sumeru, the central axis of the universe; shown surrounding Sumeru are the continents and oceans, and above it are the paradises where dwell countless Buddhist deities (fig. 8).

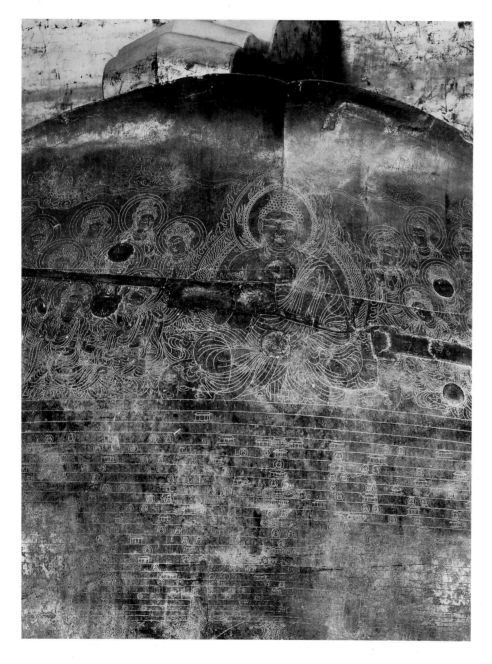

Figure 8 Buddhist paradise scene. Engraving on petal of lotus pedestal of *Daibutsu*. Late Nara period, c. 756–57. Bronze; h. of petal 200 cm. Daibutsu-den, Tōdai-ji

Figure 9 Interior of Sangatsu-dō, Tōdai-ji, showing (right) *Fukūkenjaku Kannon* and (middle) *Gakkō*. Late Nara period, mid-8th century. Hollow dry lacquer, h. 362.1 cm.; and clay, h. 204.8 cm., respectively

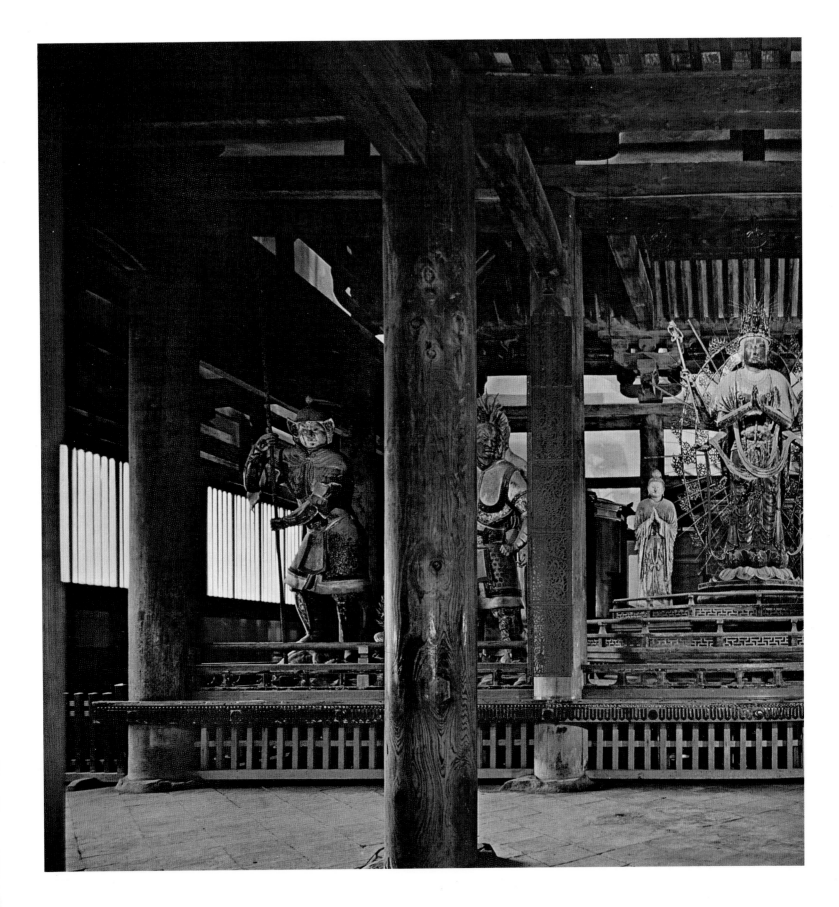

Ceremonies and art

The sculptures and ritual implements of Tōdai-ji were used in Buddhist ceremonies throughout the year. One major event was the birthday of Sākyamuni, celebrated on the ninth day of the fourth month. Tōdai-ji—like most sanctuaries—was equipped with a statue of the newborn infant and a large basin in which the statue was placed for the ritual of baptism or lustration (no. 2). Over the image monks and laymen would pour water tinted with the powder of precious stones and perfumed with incense, reenacting the infant's first bath. In addition, this ceremony included the reading of a special text and a vegetarian feast for the monks.

During the third month a formal reading was held of the most popular of all texts of Northern Buddhism, the *Lotus Sutra*—one chapter per day accompanied by lectures on its meaning. The ceremony was started by Rōben at his own hermitage, the Konshō-ji; later a special hall was constructed for it on the hillside overlooking the Daibutsu-den. This is the Sangatsu-dō (Third-Month Hall), also called the Hokke-dō (Lotus Hall) (fig. 9), which today contains a well-preserved portion of the original eighth-century architecture as well as a splendid array of Tempyō-period sculpture.

Major festivals at Tōdai-ji marked the four main seasons of the year. In midwinter was the Festival of Ten Thousand Lanterns (J: *Mandō-e*), at which thousands of lanterns (probably small earthen oil lamps) were lighted before the statue of Vairocana in the Daibutsu-den as an act of repentance. Spring was marked by the Great Kegon Ceremony (J: *Kegon no Dai-e*), when eighty chapters of the *Flower Garland Sutra* were read and explained, and patrons offered a vegetarian feast to the monks. Summer brought the Festival of Ten Thousand Flowers (J: *Manke-e*) on the fifteenth day of the seventh month, when thousands of lotus flowers were placed before the *Daibutsu* statue. The autumn festival was the *Daihannya-kyō-e*, at which the *Sutra of the Perfection of Wisdom* was read. This too was an occasion for the vegetarian feasts that were such an important means of patronage.

Shinto shrine at Tōdai-ji. Throughout Asia the Buddhist faith has allowed the worship of village and animist deities so long as they were compatible with Buddhist principles. This theological concept was extremely successful in Japan, where the native folk religions were reconciled with the imported Buddhist faith, a process in which Tōdai-ji played a pioneering role.

Emperor Shōmu had long been a devotee of the native god Hachiman, whose name means "eight [military] banners" and whose cult was originally located at Usa in Kyushu (see no. 49). Hachiman is a protective deity, and in 749 the empress Kōken, Shōmu's daughter, established a Hachiman shrine on a hillside just south of Tōdai-ji so that the deity might protect the monastery and receive worshippers from the capital. This shrine, an important element in the religious life of Nara, became the prototype for the integration of Shinto and Buddhist customs throughout the nation. Included in this exhibition are some of the most important of the shrine's artistic properties, such as its main statue of Hachiman (no. 15), which is ordinarily treated as a secret image and kept from public view. Carved in 1201 after the original one had been lost in fire, it depicts the god not as a warrior but as a Buddhist monk. Also exhibited here are remarkable masks used in shrine performances of liturgical dances (no. 33).

The New Year Water Ritual (Omizutori). The blending of Buddhist and Shinto customs at Tōdai-ji survives in the spectacular *Omizutori* (Water-Drawing) Ceremony, held annually in March of the solar year. By the old lunar calendar it takes place on the last day of the second month, which is the beginning of New Year. The ceremony is held at the Nigatsu-dō (Second-Month Hall), an imposing wooden structure raised on twenty-foot wooden pilings on the hillside east of the Daibutsu-den. At one-thirty in the morning, before thousands of shivering spectators and (in recent times) television cameras, a procession of priests and attendants solemnly descends the steep stone stairway, to the mournful wail of conch-shell trumpets. The procession approaches the Akai-ya, a small roofed hall enclosing the well that provides fresh, pure water. Here Shinto priests greet them, and a water-bearer joins the procession back to the Nigatsu-dō, where the water is presented to the deity enshrined there, the Eleven-Headed Kannon (J: *Jūichimen Kannon*). From the balcony of the Nigatsu-dō attendants brandish long torches of

Figure 10 *Omizutori* Ceremony.
Interior of Nigatsu-dō, Tōdai-ji

flaming cypress wood, the cascades of sparks and fire announcing to the heavens that the New Year has properly begun (figs. 10–12). In 1667 the Nigatsu-dō was set ablaze by these torches; a scorched sutra text in this exhibition (no. 54) bears witness to that accident.

The *Omizutori* Ceremony is the public climax of a secluded purification ritual held only at Tōdai-ji, the *Shunigatsu-e*. This is the Japanese version of the ancient Indian custom of monastic retreats in which monks are expected to undergo especially rigorous austerities to cleanse the sins of the old year. At Tōdai-ji nowadays a group of eleven priests follows a minutely prescribed schedule for twenty-seven days. They rise in unison, recite the *Avatamsaka-sūtra* and receive instruction in its meaning, chant hymns in praise of Kannon, and six times perform rites of repentance (J: *keka*) before the shrine of the Eleven-Headed Kannon in the Nigatsu-dō. The priests undertake this ritual purification not for themselves alone but also for the peace and prosperity of the nation, for the good fortune of the imperial family, for the well-being of the temple's supporters, and, indeed, for the welfare of all living creatures.

The *Shunigatsu-e* was begun in the 750s by the monk Jitchū, Rōben's chief assistant. It soon spread to monasteries throughout nation, as monks from Tōdai-ji went into the countryside to perform the ritual repentance for the sake of local believers. Today the custom survives only at Tōdai-ji, but it is performed in substantially the same manner as it was in the mid-eighth century.

Folk deities of foreign origin. Foreign folk religions are reflected in this exhibition by sculptures of deities from distant India that came to Japan as part of the massive importation of Buddhist beliefs and were absorbed into the religion of Japanese farmers and villagers. The goddess Kariteimo (no. 8), for example, originated in India as Haritī, protector of children from the dread disease of smallpox; she also bestowed children on those who prayed for them. Her consort in India, the animist deity Pancika, was worshipped in Japan under the name Daikoku-ten and became one of the most popular of all household gods. He appears here in a naive wood carving of the fifteenth century (no. 25), holding a rice bag to symbolize his role as giver of fertility and abundant crops. Also included here are

Figure 11 *Omizutori* **Ceremony.**
Preparing torches at Nigatsu-dō, Tōdai-ji

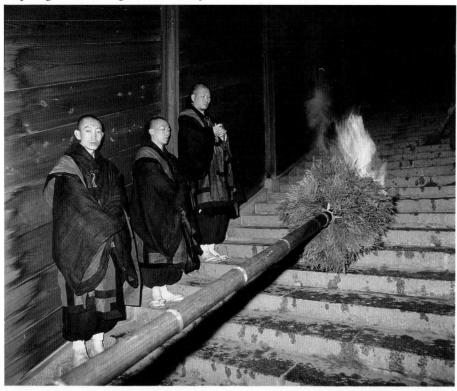

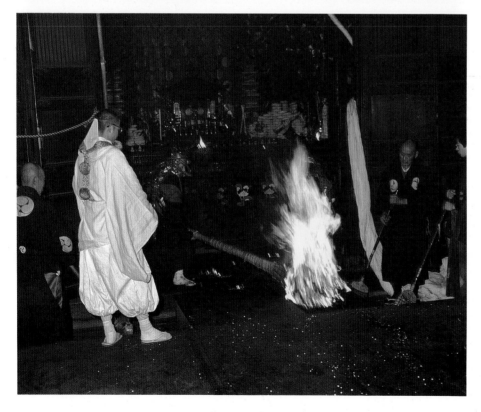

frightening statues of two of the Ten Kings of Hell, who judge the dead to determine whether they shall be punished for misdeeds. Originating in China, the Ten Kings are prominent in popular Buddhist notions of the afterlife throughout East Asia (nos. 20, 21).

Thirteenth-century renaissance

The two largest monasteries in Nara, Tōdai-ji and Kōfuku-ji, were virtually destroyed in 1180 in the civil conflict that led to the founding of Japan's first military government. A cavalry squadron led by Taira no Shigehira (1156–85) inflicted severe retribution on temples that had supported the Minamoto clan, enemies of the Taira. Among Tōdai-ji's major buildings, only the Shōsō-in treasure house and the Sangatsu-dō survived. Reduced to ashes were the Daibutsu-den, the pagodas, Ordination Hall, monks' bath house, dormitories, and dining halls.

The embers had barely cooled, however, when an imperial order was issued to commence reconstruction; and the monk Shunjōbō Chōgen (1121–1206) was appointed chief solicitor to raise funds and direct the rebuilding (see no. 28). The Minamoto clan, emerging victorious in 1185, lent its support to the reconstruction of Tōdai-ji and by doing so helped legitimatize its military government at Kamakura in eastern Japan.

At the same time the Fujiwara family began to restore the neighboring Kōfuku-ji, their tutelary temple, and there ensued a brief period of about thirty years in which the Buddhist sculptors, painters, and artisans of Nara engaged virtually in the mass production of objects needed to furnish these huge sanctuaries. There have been other such moments in the history of Buddhist arts when circumstances conspired to produce a flood of religious art, but none has been so well documented or so well represented by surviving materials. This exhibition contains some of the finest and best-preserved products of this brief renaissance—the hauntingly beautiful portrait statue of Chōgen (no. 28), for example, or three superb

Figure 12 *Omizutori* **Ceremony.**
Exterior of Nigatsu-dō, Tōdai-ji,
with torchlight and lanterns

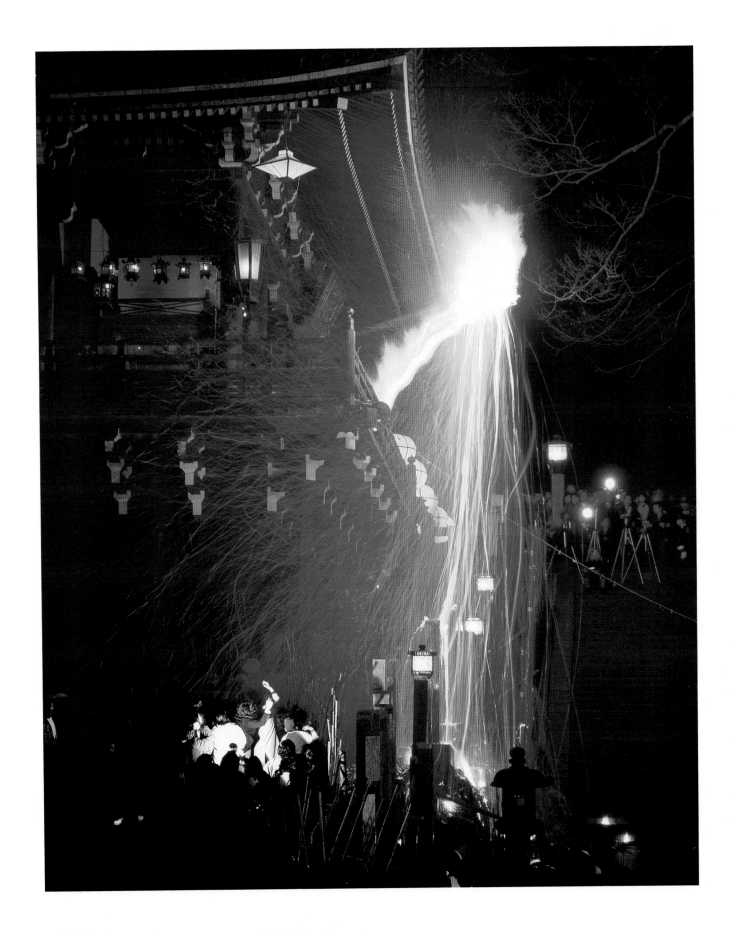

works commissioned from the Nara sculptor An'ami Kaikei (nos. 13–15).

Chōgen, harking back to the cosmopolitan atmosphere of the Tempyō court, enlisted the help of emigré Chinese craftsmen for designing the new buildings and for recasting the *Daibutsu*. Chōgen vaunted his knowledge of things Chinese, claiming to have gone three times to the mainland and to have brought back many Chinese Buddhist paintings and sculptures. Unquestionably he used a new mode of construction from the south Chinese coastal regions in all of his building projects. This mode is readily seen in the Great South Gate (J: Nandai-mon) at Tōdai-ji, the most prominent of Chōgen's surviving buildings (described in Essay 1).

Religious eclecticism. Early in its history Tōdai-ji became a setting for devotional practices of many kinds. The doctrines of all the Nara Buddhist schools were taught there, as were those of Esoteric Shingon Buddhism, introduced in the ninth century by the famous monk Kūkai (774–835). Chōgen himself established a hall for the practice of Pure Land Buddhism based on the teachings of the monk Hōnen (1133–1212), leading proponent of Amida worship and of the doctrine of salvation through rebirth in Amida's Pure Land. Chōgen's successor as chief solicitor was none other than Myōan Eisai (1141–1215), one of the leading apostles of Zen Buddhism in Japan. Tōdai-ji did not become a Zen establishment, but there is no question that the doctrines of the Meditation school were taught there. In addition the Hachiman Shrine continued to be a center for joint Buddhist-Shinto rituals.

Tōdai-ji continued through the Japanese middle ages as an active place of Buddhist practice, and the ruling Ashikaga military clan gave generous support. The Eastern Pagoda, burned in 1362, was rebuilt in 1410 and the *Daibutsu* regilded sixteen years later. Nonetheless medieval Japanese religious life was centered primarily on Zen temples and those of the Pure Land creeds, and Tōdai-ji began to fall into disrepair as Ashikaga rule weakened in the mid-fifteenth century and civil unrest began to spread. The guilds of Buddhist painters in Nara remained active, sustained by commissions from Kōfuku-ji and Tōdai-ji and provincial sanctuaries, but their work took on a somewhat rustic quality (see nos. 47–50) compared with the sophisticated narrative handscrolls of the thirteenth century. In fact, the term *Nara-e* is often used to denote all folkish narrative painting of the later middle ages, whether Buddhist or secular.

Revival in the Edo period

Civil war once again caused havoc at Tōdai-ji. In 1567 the Daibutsu-den and many other halls were burned during a prolonged struggle for supremacy among regional warlords. Once again the great bronze statue sat exposed to the elements—its head fallen, its right hand melted away, and its body warped and misshapen from the heat. Again an imperial rescript ordered immediate rebuilding and the *Daibutsu* was partially repaired, but so great was Japan's political turmoil that full reconstruction could not go ahead successfully until the 1680s, when the Tokugawa shogun Tsunayoshi (1646–1709) put the authority of the military regime behind the work. Today's Daibutsu-den and its sculptures are the products of that effort.

A zealous Tōdai-ji monk, Kōkei (1648–1705) (see no. 29), was appointed chief secretary (J: *kanji shoku*) of the reconstruction project. Modelling his activities on those of Gyōki and Chōgen before him, he toured the country in quest of contributions from all classes of society. Evidence of the magnitude of his task can be seen, for example, in temple records for the sixth month of 1699: the gift of over three thousand copper ingots from a wealthy Osaka merchant, the purchase of 133,660 clay roof tiles, and cash balances of nearly 15,000 kilograms of silver and 1,800 kilograms of gold coins. Even so, the rebuilt statue of Vairocana and the Daibutsu-den were less resplendent than their Tempyō- and Kamakura-period predecessors. The *Daibutsu*, rededicated in 1692, is over a meter smaller than the Nara-period original, and its heavy, glowering face and the rough casting of the body and hands give it far less unity and elegance than are seen in older Buddhist statues.

The great achievements of Japanese art of the Edo period (1615–1867) are not to be found in traditional Buddhist art and architecture. In an age when Confucian ethics had become the official credo of the regime and the Buddhist sects were brought under strict government control, the most creative and gifted artists found inspiration in

secular themes. One has only to compare the eighteenth-century portrait statue of Kōkei (no. 29) with that of Chōgen (no. 28), older by five centuries, to see the differences in artistic attainment. The later work, carved by monks closely familiar with Kōkei, was clearly modelled after the older one, but the subtle insight into human character shown in the Chōgen image has been replaced by a rather straightforward, factitious quality. Other eighteenth-century portrait sculptures in the exhibition show a similar relationship to the classic past; statues of the eighth-century monks Gyōki (no. 30) and Jian Zhen (J: Ganjin) (no. 31), carved during this period of reconstruction to replace lost works, are valuable historically but lack the expressive powers of their prototypes.

The latest reconstruction work at the Daibutsu-den began in 1965 and required seven years to complete. Vast sums of money were contributed by the general public as well as by the government and corporations. Rotted timbers in the Daibutsu-den were replaced, and the giant building was given a new and stronger tile roof. But the refurbishing has not made the Daibutsu-den look sparkling fresh and new. The patina of age so important to the temple's historical identity was skillfully retained by the craftsmen and the temple authorities who directed their work.

A deeply rooted trait of the Japanese national character is the veneration of the past, the desire to perpetuate the nation's historic relics. More than most temples, Tōdai-ji has embodied a political as well as religious heritage, and the restoration of Tōdai-ji has seemed a necessary condition of peace after each period of tumult and destruction. Each generation of restorers has worked in the style of its own times, but each has sought to maintain continuity with both the forms and the spirit of the past. Tōdai-ji, however, has always been more than a mere relic of the past. Its very survival is proof of its vital symbolic significance.

Over the past three decades Tōdai-ji's leading priests, aided by Japan's growing economic prosperity, have given the monastery a new surge of vitality. The clergy at Tōdai-ji are convinced that its buildings and images are still powerful expressions of Buddhist ideals; they are convinced that the Buddhist faith remains as meaningful in an age of computers and space travel as it was in the age of oil lamps and bullock carts. With the United States and Japan closely linked in economic and strategic concerns, they are sending their temple's treasures to Chicago as yet another demonstration of their vision of Tōdai-ji as a living force in this latest phase of its long history.

NOTES

1. For Buddhist doctrines and history, see Conze, *Buddhism: Its Essence and Evolution*, and Suzuki, *Outlines of Mahayana Buddhism*.

2. Cleary, *Entry into the Inconceivable: An Introduction to Hua-yen Buddhism*, and Chang, *The Buddhist Teaching of Totality: The Philosophy of Hwa Yen Buddhism*.

3. See full translation in De Bary et al., eds., *Sources of Japanese Tradition*, pp. 106–7.

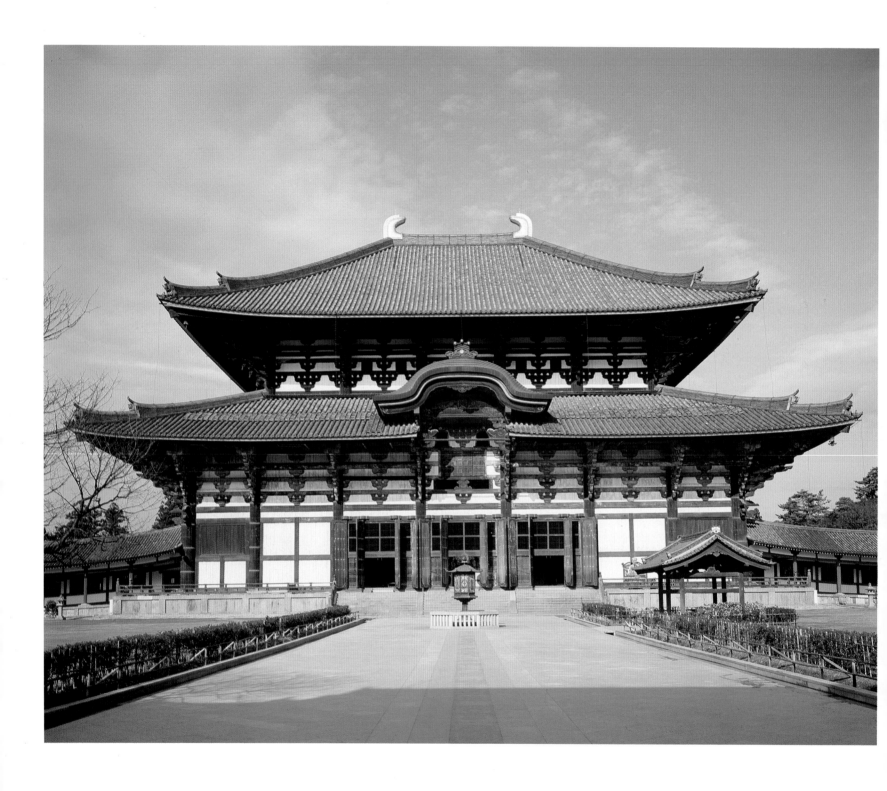

1 Architecture at Tōdai-ji

WILLIAM H. COALDRAKE

BUILT to the east of the Nara capital and set apart from the city's daily life by heavy masonry walls, Tōdai-ji was first of all a monastery. It was also a setting for public ceremonies, and those two different functions are reflected in the structural character of the temple's buildings and in their placement as well.

The lay public, composed primarily of court nobles and government officials, approached the monastery from the south—usually on foot but also in ox-drawn carriages. After passing through the towering Great South Gate, they would proceed down the long pathway to the more modest Inner Gate, and then enter a vast open courtyard. There they confronted the Hall of the Great Buddha (J: Daibutsu-den) (fig. 13), at the time the largest man-made structure in the world—its soaring gray tile roofs and cinnabar-red pillars and beams emanating an aura of enormous power and serene confidence. Inside the hall was the statue of Vairocana, symbolic core of the monastery, towering high in the darkened, incense-laden space. The colossal gilt-bronze image, framed by the geometry of great timber pillars and beams, glistened in the flickering light of candles (see fig. 4).

The community of monks lived and worked in much more modest circumstances in Tōdai-ji's northern and eastern sectors. Their austere lives were governed by the tolling of the giant bronze bell that rang out the watches of the day from its building halfway up the eastern hillside. They shared a large communal bathhouse and dining

hall, worked in vegetable gardens, performed daily rituals in votive halls, and gathered for sermons and instruction in the Lecture Hall (J: Kōdō). Their dormitories, barracks-like buildings with tiny individual cells, were linked to the Lecture Hall by covered corridors. To the west of the Daibutsu-den lay a building of utmost importance in their lives, the Ordination Hall (J: Kaidan-in). There, after years of arduous training, they were given formal rites of initiation into the priesthood.

At Tōdai-ji the two ways of life, monastic and secular, were joined together on ceremonial occasions, as when the lay public attended the reading of holy texts like the *Lotus Sutra* in the Sangatsu-dō, or commissioned vegetarian feasts in honor of the monks, or observed memorial services held in founder's halls before portraits of notable monks such as Rōben or Chōgen. On those occasions monks and laymen alike experienced at Tōdai-ji the unity of art and architecture and faith that is manifest in other great religious monuments—such as Chartres, or St. Peter's in Rome.

Tōdai-ji's sculptors, painters, and artisans produced works of art intended for ritual use. Tōdai-ji's builders planned its votive halls as settings for those rituals, and all were inspired by powerful currents of religious conviction. The works of art in this exhibition convey that spiritual content, but inevitably they have been divorced from the architectural settings that were so important to their function. This essay will introduce the architecture of Tōdai-ji in the hope of enabling the

Figure 13 Facade of Daibutsu-den, Tōdai-ji. Edo period, completed 1707

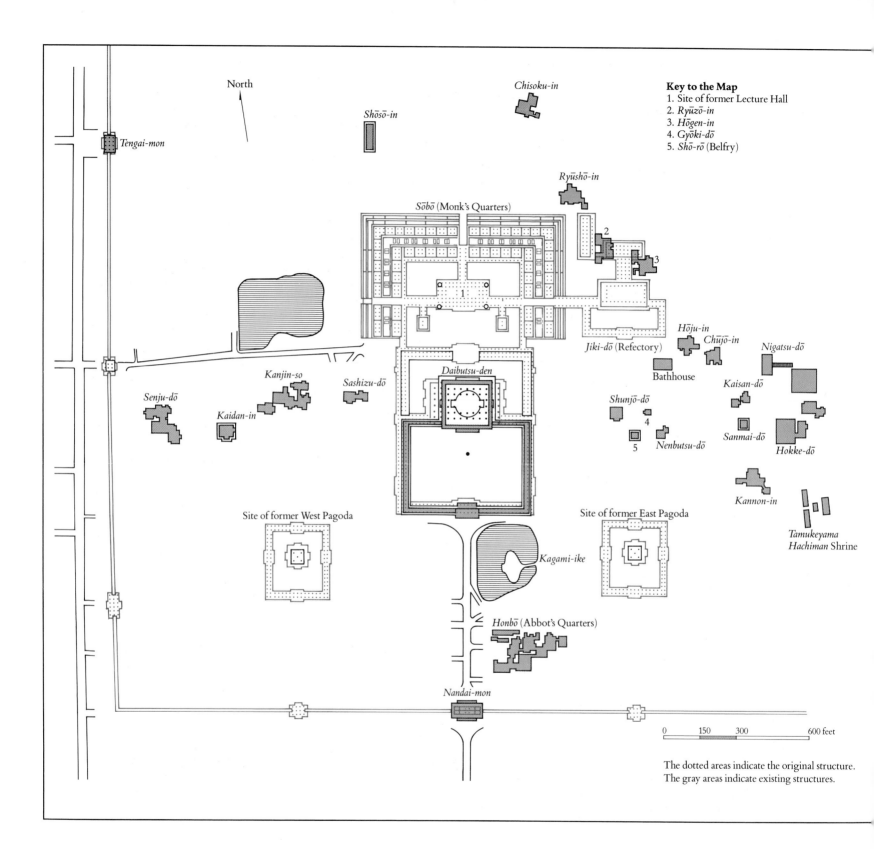

North

Chisoku-in

Shōsō-in

Key to the Map
1. Site of former Lecture Hall
2. *Ryūzō-in*
3. *Hōgen-in*
4. *Gyōki-dō*
5. *Shō-rō* (Belfry)

Tengai-mon

Ryūshō-in

Sōbō (Monk's Quarters)

2

3

Hōju-in

Chūjō-in

Nigatsu-dō

Jiki-dō (Refectory)

Bathhouse

Kaisan-dō

Kanjin-so

Sashizu-dō

Daibutsu-den

Shunjō-dō

Senju-dō

Kaidan-in

4

Sanmai-dō

5

Nenbutsu-dō

Hokke-dō

Kannon-in

Site of former West Pagoda

Site of former East Pagoda

Kagami-ike

Tamukeyama
Hachiman Shrine

Honbō (Abbot's Quarters)

Nandai-mon

0 150 300 600 feet

The dotted areas indicate the original structure.
The gray areas indicate existing structures.

Western viewer to construct a mental setting for the works on display and to understand the myriad ways in which the arts of Tōdai-ji were united by powerful faith.

Organization of the temple site today

Tōdai-ji today still follows the basic plan established at the time of its foundation. Its popular name, literally "Great East Temple," derives from its location on the northeastern side of the city of Nara. The generously scaled site, some 900 meters east-west and approximately 800 meters north-south, is level on the western side but on the east rises 50 meters in a series of terraces up the side of Mt. Wakakusa (fig. 14).

The temple is oriented approximately north-south, its central axis delineated by the main approach avenue running from the Great South Gate (J: Nandai-mon) toward the main precinct 230 meters away. Enclosing the main precinct and separating it from the rest of the temple complex is a covered cloister 110 meters north-south and 170 meters east-west. Entry is via the Inner Gate (J:

Figure 15 Plan of Daibutsu-den after 1973–80 restoration

Chū-mon). The enclosed area is dominated by the Great Buddha Hall (J: Daibutsu-den) set back across an expansive grassed courtyard where, in the fourth month of 752, over ten thousand monks and four thousand performers of court dance and music assembled for the official ceremonies to mark the completion of the primary phase of construction.

As its name implies, the Daibutsu-den houses the principal religious image of Tōdai-ji, the cast-bronze Vairocana Buddha that is called the *Daibutsu*, or Great Buddha. The building is an impressive, almost overwhelming structure, befitting its importance (figs. 1, 3). Reputed to be the largest timber-frame building in the world, the Daibutsu-den is 57 meters wide, 50.5 meters deep, and 49.1 meters in height to the roof ridge. Its form demonstrates general principles of East Asian Buddhist architecture as practiced in Japan. The plan is square, and the structure consists of a timber frame of towering pillars, some nearly 33 meters high, braced by horizontal tie beams (figs. 15–17). This structure of post-and-lintel units creates seven bays on each of the four sides of the building. The frame is set upon a stone-faced podium, much in the manner of the typical Chinese building. From the outside the Daibutsu-den is dominated visually by the upper hip roof, with a second, lower, hip roof over the outer bays of the structure at the first-story level (fig. 16). The interior, however, is a single unified space that rises up to the ceiling suspended from the main roof truss. Both roofs are covered with terra-cotta tiles—gently curved pantiles laid in long rows down the roof surfaces, and semicircular cover tiles that close the gaps between the rows of pantiles. A typical pantile weighs 15.5 kilograms, creating a load on the roofs in excess of 2,000 tons. The weight of the roof tiles and the supporting truss stabilizes the building by anchoring the timber frame to the podium, and by locking together the mortise-and-tenon joints that connect the pillars and beams.

A special feature of East Asian temple architecture is the use of bracket sets that project from the main pillars to support the eaves. It is these bracket arms that allow the bold sweep of the eaves beyond the line of the walls, which gives the buildings their characteristic appearance. The bracket set works on the mechanical principle of the cantilever: the

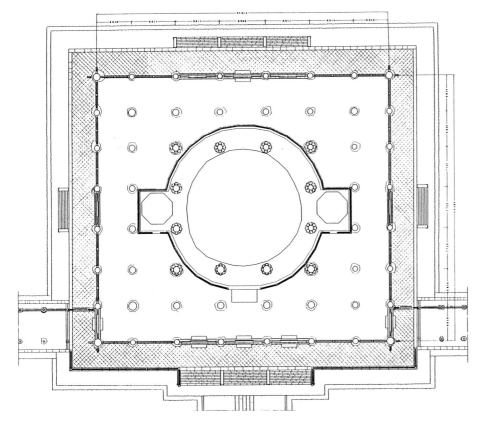

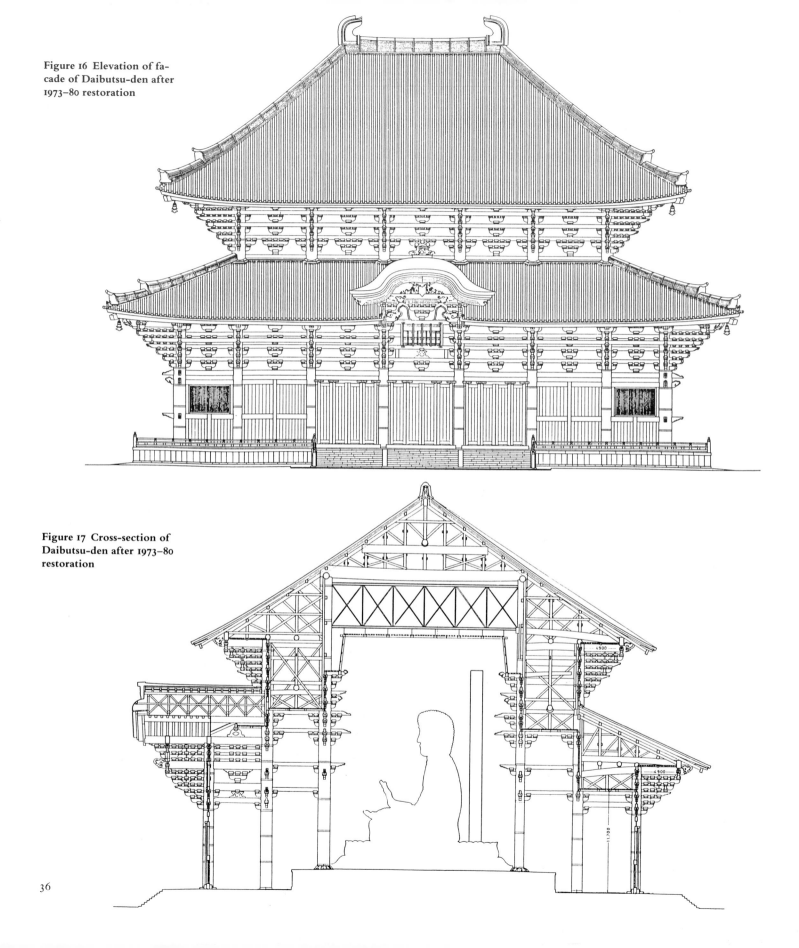

Figure 16 Elevation of fa-
cade of Daibutsu-den after
1973–80 restoration

Figure 17 Cross-section of
Daibutsu-den after 1973–80
restoration

inner end of the main bracket arm is secured into position by the load of the roof, which converts across the fulcrum of the pillar into an upward thrust to support the eaves.

Other important parts of the Tōdai-ji complex today include the Ordination Hall (J: Kaidan-in) to the west of the main precinct, and the Nigatsu-dō and Sangatsu-dō (fig. 19), halls for reading sutras in the second and third months of the year, all set into the rising ground of Mt. Wakakusa to the east of the main buildings. To the north is the Shōsō-in, the storehouse holding the household treasures of Emperor Shōmu (fig. 20), and to the south across a mirror-shaped lake are the main administrative offices of the temple, recently constructed in ferroconcrete imitation of timber-frame temple architecture.

The Tōdai-ji site follows general principles of East Asian site planning that were introduced to Japan along with Buddhism and Chinese civilization from the sixth century onward. These principles are also exemplified in the Hōryū-ji temple complex, established in the early seventh century, and in planned capital cities of the age, especially Nara,

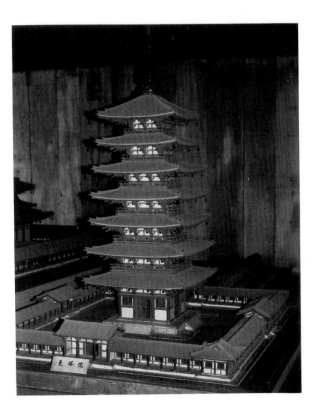

Figure 18 Model of East Pagoda, Tōdai-ji. Built late 8th century, destroyed 1180

on whose eastern edge the new temple took shape. The central concept was a direct correlation between the essential order of the cosmos and visible order in the physical world. This equation was expressed in axiality, hierarchy, and geomancy. Chief among geomantic principles was the notion that good and evil influences operated on places and on the people and activities in them. Good emanated from the south and evil from the north, therefore any building or complex, irrespective of its size or function, should face the felicitous south and be protected on its northern side.

More than a millennium later, evidence of these concepts is still apparent at Tōdai-ji. The gateways establish a hierarchy of spatial values along the main south-north axis of the temple site, with the most important building located on axis but set apart from the rest of the temple complex by an enclosed corridor. The high ground of Mt. Wakakusa to the northeast provides geomantic protection to the entire institution.

Tōdai-ji at the time of Emperor Shōmu

Tōdai-ji has lost most of its original buildings to natural disasters and to the civil wars of the twelfth and sixteenth centuries, but archaeological investigation and early descriptions and maps have established that the present layout of buildings reflects the original eighth-century plan (fig. 14).[1] The site was originally enclosed on the south and west sides by walls, each with three gateways. This was in conformity with Chinese tenets of site planning, but today the walls and all but one of the original Nara-period gateways, the Tegai-mon in the northwest corner, have disappeared.

In the eighth century there were two smaller compounds immediately south of the Daibutsu-den precinct. These enclosed a pair of matching seven-story pagodas. The symmetrical east-west placement of a pair of pagodas across the primary south-north axis of the temple was based on customary Chinese temple planning practice at the height of the Tang dynasty in the eighth century.

Each pagoda exceeded 100 meters in height, equivalent to a thirty-story office block today (fig. 18). This places them amongst the tallest wooden structures erected before the invention of steel-frame construction, and demonstrates the sophis-

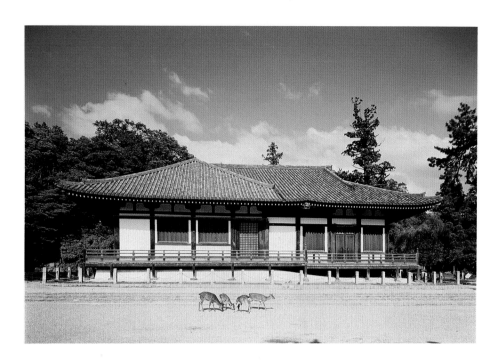

Figure 19 Exterior of San-
gatsu-dō, Tōdai-ji. Mid-8th
century

not only the Daibutsu-den itself but also the
cloister that enclosed it, the covered walkways that
linked the hall with the cloister, and the gateways
in the cloister walls. It also includes the East and
West Pagodas and their own surrounding cloisters.

Amanuma's reconstruction of the eighth-century
Daibutsu-den differs from the present-day building
in several major ways. Amanuma established that
the original Daibutsu-den was over thirty percent
wider than today's building; it measured 86.1
meters instead of today's 57.1 meters, and the first-
story facade was divided into eleven bays instead of
today's seven. The lower roof of the original
building was stepped up over the central seven
bays of the facade both for visual emphasis and for
relief from the sense of massive weight generated
by the heavy gray roof tiles.[2] Amanuma's recon-
structed Daibutsu-den is imbued with a much
stronger sense of harmonic proportion than is the
current building, whose ungainly upper story is
but five bays wide in contrast to nine bays in the
original.

The most important eighth-century building to
survive at Tōdai-ji is the Sangatsu-dō (Third-
Month Hall, also known as the Hokke-dō, or
Lotus Hall) (fig.19). As the names imply, it is used
for ceremonial readings of the *Lotus Sutra* in the
third month of each year. Set some 300 meters east
of the main compound on the second terrace up
the side of Mt. Wakakusa, the Sangatsu-dō is a
much larger building than photographs suggest. It
comprises two main parts, an inner hall (J: *hondō*)
and an outer hall (J: *raidō*) connected directly to it
on the south side. The inner hall is five bays square
with a pyramid-shaped tiled roof. Its interior space
is approximately 25 by 19 meters and is dominated
by a podium holding some of the finest sculpture
to survive from the Nara period, including the
Fukūkenjaku Kannon. The outer hall, three by five
bays, has a gabled roof with hip eaves. This roof
abuts awkwardly the pyramidal roof of the inner
hall, distorting the symmetrical clarity of its shape.
Recent restoration has confirmed that the outer hall
was added to the building in 1199,[3] possibly to
house the congregation for *Lotus Sutra* readings.

There is some controversy about the date of the
inner hall. Official temple records state that the
Sangatsu-dō was constructed as the main building
of a small temple complex, the Konshō-ji, in 733,
more than a decade before work began on Tōdai-ji

tication of the techniques of timber-frame joinery
and flexible frame construction used in Japan in the
eighth century. Both pagodas were destroyed, by
civil war and fire caused by lightning, but the
impressive earth mounds upon which each stood
are still clearly visible approximately 100 meters to
the southeast and southwest of the main com-
pound.

Tōdai-ji also maintained buildings dedicated to
the practical as well as the spiritual life of the
temple. Immediately north of the Daibutsu-den
were two large dormitories for the monks. The
buildings were **L**-shaped in plan and faced inward
to enclose a large courtyard containing the Lecture
Hall, where sutras were read and expounded to the
monks on special occasions, a bell tower, and a
sutra repository. Refectories, bathhouses, and
latrines were placed conveniently close to the
dormitories on the east.

The eighth-century Daibutsu-den does not sur-
vive, but its original form was reconstructed at the
turn of this century by the architectural historian
Amanuma Shun'ichi, using eighth-century records
and archaeological evidence. A model of the
original hall, built under Amanuma's supervision,
will be included in the Chicago exhibition. Mea-
suring 400 centimeters square, the model is one-
fiftieth of the original precinct's size and comprises

Figure 20 Exterior of
Shōsō-in, Tōdai-ji. Late
Nara period, 8th century

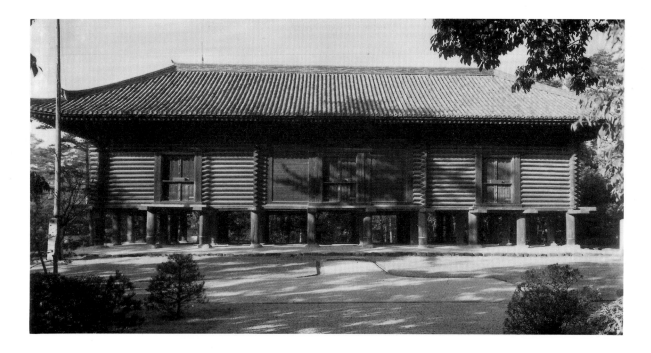

(see Introduction, "The founding of Tōdai-ji").
Other records suggest it was built in 746.[4] Physical
evidence, such as the style of some of the roof tiles
and some architectural details, hints at a slightly
later date. It may be safely assumed that the
Sangatsu-dō was built no later than the major part
of Tōdai-ji, in the middle decades of the eighth
century.

One other important building at Tōdai-ji dates to
the eighth century. This is the Shōsō-in, the
storehouse constructed to preserve the sumptuous
household possessions and art treasures of Em-
peror Shōmu after his death (fig. 20). The Shōsō-in
stands approximately 300 meters north (and
slightly west) of the Daibutsu-den. It is built in the
style of the ancient log storehouses of Japan's pre-
Buddhist age, with a floor raised high above the
ground and walls of roughly hewn cypress logs
laid horizontally and intersecting at the corners like
a log cabin (fig. 21). This building technique,
known as *azekura*, was devised to store grain, and
even at the height of continental influence it was
still considered to produce the most effective
environment in which to preserve objects. The
natural seasonal expansion and contraction of the
cypress timbers made the Shōsō-in airtight during
the destructive dampness of summer and permitted
ventilation in the dry winter months. Originally

the Shōsō-in comprised two separate square store-
houses linked by a common roof, but the space
between them was later walled in to increase
storage space.

The construction of Tōdai-ji under Emperor Shōmu

The construction of Tōdai-ji was a government
project on a scale unparalleled in Japan to that
time. It was a tangible affirmation of religious
belief as well as a demonstration of the physical
resources of the state under Emperor Shōmu. Like
the great cathedrals of Europe, however, it was not
the exclusive enterprise of a small elite but
involved the collective attention, energy, and dedi-
cation of an entire community. Begun in 745, the
Daibutsu and its hall, though still unfinished, were
dedicated in 752. Other buildings, such as the twin
pagodas, Lecture Hall, and Ordination Hall, were
not finished for several more years. Much of the
financing came from the state, but significant
public support was also generated by the ardent
nationwide fund-raising efforts of the monk
Gyōki, who had been appointed chief solicitor for
Tōdai-ji. Temple tradition holds that Gyōki elicited
contributions of timber for construction from fifty
thousand people, received donations of gold coins,

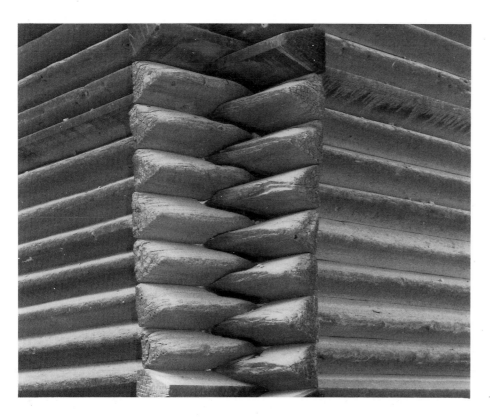

Figure 21 Detail of log-cabin construction technique (J: *azekura*) used in Shōsō-in

copper goods, and other valuable objects from as many as three hundred and seventy thousand others, and mobilized as many as 1.6 million volunteer laborers over the course of the project.

A vast army of administrators, site supervisors, skilled craftsmen, and laborers thus participated in the construction process, under the superintendence of the Office for the Construction of Tōdai-ji (J: *Zō Tōdai-ji Shi*), a government department directed by the monk Rōben and high-ranking aristocrats of Shōmu's court. The Office was divided into nine separate departments, each responsible for a different aspect of the project. One department prepared models for the *Daibutsu*, another actually cast and gilded the image. Other departments manufactured the prodigious quantity of tiles necessary to roof the many buildings, or prepared the sacred paintings for the various devotional halls, or copied sutras for the libraries. The Timber-Collection Department dispatched lumbermen west to Arima (near Kobe) for the forty-eight principal pillars of the Daibutsu-den, each 30 meters long and 1.5 meters in diameter. The mountains around Lake Biwa, north of Nara,

provided the subsidiary pillars and other hardwood timber. The Transportation Department floated the timber from mountain forests to collection points along local rivers—particularly the Uji, Iga, and Kizu.[5] The Building Department prepared and erected the timbers, employing 227 site supervisors, 917 master builders, and 1,483 laborers. At peak periods of construction over a thousand cooks prepared meals for the laborers on site.[6]

Possibly the most arduous aspect of the project is the least obvious to the observer today. The entire site for the temple was hollowed out of the side of Mt. Wakakusa. Starting in 745, half the side of the mountain, over a distance of 700 meters, was excavated to a depth of 10 to 30 meters, transforming the slope into four terraces. The most westerly terrace held the Ordination Hall and West Pagoda. On the second terrace, some ten meters higher and immediately to the east, was the main precinct, containing the Daibutsu-den. Fifteen meters farther up the site, on the third terrace, was the East Pagoda, while on the highest and easternmost level stood the Sangatsu-dō and a number of other buildings. Casual observation of the temple site today gives little indication of how radically the site was remodeled in the eighth century. The original ground level was higher than the first-story roof of the present Daibutsu-den.

The form of the Daibutsu-den was closely determined by its function as a setting for the *Daibutsu*. Neither the *Great Buddha* nor its Great Hall survives today as initially executed in the eighth century, but it is clear that the sculpture was designed and mostly completed before the building that was to house it. The Daibutsu-den was thus the architectural servant of the sculpture. Its interior was planned around the central bronze figure and even today is dominated by the dais on which it sits. The surrounding bays of the building permit worshippers to view the sculpture from all four sides. Originally the plan was rectangular, with an additional two bays on each side of the main figure for attendant bodhisattva sculptures. In both the original plan and the present-day version, therefore, the interior of the Daibutsu-den was designed to create a centrifugal focus on a sculptural core (fig. 15). This instance of a building designed around a monumental Buddhist figure stands in marked contrast to the classical Mediterranean practice of conceiving the sculptural pro-

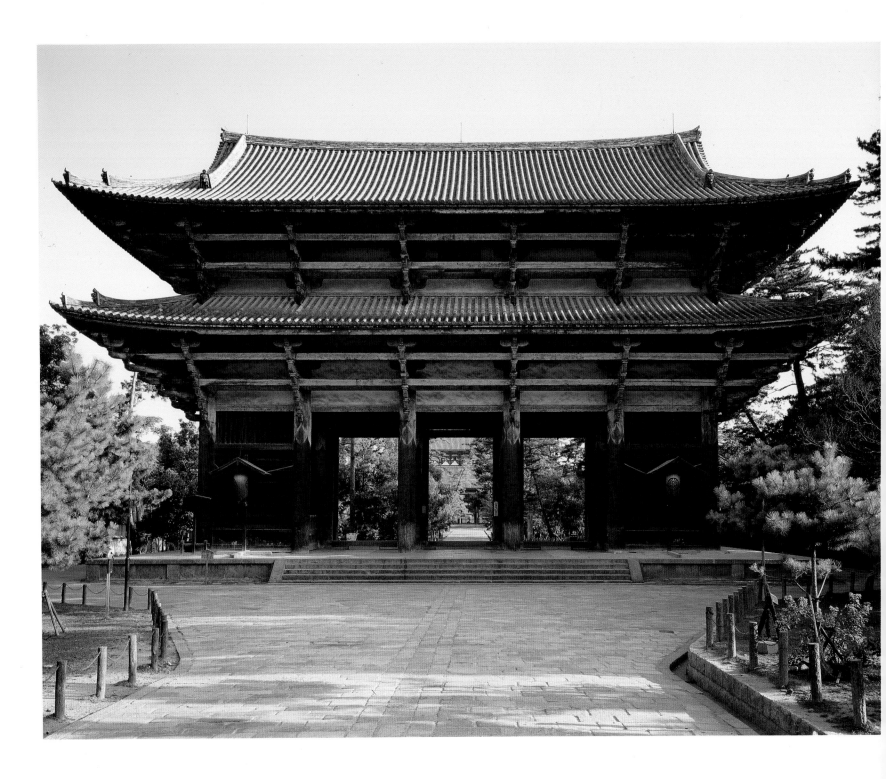

**Figure 22 Facade of Nandai–mon,
Tōdai-ji. Kamakura period, com-
pleted 1195**

gram only after the basic design of the temple had been decided upon.

The first reconstruction: Chōgen's rebuilding

Although a typhoon demolished the Great South Gate in 962, Shōmu's temple survived virtually intact until 1180, when much of the southern part of the city of Nara was ravaged by Taira forces fighting the Minamoto clan (see Introduction and no. 28). Most of Tōdai-ji, including the Daibutsu-den and its covered cloisters, was razed. Of the Nara-period buildings only the Sangatsu-dō,

Shōsō-in, and some dozen lesser structures, mainly gateways, remained standing.[7]

The following year an imperial proclamation ordered Tōdai-ji rebuilt. But the court's resources were depleted by the rebuilding of Kōfuku-ji, family temple of the all-powerful Fujiwara clan, which had also been destroyed by Taira troops. The rebuilding of Tōdai-ji was financed instead by popular contributions and, after 1185, by the newly victorious Minamoto clan. The public donations were solicited throughout the country by the monk Chōgen, who also directed the reconstruction. Minamoto patronage was motivated by politics as well as piety: their support for Tōdai-ji helped validate the new shogunal government which they founded.

Recasting of the *Daibutsu* began in 1181, and the "eye-opening ceremony" was held in 1185. Reconstruction of the Daibutsu-den was delayed several years by insufficient building materials and money. Strenuous searching by Chōgen finally located trees suitable for the principal pillars in the distant province of Suo (present-day Yamaguchi Prefecture), at the western end of Honshu. In the tenth month of 1187 the lumber, including a beam approximately 39 meters long to be used for the ridgepole, was transported by ship along the inland Sea and local rivers to Nara.[8] Actual building did not get underway until 1189, when Minamoto sponsorship had been secured, and it drew to completion in 1203.[9]

Reconstruction focused, of course, on rebuilding the Daibutsu-den. Chōgen's plan followed the basic dimensions of the eighth-century building, whose ruined podium was still visible after the fire, but the architectural style was new, based upon forms popular in contemporary southeastern China and much admired by Chōgen. In the later sixteenth century civil war again claimed the Daibutsu-den, but three buildings from Chōgen's reconstruction survive today: the Founder's Hall (J: Kaisan-dō), dedicated to the monk Rōben; the outer hall of the Sangatsu-dō; and the Great South Gate (J: Nandai-mon). The Nandai-mon, at the southern perimeter of the temple complex, was constructed in the same style as the Daibutsu-den (fig. 22).[10] Completed in 1195, it is a massive two-story building five bays wide and two deep. It stands 25.7 meters high and has a frontage 29.7

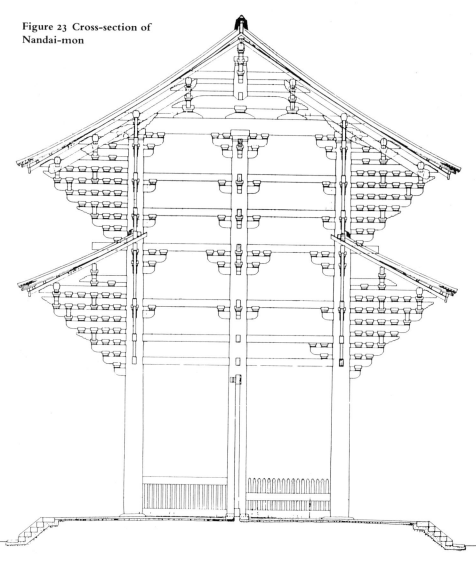

Figure 23 Cross-section of Nandai-mon

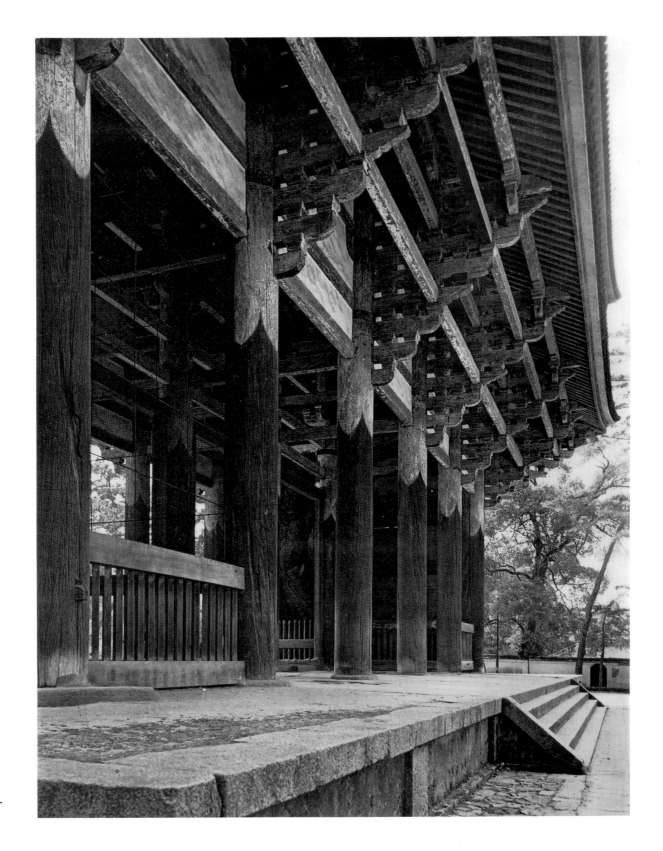

Figure 24 View of Nandai-
mon showing bracket sets

meters wide. From the outer bays a pair of guardian deities carved in wood, each over 8 meters tall, glower fiercely over the approach avenue (fig. 32).

Structurally the Great South Gate is radically different from the typical two-story gateways of the Nara period, in which the pillars of the lower and upper floors were separate members. In the Great South Gate three rows of six pillars rise 21 meters through both levels of the structure to support the roof truss (fig. 23). A grid of tie beams penetrates these pillars horizontally for lateral support, the outer ends of the ties forming part of the bracket sets that support the eaves. These are the largest bracket sets on any extant East Asian building. Each set rises through nine tiers of horizontal arms to carry the eaves over five meters beyond the wall plane (fig. 24). Single horizontal ties that run parallel to the walls of the building brace these projecting bracket arms.

The Great South Gate is the best-preserved example of this style, known in Japan as either *Tenjiku-yō* or *Daibutsu-yō*.[11] Little evidence of its Chinese antecedents survives in the coastal regions of southern China where Chōgen is said to have visited. In Japan this austerely pragmatic form did not endure much beyond Chōgen's lifetime,[12] but it permitted the efficient production of large-scale, sturdy structures at the Tōdai-ji rebuilding.[13]

The Tokugawa reconstruction

In 1567 the Daibutsu-den was again destroyed, this time during civil wars that lasted from the late fifteenth to the early seventeenth century. After the middle of the seventeenth century, when the Tokugawa family had gained control of the country and established itself as the effective government of Japan, state-sponsored construction went mostly to expanding the Tokugawa headquarters city of Edo (present-day Tokyo). Since Tōdai-ji was located neither in the new shogunal capital of Edo nor in the old imperial capital of Kyoto, reconstruction of the Daibutsu-den was not to the immediate political advantage of any of the major forces to emerge from the struggle for supremacy.

In the decades surrounding the beginning of the eighteenth century, the Daibutsu-den was finally reconstructed as the building that stands on the site

to the present day. Like its two earlier incarnations, this one was brought about by a pious individual who elicited both government and private support. Takamatsuin Kōkei was a monk profoundly moved by the sight of the *Daibutsu* in ruins. He secured the shogunate's support for recasting the statue and rebuilding its hall. Like Gyōki and Chōgen, Kōkei also solicited donations throughout the land (see no. 29). The process of recasting the *Great Buddha* began in 1685 and was completed in 1692. In 1688 plans for the new Daibutsu-den were drawn by master builders of the Nakai family from Kyoto, who had charge of shogunate construction projects in the Kyoto-Osaka area. Their plans maintained the generous size and eleven-by-seven-bay dimensions of the earlier Great Buddha halls. But insufficient funds compelled a reduction of nineteen meters and four bays in the width of the facade despite the shogun's personal donation of one thousand pieces of silver.[14] The building completed in 1707 is as deep as its predecessors and stands 2.8 meters higher than the eighth-century Daibutsu-den, but it is square rather than rectangular, with only seven bays on each side.

Suitable timber for the pillars was hard to come by in a nation seriously depleted of hardwoods after more than a century of energetic castle, palace, and temple building. Timber for the Tokugawa-period Daibutsu-den had to be brought by sea from as far away as the mountains of Hyūga Province (present-day Miyazaki Prefecture) in Kyushu.[15] Even these timbers were too narrow to provide adequate structural support, and the principal pillars had to be girded with thick slats held in place by iron bands.

Although the present building retains something of the flavor of the Chōgen structure, with such features as multiple-tier bracket sets, it also reflects stylistic innovations of the later sixteenth and early seventeenth centuries, particularly in the incorporation of a large cusped gable (J: *karahafu*) into the center of the front facade. This boldly ornamental form had become an almost ubiquitous symbol of authority in the preceding century and was considered an essential addition to the original design of the building. Its use at Tōdai-ji may also have been prompted by its presence on the Great Buddha Hall built in Kyoto by the Toyotomi clan, whose extermination consummated Tokugawa supremacy.

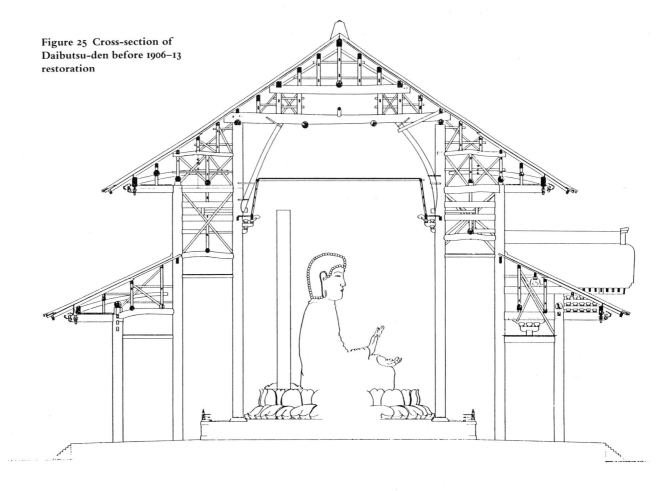

Figure 25 Cross-section of Daibutsu-den before 1906–13 restoration

Recent restorations of the Daibutsu-den

Twice since the end of the nineteenth century the Daibutsu-den has needed repairs, because age and rainwater damage had weakened structural members. Both times, the engineering and other technical problems caused by the scale of the structure challenged modern technology.

Before the restoration of 1906–13 the crucial bracket sets supporting the corners of the roofs had buckled as much as twenty degrees, and the main truss supporting the roof ridge was in danger of collapse. The Daibutsu-den was dismantled completely, structurally weakened members were replaced with new timbers, and steel braces were inserted to strengthen the roof truss. (Compare fig. 17, showing the Daibutsu-den today with its steel bracing, with fig. 25, which shows the structure immediately prior to the 1906–13 restoration.) This bald summary belies the magnitude of the project, which was a remarkable demonstration of newly acquired Japanese mastery of advanced Western engineering techniques employed to rescue a traditional building. The box trusses that helped support the original roof truss were made of Shelton steel imported from England.

In 1969–70 a detailed investigation revealed that the basic structure of the Daibutsu-den was still sound but that partial repair of the roofs was once again essential. Rain driven by high winds had leaked into the roofs, had washed away most of the mortar that affixed the tiles, and was rotting the supports beneath. Ironically, the problem was caused in part by the decision seventy years earlier to space the rows of roof tiles more widely, in order to promote structural longevity by reducing the weight of the roofs.

The ensuing restoration, which lasted from 1973 to 1980, concentrated on solving the roofing problems. It also took advantage of the partial dismantling to correct the angle of the upper roof, restoring it to the slightly lower pitch that had

been used in the reconstruction completed in 1707. The cost was nearly four billion yen, or close to twenty million dollars. Three billion yen was supplied by the national government, and Nara prefectural and city governments also contributed. Tōdai-ji itself raised 543,934,000 yen toward the cost of the project, much of it from public subscriptions. Approximately 20 percent of the total timber and 59 percent of the roof tiles had to be replaced, amounting to 528,000 cubic meters of wood and 63,595 tiles.[16] The gently concave pantiles, approximately 55 by 47 by 3.5 centimeters, weighed 15.5 kilograms, twice the size and weight of tiles used for other temple buildings. It required much experimentation and meticulous attention to the composition of the clay, shape of each tile, and exact firing temperature to create the new tiles. Roof tiles from various stages of Tōdai-ji's history are exhibited here (no. 78). Even the great steel-frame canopy that protected the Daibutsu-den during restoration represented a technical triumph, because of the size of the structure it had to enclose. The logistical magnitude and technical complexity of these recent restorations help us to appreciate the accomplishment of the original builders of Tōdai-ji.

Conclusion

Despite numerous physical calamities over the twelve hundred years since its foundation, Tōdai-ji has endured. Like most abiding religious edifices, it stands now as an expression of the faith—and the political exigencies—of successive governments and individuals. The rebuildings shed light on the processes of Japanese history, and have increased rather than diminished the architectural significance of Tōdai-ji. Its present structures exemplify building styles of which almost no other examples survive, and range from the Shōsō-in, whose style antedates the introduction of Buddhism to Japan in the sixth century, to the latest restorations of the Daibutsu-den. Tōdai-ji has thus become a physical record of major styles in Japanese architecture over twelve centuries. In common with many of the great structures of the classical world and medieval Christendom, Tōdai-ji has acquired transcendental meaning and that "lasting presence"[17] which distinguishes the monumental from the momentary.

NOTES

1. See *Nara Rokudai-ji Taikan*, vol. 9: *Tōdai-ji 1*, pp. 11–13. (*Nara Rokudai-ji Taikan*, a multivolume study of the "six great temples of Nara," devotes vols. 9–11 to Tōdai-ji. These volumes are titled *Tōdai-ji 1*, *Tōdai-ji 2*, and *Tōdai-ji 3*, and will be cited hereafter in this abbreviated form.)

2. Suzuki, "Daibutsu-den to Shōwa Daishūri," p. 163. Tōdai-ji Daibutsu-den Shōwa Daishūri Shūri Iinkai, ed., *Kokuhō Tōdai-ji Kondō [Daibutsu-den] Shūri Kōji Hōkoku-sho*, vol. 1, p. 29.

3. Nara-ken Kyōiku Iinkai, ed., *Kokuhō Tōdai-ji Hokke-dō Shūri Kōji Hōkokusho*, p. 4.

4. See *Kokuhō Tōdai-ji Hokke-dō Shūri Kōji Hōkokusho*, pp. 1–3.

5. See *Tōdai-ji 1*, app. 6, pp. 1–12.

6. These figures based on Kato, *Nara no Daibutsusama*, pp. 26–27.

7. *Tōdai-ji 1*, pp. 13–14.

8. *Tōdai-ji 1*, p. 14.

9. Tanaka, "Chūsei Shinyōshiki ni okeru Kōzō no Kaikaku ni Kansuru Shiteki Kōsatsu," p. 282.

10. The outer hall of the Sangatsu-dō reveals traces of Chōgen's influence along with attempts to make it harmonize with the form of the earlier inner hall. See Nara-ken Kyōiku Iinkai, ed., *Kokuhō Tōdai-ji Hokke-dō Shūri Kōji Hōkokusho*. The Founder's Hall had been spared from destruction during the Taira raid, but was rebuilt by Chōgen nevertheless, possibly because it was in disrepair. See Nara-ken Kyōiku Iinkai, ed., *Kokuhō Tōdai-ji Kaisan-dō Shūri Kōji Hōkokusho*, pp. 1–3.

11. Neither term is particularly germane. *Tenjiku-yō* means "Indian style" and is a term that came into general use in the late nineteenth century in the mistaken belief that the style had some association with India. *Daibutsu-yō*, or " Great Buddha style," has more general currency among present-day scholars, but its referent is a building that no longer exists.

12. In addition to reconstructing Tōdai-ji, Chōgen established seven regional monasteries affiliated with Tōdai-ji. Only one survives, the Jōdo-ji, at Ono in Hyōgo Prefecture, but all these buildings almost certainly echoed the new Tōdai-ji style. See further Tanaka, "Chūsei Shinyōshiki ni okeru Kōzō no Kaikaku ni Kansuru Shiteki Kōsatsu," pp. 282–83. The main hall of Jōdo-ji, the Jōdo-dō, displays a simpler version of the Nandai-mon style, with fewer bracket arms, no exterior lateral bracing, and less ornamentation. See *Tōdai-ji 1*, p. 23.

13. The style used under Chōgen's direction at Tōdai-ji may have been only loosely based on Song Chinese principles. There is no proof that Chōgen had the

architectural training necessary to explain technical details of Chinese construction to the Japanese carpenters at Tōdai-ji. Although official Tōdai-ji records mention the presence of as many as seven Chinese artisans at the rebuilding, these were metallurgists employed on the recasting of the *Daibutsu* image, and stone masons who rebuilt its foundations. Tanaka Tan suggests that Chōgen probably first applied his experience with Chinese Buddhist architectural styles at Daigo-ji, near Kyoto, and on Mt. Kōya, several years prior to the Tōdai-ji project. This set the stage for the integration of existing Japanese technology with imported stylistic ideas at Tōdai-ji. See Tanaka, "Chūsei Shinyōshiki ni okeru Kōzō no Kaikaku ni Kansuru Shiteki Kōsatsu," p. 283.

Ōta Hirōtarō agrees with Tanaka that the new Tōdai-ji building style was adapted in the light of existing Japanese construction techniques. He also points out that the style was in many ways a logical solution to the problem of large-scale construction. Chōgen was no doubt also aware that the earlier Nandai-mon had been destroyed by a typhoon and was anxious to ensure that his structure did not meet a similar fate. This in itself would account for much of the attention to multiple-level lateral bracing in the present building. See *Tōdai-ji 1*, p. 25.

14. Kako, *Nara no Daibutsusama*, p. 72; Suzuki, "Daibutsu-den to Shōwa Daishūri," p. 163; *Tōdai-ji 1*, p. 16.

15. *Tōdai-ji 1*, app. 6, p. 2.

16. Data supplied at *Tōdai-ji Exhibition to Commemorate the Completion of the 1973–1980 Restoration*, Nara National Museum, Nara, September–October, 1980. See also Tokyo Kokuritsu Hakubutsukan, *Tōdai-ji Ten*, pp. 163–70.

17. William J. R. Curtis, "Modern Architecture, Monumentality, and the Meaning of Institutions: A Reflection on Authenticity," in *Monumentality and the City*, The Harvard Architectural Review IV (Cambridge, Mass.: MIT Press, 1984), p. 65.

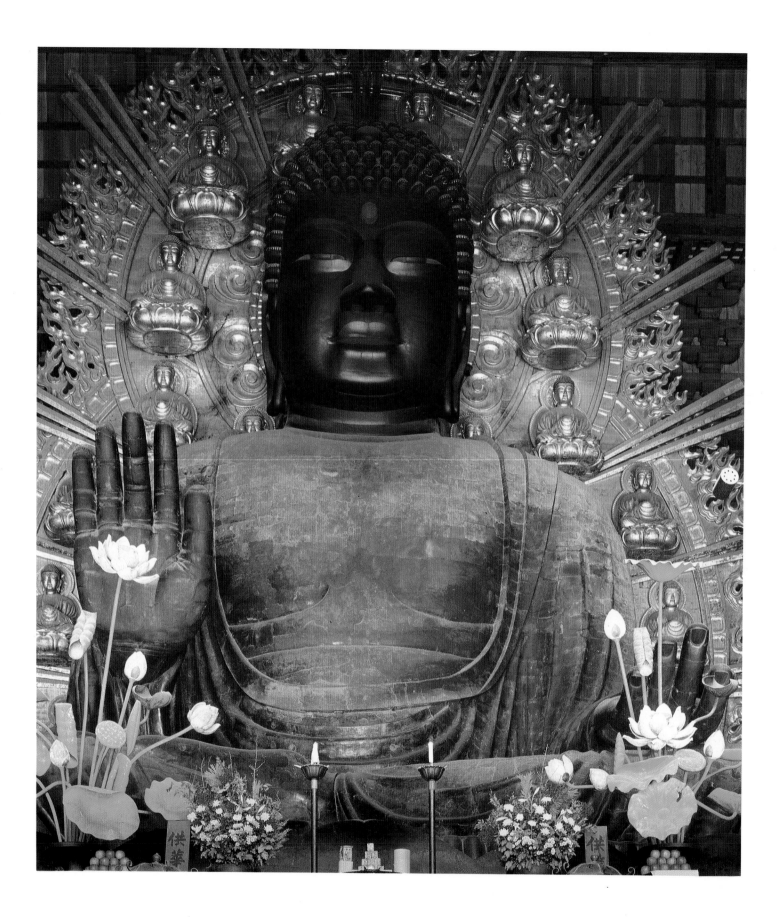

2 Sculpture at Tōdai-ji

SAMUEL C. MORSE

VIEWED by millions of visitors to Tōdai-ji from both Japan and the West, the colossal Vairocana (fig. 26), the main image of the temple, is the largest freestanding bronze statue in the world and certainly the best known of all Japanese sculptures. Tōdai-ji, however, houses a great many statues that are art-historically more important than this one. Some, such as the monumental images of Fukūkenjaku Kannon (S: Amoghapāsa) and his attendants (fig. 9), enshrined in the Sangatsu-dō on the hill to the east of the Daibutsu-den (Great Buddha Hall), can be viewed at any time. Others, including the portrait statue of the monk Rōben (689–773) (see no. 27), a founder of the temple, kept in the Founder's Hall (J: Kaisan-dō), and Rōben's personal devotional image of the guardian deity Shūkongō-jin (S: Vajradhara) (fig. 27), also in the Sangatsu-dō, are accessible to the public only once a year. Still others, such as the statue of Eleven-headed Kannon (J: Jūichimen Kannon; S: Ekādasamukha Avalokitesvara), which is the main image of the Nigatsu-dō, are too sacred to be viewed even by the monks of the temple. Taken as a whole, Tōdai-ji houses many of the most important works of Japanese Buddhist sculpture produced between the time of the original casting of the *Daibutsu* (*Great Buddha*) in the mid-eighth century and its second recasting at the end of the seventeenth century.

Twice during its history the temple was a major center of sculptural production and innovation—first during the middle decades of the eighth century, when the monastery was founded, and again during the early decades of the Kamakura period (1185–1333), when the temple was rebuilt after many of its halls had been lost to fire. These two eras differed considerably—in the circumstances of production and in the materials (and hence techniques) preferred by the sculptors. The anonymous eighth-century artists worked directly for the central government in the labor-intensive materials of bronze, lacquer, and clay; whereas the sculptors of the Kamakura period, artists such as the celebrated Unkei and Kaikei, whose careers are well documented, worked exclusively in wood and were employed by the temples themselves.

Stylistically, however, the sculpture of these two periods is closely linked. In fact, the thirteenth-century artists drew inspiration from the master-pieces of the eighth century, and many of their most important commissions were to replace original works that had been lost to fire. Furthermore the artists of both periods shared a deep interest in the expressive possibilities of an essentially naturalistic idiom and were directly influenced by contemporary styles of sculpture, painting, and ornament on the continent.

It is important to realize that there was neither any tradition of secular sculpture nor of monumental religious sculpture in Japan until the vast Buddhist pantheon was introduced from the continent in the sixth century. It is also important to

Figure 26 *Daibutsu*. Edo period, late 17th century. Bronze; h. 14.73 m. above pedestal. Daibutsu-den, Tōdai-ji

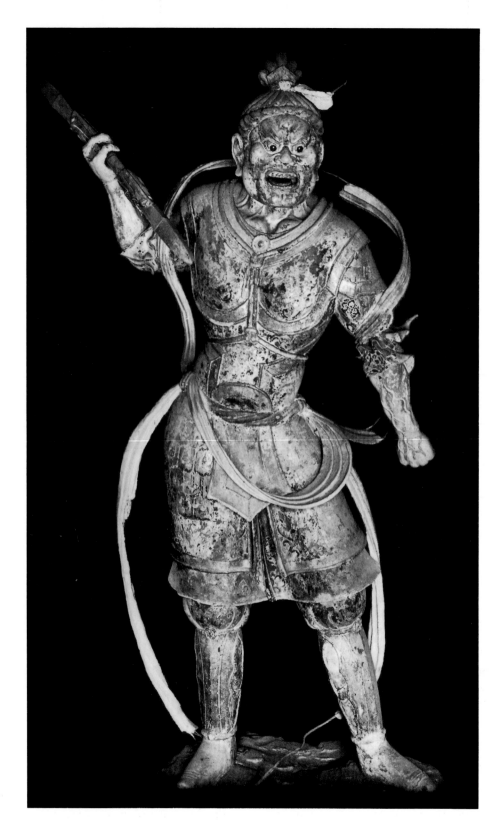

realize that the *Daibutsu* was cast only about 150 years after the first Buddhist statue was produced in Japan.[1] A succession of sculptural styles, developed over about five centuries in China, was telescoped in Japan: during the seventh and eighth centuries one style after another was introduced and was unconsciously altered as well as consciously interpreted. Each enjoyed a brief predominance before its gradual displacement by another influence. This stands in marked contrast with the stylistic development of the sculpture of the Heian period (794–1185), which took place essentially in the absence of foreign influences. The Kamakura period, on the other hand, is characterized by the interaction among new styles from abroad, revived styles from the Nara period, and the indigenous styles formulated during the intervening centuries.

The great masterpieces of eighth-century sculpture at the temple are too fragile to be moved from the halls in which they are housed. The organizers of the present exhibition, however, have assembled a group of works representative of the important periods in the temple's history and illustrative of the role Tōdai-ji played in the development of Buddhist sculpture in Japan.

Sculpture during the Nara period

From its conception in 743 until its attendant figures were completed in 757, the colossal gilt-bronze image of Vairocana, the main image of Tōdai-ji, was the focus of sculptural activity throughout the Home Provinces. Emperor Shōmu (701–56; r. 724–49) conceived of the project after seeing a large clay image of the same deity at a privately supported temple called Chishiki-ji located to the south of the Nara region. This statue had been paid for by the pious donations (J: *chishiki*) of the parishioners, all immigrants or descendants of immigrants from the continent. Inspired by their piety, Shōmu decided to commission a similar statue and to solicit support for it

Figure 27 *Shūkongō-jin*. **Late Nara period, mid-8th century. Clay; h. 170.4 cm. Sangatsu-dō, Tōdai-ji**

from all levels of society. His intention is made clear in an imperial decree of 743:

. . . if there are some desirous of helping in the construction of this image of Vairocana, though they have no more to offer than a twig or handful of dirt, they should be permitted to do so. The provincial and county authorities are not to disturb and harass the people by making arbitrary demands on them in the name of this project.[2]

For the emperor, the statue and the temple complex to house it were not only an expression of devotion to Buddhism and a device to unify the competing political factions of his nation; they were also an attempt to emulate the grandeur of similar projects on the continent.

In fact, the attitudes of the emperor and his court were thoroughly imbued with feelings of competitiveness and inferiority toward the Chinese. By the middle decades of the eighth century Japan had been drawn completely into the cultural sphere of Tang China (618–907). China had provided the Japanese with their pattern of government as well as with the Buddhist religion. Many of the most prized appurtenances of daily life at court had been brought back from the continent by official envoys, whose accounts of the splendors of Changan, the Tang capital, were more than verified by the worldly opulence of these objects.

Shōmu and his empress, Kōmyō (701–60), were aware of images commissioned by Tang Gao Zong in 672 and by his empress and successor Wu Zetian in 700. The former is an awesome Vairocana over ten meters high, carved into the Longmen cliffs and completed in 675; the latter, made of bronze for a temple in Luoyang, no longer exists, but it is likely also to have represented Vairocana, and on a similar scale. Thus, to domestic religious and political motivations the Japanese ruling family added considerations of international rivalry and prestige—Tōdai-ji and its *Daibutsu* would, they hoped, proclaim them equal to their Chinese counterparts in piety, power, and patronage.

The present *Daibutsu* is a reconstruction, dating from the late seventeenth century. The better part of the eighth-century image had survived the 1180 fire and been incorporated into the Kamakura-period restoration. But when Tōdai-ji was burned again in 1567, most of the statue was destroyed or irrevocably damaged. Obviously, no one alive in

1684, when reconstruction commenced, remembered how the statue had looked before 1567, and there was no useful pictorial record of the eighth- or even the twelfth-century version. It would be surprising if the present *Daibutsu*, which incorporates the surviving portions of its predecessors, actually conveyed much of their appearance.[3] Its imposing monumentality, however, is readily apparent even through photographs. The statue in the Daibutsu-den today towers 14.73 meters above its pedestal; the original image would have been over one meter higher.[4]

The casting of the eighth-century original was a lengthy and difficult process. In 744 a preliminary clay model was begun at Shigaraki, to the north of the Nara capital; not until the following year was work begun at Tōdai-ji. The clay core, modelled into the precise form and size that the final image was to take, was completed in 746. From this model the sculptors made the outer mold in sections and then pared down the model (or core) so that when molten bronze was poured between model and molds it would form a layer of uniform thickness. Actual casting did not begin until 747 and was not finished until over two years later, in 749.

The monumental statue was cast in eight stages, working upward from the base to the head. After the bronze for each level had been poured, the molds for the next level were positioned and earth was piled up around them, both to hold them in place and to provide a surface for the bronze foundries. Thus by the time the casting was complete the entire statue was covered with a mound of earth. As each level of molds was removed, imperfections in the casting had to be repaired: the flashing that would have occurred along the seams of the mold would have required chasing, and the hollows caused by gassing would have required recasting. This time-consuming process lasted from 750 until 755; moreover, the 966 snail-shaped curls had to be cast one by one and set onto the head. At the time of the dedication ceremony in 752 the image was only partially completed. By 757 the statue and its base had been gilded, the representations of the paradise of Sākyamuni had been engraved onto the base, and attendant statues of the bodhisattvas Kokūzō (S: Ākāsagarbha) and Nyoirin Kannon (S: Cintāmanicakra Avalokitesvara) and the Four Heav-

enly Kings (J: Shitennō) were completed, just in time for the first memorial service for Shōmu, who had died the year before.

The vast scale of the project can be inferred from the amounts of materials and labor consumed, as recorded in the *Tōdai-ji Yōroku*, the traditional history of the temple compiled in 1106. To cast the statue required 739,560 *kin* (444 metric tons) of refined copper, 12,680 *kin* (7 metric tons) of unrefined tin, 10,436 *ryō* (391 kg.) of gold leaf, 58,620 *ryō* (2.2 metric tons) of mercury, and 16,656 *koku* (4.66 cu. km.) of charcoal. The skilled casters who participated in the project toiled 372,075 man-days and the unskilled laborers under them 514,902 man-days; the skilled carpenters logged 51,590 man-days and the unskilled laborers under them 1,665,071 man-days.[5]

The political costs of the project were equally great. The imperial institution lost much of its authority due to the excesses of Shōmu and Kōmyō in the name of the Buddhist church. By the late 750s the nation's coffers had been severely depleted by the great cost of the *Daibutsu* project. This did not prevent Shōmu's daughter Kōken (718–70; r. 749–58 and 764–70) from commencing a grand temple of her own on the western edge of the capital in 765, the year after she took the throne for the second time. Calling it Saidai-ji (Great Western Temple), Kōken intended this compound as a rival to Tōdai-ji, her father's temple to the east. The nation, however, was so impoverished that little of Saidai-ji was ever completed. In addition, during the late 760s Kōken attempted to elevate her adviser and closest confidant, the conniving monk Dōkyō (?–772), to a position of political authority unprecedented for a cleric. Dōkyō then attempted to take the throne but was thwarted by a group of courtiers loyal to the imperial line. In consequence of this lavish support of the Buddhist faith, Shōmu's line lost the succession to a collateral branch of the imperial family and the political power of the Buddhist establishment was severely diminished. In fact, the shift of the capital to Heian (present-day Kyoto) in 794 by a rival branch of the imperial family can be directly attributed to the political turmoil caused by the *Great Buddha* project.

All the statues in the Daibutsu-den perished when the structure burned in 1180. But the deities in the paradise of Sākyamuni engraved on the petals of the lotiform pedestal (fig. 28), and the gilt-bronze image of Shaka at Birth (no. 2), which is thought to date to 752, may suggest how the original *Daibutsu* appeared. Naturalistic proportions and shape, a full, round face with refined features, and a simple, fluidly draped skirt characterize the diminutive image of Shaka at Birth. To these traits the engraved representations of Sākyamuni and attendants have added considerable animation of pose and drapery. Ultimately these stylistic traits derive from the worldly naturalism popular in metropolitan China during the first half of the eighth century. The original *Daibutsu* shared these qualities, making it a more graceful and elegant image than the one in the hall today.

The statue of Shaka at Birth, like all the other eighth-century works of sculpture at Tōdai-ji, was almost certainly produced at a government-supported institution called the Office for the Construction of Tōdai-ji (J: *Zō Tōdai-ji Shi*). From its inception in 746 until it was closed in 789 (after Nara had ceased to be the capital), the Office was the center of artistic activity in Nara. Originally founded to oversee the making of the *Daibutsu* and the temple structures to house it, the Office acquired control as well over all government-sponsored Buddhist artistic activity throughout the nation and dispatched artists to work on sculpture and construction projects throughout the Home Provinces. Consequently the sculptors employed by the Office for the Construction of Tōdai-ji dictated the sculptural styles of the entire nation.[6]

Although work on the *Daibutsu* had begun as early as 745, the first project completed by the Official Buddhist Sculpture Construction Workshop (J: *Zō Bussho*; a department of the Construction Office) was the monumental assemblage of Fukūkenjaku Kannon with six attendants in the Sangatsu-dō (fig. 9), datable to 747 and 750. These works were sculpted under the direction of Kuninaka no Kimimaro (?–774), an artist born in Japan of Korean parents, who also directed the production of the *Daibutsu*. In their ornately decorated robes and armor these seven figures, done in the hollow dry lacquer technique (J: *dakkan kanshitsu*), reflect the lavish tastes of Shōmu's court.[7]

Lacquer seems to have been the preferred material at the Sculpture Workshop in the eighth century, replacing bronze, which had dominated the sculp-

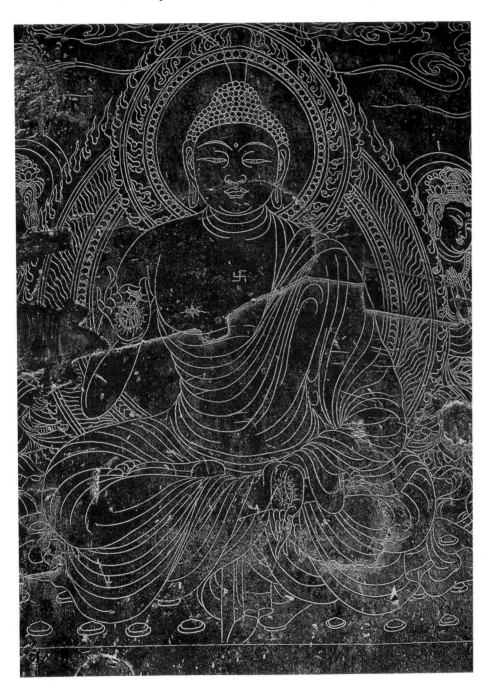

Figure 28 *Shaka Nyorai.* Engraving on petal of lotus pedestal of *Daibutsu.* Late Nara period, mid-8th century. Bronze. Daibutsu-den, Tōdai-ji

tural production of the previous century. A number of important works, however, were done in a rough, sandy clay, most notably the Four Heavenly Kings now in the Ordination Hall (J: Kaidan-in) on the temple grounds, and the statue of Shūkongō-jin (fig. 27) kept in a locked cabinet behind the altar of the Sangatsu-dō. With his highly articulated posture, threatening gesture, and expressive face, this guardian wielding a single-pronged *vajra* (thunderbolt) reflects the descriptive realism favored by Workshop artists in the mid-eighth century.

Work on the *Daibutsu* project was essentially completed by the early 760s, and activity at the Workshop declined radically as the interests of the aristocracy in the Nara capital shifted from religion to politics. In the face of decreased financial support the hollow dry lacquer technique was abandoned by the artists of the Workshop for the less technically exacting wood-core dry lacquer process (J: *mokushin kanshitsu*).[8] By the time the Official Buddhist Sculpture Workshop was shut down in 789, lacquer, bronze, and clay were being replaced by wood, which was readily available and inexpensive, as the most popular medium of Buddhist sculpture in Japan.

Sculpture during the Heian period

The close of the Official Sculpture Workshop and the shift of the capital to Heian (present-day Kyoto) deprived Tōdai-ji of much of the governmental patronage it had enjoyed during the middle decades of the eighth century, and this loss greatly curtailed artistic activity at the monastery. But although the temple itself ceased to be major center for the production of Buddhist sculpture by the start of the ninth century, the legacy of the Official Buddhist Sculpture Workshop remained strong. Numerous important images made in the new capital reflect styles that were current in the Workshop during the second half of the eighth century. In fact, it seems safe to conclude that the first generation of sculptors in Heian had been trained at Tōdai-ji. The best-known Early Heian works that reflect the styles formulated at Tōdai-ji are the statues, dated to 839, of the Five Bodhisattvas (J: Go Bosatsu) and of Bon-ten (S: Brahma) and Taishaku-ten (S: Indra) in the Lecture Hall at Tō-ji.

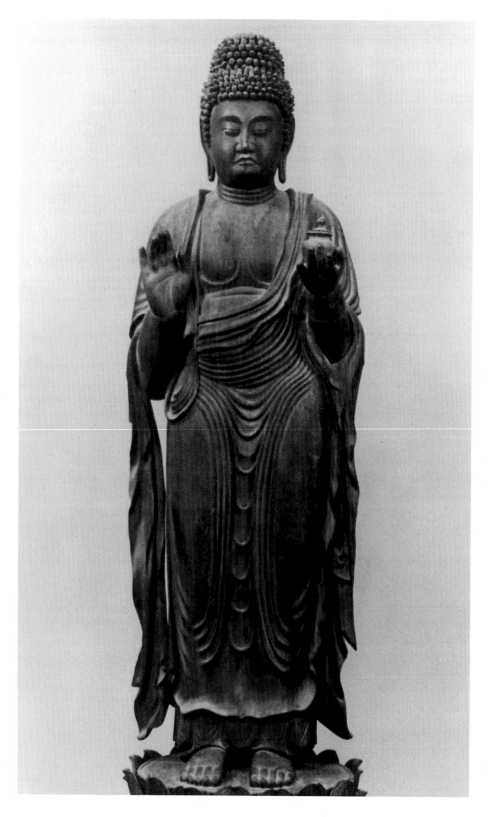

In contrast with the preceding Nara period, when one style of sculpture existed throughout Japan, statuary in the Early Heian period was extremely varied—formally, technically, and iconographically. Two developments coincided: as sculptors came to work increasingly in wood, they increasingly abandoned the idealized realism that had characterized works of the mid-eighth century. Drapery folds became sharply edged instead of softly rounded in cross-section; hard, stylized facial features replaced soft, naturalistic ones; and stiff, massive bodies supplanted those with more natural stances and proportions. This new spirit of expression was particularly prevalent among sculptors who worked in unpainted wood primarily in the Nara region during the first half of the ninth century.

The best-known work in this style is the standing Yakushi (Buddha of Healing; S: Bhaisajyaguru) now in the collection of Jingo-ji in Kyoto (fig. 29); another, the seated icon called *Miroku Buddha* (S: Maitreya) at Tōdai-ji, is number 4 in the present exhibition. Although the provenance of this statue is unknown, it has long been associated with Tōdai-ji and in fact bears the popular nickname "the Preliminary Great Buddha." This image, carved from a single block of Japanese cypress (J: *hinoki*) and with only faint touches of color heightening the lips and eyes, is one of the most extraordinary works of Early Heian sculpture. Though in fact quite small, its radically foreshortened lower torso and oversized head make it seem monumental. The long, narrow eyes are half closed, and though their expression is brooding, they rivet the viewer's attention. In the smooth fleshiness of the broad face the sharply carved contours of arched eyebrows, narrowed eyes, and full, protruding lips create a tension that enhances the severity of the expression. The highly abstract quality of this face is in sharp contradistinction to—perhaps in reaction against—the idealized opulence and elegance typical of the works of the previous century.

Figure 29 *Yakushi*. **Early Heian period, 782–94. Wood; h. 169.7 cm. Jingo-ji, Kyoto**

To create such imposing icons, the customary ninth-century technique was single woodblock construction (J: *ichiboku zukuri*) (see no. 12). In this technique, as its name implies, sculptors attempted to carve as much of a statue as possible out of a single block of wood. Sometimes a single block could be made to yield the whole length of an image from the top of the head to the socle attaching it to its pedestal, with only the hands, and occasionally the forearms and feet, carved from separate pieces of wood and attached. The portrait statue of the monk Rōben (no. 27) and the small seated *Miroku Buddha* discussed above have this technique in common, and the commanding presence of the monk, like that of the deity, is due at least in part to the artist's ability to exploit the single woodblock technique.

Since solid blocks of wood, such as those used for the *Miroku* and the portrait of Rōben, were subject to checking, the sculptors soon evolved a technique of hollowing out the blocks from the back; this removed the core of the tree, which contained the most moisture, and thus alleviated the problem. By the second half of the ninth century sculptors realized that if they split the main block in two they would be able to remove even more of the unwanted core. They continued the practice, however, of carving as much of an image as possible from a single block of wood.

During the early tenth century sculptors began combining the hollowing and the joining techniques so as to produce monumental seated images out of two main blocks, both hollowed, one for the head and torso and one for the crossed legs. Despite this technical advance such works are still considered to be single woodblock statues.

By the middle of the tenth century sculptors were combining the joining, splitting, and hollowing techniques to produce works constituted of as many as five main blocks of wood. This marks the appearance of joined woodblock construction (J: *yosegi zukuri*) (see no. 13, n. 3), which was subsequently perfected by Jōchō (?–1057), an artist working in the Heian capital during the first half of the eleventh century.[9]

Jōchō's seated *Amida Buddha* (S: Amitābha) (fig. 30), in the Byōdō-in at Uji, south of Kyoto, and dated to 1053 is an example of joined woodblock construction. An unquestioned masterpiece, its values are quite the reverse of those seen in the seated *Miroku* and in the portrait of Rōben. Here idealization is again supreme: perfect body proportions, an expression introspective but mild, the posture stable but relaxed. The robe, shallowly carved, suggests thin fabric exquisitely draped. Stern command has been replaced by serene benignity, physical power by self-conscious grace, reflecting the highly refined tastes of the wealthy aristocrats of the capital. The popularity of Jōchō's style among this elite is attested by the plethora of works dating from the late eleventh and early twelfth centuries that are formally derived from the statue at the Byōdō-in. To satisfy the aesthetic preferences of their patrons, sculptors of the twelfth century relinquished their artistic individuality. In consequence, the resulting works were for the most part little more than formulaic replications of the Jōchō style, devoid of the deep spirituality with which Jōchō had imbued his images. Contemporary diaries record the dissatisfaction of noble patrons when the icons they had commissioned in direct imitation of Jōchō's *Amida* fell short of the revered prototype.[10]

Jōchō never worked at Tōdai-ji, and for much of the Late Heian period the temple was outside the center of artistic activity in Japan. Nevertheless a number of the works included in the present exhibition reflect the dominant stylistic currents of Late Heian sculpture. For example, the *Eleven-Headed Kannon* (no. 11), with its elongated torso, shallowly carved drapery, and detached expression, has much in common with Jōchō's masterpiece. Like a number of the Late Heian-period works presently in the collection of the temple, this image was not originally carved for Tōdai-ji but was moved there for safekeeping at a later date. Another typical Late Heian work brought to Tōdai-ji from a nearby temple that had fallen into disrepair is the statue of Aizen (S: Rāgarāja) (no. 7), the Esoteric Lord of Passion. Notwithstanding his ferocious expression and the arsenal of weapons brandished by his multiple arms, the deity sits placidly on his pedestal, each shallowly carved fold of his garment perfectly arranged.

Besides being efficient, economical, and productive of images resistant to warping and cracking, the joined woodblock technique allowed sculptors to create images mostly at their ateliers and then assemble them at the temples. It also permitted them to mass-produce works in an unprecedented

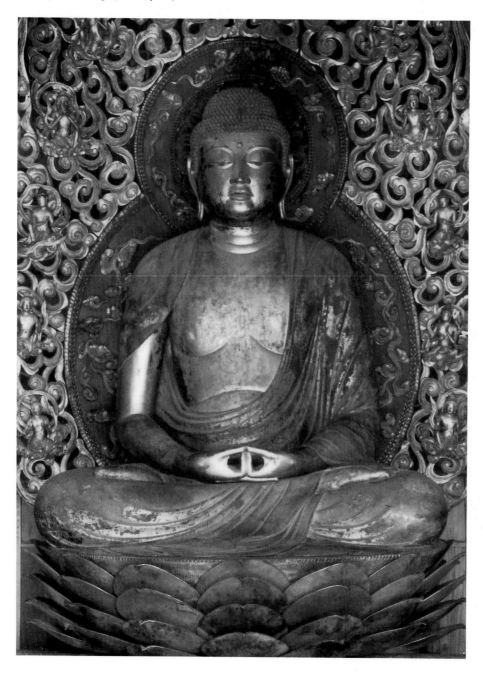

Figure 30 *Amida Buddha.* **By Jōchō.
Late Heian period, 1053. Wood; h. 284
cm. Byōdō-in, Uji (near Kyoto)**

fashion, which further conduced to a formulaic and lifeless quality in statues of the late twelfth century. Although sculpted under such circumstances, the set of the Twelve Divine Generals (J: Jūni Shinshō) (no. 5), attendants to the Healing Buddha, indicates that a high level of artistic accomplishment was still possible during the Late Heian period. The restrained poses, elegant armor set off with scarves, and relatively temperate expressions of the generals are fully in keeping with the highly idealized styles popular in the capital. Yet upon careful examination it can be seen that the sculptor did repeat postures, gestures, and clothing details in many of the works.

For the hundred years after Jōchō's death Heian continued to be the center of religious as well as artistic activity. Despite the revival of interest, during the second half of the twelfth century, in the Buddhist schools of the Nara period, the sculptors of the Nara region worked in relative obscurity, repairing old works and only occasionally receiving commissions for new ones. It took a disaster of unprecedented scale to return Nara, and Tōdai-ji in particular, to the center of sculptural activity in Japan.

Sculpture during the Kamakura period

In the twelfth month of 1180, troops of the Taira clan set fire to Tōdai-ji and the neighboring monasteries of Kōfuku-ji, tutelary temple of the Fujiwara clan, and Gangō-ji, one of the most important temples of the eighth century. The Buddhist establishment had become so far politicized that these three of the seven great temples of Nara were viewed as effective centers of anti-Taira sentiment by the military leaders in the Heian capital. Destroyed in the conflagration were most of the halls of the three monasteries and a majority of the statues housed in them. Many of the works lost were those produced by the Official Buddhist Sculpture Workshop at Tōdai-ji when the temples had been founded. This lamentable destruction afforded the sculptors of Nara an unparalleled opportunity: thrust into the forefront of sculptural activity to restore and replace the burned statues, the Nara sculptors (J: Nara *busshi*) responded with a burst of creativity. By the last decades of the twelfth century Nara was once again the dominant locus of sculptural production.

The Nara sculptors who refurbished the temples had learned their craft primarily through repairing works produced during the Nara period. The most influential of these artists, known collectively as the Kei school, formulated a new style of Buddhist imagery, informed by the naturalistic styles of the eighth century, which eventually became the dominant mode of sculpture throughout the Kamakura period.[11] The Kei school traditionally traced its roots to the sculptor Raijo (1044–1119), a second-generation disciple of Jōchō. No works by Raijo remain today, but documentary evidence indicates that he came to Nara in 1096 to repair and replace works at Kōfuku-ji that had been burned. Rather than return to the Heian capital, there to compete with the fashionable En and In ateliers for commissions to produce images in the Jōchō style, Raijo

Figure 31 *Dainichi*. By Unkei. Late Heian period, 1176. Wood; h. 98.2 cm. Enjō-ji, Nara

and his successors chose to remain in Nara and work in relative obscurity. Although the specific connection between Raijo's disciples and Kōkei (act. 1175–1200), who is generally credited with founding the Kei school, remains unclear, by the 1170s Kōkei and his son Unkei (?–1223) were producing icons that embodied a new sense of vitality for temples in the Nara region.

The earliest work attributable to Kei school artists is the seated *Dainichi* (S: Mahāvairocana) (fig. 31), dated to 1176, at Enjō-ji in the hills east of the city of Nara.[12] The same serene loveliness that Jōchō had made into an iconic paradigm over a century earlier is still apparent in this image carved by Unkei and his father. But the formulaic prettiness to which the Jōchō style had descended by the later twelfth century is here replaced by an appearance of youthful vigor and assurance in a figure naturalistically proportioned and realistically modelled. The use of inlaid crystal for the eyes, also in the interests of greater realism, was revolutionary. This device, unique to Japan, was invented in Nara during the middle decades of the twelfth century and subsequently adopted by the Kei school artists as one means of lending animation to icons and portrait sculptures.[13] The crystal eyes provided Unkei's *Dainichi* and other statues with a symbolic naturalism that enlivened Buddhist imagery in unprecedented fashion. Widely adopted during the Kamakura period, they can be seen in a number of works in the present exhibition, including the *Amida* (no. 13) and *Jizō* (no. 14) by Kaikei, the standing *Shō Kannon* (no. 19), the Kings of Hell *Emma* and *Taizan* (nos. 20, 21), and the portrait statue of Chōgen (no. 28).

The destruction of Tōdai-ji and Kōfuku-ji had a profound impact on Kōkei's son Unkei and on his other leading disciple, Kaikei (act. c. 1185–1223). In an inscription on a copy of the *Lotus Sutra* that Unkei, Kaikei, and other members of the Kei school commissioned in 1183, the artists indicated that they were dedicating the scrolls to Kōfuku-ji as earnest of a great vow, a phrase that Japanese scholars interpret as a promise to restore the statues that had been damaged or destroyed. Lending credence to this interpretation is the fact that the rollers of the sutra scrolls were made of charred wood from the pillars of Tōdai-ji's Daibutsu-den.

When peace was restored in 1185, Japan had two capitals: the imperial capital remained at Kyoto,

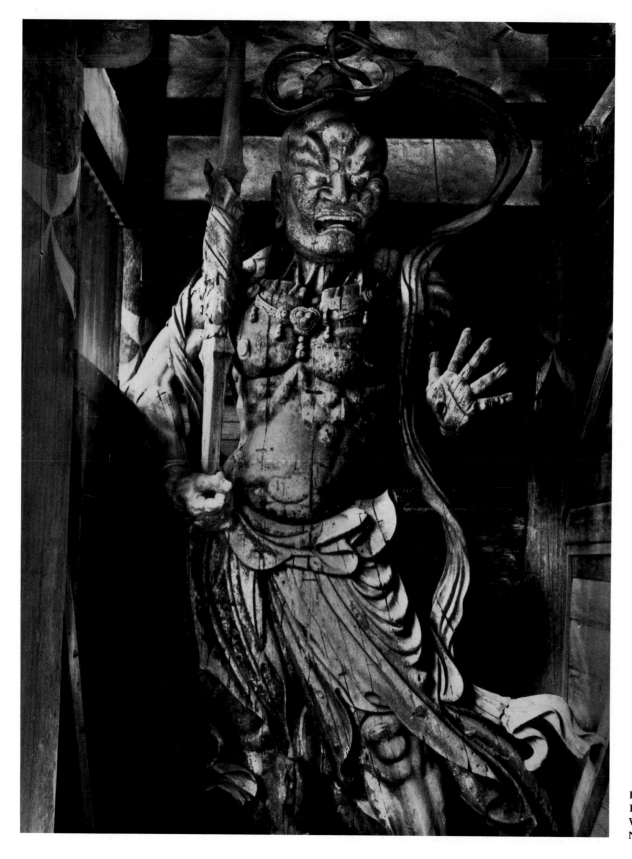

Figure 32 *Ni-ō*. By Unkei and
Kaikei. Kamakura period, 1203.
Wood; h. 836.3 cm. and 842.3 cm.
Nandai-mon, Tōdai-ji

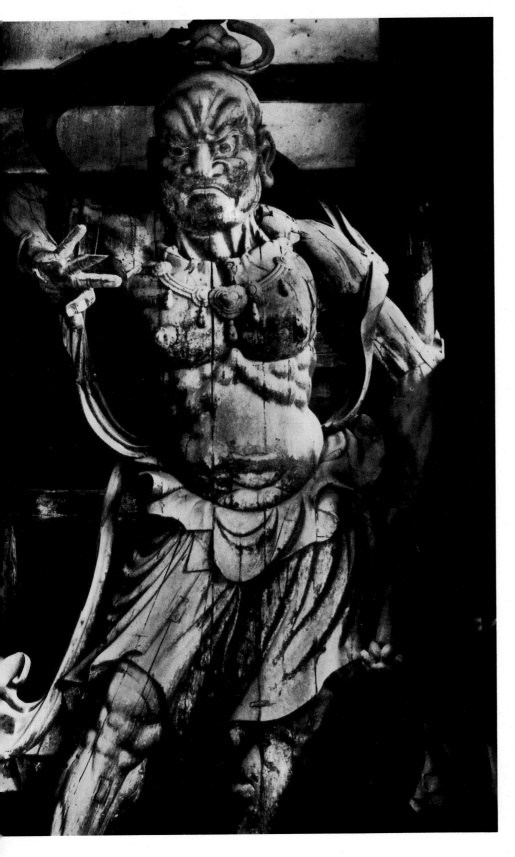

while at Kamakura, some three hundred miles to the east, the victorious Minamoto leaders established a military, or shogunal, capital. Immediately the Kei school was pressed into service, both by the Minamoto clan and by Fujiwara nobles eager to restore Kōfuku-ji, their family temple. Unkei went east to work for the Minamoto and allied lords in and around Kamakura, while Kōkei and Kaikei remained in Nara and concentrated their efforts on the reconstruction of Kōfuku-ji. Kaikei's earliest extant image, the standing *Miroku* now in the collection of the Museum of Fine Arts, Boston, was done for Kōfuku-ji in 1189.

By the early 1190s Kōkei, Unkei, his younger brother Jōkaku (act. c. 1180–1200), and Kaikei were focusing their activities at Tōdai-ji, where reconstruction was being supervised by the monk Chōgen (1121–1206). In 1194 Jōkaku and Kaikei collaborated on images of two of the Four Heavenly Kings—Jikoku-ten (S: Dhritarāshtra) and Tamon-ten (S: Vaisravana)—to be installed as guardian figures in the Inner Gate (J: Chū-mon). Two years later all four men worked on attendant statues of the Great Buddha—the bodhisattvas Kokūzō (carved by Kōkei and Unkei) and Nyoirin Kannon (carved by Jōkaku and Kaikei) and another complete set of the Four Heavenly Kings, projects that were supported directly by the new military government in Kamakura. Finally, in 1203, Kaikei and Unkei collaborated on the two monumental *Ni-ō* (Two Kings; S: Vajradhara) (fig. 32) for the recently rebuilt Great South Gate (J: Nandai-mon). These heroic images are dynamic in every aspect, with rippling muscles, intense expressions, emphatic *contrapposto*, and swirling skirts and scarves that accentuate the vigor of their arrested motion. Of the ten images produced jointly, only these two survive.

Unkei, Kaikei, and the team of apprentices working under them finished the *Ni-ō*, which measure over 8.5 meters in height, in just over two months. Japanese scholars generally believe that to carve such large works in so short a time, the two artists first fashioned clay models of the images one-tenth the size of the final works.[14] The sculptors then extrapolated from these *bozzetti* to determine the dimensions of the final works, which were carved using the joined woodblock method. Rather than doing the actual carving themselves, it is thought, Unkei and Kaikei served

primarily as directors of the project. The highly collaborative nature of sculptural production among the Kei school artists sets them apart from the sculptors of previous generations; nevertheless, it did not prevent each artist from developing an individual style.

Much is similar about the careers of the Unkei and Kaikei: both were devout Buddhists, both derived their styles from the idealized naturalism of the eighth century, and both were intent on breaking with the lifeless, formulaic productions characteristic of the Late Heian period. Their individual styles, however, were almost diametrically opposed. Whereas Unkei balanced naturalism with idealization to create works of great dynamism, intensity, and inner power, Kaikei

strove to refine the naturalistic elements in his works to create images characterized by a perfection of external form.

Unkei worked for a number of patrons and eventually established an atelier in Kyoto. Kaikei, in contrast, formed a close personal relationship with the monk Chōgen and eventually became a devotee of the Pure Land doctrines espoused by his patron. Chōgen was particularly attracted to Song Chinese styles of Buddhist art, which had gradually been making their way into Japan since the revival of relations with the continent in the late twelfth century. Kaikei often incorporated Song styles, derived directly from paintings, in works he produced for Chōgen. The best-known such carving by Kaikei is the *Amida Triad* done in 1197 (fig. 33) for Jōdo-ji, a temple built by Chōgen on one of the ancient estates of Tōdai-ji (in present-day Hyōgo Prefecture). The standing *Miroku* at the Chūshō-in (no. 16), often attributed to Kaikei, reflects Song traits in its high topknot, rippling, fluttering garment hems, and youthful face with a round nose and full cheeks.

The *Amida* (no. 13) and the *Jizō* (S: Ksitigarbha) (no. 14) in the present exhibition were sculpted by Kaikei at the peak of his career, sometime between 1201 and 1210.[14] Both statues are less than one meter in height, a size that was particularly favored by the master and became characteristic of the "An'ami style," so called after the religious name An'amidabutsu, conferred on him by Chōgen. In comparison with his earlier works, such as the *Amida* and *Shaka* in the Kengō-in in Kyoto (fig. 34), datable to the end of the twelfth century, both statues appear less massive and more balanced. Moreover, the Song Chinese elements, almost obtrusively conspicuous in his early works, have by this time been completely assimilated. The sculptor's interest in realism is particularly evident in the naturalistic proportions of the bodies, the tactile surfaces of the flowing robes, and the precisely formed hands. At the same time he is equally concerned with external perfection—no fold is out of place, and the lavish surfaces of the garments are ornamented with intricately cut gold leaf.

Kaikei's ability to employ naturalism to such idealized effect is equally evident in a slightly earlier work, the statue of the Shinto god Hachiman in the guise of a monk (no. 15). The

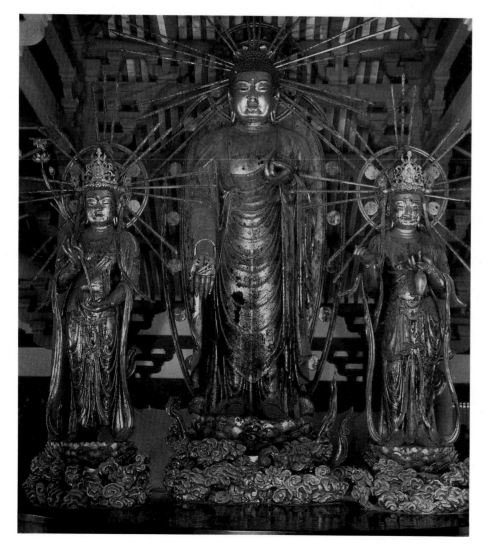

Figure 33 *Amida Triad.* **By Kaikei. Kamakura period, 1197. Wood; h. (Amida) 530 cm., (attendants) 371 cm. Jōdo-ji, Hyōgo Prefecture**

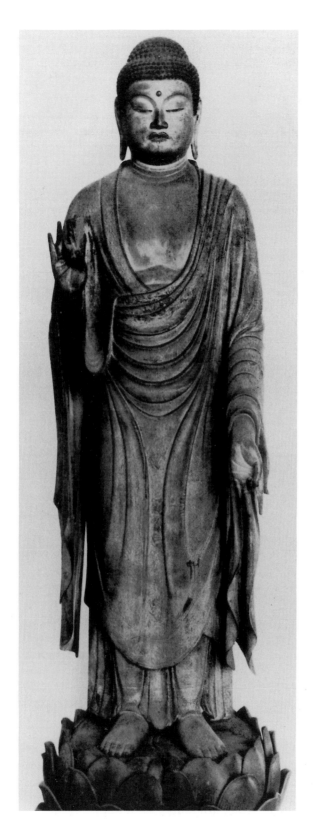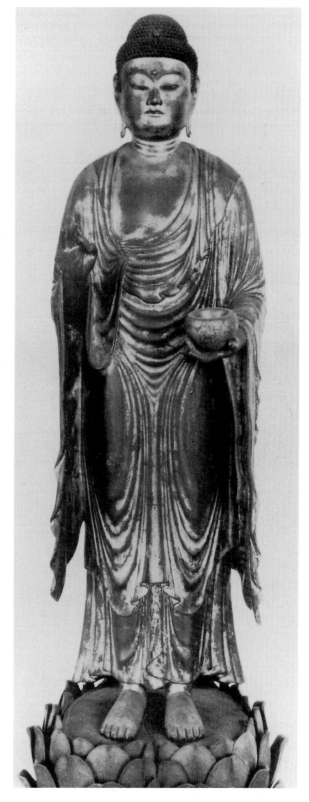

Figure 34 *Amida* (left) and *Shaka* (right). By Kaikei. Kamakura period, 1194. Wood; h. 98.9 cm. and 98.2 cm., respectively. Kengō-in, Kyoto

artist meticulously depicted each wrinkle on the deity's face and each detail in the lavish pattern of his robe, at the same time creating an image of austere and unapproachable majesty. Christine Guth Kanda has described the realism employed by Kaikei in the following terms: "His realism is not grounded in a scientific study of human anatomy and movements, but rather in an interest in precise outward appearances, reflecting a new awareness of the realities of the phenomenal world."[16] As evidenced in the statue of Hachiman, Kaikei perfected a certain kind of realism to convey the notion of divinity in an essentially human form.

The different approaches to realism current among the Kei school artists are especially evident when *Hachiman in the Guise of a Monk* is compared with the portrait of Chōgen (no. 28), which was sculpted at approximately the same time. Both are realistic images, but created for entirely different ends: the one a metaphor of divinity, the other a revelation of particular and exceptional humanity subjected to the universal condition of old age. Chōgen's face etched with wrinkles, his sunken eyes and weary, aged posture, and his immutably dour mouth communicate with astonishing immediacy the unremitting effort and strength of will that had gone to rebuild Tōdai-ji.

The Kei school artists primarily used the joined woodblock technique for their works but did not hollow out the interiors of their statues as fully as their Heian-period predecessors had been accustomed to do. A thicker layer of wood could be more deeply carved, which allowed sculptors to create images in highly articulated, active poses and wearing naturalistic, complex garments.

As well as reviving the naturalistic style of the eighth century, the Kamakura-period sculptors revived a number of techniques that had been popular during the eighth and ninth centuries. Although the form of the *Amida Meditating Through Five Kalpas* (no. 12) reflects a Song Chinese iconographic type favored by Chōgen, the statue is carved in a variation of the single woodblock technique popular during the Early Heian period. The small seated image of Sākyamuni by Zen'en (no. 17), dated to 1225, reflects the tradition of unpainted images precisely carved in aromatic woods (J: *danzō*) that had been introduced into Japan in the eighth century. Throughout the Buddhist world such works were considered particularly sacred, as simulacra of the legendary first image of the Buddha that was carved from life out of sandalwood and left unpainted.[17]

The renaissance of Tōdai-ji as a major sculptural center, however, was short-lived. Unkei, the most creative sculptor and paramount master of the Kei school, moved his atelier to Kyoto in the early decades of the thirteenth century. Once the halls of Tōdai-ji and Kōfuku-ji had been rebuilt and their interiors refurnished with images, Kyoto came again to the fore as the sculptural center of the nation. Nevertheless, the uses of naturalism formulated by Kei school artists in Nara during the 1180s and 1190s dominated sculpture not only in Nara and Kyoto but throughout Japan for the next two hundred years.

Sculpture after the Kamakura period

As related in the Introduction, the religious and artistic center of Japan gradually moved away from Nara and its temples after the end of the Kamakura period. With the rising popularity of the Zen and Pure Land sects, whose devotional practices depended less on icons than those of the Nara and Esoteric schools, the production of Buddhist imagery declined throughout the nation. Statues produced for Tōdai-ji after the end of the Kamakura period, such as the *Monju Bosatsu Riding on a Lion* (no. 22), dated to 1337, and *Fudō Myō-ō with Two Attendants* (no. 23), dated about 1373, simply follow the naturalistic styles of the Kamakura period. By the fourteenth century, however, the intensity of expression created so successfully in early thirteenth-century works such as the *Emma-ō* (no. 20) and *Taizan Fukun* (no. 21) had dwindled almost entirely away, leaving a sculptural tradition of stylized, codified, and comparatively lifeless realism that we see in the portrait statues of Kōkei and Gyōki (nos. 29 and 30, respectively; see also Introduction).

Pious contributions from all levels of society enabled Emperor Shōmu to construct the Great Buddha and the temple that housed it. So significant did image and temple become to the Japanese people that the destructions of the twelfth and sixteenth centuries were both remedied by new outpourings of contributions from the populace to recast the image and refurbish the temple. But

whereas the statues in the Sangatsu-dō reflect the glory of the temple at its founding, and the statues by Kaikei embody the renewal of that glory immediately following its destruction, the images made in the Edo period, including the present *Daibutsu*, cast in 1692, reflect a much lower level of artistic attainment. The works in this exhibition illustrate the crucial role that Tōdai-ji has played in the history of Buddhist sculpture in Japan.

NOTES

1. The first Buddhist sculpture produced in Japan is generally thought to be the badly damaged image of the historical Buddha at Asuka-dera (Hōkō-ji) at the southern edge of the Nara plain, commissioned in 592 and completed in 606 by the immigrant sculptor Tori Busshi.

2. Translation of the complete passage in the *Shoku Nihongi*, the official history of the eighth century, can be found in De Bary et al., eds., *Sources of Japanese Tradition*, p. 104.

3. The only extant drawing of the original *Daibutsu* appears in the third roll of the *Shigisan Engi Emaki* (*Illustrated Legends of Mt. Shigi*). The artist was familiar enough with the original sculpture to include in his drawing the representations of the paradise of Sākyamuni on the lotus petals of the pedestal. As represented in the scroll, the proportions of the statue and the treatment of its drapery generally correspond with the engraved representations of Sākyamuni on the surviving bronze lotus petals. But since the handscroll dates to the Late Heian period, it is not possible to draw extensive conclusions from these similarities. For a discussion of the original statues in the Daibutsu-den, see Tamura, "Nara Jidai Tōdai-ji Rushana Butsu no Ryō Wakiji ni Tsuite," pp. 70–91.

4. Two figures exist for the height of the original *Daibutsu*: 51.4 *shaku* (Japanese foot) and 53.5 *shaku*. Since we are not certain of the length of a Japanese foot during the Nara period, it is impossible to determine the height of the original statue in modern measurement. The height of the present statue in Western feet (1 Japanese foot = 0.994 Western foot) is 48.6 feet.

5. These figures are taken from Sugiyama, *Classic Buddhist Sculpture*, p. 122.

6. The Office was divided into three units: one in charge of sutra copying, one in charge of management, and one, the largest of the three, in charge of building and repairs. This last unit was further divided into a number of sections, the most important of which was the Buddhist Sculpture Workshop (J: *Zō Bussho*), but which also included a Painting Atelier (J: *E-dokoro*), a Manufacturing Shop (J: *Zō Butsu-jo*), a Foundry (J: *I-dokoro*), a Woodworking Shop (J: *Mokkō-jo*), and a Tile Kiln (J: *Zōga-jo*). The sculptors, though not the greatest in number, were chief in importance among the artists and artisans of the Office.

7. For a hollow dry lacquer image the sculptors had first to model a full-sized armature out of clay. When the clay armature had air dried, it was wrapped in layer after layer of lacquer-soaked cloth, each layer being allowed to harden completely before the next could be applied. Once this lacquer shell had been completed, the core was removed and a wooden frame inserted to prevent the statue from warping. Finally the artists modelled the details of facial features and drapery in lacquer paste and then painted and perhaps gilded the image. The technological history of Japanese Buddhist sculpture is discussed in Nishikawa and Sano, *Great Age of Japanese Buddhist Sculpture*, pp. 47–54.

8. This technique required fewer layers of lacquer-soaked cloth than the hollow dry lacquer technique. These would be wrapped over a roughly carved wooden core and the final form modelled in a layer of lacquer paste overlying the cloths. In some instances the layer of lacquer is so thin that it is actually the wooden core that determines the final form of the image.

9. For an excellent discussion of Jōchō and the *Amida* at the Byōdō-in, see Fukuyama, *Heian Temples: the Byōdō-in and Chūson-ji*, pp. 72–78 and numerous illustrations throughout the text.

10. Nishikawa, "References to Production of Buddhist Statues Contained in Noblemen's Diaries."

11. A history of the Kei school and the sculpture of the Kamakura period can be found in Mori, *Sculpture of the Kamakura Period*.

12. For photographs of this and Unkei's other works, as well as an excellent English summary of the Japanese text, see Kuno, *The Sculpture of Unkei*.

13. The *Amida Triad* at Chōgaku-ji in Tenri City south of Nara, a work dated to 1151, is the earliest known work to use this technique, whose invention is generally attributed to the Nara sculptors. Jōchō's formula is still apparent in these images, although their body mass is greater than he would have allowed.

14. Sugahara Yasuo, as quoted by Nishikawa Shinji, "Kongō Rikishi Ryuzō," *Tōdai-ji 3*, p. 11.

15. For illustrations of all of Kaikei's extant works, see Mōri, *Busshi Kaikei Ron*, pp. 74–122.

16. Kanda, "The Tōdai-ji Hachiman," p. 201.

17. See Soper, "The Best-Known Indian Images," pp. 259–65.

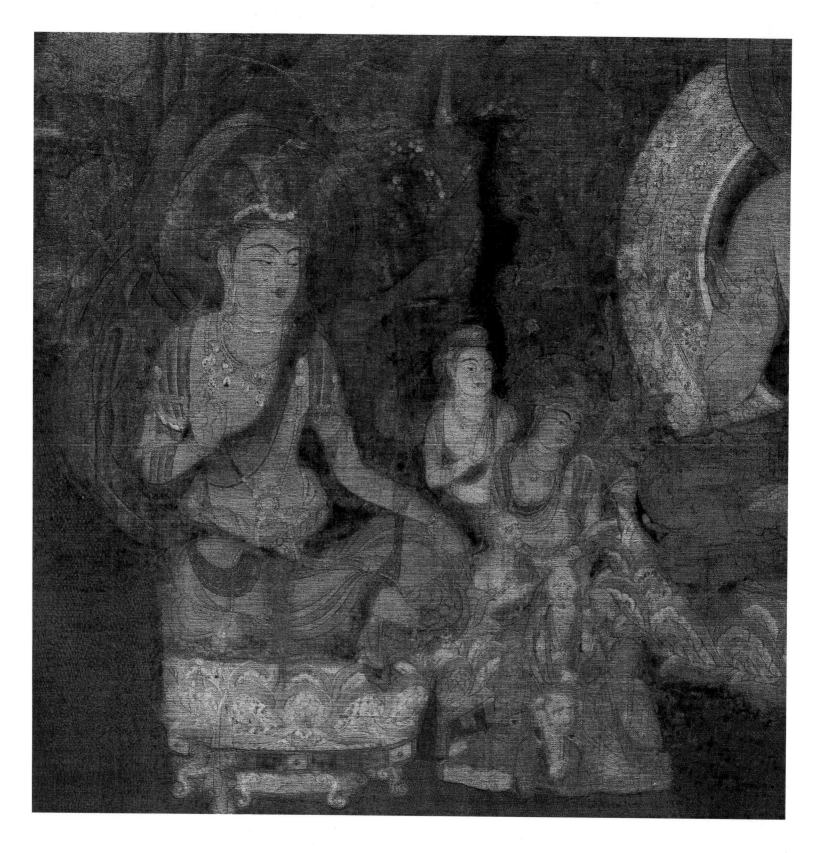

3 Painting at Tōdai-ji

CHRISTINE M. E. GUTH

Now the statue's melted head lay on the ground; its body had fused into a shapeless mass. The myriad beauties of this Buddha were wrapped in smoke, just as the autumn moon is obscured by the five-fold clouds. The jeweled ornaments on his head and body were scattered like the stars that drift in the wind of the Ten Evils. The smoke filled the sky, and the flames devoured the earth. Those who stood near the fire could not bear to gaze at it. Even those who merely heard the news were terrified. The scrolls of the sacred sutras of the Hossō and Sanron sects were destroyed. Not only in our country but even in India and China, no such disaster had ever fallen on the Buddha's law.

The Tale of the Heike (Trans. Kitagawa and Tsuchida)

RECOUNTED over the centuries in popular tales, drama, and song, the 1180 destruction of Tōdai-ji and adjacent Kōfuku-ji is as familiar to Japanese as the burning of the White House and Capitol in 1814 is to Americans. The flames that engulfed the *Daibutsu* also reduced to ashes virtually all traces of eighth-century painting at the temple. Although sculpture has survived in relatively large numbers, today Tōdai-ji possesses not a single painting from that classical era.

The vicissitudes of politics and nature have influenced the patronage and the preservation of painting at Tōdai-ji throughout its history. Intense artistic activity marked the height of the temple's prestige in the eighth century and revived during the reconstruction programs that followed the conflagrations of 1180 and 1567. In the interims, however, the sponsorship of works of art was sporadic. As a result, surviving works at Tōdai-ji reflect only some of the successive phases of Buddhist painting in Japan, and those phases are not necessarily representative of the stylistic mainstream. A special strength of Tōdai-ji's collection is the large corpus of works produced by painters in Nara. Organized into workshops situated in or adjacent to the Tōdai-ji and Kōfuku-ji compounds, these artists specialized in devotional themes of special relevance to the temples and shrines of Nara.

Viewing the paintings in a museum exhibition hall, it is easy to forget that they were not intended primarily for aesthetic appreciation but rather to give convincing form to the temple's deities, saints, and sacred history. Along with sculptures, paintings served as the focal points of worship, festivals, and meditation. The *Spiritual Teachers of the Kegon Ocean Assembly* (no. 35), for instance, was hung to accompany a recitation of the *Gandhavyūha Sutra* (see no. 56) during the annual Great Kegon Ceremony (J: *Kegon no Dai-e*) (see Introduction, "Ceremonies and Art," and nos. 32, 54).

As described in the Introduction, Tōdai-ji is the official headquarters of the Kegon school of

Figure 35 *Hokke-dō Kompon Mandara* (detail showing attendant bodhisattvas). See fig. 32

Buddhism, but in the Nara period it was also the seat of five other schools: the Sanron, Ritsu, Jōjitsu, Kusha, and Hossō. Until their destruction in 1180, the sacred scriptures of these six Nara schools were kept in the Daibutsu-den within miniature shrines (J: *zushi*) decorated with portraits of the respective school's patriarchs.[1] Over the centuries Tōdai-ji retained its eclecticism. Monks of many schools visited and studied there, and some were ordained there, since it was one of a limited number of temples with an officially sanctioned ordination platform. Monks of the Shingon sect numbered among Tōdai-ji's intendants (J: *bettō*), and monks of Pure Land or Zen affiliation among its solicitors (J: *kanjin shoku*). The paintings preserved at Tōdai-ji reflect this richly variegated religious and intellectual climate.

Painting in the Nara period: the *Hokke-dō Kompon Mandara*

In its eighth-century heyday the halls of Tōdai-ji were lavishly decorated with wall paintings and hanging scrolls. The clay and lacquer sculptures that dominated its altars were painted in brilliant mineral pigments, and some were installed within equally lavishly painted miniature shrines. All this pictorial decoration was the job of the Tōdai-ji Painting Atelier (J: *E-dokoro*). Like the sculpture workshops described in Essay 2, the *E-dokoro* was part of the government-sponsored Office for the Construction of Tōdai-ji (J: *Zō Tōdai-ji Shi*). The organization of the Tōdai-ji *E-dokoro* was hierarchical and membership tended to be hereditary, the painters being drawn largely from families of

Figure 36 *Hokke-dō Kompon Mandara.* **Late Nara period, 8th century. Ink and colors on hemp; h. 107 cm., w. 143.5 cm. Museum of Fine Arts, Boston**

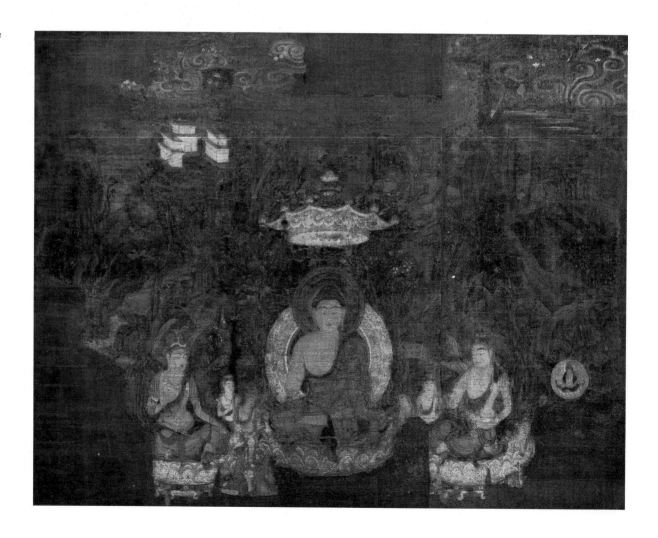

Figure 37 *Nikkō* (left) and
Gakkō (right). Late Nara
period, mid-8th century.
Clay; h. 207.2 cm. and 204.8
cm., respectively. Sangatsu-
dō, Tōdai-ji

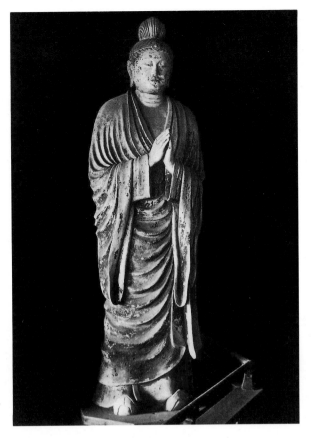

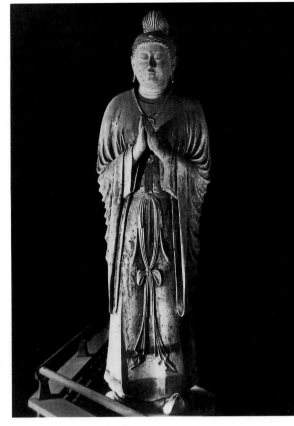

Chinese or Korean descent settled in Japan for several generations. Painting was a collective undertaking, and individual initiative was discouraged. Each artist was assigned a specific task determined by rank and skill and was paid accordingly. These tasks ranged from preparing the white ground and filling in the background to drawing the contours and adding colors to figures.[2] The quasi-magical powers that Japanese Buddhists attributed to their icons required close adherence to models of proven efficacy that had been imported from China or copied from such imports; this further contributed to a high degree of uniformity.[3] There did not yet exist among painters or their audience a clear sense of artistic individuality.

One of the rare examples of Tōdai-ji's early painting to survive the 1180 fire is now in the collection of the Museum of Fine Arts, Boston: the *Hokke-dō Kompon Mandara* (figs. 35, 36), a pan-

oramic painting depicting Sākyamuni Buddha on Mt. Grdhrākūta (see no. 36) attended by bodhisattvas and monks.[4] As its name indicates, it once belonged to Tōdai-ji's Hokke-dō (Lotus Hall), more popularly known as the Sangatsu-dō (Third-Month Hall). Dire need of funds, however, caused Tōdai-ji to sell it, along with other temple treasures, in the Meiji period. Unquestionably it is one of the most important examples of Japanese painting in the West.

The full bodies, graceful poses, and flowing drapery of the figures, as well as the treatment of the mountainous landscape setting, correspond so closely to eighth-century Chinese pictorial styles that many scholars once believed the *Hokke-dō Kompon Mandara* to be a work from the continent. Today it is generally acknowledged to be a unique Japanese vestige of the international Buddhist style of painting that prevailed from India to Japan in the mid-eighth century. In their naturalistic proportions and sublimely spiritual expressions the

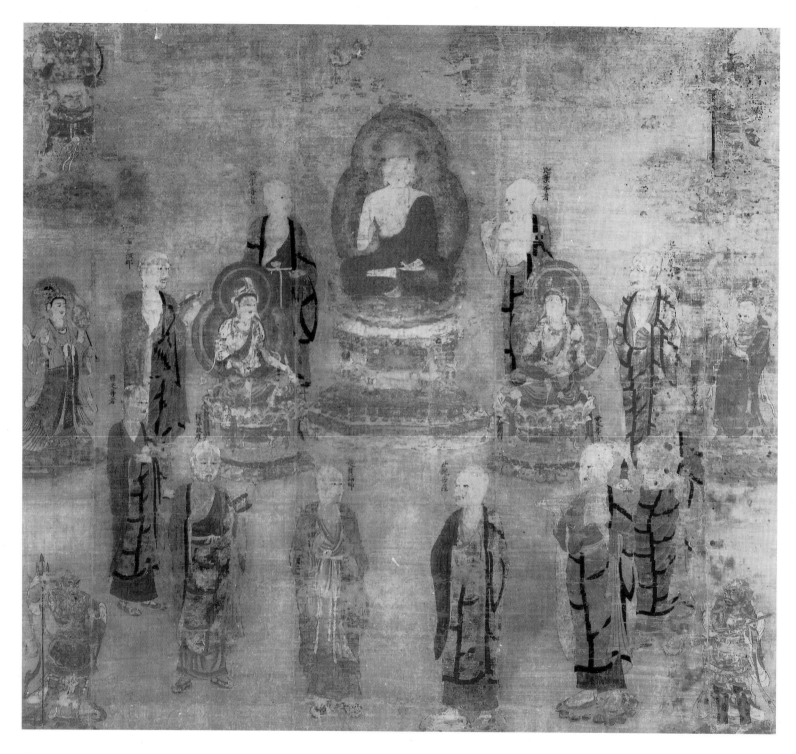

Figure 38 *Kusha Mandara.* By
Chinkai. Late Heian period, 12th
century. Ink and colors on silk;
h. 164.5 cm., w. 176.5 cm. Tōdai-ji

bodhisattvas in the painting closely resemble the contemporary clay figures of Nikkō and Gakkō (bodhisattvas of solar and lunar radiance) (see no. 26) in the Sangatsu-dō (fig. 37). Such resemblance testifies to the stylistic unity of painting and sculpture resulting from the centralization of artistic production at Tōdai-ji. The pictorial style exemplified in this work laid the foundations for later Buddhist painting in Japan.

Painting in the Heian period: the *Kusha Mandara*

Tōdai-ji ceased to be a major center of painting following the removal of the court and capital in 784 and the closing of the temple's workshop in 789. But the ninth-century pictorial styles dictated by Tō-ji and Sai-ji, the new government-sponsored Shingon temples in Kyoto, reflect the naturalism of the Nara period; painters from Nara, like sculptors, may have taken up residence there. Following the lapse (in the mid-ninth century) of regular diplomatic exchange with China, however, a more indigenous taste began to assert itself. By the eleventh and twelfth centuries Buddhist painting exhibits a decorative, two-dimensional quality completely in keeping with Japanese aesthetic values.

Lacking regular employment, the painters active in Nara during the Heian period decreased both in number and status. Tōdai-ji and nearby Kōfuku-ji called in painters from Kyoto to restore and replace paintings. Kyōzen (d. 1075) was a painter renowned for his part in the decoration of Hōjō-ji, one of many temples in the Kyoto suburbs built under imperial and aristocratic patronage. Significantly, this Kyoto artist was commissioned to repaint the pillars in Kōfuku-ji's Golden Hall (J: *kondō*) and to copy the portraits of the Hossō patriarchs from the inside of one of the miniature shrines in Tōdai-ji's Daibutsu-den.[5] The monk-painter Chinkai (1091–1152), who restored the *Hokke-dō Kompon Mandara* in 1148, was also from Kyoto.[6]

Chinkai may have painted the *Kusha Mandara* (fig. 38), one of Tōdai-ji's most treasured devotional images but too fragile to be included in the present exhibition.[7] The *Kusha Mandara* resembles a *tableau vivant* centered on the seated figures of Śākyamuni

Buddha and two attendant bodhisattvas. Encircling this triad are ten monks, clearly identified by inscriptions next to their heads as the eight Indian patriarchs of the Kusha school and the Buddha's two chief disciples, Ānanda and Kāśyapa. Brahma and Indra, Hindu gods who had been absorbed into the Buddhist pantheon (J: Bon-ten and Tai-shaku-ten), figure to the left and right of this group; two Guardian Kings (J: Ni-ō) figure before it; and the Four Heavenly Kings (J: Shitennō) stand guard in the four corners of the composition.

Called a *mandara* (mandala) after the diagrammatic arrangements widely used in Esoteric Buddhism to show relationships among divinities, this work commemorates the intellectual and spiritual fathers of the Kusha (S: Abhidharma) school. It was produced as part of a movement to revive Kusha teachings. This movement, led by the Tōdai-ji monk Kakujū, included Chinkai, the painter who restored the *Hokke-dō Kompon Mandara*, and Kanshin, the monk who commissioned the restoration. Chinkai's personal involvement in the Kusha revival gives credence to the tradition that he painted the *Kusha Mandara*.

A comparison of the *Kusha Mandara* and *Hokke-dō Kompon Mandara* reveals the efforts of the Heian-period painter to adhere faithfully to Nara-period models. His work derived its spiritual and aesthetic authority in large part from its relationship to such venerable sources. The figures of the Buddha and two flanking bodhisattvas were copied from the central portion of the *Hokke-dō Kompon Mandara*. Those of the circumambulating monks may derive from the paintings of patriarchs on the walls of the miniature shrines in the Daibutsu-den. The Four Heavenly Kings are believed to have been modelled after other, now lost, eighth-century paintings or statues. But the *Kusha Mandara*'s resemblance to Nara painting is only superficial. The directness and grandeur of conception inherent in the *Hokke-dō Kompon Mandara* are absent. Though the bodies are full and the draperies undulating, they are flattened and weightless by comparison with those of the Nara period. The *Kusha Mandara* reveals its twelfth-century date most patently in its two-dimensional treatment of space.

Chinkai, who received monastic training at the Shingon temple Daigo-ji and was later affiliated with both Tō-ji (also Shingon) and Tōdai-ji,

typifies the painter of the Heian period. Although the workshop (J: *e-dokoro*) system was maintained by major temples as well as the imperial palace, there arose during this period a new class of monk-painter, for whom painting was both a part of religious training and a form of personal artistic expression. Painting was believed to aid in visualization of abstruse doctrine and in achieving a mystic unity with the divine, the latter a particular goal of Shingon adepts. Monk-painters often reproduced the same figure time after time to gain full understanding of its attributes. Because monks often moved from one master and temple to another in the course of their training, they had access to a wider range of pictorial models and styles than the professional painter-craftsmen of earlier periods. Although monk-painters only rarely signed their work, the Late Heian period signals an incipient awareness of artistic individuality and of period style.

The creation of the *Kusha Mandara* was an isolated phenomenon. A full-scale renaissance of Nara-period styles began only fifty years later, in the 1180s, in connection with the restoration of Tōdai-ji and Kōfuku-ji (see Introduction, Essays 1 and 2, and no. 28). Many of the painters involved in this revival claim descent from Kyoto-trained painters such as Kyōzen and Chinkai.

The Kamakura period: portraiture and narrative painting

The schools of Buddhist painting that arose in Nara during the restoration of Tōdai-ji and Kōfuku-ji are not as well documented as the contemporary Kei school of sculpture. This may be due in part to the scarcity of extant signed works, to the absence of towering artistic personalities comparable to Unkei and Kaikei, and perhaps most importantly to the fact that the Nara painters did not set up ateliers in Kyoto, the capital. Their close identification with the city and temples of Nara is signalled by the terms *Nanto E-dokoro* (Painting Atelier of the Southern Capital) and *Kōfuko-ji E-dokoro* (Painting Atelier of Kōfuku-ji), which frequently appear in connection with their names.

The term *e-dokoro* had lost its old meaning as a highly organized atelier under government or temple supervision. The Nara painters who adopted this term rose to prominence at the end of the twelfth century during the refurbishing of Tōdai-ji and Kōfuku-ji. All bore priestly names and titles and resided in temple halls. Their professional duties, however, were limited to painting, and they were loosely organized into family-based groups. When the restoration of Tōdai-ji and Kōfuku-ji had been completed, these groups inevitably came into competition for outside commissions, thus engendering rivalries that helped to consolidate them into *za*. The *za* were hereditary guilds resembling those of medieval Europe. By the end of the Kamakura period three painting *za* were active in Nara: the Handa, Shiba, and Shōnan-in.[8]

Family genealogies recorded in fifteenth-century documents claim the illustrious painter Kose no Kanaoka (act. late 9th–early 10th centuries) as the ancestor of the Handa *za*, but Yūzon (act. 1190–1220) is a more plausible choice. Yūzon's name appears in the dedicatory inscription of Kaikei's statue of Hachiman, sculpted in 1201 (no. 15). He also helped to paint the now lost statues of two of the Four Heavenly Kings carved by Kaikei and Jōkaku in 1194 for the Chū-mon (Inner Gate) of Tōdai-ji. The Shiba *za* was formed by some of Yūzon's followers breaking away from the Handa *za*; its members are generally identified by the character *Kan* in their names. Kanjō, the painter of *Four Saintly Persons* (no. 38), was a member of the Shiba *za*. The Shōnan-in guild was established by Sonchi (act. 1207–24), an artist known for his paintings of both secular and religious subjects.

Nara painters were highly versatile and treated a broad range of subjects. This was essential in securing regular employment from a diverse patronage that included temples of various schools in the Nara region, aristocrats, warriors, and religious confraternities.[9] In addition to hanging scrolls they painted wall panels, shrine interiors (e.g., no. 24), and wooden statuary (e.g., no. 15), and their subject matter encompassed Buddhist and Shinto deities, landscapes and architecture, and portraiture.

Tōdai-ji is especially rich in portraits by Nara painters depicting its founders and other saintly persons associated with its history. As these include semilegendary figures from the distant

past, many of them of Indian, Chinese, or Korean origins, artists were hard-pressed to convey the special quality of each individual. Only rarely did they have firsthand knowledge of their subject's physical appearance, or access to sketches or paintings made from life. More often than not, they were forced to rely on iconographic formulae used to depict the Buddha's disciples or *arhats*. As portrayed by thirteenth-century painters, the sixth-century Chinese monks Ji Zang and Hui Yuan (nos. 41, 42), for instance, closely resemble the patriarchs figuring in the *Kusha Mandara*. Much of the Kamakura-period "portraiture" at Tōdai-ji is thus conventionalized and cannot be defined in the Renaissance sense as a "depiction of an individual in his own character."[10]

Though Nara painters seem to have eschewed the more calligraphic lines and muted tones favored by Kyoto artists from the mid-thirteenth century, they did in fact practice a wide range of styles. The portraits of Ji Zang and Hui Yuan (nos. 41, 42), painted about 1257, feature a conservative painting style, distinguished by taut, even bounding lines and graded colors, that has since become synonymous with the *Nanto E-dokoro*. This pictorial style reflects aesthetic premises of the Nara period; by contrast, the mid-thirteenth-century portrait of the monk Fa Zang (no. 44) exhibits a love of decorative pattern and pastel colors more in keeping with aristocratic tastes of the Late Heian period. Such stylistic diversity reflects both the influence of particular models and the artistic leadership of each *za*.

Together with portraiture, Tōdai-ji is rich in illustrated Buddhist narratives in both hanging and horizontal scroll formats. Beginning in the eighth century, large wooden panels and hanging scrolls were frequently employed to present panoramic landscapes incorporating a multiplicity of loosely related vignettes. Narrative works of this type are exemplified here by the *Legends of Tōdai-ji* (no. 46). Such works were often employed as didactic aids by "picture-telling" monks (J: *e-toki*), who showed the paintings as they narrated or explained their contents to a lay audience.

Handscrolls combining text and illustration were initially used to render the content of Buddhist scriptures more lively and appealing. The narrow, elongated format of the handscroll, meant to be unrolled a section at a time, is especially well suited to the sequential presentation of continuous narratives. By continuously rolling up the portion of the scroll that has already been seen and unrolling the next portion, the viewer sees the action as it occurred, over time, and this imparts a cinematographic quality to the handscroll. Viewing the *Illustrated Handscroll of Zenzai Dōji's Pilgrimage* (no. 34) in this fashion not only brings to life the story of Zenzai Dōji but in a sense allows one to reenact the youth's pilgrimage. The close physical relationship thus established between viewer and painting—as well as the relatively small size of handscroll illustrations—makes the handscroll an especially intimate art form, best viewed by no more than a few people at a time. Many handscrolls were commissioned for private edification and enjoyment rather than for public display.

We do not know who illustrated *Zenzai Dōji's Pilgrimage*, but he (or they) probably did not belong to the *Nanto E-dokoro*, whose members seem not to have specialized in narrative handscrolls until the Muromachi period.[11] During the Kamakura period, when *Zenzai Dōji's Pilgrimage* was painted, the two most important handscroll commissions from Nara went to artists elsewhere. The *Tōsei E-den*, an illustrated account of the monk Ganjin's life (see no. 31), was painted by artists in Kamakura even though it was commissioned by Ninshō (1217–1303), a monk with close ties to Nara temples. Donated in 1289 to Tōshōdai-ji (the Nara temple founded by Ganjin), it was later borrowed by members of the *Nanto E-dokoro* desirous of studying its Chinese-inspired style.[12]

The *Kasuga Gongen Reigen-ki*, an illustrated narrative in twenty rolls relating the history and miracles associated with Kasuga Shrine and its affiliated temple Kōfuku-ji, was painted in the Imperial Painting Atelier (J: *Kyūtei E-dokoro*) under the direction of Takashina Takakane (act. 1309–30).[13] Its highly stylized figures with minute, expressionless facial features, and its steep aerial views into roofless interiors, all painted in layers of thick pigments, embody a style derived from the courtly painting of the Heian period. These are the most apparent characteristics of the style that has come to be called *Yamato-e*. The scroll was donated in 1309 by its patron, the courtier Saionji Kinhira, to Kasuga Shrine. Like the *Tōsei E-den*, it too

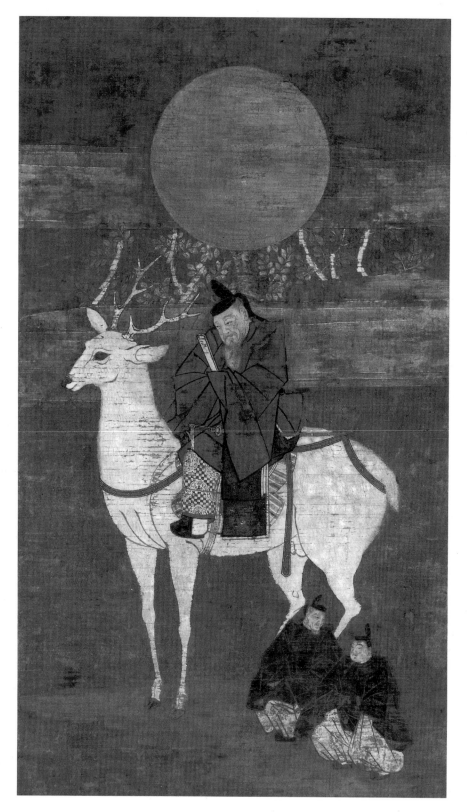

became a compendium of style and motifs for Nara painters of the Muromachi period.

The Muromachi period: the *Daibutsu Engi Emaki*

Paradoxically, the century of warfare that began in 1467 released a new burst of creative energy in Nara, as many courtiers fleeing the devastation in Kyoto (then the seat of both the imperial and shogunal courts) took refuge there. Lectures on classical literature and poetry competitions sponsored by prominent courtiers were held in temple compounds, and Kyoto artists took up temporary residence in Nara temples.[14] Such activities helped to revitalize cultural life in the former capital.

While the civil wars disrupted the lives of the Kyoto aristocracy, they also contributed to the rise of a new bourgeoisie. As production and trade of consumer goods flourished, urban communities flourished. Merchants and artisans in Nara, Sakai, and even Kyoto enjoyed new prosperity. Many impoverished courtiers earned a living instructing these upwardly mobile merchants in poetry and classical literature. Thus social bonds were created between the court aristocracy and the prosperous merchant class.

Like other commercial and craft guilds, the Nara painting *za* benefited from the social ferment. To cater to the needs of the newly wealthy bourgeoisie, they opened new workshops in various districts of Nara as well as in the compounds of temples other than Kōfuku-ji and Tōdai-ji. The Handa *za*, for instance, maintained ateliers at Daian-ji, in a district of Nara that is still called Handa (though written now with different characters) located to the east of Women's College, and on Second Avenue.[15] The Tōdai-ji painting workshop, which had lapsed into obscurity after completing restorations in the second decade of the

Figure 39 *Kasuga Deer Mandara.* **Muromachi period, c. 1428. Colors and gold on silk; h. 141 cm., w. 80 cm. Seattle Art Museum, long-term loan from Donald E. Padelford family**

thirteenth century, became active once again. There, artists affiliated with the Shiba, Handa, and Shōnan-in *za* collaborated on many projects. In 1547, for instance, the Tōdai-ji *E-dokoro* carried out a periodic ritual renewal of Hachiman Shrine, allotting to each *za* a certain number of rooms for redecoration. At that time the most renowned painter at Tōdai-ji was the Handa *za*'s Rinken (act. 1536–91), who had worked on the *Illustrated Legends of the Daibutsu* (J: *Daibutsu Engi Emaki*) (no. 47) eleven years earlier.[16]

The combined influence of aristocratic and merchant culture gave new direction to the activities of Nara painters. They continued to fill temple commissions for traditional devotional paintings and portraits. The two genres now dominating production, however, were religious paintings inspired by the syncretic Buddhist-Shinto cults that had evolved in the Nara region, and illustrated narratives, both secular and religious, in handscroll and book form. Especially popular among the religious communities in Nara and surrounding areas were hanging scrolls depicting Kasuga Shrine or showing the deities of that shrine astride sacred deer (fig. 39).[17] Illustrated narratives such as the *Daibutsu Engi Emaki* and other scrolls relating Tōdai-ji's sacred history (nos. 47–50) appealed to all social classes.

The *Illustrated Legends of the Daibutsu*, a narrative handscroll in three rolls relating the history of the Great Buddha of Tōdai-ji, was commissioned by Sanjōnishi Sanetaka (1455–1537) (see nos. 47, 49, 50). This noted courtier, scholar, and patron of the arts had become a strong supporter of Tōdai-ji through the efforts of its solicitor, the monk Yūzen.[18] Sanetaka was at the same time a lover of narrative handscrolls, especially *engi*, which dealt with the legendary origins of shrines and temples. He often borrowed Kamakura-period examples, including the *Kasuga Gongen Reigen-ki*, to study and to show to Tosa Mitsunobu (1434–1525), chief painter of the Imperial Painting Atelier. Mitsunobu painted many *engi* at Sanetaka's request. The richly colored, detailed realism of his late style, seen in works such as the *Kiyomizu-dera Engi* of 1517, is a reinterpretation of the courtly style practiced by Takashina Takakane two centuries earlier.[19] Mitsunobu's style came to represent a new standard of orthodoxy that other artists of the sixteenth and

seventeenth centuries would emulate. So influential was Mitsunobu that the name Tosa became synonymous with *Yamato-e*.[20]

The style of the *Daibutsu Engi Emaki* and other sixteenth-century scrolls relating Tōdai-ji's sacred history reflects the new direction in narrative painting initiated by Tosa Mitsunobu. Its lavish colors, profuse ornamental detail, and descriptive directness are especially close to scrolls painted by Mitsunobu's son and successor Mitsushige (1496–1559). Indeed, although Rinken's painting lacks something of the courtly splendor and precision of Mitsushige's, the two men unquestionably shared the same aesthetic premises. Both were exponents of the orthodox *Yamato-e* style, and they had collaborated in the creation of the *Taima-dera Engi* of 1532.[21]

The *Illustrated Legends of the Daibutsu* has been described as naive, even crude, but its courtly patronage and stylistic derivation are ample evidence that it was appreciated by the most sophisticated and discriminating members of the nobility. Even as it satisfied a nostalgic longing for the courtly traditions of the Heian period, it evinced a straightforwardness in keeping with the realities of a new era far removed from the refined sensibilities and closed society of the Heian court. Rinken and other members of the Tōdai-ji *E-dokoro* active in the second quarter of the sixteenth century were in the very mainstream of *Yamato-e* painting.

Painters at Tōdai-ji fell on hard times after Sanetaka's death in 1537. No single patron took his place. Indeed, the economic climate was such that restoration of the *Daibutsu*, damaged once again during civil wars in 1567, had to wait for over a century. The decline of Nara forced members of the *Nanto E-dokoro* to seek clientele beyond their traditional boundaries, and increasingly to tailor their work to the taste of a plebeian audience. Some painters moved from Nara to Kyoto to set up new ateliers or to join existing ones. Many undoubtedly illustrated the books and scrolls of amusing folk stories or much-simplified Buddhist tales that flooded the market from the late Muromachi period.[22] The term *Nara-e*, "Nara pictures," used to designate these brightly colored, often folkish, works testifies to the rich and varied traditions of painting associated with the ancient Nara capital.

NOTES

1. *Shōsō-in Monjo*, quoted in *Tōdai-ji 3*, pp. 55–57.
2. On the painting workshop of the Nara period, see Nara-shi Shi Henshūban Kōkai, comp., *Nara-shi Shi, Bijutsu-hen*, pp. 369–74.
3. Magic, of course, requires formulaic accuracy. For Japanese Buddhists China was "the source," and Chinese origin conferred unimpeachable sanction on teachings, teachers, and images.
4. Despite its overwhelming importance in understanding the development of Japanese Buddhist painting, this work has not received extended treatment by Western scholars. It is discussed briefly in Akiyama, *Japanese Painting*, pp. 27–28. For fuller discussion and bibliography in Japanese, see Shamada, ed., *Zaigai Nihon no Shiho*, vol. 1, *Bukkyō Kaiga*, pp. 122–23.
5. *Nara-shi Shi*, p. 386.
6. On Chinkai, see Hamada, *Zuzō*, pp. 66–67.
7. On the *Kusha Mandara*, see *Tōdai-ji 3*, pp. 55–57.
8. On workshops, see Shimizu, "Workshop Management of the Early Kano Painters, ca. 1530–1600," pp. 32–47. On the Nara workshops, see Morisue Yoshiaki's pioneering study, *Chūsei no Shaji to Geijutsu*, pp. 305–425. More up-to-date treatment of the subject appears in *Nara-shi Shi*, pp. 390–504.
9. The monk Eizon of Saidai-ji (Nara) was influential in the formation of many such confraternities. Both he and his followers commissioned many works from the *Nanto E-dokoro*. See Hirata, "Saidai-ji Eizon no Zōzō Seikatsu ni Okeru Butsuga ni Tsuite," pp. 98–113.
10. Quoted in Mori, *Japanese Portrait Sculpture*, p. 11.
11. The production in 1337 of the now lost *Illustrated Legends of Tōdai-ji* (see no. 47) in twenty rolls may have been the catalyst as well as the training ground for Nara artists interested in illustrating handscrolls. In any case,

they were well established as painters of *emaki* by the last quarter of the fourteenth century, when several were invited to Tō-ji (Kyoto) to collaborate in illustrating the biography of Kōbō Daishi.
12. For a reproduction of the *Tōsei E-den*, see *Nihon Emakimono Zenshū*, vol. 21, and *Nihon Emaki Taisei*, vol. 16. On its importance to Nara painters, see *Nara-shi Shi*, p. 435.
13. For a reproduction of the *Kasuga Gongen Reigen-ki*, see *Nihon Emakimono Zenshū*, vol. 16, and *Nihon Emaki Taisei*, vols. 14 and 15.
14. Ichijō Kanera, a prominent courtier, scholar, and patron of the arts, for instance, fled there in 1470. For a discussion of the activities of such courtiers, see Nagashima, *Ichijō Kanera*, pp. 45–74.
15. *Nara-shi Shi*, p. 444.
16. Morisue, *Chūsei no Shaji to Geijutsu*, pp. 403–5.
17. On the Kasuga cult and its imagery, see Nagashima, *Nara Bunka no Denryū*, pp. 197–250.
18. On Sanetaka's close ties with Tōdai-ji through the fund-raiser Yūzen, see Kawahara, "Yūzen to Rinken," pp. 149–71.
19. For reproductions of a section of this scroll, see Yoshida, *Tosa Mitsunobu*, pl. 30.
20. Carolyn Wheelwright, "Revivals of Genji: the Courtly Tradition in Muromachi Painting," p. 24 (at press).
21. Kawahara, "Yūzen to Rinken," pp. 162–63. The *Daibutsu Engi Emaki* is also very close in style to Mitsushige's *Kuwanomi-dera Engi*, painted in 1532. For reproductions, see Yoshida, *Tosa Mitsunobu*, pls. 31–32.
22. For an introduction to the problems of these works, see Sayre, "Japanese Court-Style Narrative Painting of the Late Middle Ages," pp. 71–82.

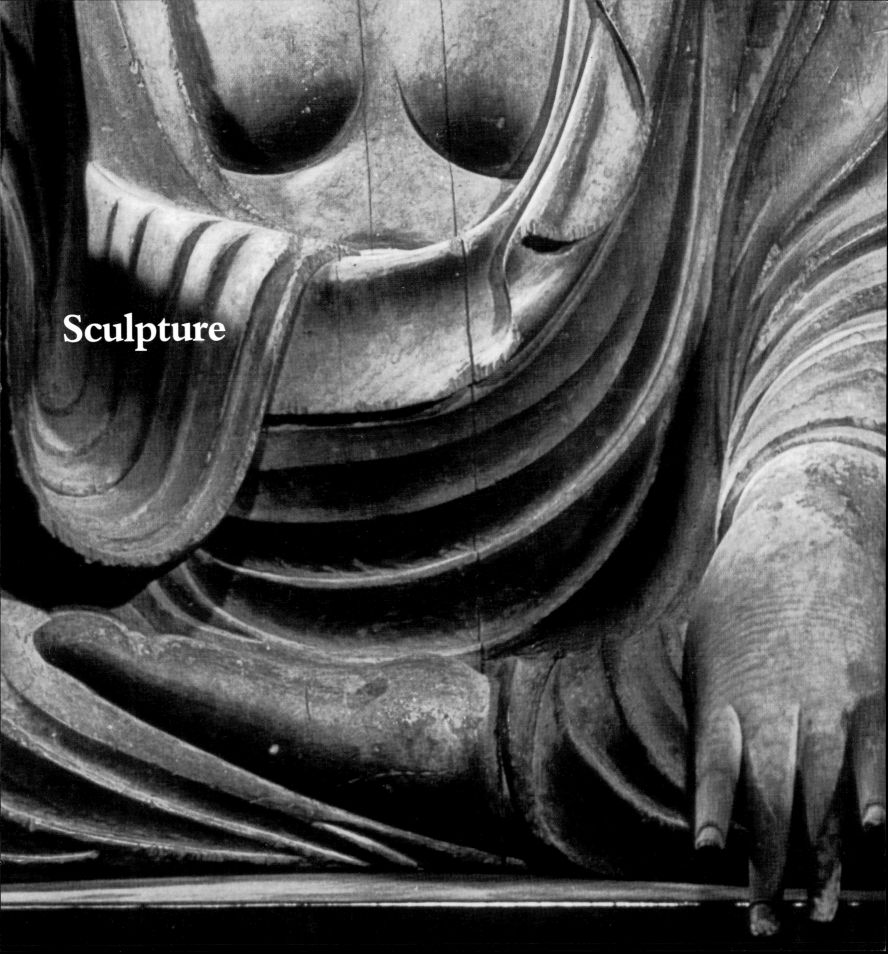

Sculpture

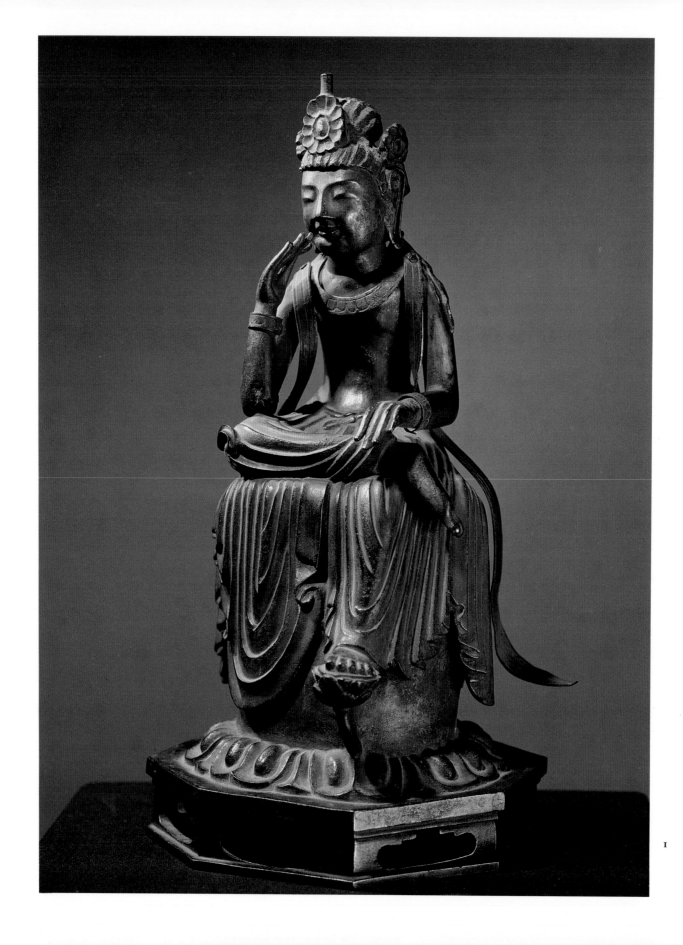

I

1

Meditating Bodhisattva

Bronze

H. 32.8 cm.

Late Nara period, 8th century

Important Cultural Property

ACCORDING to temple legend this statue was the private devotional image of Emperor Shōmu (701–56; r. 724–49). Shōmu's especial divinity was a proto-Esoteric manifestation of Kannon, the Bodhisattva of Compassion (see no. 11), called Nyoirin Kannon (S: Cintāmani-cakra Avalokitesvara). Therefore this image has been traditionally dubbed Nyoirin Kannon.

The deity is shown in a highly distinctive meditative pose called *hanka shi-i*: right hand to cheek, left leg pendent, right ankle supported on left knee, the expression sweetly withdrawn and contemplative. Like almost all images of this type, this one bears no identifying inscription. Of the images that are inscribed, some of those from China are labelled Siddhārtha (the given name of Sākyamuni Buddha) and others simply "contemplative image" (C: *si wei*). In Korea and Japan numerous such images exist, but of these only one is inscribed. This is a Japanese image labelled Miroku (S: Maitreya), the Bodhisattva of the Future who will become Buddha in time to come.

The cult of Maitreya had flourished in fifth- and sixth-century China and in seventh-century Korea, whence this image type was brought to Japan. Since Maitreya is considered equally a Buddha and a bodhisattva, and since Siddhārtha when so called was still a prince and had not yet become a Buddha, the jewelled crown, pectoral, and scarves on this figure (worn by bodhisattvas but never by Buddhas) do not prescribe or preclude either identification.

This image differs in many technical respects from other bronzes produced in Japan through the seventh century. During the Asuka and Early Nara periods the entire image would have been cast in one piece, but in the Tōdai-ji image the right forearm was cast separately, as were the pectoral and the scarves. The walls of the Tōdai-ji figure are quite thin, marking an advance in lost-wax casting technique over the earlier period.

Stylistic differences are apparent as well. The

ribbons that fell from the sides of the crown in many earlier images are absent here. And the drapery is far more strikingly rendered in the Tōdai-ji image, with deeply carved elliptical folds and undulating hem. Although the presentation of the figure is essentially frontal, a new concern with all dimensions is apparent, and the face is more fully modelled than on earlier icons.

The image is seated upon a lotus pedestal with inverted petals; the pedestal, in turn, rests on an octagonal base with moldings perforated in a lobed design (J: *kōzama*). The deity's pendent foot rests upon a single lotus blossom growing up from the inverted petals. CJB

2

Shaka at Birth with Ablution Basin

Gilt bronze

(Shaka) H. 47.5 cm.; (Basin) Diam. 89.4 cm.

Late Nara period, 8th century

National Treasure

ACCORDING to several Buddhist sutras Shaka, the historical Buddha, was born to Queen Māyā on the eighth day of the fourth month in a pleasure grove of *sāla* trees known as the Lumbinī Garden. There she grasped the branch of a flowering tree and an infant sprang from her right side without causing her pain or trauma. The scriptures relate that the infant Buddha immediately took seven steps and looked to the four quarters of the earth. Then, gesturing heavenward with his right hand and earthward with his left, he pronounced, "I alone am Prince of that above and below the heavens." The *Tanjō Shaka* (literally, Birth Buddha) image shown here represents the newborn at this moment.

In Japan a *sai-e*, or Buddhist vegetarian feast, has been held on the Buddha's birthday, beginning in the year 606 during the reign of Empress Suiko (r. 593–628). It is likely that this Shaka image was used in the Buddha's birthday celebration held as part of the "eye-opening ceremony" for the *Daibutsu* in the fourth month of 752.[1] The relatively large size of both the figure and its accompanying basin would have been appropriate for use at this magnificent ritual.

A smile plays about the plump, childish face,

and the fleshiness of the half-nude body almost seems to restrict the figure's movement. The soft puffiness characteristic of an infant's physiognomy, with folds of flesh on the arms and midriff, is most convincingly and naturalistically modelled. In Chinese art of the mid-eighth century, which greatly influenced Japanese, corpulence was the dominant ideal of figural beauty—an ideal superbly expressed in the *Buddha at Birth* image. On the contemporary octagonal lantern that stands before the Great Buddha Hall (see no. 62) are musician-divinities with similar plump, broad, naively smiling faces and similarly modelled noses and eyebrows.

The *Tanjō Shaka* was cast in a single piece, with the exception of the right forearm, which is a restoration. A seam and hole are clearly visible where the forearm was attached. Although the statue is small it is surprisingly heavy, probably because pieces of the clay core were left inside after the casting process. The original pedestal has been lost and replaced by a wooden base.

The statue stands in the middle of an engraved bronze ablution basin used in the birthday celebration ceremony. The bathing of the Infant Buddha image, a ceremony called *Kambutsu*, has its origin in scriptural accounts of the newborn being bathed, immediately after his first words, by two *nāga* (serpent divinities, in East Asia transmuted into dragon divinities). First performed in Japan in the seventh century, it is apparently unknown in other Buddhist countries.[2] Two types of lustration ceremonies are known, one utilizing a basin of perfumed colored water that is poured over the Shaka image. This basin would be appropriate for such a ritual and is in fact used during the annual ceremony at Tōdai-ji. Currently, however, fragrant herbal tea (*ama cha*) has replaced perfumed water, a practice that dates to the late nineteenth century.

The basin, the largest of its type known, must have been even more resplendent in the eighth century, when its gilding was intact. Today, somewhat darkened by age, its surface still reveals fluently engraved hairline designs scattered across a ground of dense dots hammered with a burin (J: *nanako*; fish-roe ground). A cloud motif decorates the rim, and the outside of the body is engraved with mountain peaks, cloud forms, pagodas, flowering grasses, trees and shrubs, butterflies, real and imaginary

animals and birds, and humans of various types. Many of these motifs are secular and without Buddhist connotation, and many were borrowed from the Chinese decorative repertoire so popular in Nara-period Japan. Some, such as the hermits carrying banners as they ride upon birds, foreigners astride Chinese lions, and children in Chinese garb chasing tigers, are also found on metalwork that was placed in the Shōsō-in in 767.[3] CJB

1. At the eye-opening ceremony a high-ranking prelate brought the image to spiritual "life" by painting in its eyes. Usually many prominent laymen and ecclesiastics participated in this meritorious act by holding on to a long multicolored cord attached to the brush while the eyes were being painted.

2. See Pal, *Light of Asia*, pp. 41, 187 and nos. 25–29.

3. The Shōsō-in is a storehouse, or treasury, belonging to Tōdai-ji (though now administered by the Imperial Household Agency), in which imperial treasures and ritual objects were from time to time deposited. Such objects were not simply stored but rather dedicated as religious offerings.

3
Shaka Nyorai and Tahō Nyorai
Gilt Bronze
(Shaka) H. 25 cm.; (Tahō) H. 24.2 cm.
Late Nara period, 8th century

SHAKA (S: Sākyamuni) and Tahō (S: Prabhūtaratna) are the Buddhas of the present age and of an extinct past age, respectively. Their representations here are based on descriptions in the Buddhist scripture most important in Japan, the *Lotus Sutra* (J: *Hokke-kyō*). In chapter 11, "Apparition of the Jewelled Stupa" ("Mihōtō"), the emanations of Sākyamuni

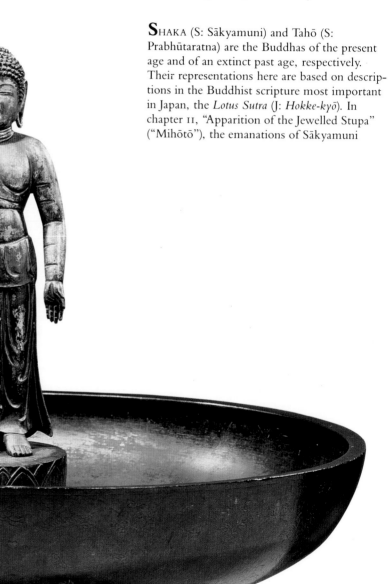

2

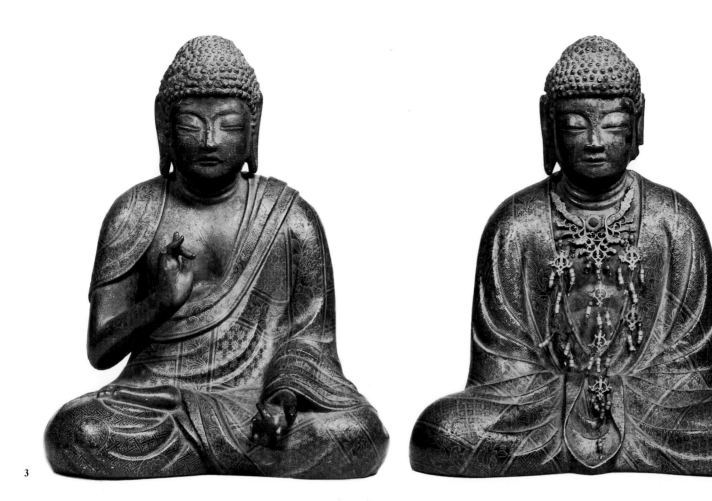

3

Buddha assemble, seat themselves on a lion throne, and request Sākyamuni to open the door to a seven-jewelled stupa. This structure, described in detail in the beginning of the chapter, represents the whole body of the Buddha and wells up from the earth each time the *Lotus Sutra* is preached, as predicted by Tahō Buddha (whose name means "Many Jewelled"). The Buddhas and Sākyamuni all rise into the air, whereupon Sākyamuni opens the stupa to reveal the Tahō Buddha in relic form, also seated upon a lion throne, praising the *Lotus Sutra*. The Buddhas scatter Tahō with divine-jewel flowers, and he then offers half his seat to Sākyamuni, where they sit cross-legged side by side.

Although artistic representations of this chapter from the *Lotus Sutra* are known to have been common in China from the Northern Wei period (386–535) onward, they do not appear to have been as popular in Japan. There the earliest example known, a fine bronze plaque

depicting the apparition, is at Hase-dera, Nara, inscribed with a cyclical date that may correspond to 686 and a dedication to the spirit of the deceased emperor Temmu (r. 673–86).

Each statue was cast as a single piece by the lost-wax method. Great stylistic similarity suggests that both images are by the same artist. Certain differences, such as the hand gestures and the arrangement of the garments, relate to iconographic prescriptions contained in the sutra. Shaka is seated in lotus position, with one shoulder bare except for one end of the robe pulled over it like a capelet. He wears no jewelry at all, and his contemplative face is generously modelled. Tahō sits in a more compact and simplified rendition of the same pose, with both hands concealed inside a robe that covers both shoulders and falls in a stylized loop where his ankles cross. A filigree pectoral with glass beads extends almost to the bottom of the figure.

Temple legend has it that the great Chinese

monk Jian Zhen (J: Ganjin; 689–763) (see no. 31) brought the Tahō and Shaka statues with him to Japan in 753, and that they were placed in a "Tahō pagoda"[1] at the center of the altar in the Ordination Hall (J: Kaidan-in) at Tōdai-ji, where Ganjin conducted ordination ceremonies. Based on written records and stylistic analysis, however, it appears more likely that they were made in Japan as icons for that hall and that they date to the late eighth or early ninth century. Because gilded bronze statues from this period are rare, the two images are valuable evidence for the study of Nara sculpture. The gold lacquer inlay patterns that decorate the Buddhas' robes were added during the Edo period. CJB

1. The pagoda is the Chinese and Japanese form of the Indian stupa, or reliquary mound, and miniature pagodas served as shrines and reliquaries inside temples.

4
Miroku Buddha

Wood

H. 39 cm.

Early Heian period, 9th century

Important Cultural Property

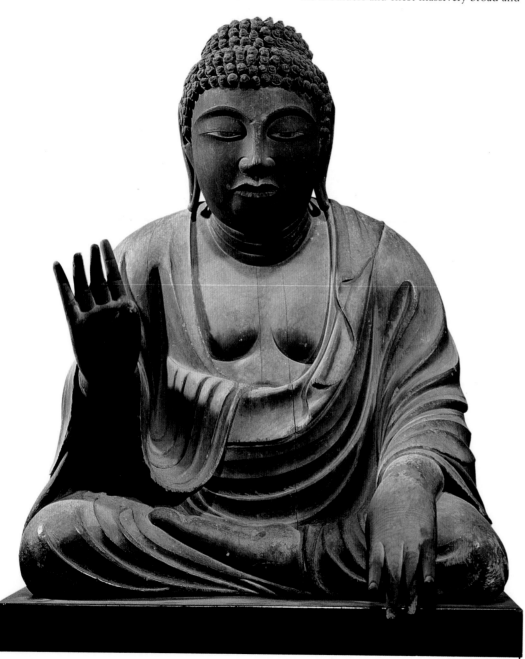

THIS small seated image is traditionally identified as Miroku (S: Maitreya), the Buddha of the Future. It is an amazing work—barely sixteen inches high, yet projecting unsurpassed monumentality and power and an almost hypnotic intensity (which is never reproduced in photographs). Completely ignoring naturalistic proportions, the sculptor made the head large and the shoulders and chest massively broad and full. The facial features, too, are large, bold, and sharply defined, and all the body contours are swelling and taut. Even the robe adds to the effect of massiveness, being ample and generously draped and carved to suggest thick, heavy cloth. In carving it, the sculptor skillfully exploited the contrasts between deep and shallow, wide and narrow folds, thereby making clear that his overall exaggeration of naturalistic forms was intentional. Indeed, this kind of exaggeration represents one major stylistic tendency in Early Heian sculpture and informs many if not most of the small number of surviving ninth-century images.

Except for the small, snail-shaped curls and the right hand, the image was carved from a single block of Japanese cypress and was not hollowed out, only shallowly gouged at the base. (The left hand was once broken off and subsequently reattached.) The figure has been left unpainted, except for eyebrows heightened with black, eyes with blue-green, and lips with faint red, and the lack of color and ornament augments its impressiveness.

Tradition has it that this was the personal devotional image of the monk Rōben (689–773), who founded the original temple (Konshō-ji) on the site of Tōdai-ji and later became Tōdai-ji's first high priest (see no. 27, n.1). But the fully mature wood-carving technique testifies to an early ninth-century date.
SCM

5
Twelve Divine Generals

Emperor's Hall of Tōnan-in

Wood

H. 95 cm.–110 cm.

Late Heian period, 12th century

Important Cultural Property

THE Twelve Divine Generals (J: Jūni Shinshō) are attendants of Yakushi (S: Bhaisajyaguru; the Healing Buddha), each being a manifestation of one of Yakushi's twelve vows to save humankind, from physical as well as spiritual tribulations. By the eleventh century the Twelve Divine Generals had become associated with the "twelve branches," horary signs for the twelve two-hour periods of the day. The idea of "twelve branches" had come to Japan from

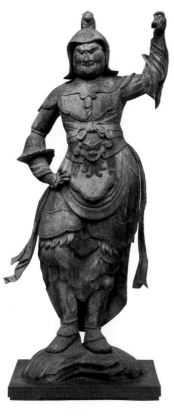
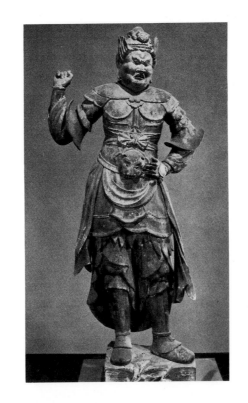
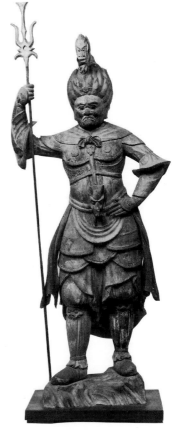
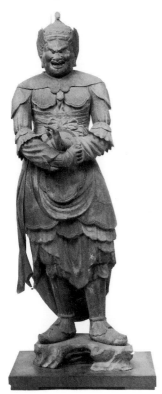
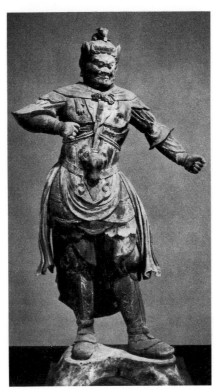
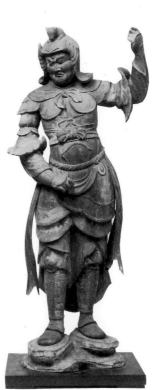

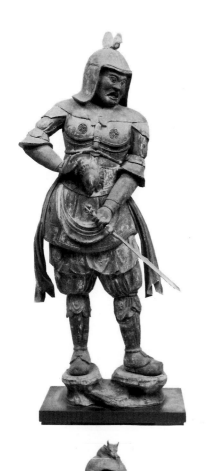

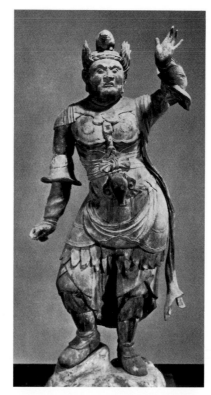

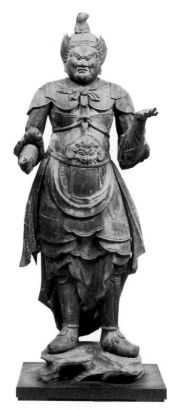

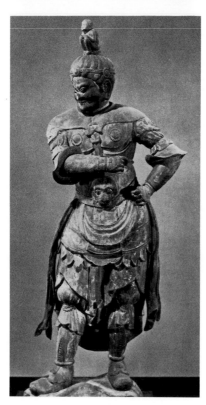

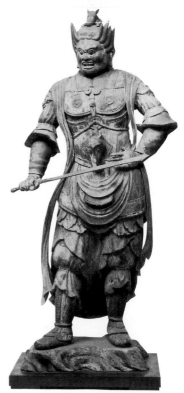

5

China, each branch symbolized by one of the animal signs of the Chinese zodiac. The twelve generals shown here can each be identified by the zodiacal animal placed, as was customary, atop his helmet or hair.

These twelve figures, kept in the Emperor's Hall of Tōnan-in, are preserved almost intact. All are armed warriors, but by artfully distinguishing their postures, expressions, and accoutrements the sculptor has created interesting variety within a coherent assemblage.

All the statues were made of cypress in the joined woodblock technique, but different methods were used to construct different postures, demonstrating the craftsman's considerable technical skill. Over a kaolin-based white primer coat various hues of red, blue, and blue-green were applied. Several different patterns of cut gold leaf further enhanced the brilliant effect.

Although these statues represent fierce warrior deities, their expressions are relatively restrained, clearly reflecting the Late Heian preference for serenity and refinement.[1] This characteristic, together with the mature style and confident technique, argues a date in the twelfth century. JDP

1. By comparison, a set of *Twelve Divine Generals* by Chōsei (1010–91), in Kōryū-ji, Kyoto, dating to 1064, appears far more bristling.

6
Amida Buddha
Shigatsu-dō
Wood
H. 85 cm.
Late Heian or early Kamakura period, 12th–13th century
Important Cultural Property

AMIDA is shown seated on a nine-tiered lotus pedestal, with his hands in the gesture of concentration (J: *jō-in*; S: *dhyāna mudrā*). Traditionally this gesture is derived from the position of Sākyamuni's hands as he meditated just prior to Enlightenment, hence it symbolizes supreme concentration and the suppression of all spiritual unrest. The two hands describe a circle divided vertically by the bent index fingers, and this shape symbolizes the harmony

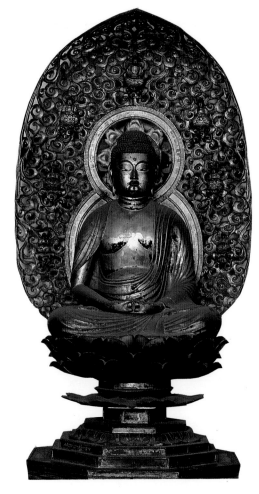

6

between the world of the Buddha and the world of sentient beings. The gesture is peculiar to seated images and particularly common in Esoteric images of Amida.[1]

Both the figure and the lotus dais are of Japanese cypress (J: *hinoki*). The head and torso were carved from a single block of wood, with the lap and arms carved out of separate pieces and attached. The head was then detached from the torso and both were split laterally from top to bottom and liberally hollowed out, a procedure that prevents checking as the wood dries. The split between head and torso was customarily angled, as here, so that the join would not show when the pieces were fit together again. This later refinement of the single woodblock technique (J: *ichiboku zukuri*) (see Essay 2 and no. 12, n. 2), called "split and join" (J: *warikubi*), became popular in the mid-ninth century.

Harmonious proportions and smooth surface characterize the modelling of this *Amida*. Chest and arms lack muscular definition, the drapery-clad shoulders are rounded and sloping, the legs are low and considerably flattened along the horizontal. The garment flows over the body, its pleats carefully arranged in parallel. In the somewhat puffy face the eyes, nose, and brows are, by contrast, sharply delineated. The snail-shell curls of the hair are unusually small and arranged in tight rows. To some viewers, the icon conveys calm and serenity, to others a certain slackness.

Much of this image is not of the original date. Its markedly slanted eyes may have been recarved; the right shows traces of chisel marks from possible recarving, and the inlaid crystal eyeballs were, in fact, a later addition. The elaborate flame-shaped mandorla, with seven Buddhas in relief against an openwork cloud pattern, is of recent date, as is the lacquer-ground gilding of the figure.

This *Amida* is housed in the Sammai-dō (Supreme Concentration Hall).[2] A small building east of the Daibutsu-den, it is more commonly known as the Shigatsu-dō, or Fourth-Month Hall, after rites of repentance (called *Hokke-sembō*) performed there in the fourth lunar month. CJB

1. See Saunders, *Mudrā*, pp. 85–93. For a brief definition of Esoteric Buddhism, see Lee, *History of Far Eastern Art*, p. 288.
2. *Sammai* (S: *samadhi*; deep concentration) is the state in which the distinction between the mind and the objects of thought has been transcended. It is the state immediately preceding Enlightenment.

7
Aizen Myō-ō
Shunjō-dō
Wood
H. 98.4 cm.
Late Heian period, 12th century
Important Cultural Property

AIZEN Myō-ō (S: Rāgarāja; Lord of Passion) transforms the human passions, particularly lust and avarice, into energies leading to Enlightenment even in a single lifetime. He embodies the idea that every phenomenon

contains its latent opposite, specifically that human desires, which Buddhism considers the origin of delusion and suffering, are at the same time the seedbed of Enlightenment. Aizen is one of the five *myō-ō* (S: *vidyārāja*; Kings of Bright Wisdom, i.e., Esoteric knowledge), emanations and attendants of Dainichi (S: Mahāvairocana, most powerful of the Esoteric deities).

As guardians of Buddhist truth, the *myō-ō* take appropriately ferocious forms. The three eyes and six arms seen here are Aizen's customary iconographic features, as are his wrathful expression, hair standing on end, red body color (red being the color of the passions) and flaming mandorla, and the lion's head atop his own. One of his attributes is missing; the others are a bow, bell, thunderbolt, arrow, and lotus bud. These characteristics derive from one of the most important Esoteric sutras, called in Japanese by the abbreviated title *Yugi-kyō*.

Aizen was introduced into Japan in the ninth century, but his popularity burgeoned later, during two times of trouble: at the tumultuous close of the Heian period (see no. 13), and even more strongly during the Mongol invasion attempts that traumatized Japan (late thirteenth–early fourteenth century). During the Mongol threat Aizen and Fudō (S: Acala; the Immovable One, another of the Wisdom Kings) were specifically invoked by the Buddhist establishment at the government's request for the protection of the nation.[1]

The image was constructed of cypress in the joined woodblock technique, one block for the right side and another for the left. The center was hollowed out, and then separate pieces for the front of the lap and the back of the statue were attached. Although substantial repairs have been made to the entire image, the Late Heian-period style is still evident in the slight build, the gentle modelling, and the shallow carving.

Originally this figure was kept in the pagoda of Jubusen-ji (Konkai-ji) in Kyoto. Thereafter it was moved a number of times, till in the mid-1650s it was donated to a monk of Konju-in at Tōdai-ji. Since the Meiji period the image has been housed in a miniature shrine in the Shunjō-dō (see no. 13). JDP

1. See Lee, *History of Far Eastern Art*, p. 329. See also no. 23.

8

Kariteimo

Sanrōjo Jiki-dō of Nigatsu-dō

Wood

H. 42.2 cm.

Late Heian period, 12th century

Important Cultural Property

ORIGINALLY Kariteimo (S: Hāritī) was an ogress whose food was human children. To teach her compassion, the Buddha kidnapped her own favorite child and imprisoned it under his overturned alms bowl. In return for her promise to stop killing, the Buddha granted her a sight of her child, and in return for her conversion to Buddhism he restored the child to her. Not unreasonably, Kariteimo pointed out that without their customary food source she and her children would starve, so the Buddha promised her a daily offering from Buddhist monasteries. Thereupon Kariteimo became the protectress of women and children (illustrating the concept, discussed in no. 7, that every phenomenon contains its latent opposite). In honor of the Buddha's promise it has long been customary for monks to offer daily prayers to an image of Kariteimo enshrined in the refectory, and this statue is housed in the Sanrōjo Refectory (J: Jiki-dō) associated with Nigatsu-dō.

Here Kariteimo is dressed like a Japanese noblewoman and wears her hair in the "jewelled topknot" of a heavenly being. On her lap she holds a child. In Buddhist iconographic tradition Kariteimo is generally accompanied by three, five, seven, or nine children, so we can assume that figures of two more children originally flanked the image. There may also have been a pomegranate (ancient Chinese

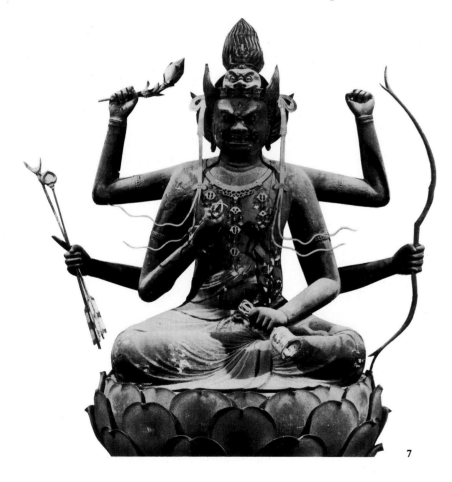

7

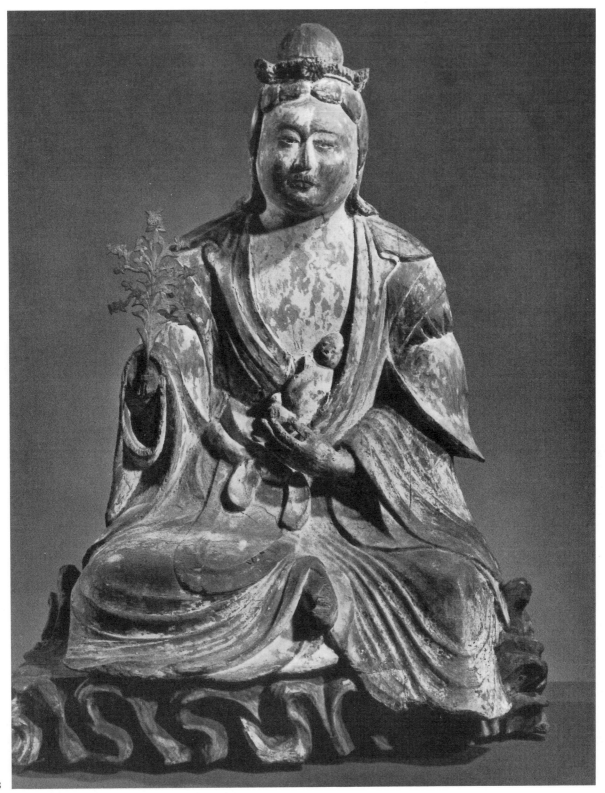

8

symbol of fecundity) in the now missing right hand.

This statue is made in the joined woodblock technique, the right and left sides being carved of separate pieces of cypress. The legs were made of three joined pieces, one for the right calf and the knees, one for the lap, and another for the left calf and foot. The entire surface was covered with a kaolin-based white undercoat, and although a circular motif has peeled off the sleeves, the original flesh tone of the body and the yellow-ochre, vermilion, and greenish white of the robes remain.

Shallowly carved drapery and an overall tranquil representation mark this as a product of the latter part of the Late Heian period. In proportion to the body, which lacks depth, the head is small. Full, rounded cheeks, small facial features, and the slight leftward inclination of the head create a benevolent aspect most appropriate to this "goddess of children."
JDP

9
Jikoku-ten and Tamon-ten
Wood
(Jikoku-ten) H. 201 cm.; (Tamon-ten) H. 186.5 cm.
Late Heian period, 12th century
Important Cultural Properties

JIKOKU-TEN (also called Daizurata-ten; S: Dhritarāshtra) and Tamon-ten (also called Bishamon-ten; S: Vaisravana) are two of the Shitennō (S: Lokapāla), or Four Heavenly Kings. These were originally Hindu protective deities, absorbed into the Buddhist pantheon and assigned to guard the four cardinal directions against evil. Popular as protectors of individuals, temples, and entire nations against danger and illness, these four became standard figures at the four corners of Buddhist altars in Japan. Tamon-ten, who protects the north, is the chief of the Four Heavenly Kings and even came to be worshipped independently of the others. Jikoku-ten guards the east. These two examples are "guest images": originally kept in Eikyū-ji, a temple in the hills south of Nara, they were moved to Tōdai-ji when Eikyū-ji was ruined in the anti-Buddhist movement of the early Meiji period.

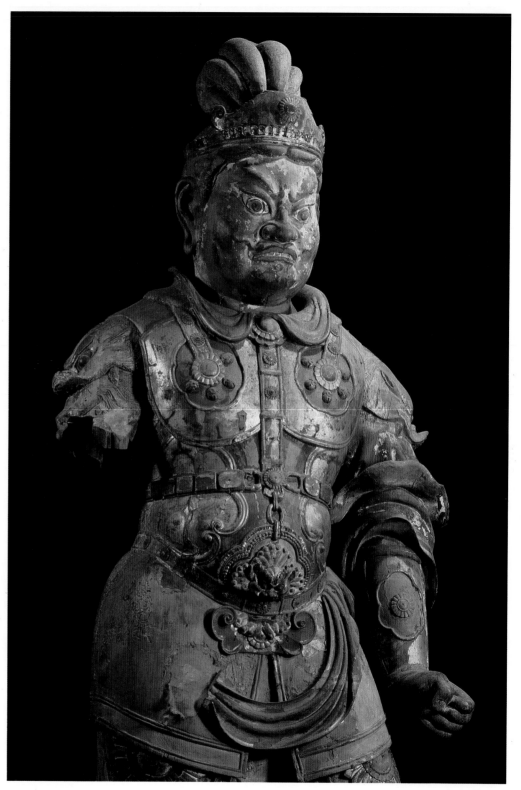

9

86

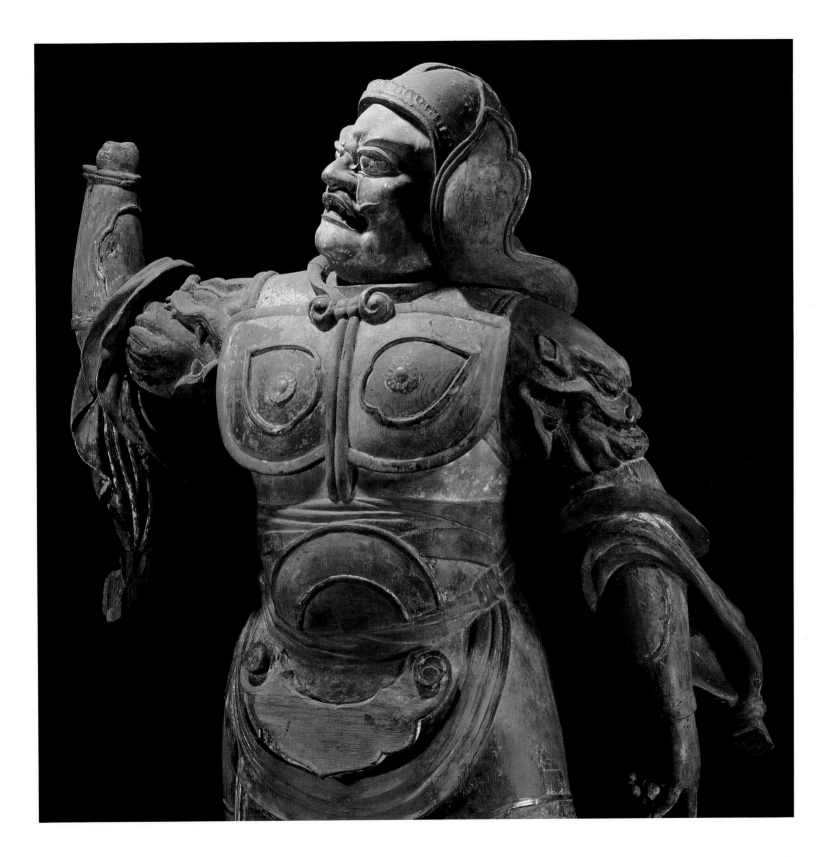

Jikoku-ten stands on a stone platform, his weight mostly on his right leg, glancing slightly downward. Probably a lance or spear was the object originally clasped in his left hand. His right arm is now lost, but it was probably bent at his elbow, with a wish-granting jewel held in the hand. The image is made of joined and hollowed-out cypress woodblocks, and the ornaments on the armor were carved separately and affixed to the body. Dedicatory articles found inside the statue date from repairs in 1160 and 1178.

Tamon-ten too stands on a stone platform. His legs are splayed and braced and his head is thrown back and turned to the side, his glance directed toward the miniature pagoda (his chief attribute) that was surely supported on the palm of his now missing right hand. With his left hand he points to the earth. Appropriate to his role of guardian, he wears leather armor, with a helmet in place of Jikoku-ten's crown

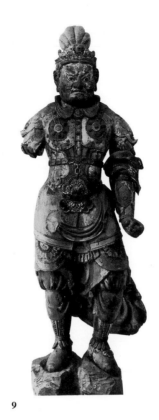

9

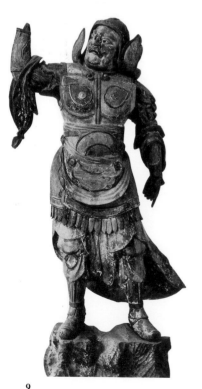

9

and topknot. This image is also of joined cypress woodblocks, but in contrast with the *Jikoku-ten* the ornamentation is carved directly into the main blocks. Both statues have been painted. Dedicatory documents placed inside the *Tamon-ten* during repairs are dated to 1159.

Both these statues are particularly valued as early examples of the new style of the Kamakura period—a style manifested in their stout figures overflowing with strength, in their determined stances, and in their vividly expressive faces. Slight differences between the two statues can be attributed to a difference in age, the Jikoku-ten image being somewhat advanced in style and technique over the older Tamon-ten image. JDP

10

Seimen Kongō

Wood

H. 169.4 cm.

Late Heian period, 11th-12th century

Important Cultural Property

As the god who inflicted illness, specifically tuberculosis, Seimen Kongō was worshipped to appease his wrath and avert this wasting disease. The first known description of him appears in a sutra called the *Darani-jikkyō*, which represents him as blue, entwined with snakes, and holding four attributes in his four hands.

The *Darani-jikkyō*, which describes a variety of deities, is one of the most important proto-Esoteric texts. Proto-Esotericism, or Miscellaneous Esotericism (J: *zōmitsu*), is a term devised by modern scholars to describe the magical practices for worldly benefit that were introduced into Japan in the eighth century. These included primarily chanted invocations to Mahayana deities (J: *darani*; S: *dhāraṇī*) and the recitation of magical formulas (mantras). Although *zōmitsu* originated in the same Indian Mahayanist practices as Esoteric Buddhism, it had nothing of the intellectual sophistication and systematization that would be exemplified in the Esoteric teachings of the Shingon school, brought to Japan in the ninth century. What it offered instead was exotic and awesome icons and ceremonies that promised present well-being—an emotionally potent combination that made *zōmitsu* increasingly popular among laymen, even of the upper class.

Tōdai-ji's image of Seimen Kongō differs somewhat from the description in the *Darani-jikkyō*, having six arms instead of four, and a third eye, placed vertically in the middle of his forehead, which attests his spiritual insight. Originally each of his six hands held an attribute, but only two of these remain: the Wheel of the Buddhist Law raised high on the palm of a left hand, and a *vajra*-hilted sword (J: *hōken*) gripped in one of the right hands. The sword is held stiffly in front of the body with its point up, in exactly the manner in which Fudō (no. 23) usually holds an identical *vajra*-hilted sword. The *vajra* (J: *kongō*) symbolizes the thunderbolt, and the *vajra*-hilted

sword in the hands of a Buddhist deity struck through or cut down ignorance of the Law.

As represented here, Seimen Kongō was intended to strike terror in the beholder. His hair, bound by twined snakes, rises like flames. Entwined snakes form his necklace, bracelets, and earrings, the sash across his left shoulder, and his belt. Fangs jut upward from the corners of his mouth. Apart from the snakes, he is naked to the waist. The image stands on a lotus pedestal.

Seimen Kongō images, of which this is the oldest extant, are not common in Japan. This one, probably of Japanese nutmeg (J: *kaya*), has been made in the single woodblock technique (see no. 12, n. 2). The main block has been slightly hollowed out from the back in the area of the hips, and the gouged area covered over with a board. But in contradistinction to such technical archaism, the very shallow carving of the surface, which is characteristic of the later Heian period, bespeaks a date about the year 1100.

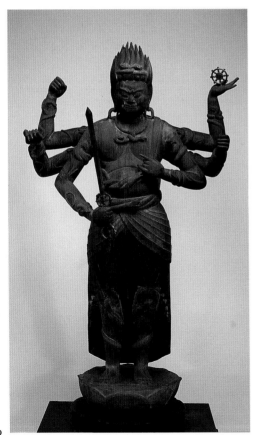

10

Originally this Seimen Kongō image stood in the Shunjō-dō (see no. 13). After several moves within Tōdai-ji, it is now housed in the Tokyo National Museum.

11
Eleven-Headed Kannon
Wood
H. 175.2 cm.
Late Heian period, 12th century
Important Cultural Property

Eleven-headed Kannon (J: Jūichimen Kannon; S: Ekādasamukha Avalokitesvara) is one of the first Esoteric forms of the Bodhisattva of Compassion to have been worshipped in Japan. According to Buddhist scripture Kannon's eleven heads symbolize the deity's eleven vows to save all sentient beings. The topmost head, as always, is that of Amida Buddha (S: Amitābha), Kannon's spiritual source.

Unlike Early Heian Esoteric sculpture, this Late Heian standing image, slender and with curved shoulders, seems mild and easily approachable. It was carved from a single block of Japanese cypress (J: *hinoki*) that was then split and hollowed out. Both arms were formed from separate pieces of wood, the right joined at the shoulder and wrist, the left at the shoulder, elbow, and wrist.

Cut gold leaf ornaments the robe in a pattern of Chinese floral arabesques (J: *karakusa*), linked swastikas (J: *manji*; a Buddhist symbol of auspiciousness), and stylized hemp leaves (J: *asa no ha*). This *kirikane* decoration is original, but the polychromy covering exposed parts of the body is from a later restoration. The formal characteristics of the statue, the carving style, and the manner in which polychromy and cut gold leaf are combined suggest that the figure dates from the end of the Heian period, though the base and the mandorla are later restorations.

The statue was originally housed at the now abandoned Tō-o-ji in Nara. During the third quarter of the nineteenth century it was moved to Tōdai-ji and installed in the Nigatsu-dō.[1] Recently it was moved into a fireproof storehouse on Tōdai-ji's grounds. SCM

1. The present Nigatsu-dō (Second-Month Hall) was built in the Tōdai-ji compound in 1669, after a fire destroyed the original eighth-

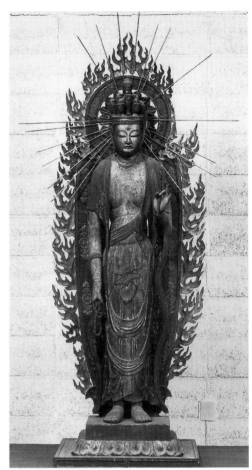

11

century structure in 1667. It was the scene of an annual offering to Eleven-Headed Kannon in the second lunar month (the *Omizutori*; see Introduction), hence its name and hence also the appropriateness of locating an Eleven-Headed Kannon there.

12
Amida Meditating Through Five Kalpas
Wood
H. 106 cm.
Kamakura period, 13th century
Important Cultural Property

The *Amida Meditating Through Five Kalpas* is one iconographic type of the Lord of the Western Paradise. According to Buddhist texts this Amida, in order to realize the Forty-eight

Great Vows for the salvation of humankind, sat in meditation and deep concentration for an inconceivably long time, as evidenced by the length to which his hair grew. In Buddhist terminology the Sanskrit word *kalpa* denotes an aeon—the unimaginably long time in which an adamantine mountain would be worn away by a bird's wing brushing it once a century.

Only eight such images, including this one, are extant. Common to all of them is of course the thick helmet of hair, the seated posture, and the robe covering both shoulders. Their symbolic hand gestures, however, differ. Three of the figures, including this one, join their hands in prayer; the remaining five display the meditation gesture, and on three of these the sleeves cover the hands.[1] Thus there seem to have been three iconographic variants of this type of Amida. All the statues were made between the Kamakura and the Edo period.

The flat face, with its full, squared cheeks and small, close-set features, differs conspicuously from most representations of Amida. Temple legend has it that the monk Chōgen (see no. 13) brought this statue back with him from a period of study in Song China, but since the wood is Japanese cypress (J: *hinoki*), the work was most likely carved in Japan during the Kamakura period, based upon Song Chinese models. If this is indeed the case, then it may explain the statue's singular face and strangely thick drapery folds.

Although the techniques of joined woodblock construction (see no. 13, n. 3) and inlaid crystal eyes were particularly popular when this image was sculpted, the carving here is in the older single block technique[2] and without inlaid eyes. SCM

1. Two of the others are also in Tōdai-ji, one in the Gokō-in and another, barely ten centimeters high, in the Kanjin-sho. Single examples are kept at Jūrin-in (Nara), Saikō-ji and Dairen-ji (Kyoto), Dōjō-ji (Wakayama), and Jōshin-ji (Tokyo). Hands joined in prayer characterize the Jūrin-in and Dairen-ji images, hands in meditation the Saikō-ji and Jōshin-ji images, and concealing sleeves the Kanjin-sho, Dōjō-ji, and Gokō-in images.

2. The method of carving a statue from a single block of wood was dominant in Japan in the ninth century and still widespread in the tenth; it became less common thereafter. Images carved largely from a single block, with the hands and perhaps part of the legs made

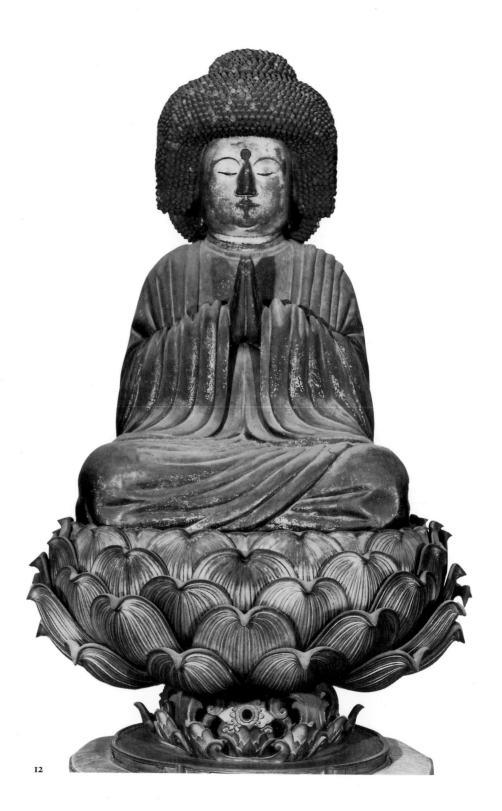

12

separately and attached, are still considered *ichiboku* construction. For a clear description of this technique, and of the processes of hollowing-out (J: *uchiguri*) wooden sculptures and inserting crystal eyes (J: *gyokugan*), see Nishikawa and Sano, *Great Age of Japanese Buddhist Sculpture*, pp. 50–52, 54.

13
Amida Buddha
By Kaikei (act. c. 1185–1223)
Shunjō-dō
Wood
H. 98.7 cm.
Kamakura period, 1202–8
Important Cultural Property

THIS three-foot-tall statue of Amida (S: Amitābha), Lord of the Western Paradise, is usually enshrined in a closed cabinet on the left altar of the Shunjō-dō, the hall at Tōdai-ji dedicated to Shunjōbō Chōgen (1121–1206). Chōgen, the enormously forceful and influential monk who supervised the reconstruction of Tōdai-ji after its destruction during the civil war of 1180–85, became the patron of the Buddhist sculptor Kaikei.

Beneath the feet of the image, on a socle attaching the figure to its base, is an inscription recording the application of intricately cut gold leaf (J: *kirikane*) to the robe. The inscription, which in all likelihood postdates the carving of the image, includes the first character of Kaikei's religious name (An'ami) and a date corresponding to 1208.

From this inscription, and from a report dated to 1243 and contained in a collection of documents relating the history of Tōdai-ji, the history of the image and the circumstances surrounding its carving can be determined.[1] Namely, that Chōgen, using his own funds, commissioned Kaikei, one of the most important sculptors of his time and a member of the Kei school of Buddhist sculptors who were working to refurbish the Nara temples after the devastation of the 1180s, to sculpt the statue during the years 1202–3. For some reason the cut gold leaf was not applied to the statue during Chōgen's lifetime; in 1208, after Chōgen's death, this finishing touch was added by order of Kanken, Tōdai-ji's new high priest.

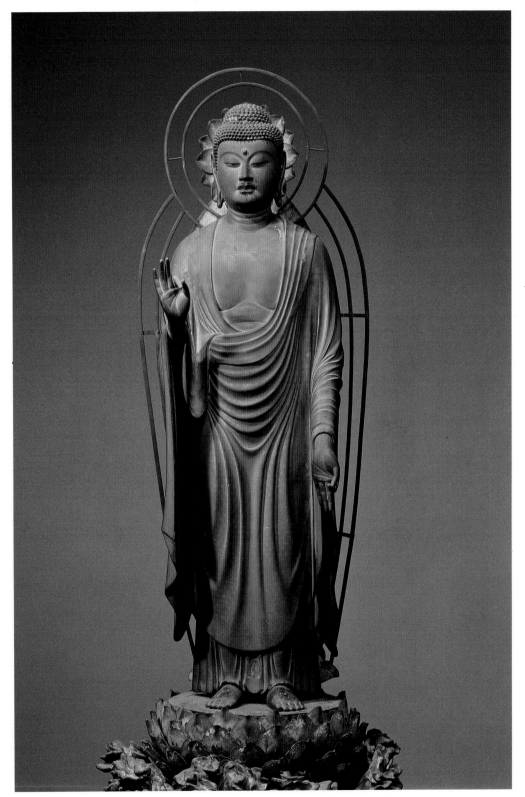

13

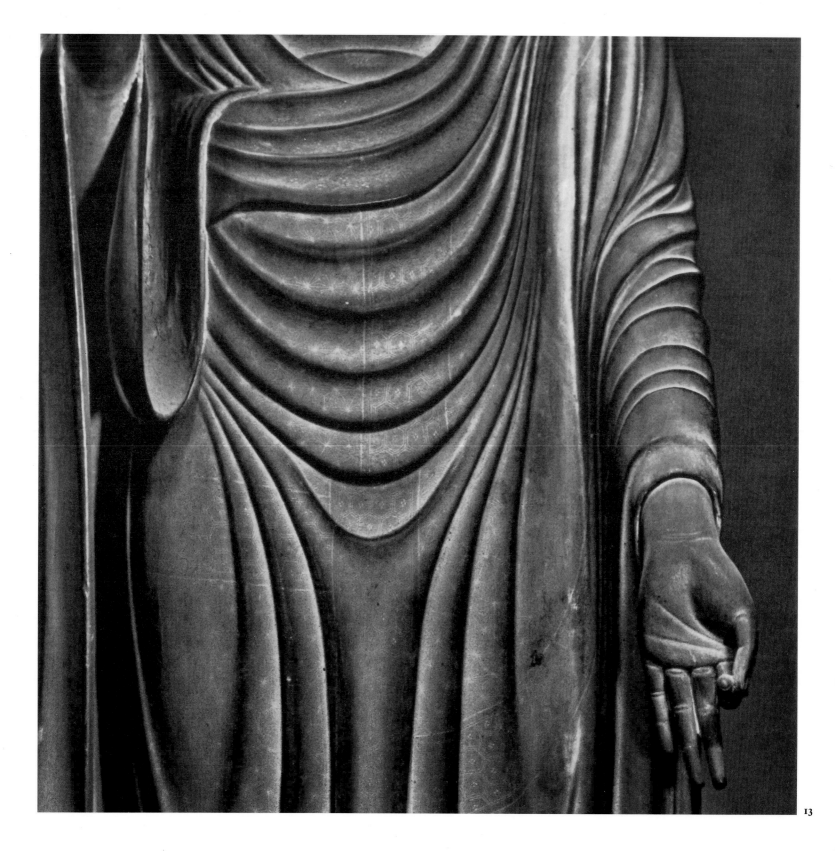

13

At all levels of society it was popularly believed that holding one end of a braided five-colored cord whose other end was attached to the hand of an Amida image would "draw one up" to the realm of bliss that was Amida's Western Paradise (S: Sukhāvatī). In such fashion Kanken died in 1216, holding a cord connecting him to this image.

Amida stands with his left foot slightly advanced and his hands in the gesture of welcoming the believer to paradise (in Japanese this gesture is called *raigō-in*, in Sanskrit *vitarka mudrā*). This identical posture is seen in many Amida images of the period.[2] Compared with Kaikei's earlier works, of the decade 1190–99, this image shows a more restrained sense of mass and a gentler handling of bodily volumes, reminiscent of Late Nara-period Buddhist sculptures. Eyes, nose, and lips are exquisitely modelled, and the folds of the robe ripple like water, with an almost musical rhythm. The image resembles other large-scale works of the same period by Kaikei, such as the *Monju Riding a Lion* at Monju-in (southern edge of the Nara plain) or the Buddha at Shin Daibutsu-ji (Mie Prefecture). Like the sculptors of classical Greece, Kaikei chose to express divinity through supreme idealization of the human form.

The image was carved in the joined wood-block technique (J: *yosegi zukuri*)[3] out of Japanese cedar. The head was split off at the base of the neck and the body split in two vertically to allow the interior to be hollowed out. This also permitted the insertion of inlaid crystal eyes (J: *gyokugan*) and the installation of dedicatory objects in the body cavity. The sleeves, hands, and feet were carved from separate pieces of wood and joined to the torso. Glass crystal forms the *urna* (raised curl of hair between a Buddha's eyebrows) and the jewel in the *usnisa* (extracranial protrusion). The hair was painted green, the lips cinnabar red, and the body and robe a soft, shining gold. Cut gold leaf in a pattern of hexagons (J: *kikkō mon*; tortoise-shell pattern) and stylized hemp leaves was then applied to the robe over a thin layer of damp lacquer that served as adhesive. The mandorla and base are later restorations. SCM

1. The author of this report was Senkan, Great Master of the Buddhist Law, and the document collection is the *Tōdai-ji Shoshū*.

2. One such image, by Kaikei himself, is in the Saihō-in (Nara); another, of bronze, is in the Los Angeles County Museum of Art. See Nishikawa and Sano, *Great Age of Japanese Buddhist Sculpture*, no. 25, and Pal, et al., *Light of Asia*, no. 172.

In Buddhist iconography distinctive hand positions, called mudras, indicate the activity in which the divinity or patriarch is engaged.

3. In joined woodblock construction the head-and-torso section of a statue is made from more than two separate blocks of wood. Each block is carved separately and hollowed out, and then the finished blocks are assembled to form the complete sculpture. This technique, prevalent after the tenth century, was particularly advantageous for making large images. For a clear summary of the process, see Nishikawa and Sano, *Great Age of Buddhist Sculpture*, pp. 52–53.

14
Jizō Bosatsu

By Kaikei (act. c. 1185–1223)

Kōkei-dō

Wood

H. 89.8 cm.

Kamakura period, 1203–8 or 1203–10

Important Cultural Property

JIZŌ Bosatsu (S: Ksitigarbha Bodhisattva) was introduced into Japan in the eighth century as one of the many bodhisattvas of the Esoteric tradition. But as the Heian period (794–1185) drew to a close in lawlessness, civil war, and suffering, the Pure Land (Amidist) sect of Buddhism, preaching salvation by simple faith in Amida, swept all before it. In the ground swell of popular enthusiasm for salvific deities, Jizō was transmuted into the special guardian of those suffering hell's torments.

This Jizō wears monastic dress with a single necklace. The customary staff (J: *shakujō*) once grasped in the right hand is now missing, but the wish-granting jewel (J: *hōju*; S: *cintāmani*) still lies in the palm of his left hand.

As in most of Kaikei's work, refinement and elegance of feature and form have created a serenely approachable, benign, compassionate image. The linear and painterly folds of the robe add to the impression of grace and beauty, as do the colors and the cut gold leaf on the robe, which are original. The petals of the

lotiform pedestal seem to belong to a different statue, and the clouds and the lower section of the pedestal are later restorations.

An inscription on the socle that attaches the foot of this image to the base reads, "Skilled craftsman Hokkyō Kaikei." This lets us know that the statue was carved some time between 1203 and 1208 or 1210, for Kaikei (see no. 13) was awarded the rank of *hokkyō* probably in 1203 and raised to the higher rank of *hōgen* between 1208 and 1210.[1] By the early thirteenth century Kaikei was in his artistic maturity, experienced at carving images of all sizes and genres, from monumental to delicate and from ferocious to benign.[2] His best work, however, is exemplified by images finely carved, graceful in form and gracious in aspect, and only about three feet high, like the Amida in the Shunjō-dō and this figure of Jizō. Such works are considered to be in the An'ami style—after Kaikei's religious name, An'amidabutsu—and images in this style constitute the major portion of his extant oeuvre. SCM

1. *Hokkyō* (Bridge of the Buddhist Law) and *hōgen* (Eye of the Buddhist Law) were honorific ecclesiastical titles awarded to highly regarded artists.

2. These include the monumental sculptures at Jōdo-ji in Hyōgo Prefecture and at Shin Daibutsu-ji, the *Four Heavenly Kings* at Kongōbu-ji, the seated *Fudō* in the Sampō-in of Daigo-ji, and the *Monju Bosatsu with Attendants* at the Monju-in of Tōdai-ji, as well as the *Amida* at the Shunjō-dō (no. 13) and the Jizō discussed here.

15
Hachiman in the Guise of a Monk

By Kaikei (act. c. 1185–1223)

Hachiman-den of Kanjin-sho

Wood

H. 87.1 cm.

Kamakura period, 1201

National Treasure

IN 749 Hachiman, a hitherto rather obscure Shinto divinity (J: *kami*) whose main shrine was at Usa on the island of Kyushu, was made tutelary deity of Tōdai-ji. This official act of syncretism, intended to increase popular and

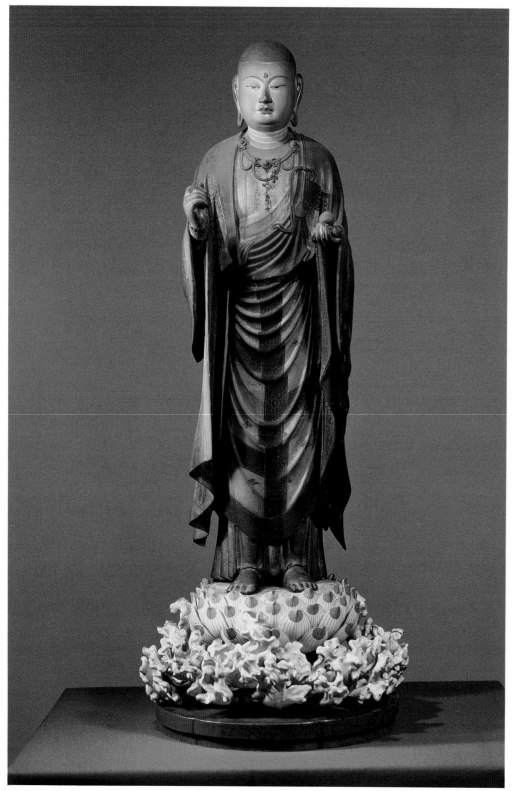

financial support for the enormously costly *Daibutsu* project, was an early instance of the policy of conflating Buddhism and Shinto for their mutual advantage and the greater protection of the state. Another expression of this policy was the depiction of Hachiman, as here, in the garb of a Buddhist monk. This image, dedicated in 1201, replaced one that had been burned in the first year of the civil war of 1180–85, when Taira forces fired Tōdai-ji because its monks had aided the Minamoto side.

Red-painted cloth lines the hollow interior of the figure, possibly for ritual reasons. Written on the inside is also a dated dedicatory inscription, which notes that the statue was commissioned by Emperor Tsuchimikado (1195–1231; r. 1198–1210), Retired Emperor[1] Go-Toba (1180–1239; r. 1184–98), two retired empresses, the intendant[2] of Tōdai-ji, the prominent Kegon high priest Myōe Shōnin (see no. 17), and the Amidist monk Myōhen (1142–1224). Its chief sculptor was Kaikei, assisted by twenty-eight apprentice carvers, three lacquerers, and one metalworker.

Chōgen's name (see no. 13) does not appear in the inscription, but we know from other documents that he was instrumental in having the statue made and that the circumstances of his involvement were curious. Chōgen had intended furnishing the rebuilt Hachiman Shrine at Tōdai-ji with a painting of Hachiman in the Guise of a Monk, then in the collection of Retired Emperor Go-Toba and kept at Shōkōmyō-in. This painting had originally belonged to Jingo-ji (near Kyoto), and Chōgen discovered, too late, that it had already been reclaimed for Jingo-ji by the prominent Shingon ecclesiastic Mongaku. This was perhaps one of the few occasions on which the shrewd and redoubtable Chōgen found himself forestalled. The sculpture that we see here was Chōgen's substitution for the unavailable painting.

A Kamakura-period copy of the painting obtained by Mongaku remains at Jingo-ji today. So exactly does it correspond in all its details with Kaikei's carved Hachiman at Tōdai-ji, even to the lined forehead, that the statue must have been based on the original painting. This Hachiman was not the first image that Kaikei had copied after a painting. He had a remarkable ability to translate the beauty of the painted line into a carved image without vitiating any of that image's sculptural power.

14

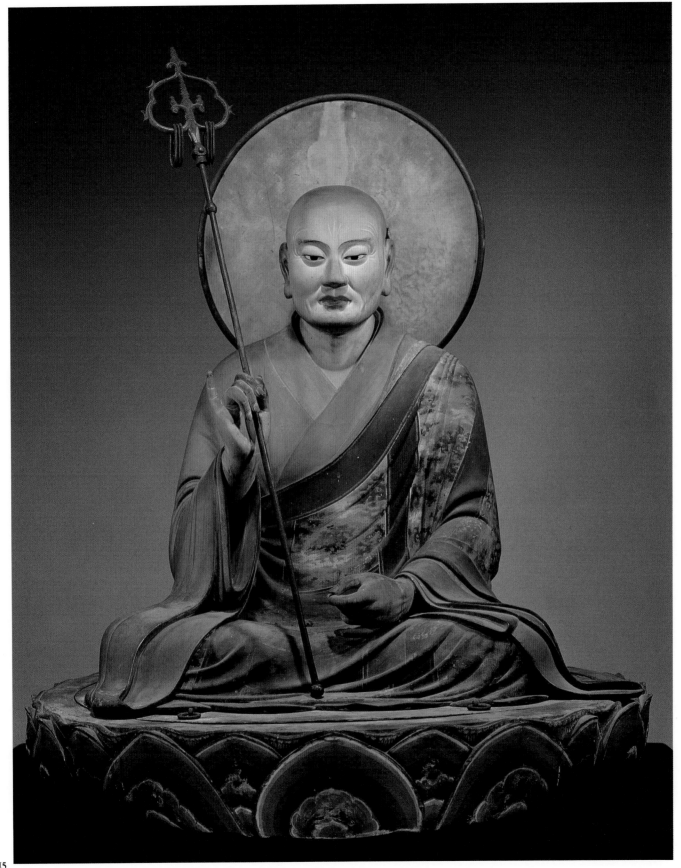

The idealized naturalism of this figure, apparent in the austere, concentrated, but intensely human face and in the suggestion of a real body beneath the robes, calls to mind a portrait sculpture. Perhaps because this is a Shinto image, the eyes are not inlaid crystal but black lacquer. SCM

1. Under the system of retired emperors, or "cloister government," the sovereign abdicated in favor of his heir, took Buddhist orders, and continued to direct the state from his monastic apartments. In practice the system could become vastly complicated, but this is the gist of it.

2. Temple intendants (J: *bettō*) were monks designated by the government as chief administrators (in a sense) of Buddhist temples. They were in charge primarily of the physical premises—i.e., construction and repairs—rather than the spiritual proceedings, which were the province of the high priest (J: *sōjō*).

16
Miroku

Chūshō-in
Wood
H. 102.7 cm.
Kamakura period

THIS statue originally stood beside the altar of the Senju-dō, one of the halls of the Kaidan-in, a subtemple of Tōdai-ji. In 1932, however, it was moved to the Chūshō-in, another subtemple, where it was made the main image. Discovered inside the image during a restoration was a badly damaged roll of the *Miroku Jōshō-kyō*, a sutra describing Miroku's ascent to the Tusita Paradise (J: Tosotsu-ten). From this we conclude that the image represents Miroku (S: Maitreya), the Bodhisattva of the Future who dwells in the Tusita Paradise until the time when he will be reborn as a Buddha. At the end of this scroll an inscription from the Kenkyu reign-period (1190–99) provides an approximate date for the sculpting of the image.

This *Miroku* stands with its hips bent slightly to the left and its weight more on the left foot than the right—a graceful pose that reflects the artist's interest in naturalism. Its left hand is raised as if holding something, its right extends downward, and its glance is also downward and to the right. The full volumes of the body have been precisely modelled, enhancing the sense of animation.

Inlaid crystal eyes, gilt surface, and exquisite cut-metal crown and jewelry belonged to the original work, which was carved from Japanese cypress in the joined woodblock technique. Often attributed to Kaikei (act. c. 1185–1223), this image closely resembles the sculptor's earliest extant work, the standing *Miroku* in the Museum of Fine Arts, Boston. The Song Chinese traits seen in Kaikei's early works are apparent here in the highly massed hair style, the rippling hem of the robes, and the plump, youthful face.

The gilded lotus pedestal was formed in two sections, one supporting each foot. It and the

16

six-layer wooden base are both inscribed with a date of 1628, indicating that the base and the mandorla were replaced at this time. SCM

17
Shaka Nyorai

By Zen'en (act. first half of 13th century)
Wood
H. 29 cm.
Kamakura period, 1225
Important Cultural Property

TWO inscriptions—one on the base, the other a dedication placed with other offerings inside the hollow sculpture—reveal that this Sākyamuni Buddha was commissioned by the monk Kakuchō for the repose of his deceased mother's spirit.

Japanese Buddhism in the Kamakura period saw a movement to revive the principal forms of Nara-period Buddhism, which had fallen into desuetude in the intervening centuries. Kakuchō is significant as one of the line of scholar-monks instrumental in reviving the Ritsu (S: Vinaya) emphasis on adherence to monastic regulations. In this he followed the monks Kainyo (act. first half of thirteenth century) and Jōkei (1154–1213) and was the teacher of Eison (1201–90) at Saidai-ji (Nara). Kakuchō himself lived in the mountains just north of Nara, at the Jūrin-in subtemple of Kaijusen-ji, a temple founded some five centuries earlier by Rōben (689–773), who became first high priest of Tōdai-ji. Even this summary account reveals the intimate connections and mutual influences, continuing over centuries, among the religious and artistic masters of Japanese Buddhism.

The sculptor Zen'en began the image on the sixteenth day of the tenth month of 1225 and finished it on the second day of the eleventh month of the same year. Ten months later, on the twenty-second day of the ninth month of 1226, Myōe Shōnin (1173–1232), the prelate and great patron of the arts who was responsible for reviving the Kegon sect, performed the "eye-opening ceremony" to consecrate the image.[1] This was done at Kōzan-ji, in the hills northwest of Kyoto.

Zen'en seems to have been a member of a line

of sculptors distinct from the Kei school of which Kaikei (see no. 13) was a member but also working at the temples of the Nara region. His statue of Eleven-Headed Kannon (J: Jūichimen Kannon) in the Nara Museum was made in 1221 and his Aizen (an Esoteric Buddhist deity) at Saidai-ji was commissioned by Eison in 1247.

All these works are small, elegant, and clear of line. The *Shaka Nyorai* exhibited here shows precise features, rhythmic drapery folds, and youthfully smooth body contours. The work is in the tradition of the legendary sandalwood first image of the Buddha, which conferred high sanctity on unpainted images of Śākyamuni in aromatic woods throughout the Buddhist world.[2] Such images are characterized by fine carving, small size, and unpainted surfaces. As is typical of images in this tradition, this one is unpainted except for the small snail-shaped curls, eyebrows, eyes, and lips. The mandorla is missing, but the image and its nine-layer lotiform pedestal preserve their original appearance. SCM

1. See no. 2, n. 1.
2. For the history of this legendary image, see Soper, "The Best-Known Indian Images," pp. 259–65.

18
Jizō Bosatsu
Chisoku-in
Wood
H. 97.2 cm.
Kamakura period, 13th century
Important Cultural Property

THIS statue of the bodhisattva Jizō (see no. 14) is said to be the image from which the monk Gedatsubō Jōkei (1154–1213), a vigorous proponent of the revival of Nara-period Buddhism, received instruction when he secluded himself at Kasuga Shrine in Nara in 1195. In 1251 Ryōhen, a well-known monk affiliated principally with Kōfuku-ji in Nara, took the image to Chisoku-in, a subtemple of Tōdai-ji that had been rebuilt the previous year; it was installed as the principal icon, and remains there to the present day.

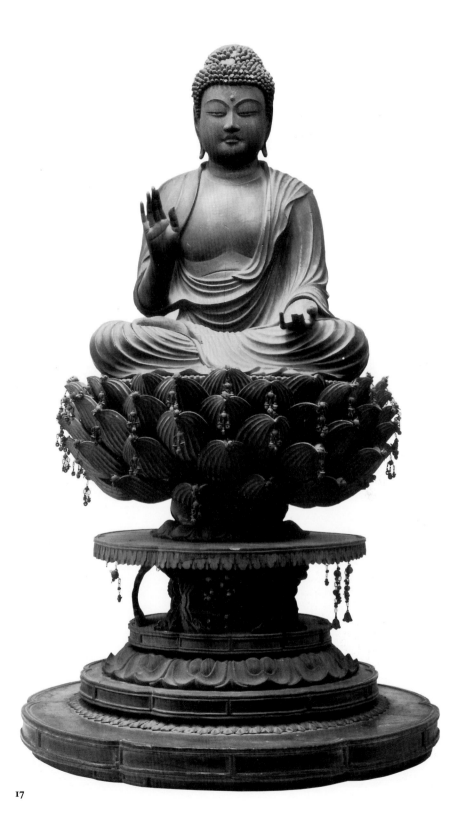

17

Typically, Jizō's left hand holds the wish-granting jewel on a lotus pedestal, his right the monk's staff with its six rings at the top. The garment style, with several layers of robes clearly indicated, is unusual among Jizō images, as is the severe expression. Together with the putative connection among this image, the monk Jōkei, and the Kasuga Shrine, these features suggest that the Jizō shown here may represent the Buddhist "essence" of a Shinto deity.[1] The modelling of the entire image, particularly the tautly rounded cheeks and belly, is naturalistic. Like the drapery treatment, it reflects the characteristics of Kamakura-period sculpture.

This joined woodblock statue has been carved of a block of Japanese cypress split vertically along its whole length and hollowed out. Following this, the head was split from the main block and inlaid with crystal eyes, and additional pieces of wood were attached at the sides to make the cascading outer garment. A thin base coat of lacquer was applied over all and painted, and the clothing was further adorned with cut gold leaf in a pattern of stylized hemp leaves, lotus arabesques, linked swastikas, and tortoise-shell hexagons. Both technique and freshness of style indicate a date in the mid-thirteenth century.

The cabinet in which the statue is housed is of black lacquer over wood. On its inside walls, painted in bright colors and gold, are various divinities and locales of Buddhist scripture: Bishamon-ten, the Guardian King of the North, and his attendants; Fudō, a fierce Esoteric divinity symbolizing power over evil, with his attendants; and four of the Six Realms of Sentient Existence. The rear panel, a replacement, shows Amida descending (see no. 13), but the original must have depicted the remaining two Realms of which Jizō is savior. The paintings, which follow the style of the capital painting ateliers of the Nara period, are later than the statue, probably from some time in the Nambokuchō period.　SCM

1. For an explanation of the syncretic pairings of Shinto and Buddhist deities, see Kageyama and Kanda, *Shinto Arts*.

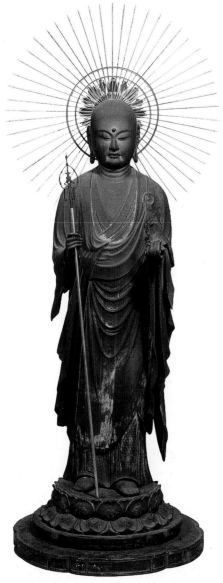

18

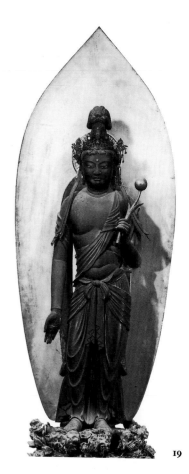

19

19
Shō Kannon
Wood
H. 183 cm.
Kamakura period, 13th century
Important Cultural Property

THIS gracious figure of the Bodhisattva of Compassion (S: Ārya Avalokitesvara) is known as a "guest image." At the time of the Meiji Restoration, when affiliated Buddhist-Shinto sanctuaries were split up and the temples dismantled, this statue was moved to the Nigatsu-dō at Tōdai-ji from Eikyū-ji, a large temple south of Nara that had been affiliated with Isonokami Shrine.[1]

The hair massed in a high topknot, the complex patterns created by the braids, the technique used for the inlaid crystal eyes, and the realistic drapery all indicate that this image was made during the mid-Kamakura period, through the downward glance and firm, full cheeks recall works by the master Kaikei (see

nos. 13, 14, 15), whose style is representative of the first half of the Kamakura period. Additional evidence for this similarity is provided by two standing images of Miroku (the Buddha of the Future; S: Maitreya) that are stylistically close to Kaikei's work and also not unlike the *Shō Kannon*. One of these, originally from Kōfuku-ji (Nara) and now in the Museum of Fine Arts, Boston, is dated to 1189 by an inscription discovered inside the statue, and the other (no. 16) is in the Tōdai-ji subtemple Chūshō-in. Detailed comparisons with Kaikei's works, however, reveal slight but telling differences: the bodily volumes of the *Shō Kannon* have been treated differently, the garment has been simplified, and the tension seen in the earlier work is absent here.

Although the clouds surrounding the lotiform pedestal suggest that the statue is a *raigo*—a representation of Kannon descending on clouds to the believer—the temple records of Eikyū-ji make no mention of a *Shō Kannon* corresponding to this image. The stylistic similarities between this image and the two Miroku images discussed above allow the supposition that this sculpture in fact corresponds to a Miroku listed in Eikyū-ji's records.

Only the parts of the mandorla directly behind the head and body are original; the outer edge is a later restoration. The base of the statue is original.　　　SCM

1. Note that Buddhist religious establishments are referred to as temples, Shinto as shrines.

20
Emma-ō
Wood
H. 123 cm.
Kamakura period, 14th century

EMMA-Ō, chief among the Ten Kings of Hell, originated in the Vedic tradition of India as Yama Rāja, god of death. The cult of the Ten Kings of Hell originated in Song-dynasty China, and from there Emma-ō, transmuted into paramount King of Hell, reached Japan. In the Esoteric tradition he is considered to be a guardian deity (J: *ten*; S: *deva*). Here, however, Emma is presented as the Lord of Hell, who with his infernal associates judged each sinner at ten prescribed intervals after death.

His hat and robes resemble those worn by magistrates in Song China, and in his right hand he holds a baton of office like theirs. But in place of the *gravitas* proper to a Song magistrate, Emma-ō shows a face contorted in fury. His bulging eyes glare, his mouth is open in a yell, even his posture looks implacable. Images of the Kings of Hell were meant to strike fear into the believers, and the sculptor here has understood and achieved this iconographic requirement.

This polychrome statue was made of cypress wood in the joined woodblock technique and has inlaid crystal eyes.　　　SCM

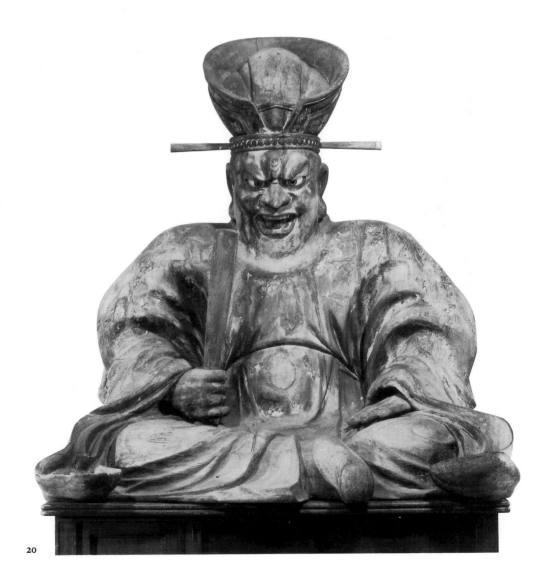

20

21
Taizan Fukun
Wood
H. 124 cm.
Kamakura period, 14th century

Taizan Fukun, the god of Mt. Tai in Shandong Province, China, was widely worshipped in China, eventually becoming one of the Ten Kings of Hell (see no. 20). Taizan is usually depicted garbed as a Chinese magistrate and holding a brush in his right hand as if about to write. His left hand holds a staff with a finial composed of two heads which symbolize good and evil. Like Emma-ō, his expression is always angry; unlike Emma, however, whose mouth is always open, Taizan Fukun keeps his firmly closed, with one side pulled lower than the other.

This statue of Taizan was done in the joined woodblock technique, using many separate blocks of Japanese cypress, carefully assembled. The original polychromy has flaked off, exposing the wood surface. Inlaid crystal makes the eyes. Like the *Emma-ō*, this *Taizan Fukun* is a revealing example of the religious imagination of the Kamakura period. SCM

22
Monju Bosatsu Riding on a Lion
Wood
H. 90 cm.
Nambokuchō period, 1337

Monju Bosatsu (S: Manjusrī Bodhisattva) embodies the supreme wisdom of the Buddha, as Fugen Bosatsu (S: Samantabhadra) embodies his supreme compassion. These two complementary aspects of Buddha-nature may be depicted independently or flanking the Buddha as his principal attendants. Monju is usually shown, as here, riding on a lion, the upraised sword in his right hand symbolizing the triumph of wisdom, and the lotus in his left symbolizing purity. The concept of a divine being having a specific animal "vehicle" was borrowed from Hinduism, and the form of the lion, which was unknown in Japan, was borrowed from China—where lions were equally unknown. Not surprisingly, then, Monju's lions are iconographically orthodox but zoologically fanciful. Like lions in many other cultures, they symbolize kingly power—in this case, the kingly power of the Buddha's wisdom.

Worship of Monju began in Japan in the eighth century (Nara period) and flourished particularly during the thirteenth and early fourteenth centuries, when he became, in addition to the embodiment of spiritual wisdom, a patron of the powerless and unfortunate. An inscription found on a document inside this image dates it to 1337, when Monju's cult was still popular.

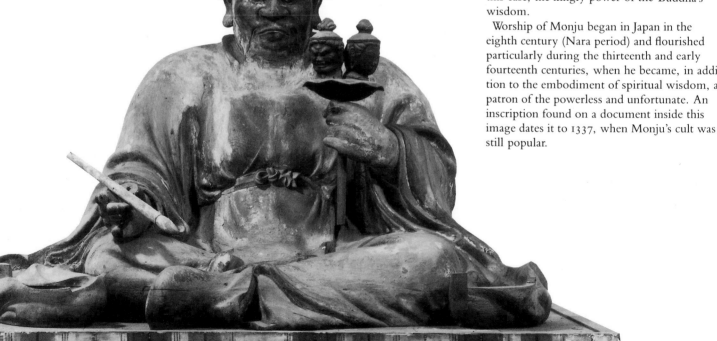

21

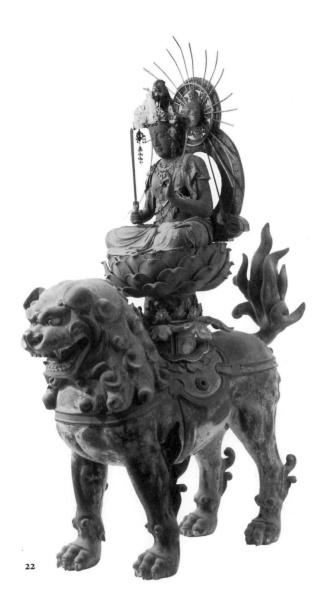

22

This image was carved of cypress wood, using the joined block technique. Inlaid crystal forms the eyes, and cut gold leaf was applied to the robe in patterns of linked circles, tortoise-shell hexagons, hemp leaves, and "lightning" (J: *inazuma*) zigzags. None of the present jewelry is original. The petals of the lotus throne have been painted blue-green and embellished with cut gold leaf; cut gold leaf and color over Chinese white finishes the lotus stem, leaves, and flower center. The lion was likewise made in the hollowed-out joined woodblock technique, colored, and adorned with crystal eyes.

The figure is a competent example of the sculpture of the Nambokuchō period. JDP

23
Fudō Myō-ō with Two Attendants
Sangatsu-dō
Wood
(Fudō) H. 86.5 cm.; (Seitaka) H. 78.7 cm.;
(Kongara) H. 78 cm.
Nambokuchō period, c. 1373
Important Cultural Property

Fudō Myō-ō (S: Acala; the Immovable) originated in India as a manifestation of the Hindu god Siva but was metamorphosed in Esoteric Buddhism into the most important of the Five Kings of Bright Wisdom—a manifestation of Dainichi Nyorai and of the Buddha's power against evil (see nos. 7, 24). Fudō was worshipped far more in Japan than he had been in China or India, and his cult was particularly strong among devotees of the Esoteric Shingon and Shugendō teachings. Of his full complement of eight boy attendants, the two most often represented are the ones seen here—the classically featured Kongara (S: Kimkara) and the rather more brutish-looking Seitaka (S: Cetaka). The sword, noose, and flaming halo are Fudō's customary panoply.

The images are of cypress wood, made by the joined block method, and have eyes of inlaid crystal. Over a base coat of gesso the iconographically correct colors would have been applied—blue or red or yellow for Fudō, white or pale flesh tone for Kongara Dōji, darker flesh tone for Seitaka Dōji. Then cut gold leaf was added to the hems of their robes. Although some of the gold leaf has survived, the pigments have all been worn away. Rough blocks of wood, weathered and irregular, were used for the rock on which Fudō sits to symbolize his immobility. The rock and the flaming mandorla, also of wood, are of the same period as the figures. Despite the loss of pigment, this image is in an excellent state of preservation, retaining even the original copper necklace and arm, wrist, and ankle bracelets.

Documents found in the leg socle of the Seitaka figure tell us that all three figures were produced in 1373. Three small relics were also found inside the statue, as was a dedication registry recording the names of those associated with its construction. Finally, an inscription bearing the name Hokkyō Seigen was found inside the image. Seigen, Bridge of the Law (act. c. 1375), was a painter of Buddhist images in the atelier of Kōfuku-ji in Nara, and he is known to have worked also on a Fudō group at nearby Hōryū-ji. Presumably he painted, or supervised the painting of, the Tōdai-ji icon. Though the carver's name is not mentioned, he may well have been Takama Engen, who in 1372 repaired a Fudō image formerly in the Sangatsu-dō.

The well-balanced composition and the soft, fluid modelling of the bodies follow the realistic tradition of Kamakura-period sculpture. But the solemn expressions and the largely decorative cluster of curving folds at the hem of Fudō's garment are distinctive characteristics of sculptures made during the third quarter of

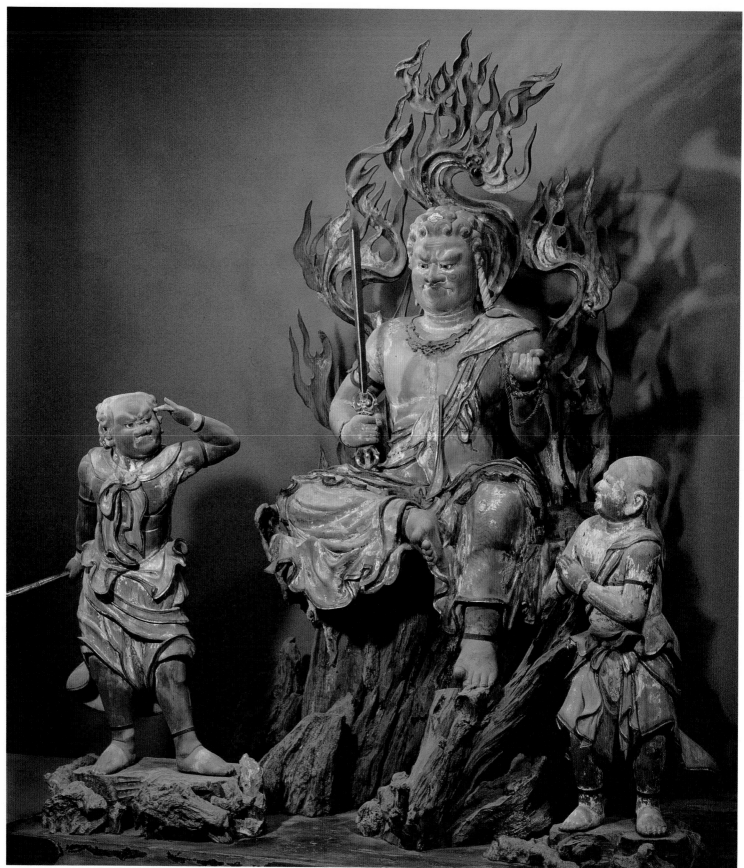

the fourteenth century. These statues are valuable as dated examples of Nara sculpture.

This group occupies the southeast corner of the Sangatsu-dō's altar.[1] It is said to have been made for worship in the *tōgō* ritual performed in the Sangatsu-dō until the latter part of the Edo period. *Tōgō* is a rigorous ascetic practice carried out primarily by *ajari* (S: *ācārya*), high-ranking monks of the Esoteric sects. Each day, on foot in summer rain or winter snow, the *ajari* visits a number of temples and shrines in which he worships the central image. After making this circuit every day for one thousand days, then undergoing a period without food or sleep, the monk is considered to have become a living bodhisattva. JDP

1. Sangatsu-dō (Third-Month Hall) is the scene of annual readings of the *Lotus Sutra* (J: *Hokke-kyō*) during the third month of the year, hence the same Sangatsu-dō or Hokke-dō. It is the only original structure surviving at Tōdai-ji.

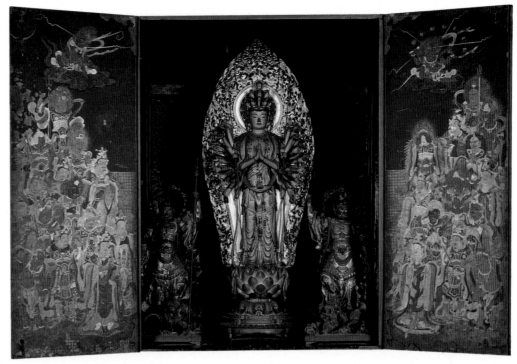

24

24
Thousand-Armed Kannon with Four Heavenly Kings in Shrine
Senju-dō of Kaidan-in
Wood
(Kannon) H. 74.2 cm.; (Heavenly Kings) H. 43.8 cm.–44.5 cm.
Muromachi period, 14th century

KANNON, the Bodhisattva of Compassion (see no. 19), vowed to supply himself with one thousand arms and wisdom eyes in order to reach all sentient beings and help them achieve salvation—thus the iconographic form of the Thousand-Armed (J: *Senju*; S: *Sahasrabhuja*) Kannon. The arms and eyes symbolize both the infinite extent of this Kannon's power and the infinite number of expedient means (J: *hōben*; S: *upāya*) at his disposal to save suffering beings. Highly popular in China as the Kannon of Great Compassion, this form was also one of the earliest aspects of Kannon worshiped in Japan. Although statues do exist that actually have the full thousand arms, this more common version has just twenty arms on each side, each with an eye of wisdom in the palm, and each of which is said to save the sentient beings of twenty-five different worlds. The image

here, like virtually all Thousand-Armed Kannon figures, is also eleven-headed (see no. 11).

The Thousand-Armed Kannon and the standing images of the Four Heavenly Kings (J: Shitennō; S: Lokapāla) have all been extremely well preserved within this large shrine in the Thousand-Armed Kannon Hall (J: Senju-dō) of the Ordination Hall complex. The interior of the shrine is painted with figures in brilliant colors. On the inside of the front doors are the twenty-eight *bushū*, followers of the thousand-armed form of Kannon, who themselves each have hundreds of followers. The Five Kings of Bright Wisdom (J: Godai Myō-ō) are depicted on the interior walls of the shrine, with the most powerful of them, Fudō the Immovable (see nos. 7, 23), holding a sword around which coils the Dragon King Kurikara (S: Kulikah), symbol of the power of Fudō's wisdom. On the back wall of the shrine interior is Mt. Fudaraka (S: Potalaka), Kannon's luxuriously fragrant island paradise, which the Indians and Chinese believed lay off their southern coasts.

Within the shrine the Thousand-Armed Kannon stands on a lotus pedestal gorgeously colored in blue-green and cut gold leaf (see no. 13). Behind the figure is an openwork wooden

mandorla in an arabesque pattern of imaginary flowers (J: *hōsōge*) that are specific to Buddhist contexts. Nearly the entire body, which is made of cypress in the joined woodblock technique, is covered with a dark red lacquer flecked with gold dust. Meticulously cut gold leaf in hemp leaf, swastika, and lotus flower arabesque patterns has been applied to the garments. The subtle contrast in tone and hue between the cut-gold-leaf pattern and the background of gold dust embedded in lacquer creates a distinctive decorative effect.

At the four corners of the shrine stand the Four Heavenly Kings, who guard against evil from the four directions. These figures, originating in India, became extremely popular divinities in Chinese and Japanese Buddhism. They are beings of great physical power and ferocity, invariably shown armed (though some of the weapons have not survived) and armored in the Chinese style of the Tang dynasty. Here their images are brilliantly colored and patterned and their stances artfully contrasted. The two in front guard the east (J: Jikoku-ten; S: Dhritarāshtra) and south (J: Zōchō-ten; S: Virūdhaka); behind Kannon, somewhat less energetically but still powerfully posed, are the

kings of the west (J: Kōmoku-ten; S: Vir-ūpaksha) and north (J: Tamon-ten; S: Vaisravana).

Elaborate decoration and fine workmanship distinguish the *Kannon* and the *Guardian Kings*. In this respect they are very close to the *Four Heavenly Kings* in the three-storied pagoda of Reizan-ji (Nara), which are dated by inscription to 1355. The statues exhibited here may well be the work of a Nara sculptor of the fourteenth century.

The shrine itself is an example of the Kasuga shrine style, simple and graceful of form, with a black lacquer exterior, an array of related images painted on the interior, and a gently sloping roof with four corner ridges rising to a single point. In front a pair of doors opens from the center in a manner known as a "Kannon opening," so named because it was first used, as here, for the exhibition of an image of Kannon. The paintings on the shrine are in the style of a professional Buddhist painter from Nara, and the shrine itself seems to have been constructed about the same time as the sculptures within. JDP

25
Daikoku-ten
Chōzu-ya of Sangatsu-dō
Wood
H. 139.4 cm.
Muromachi period, 15th century

IN ancient times Daikoku-ten (S: Mahākāla) was venerated as a protector of temples, shrines, and monastery kitchens, and his images wore the fierce scowl appropriate to guardian deities.[1] This figure wears a wide smile and the short jacket and divided skirt of a Japanese commoner—evidence that he has taken his place as God of Plenty among the Seven Gods of Good Fortune (J: Shichi Fuku-jin) that first became popular with commoners during the late Muromachi period. Following older iconographic tradition, Daikoku-ten's right arm is akimbo, his left holds a sack (of goods) slung over his shoulder, and a noble-man's hat is on his head.

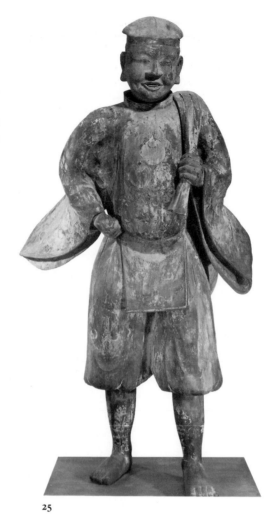

25

This statue has been preserved in a building called Chōzu-ya (Holy-Water Stand) associated with the Sangatsu-dō. It was made of cypress wood in the joined woodblock technique and was originally painted, but the paint has mostly flaked off. The drapery folds are shallowly but very skillfully carved, and this, together with the amiable grin, marks the image as a likely product of the Muromachi period. According to Tōdai-ji records a painting of Daikoku-ten existed in the Sangatsu-dō Chōzu-ya as early as the mid-fifteenth century. The statue must have been constructed shortly before that time.
JDP

1. See Lee et al., *Reflections of Reality in Japanese Art*, no. 6 and pp. 21, 215.

26
Yakushi Buddha
By Tankai (1629–1716)
Wood
H. 90 cm.
Edo period, 17th or early 18th century

SINCE there had never been any tradition of monumental secular sculpture in Japan, the decline of Buddhism, beginning in the late Muromachi period and continuing through Momoyama and Edo periods, was accompanied by the decline of statuary. Skill and imagination in carving did not disappear but found new outlets in smaller formats: theatrical masks, particularly for *Nō* and *Kyōgen*, and the ubiquitous *netsuke*.[1]

Nevertheless, traditional Buddhist sculpture, though nearly moribund, survived, as this image of Yakushi, the Buddha of Healing, attests. Unlike the men who furnished the temples from the Nara through the Kamakura periods, Tankai was not primarily a profes-sional sculptor (J: *busshi*) but rather a monk and scholar for whom carving was more an act of piety than of artistry. A monk of the Esoteric Shingon sect, Tankai entered the priesthood at eighteen and rose to the ecclesiastical rank of *risshi* (Master of the *Ritsu*). He is known as Tankai Risshi or, alternatively, as Hōzan Tankai, after Hōzan-ji, the temple he founded on Mt. Ikoma in present-day Nara Prefecture. The image was commissioned by the monk Kōkei, who was instrumental in the Edo-period recon-struction of the *Daibutsu* and the Daibutsu-den (see no. 29).

The earliest Buddhist (Pali) canon lists medi-cine, along with food, clothing, and lodging, as the four requisites for life, noting also that the supreme medicine is the Buddhist Law. Two Bodhisattvas of Healing, known as King of Healing and Supreme Healer and generally referred to as brothers, figure in chapters of the *Lotus Sutra* (J: *Hokke-kyō*; S: *Saddharma-pun-darīka-sūtra*) dated to the first century B.C. and the first and second centuries A.D.

But the Buddha (as opposed to bodhisattvas) of Healing appears to have entered the pan-theon only with the dissemination of the *Bhaisajya-guru-sūtra* (J: *Yakushi-kyō*), which was

probably composed in India in the late third century. According to tradition it was first translated into Chinese in the first decades of the fourth century (though references to a Healing Buddha occur in Chinese texts of the third century). Certainly no image of the Buddha of Healing from before the fourth century survives anywhere, if indeed his cult existed before then. Over the next four centuries, however, the sutra was retranslated into Chinese four times, and the cult of the Healing Buddha (S: Bhaisajya-guru; C: Yao-shi Fo; J: Yakushi) flowered in Tang-dynasty China and was adopted with enthusiasm in Nara-period Japan. Devotion to Yakushi was greater in East Asia than it had ever been in India, reaching perhaps its zenith in Heian-period Japan. The stimulus to this zeal was Yakushi's twelve vows to heal not only the spiritual but the physical sufferings of humanity: one could invoke Yakushi's aid against fire, sword, prison, predation (human and animal), and illness, as well as against one's own spiritual turpitude.

Yakushi presides over the Pure Land of Lapis Lazuli Light (J: Jōruri) in the East.[2] He and Amida, Buddha of the Pure Land in the West, often form a trinity with Shaka Nyorai—Amida presiding over the souls of the virtuous dead and Yakushi over the living. Iconographically, Yakushi is intimately connected with light and with lapis lazuli (S: *vaidūrya*): the sutras stress his blue radiance; his own attendants are Nikkō (S: Sūryaprabha; Solar Radiance) and Gakkō (S: Chandraprabha; Lunar Radiance); and lapis, associated in Buddhism with purity, is mentioned remarkably often in the sutras in conjunction with Yakushi. In East Asian lore generally, gemstones as well as precious metals were considered to have curative and strengthening powers, and the medicine bowl that images of Yakushi commonly hold is by convention made of lapis and contains a dew, or elixir, of immortality (S: *amrita*). Alternatively, Yakushi may hold the Herb of Healing (J: *haritaki*; myrobalan, whose fruit, resembling a large jujube, was so valued in East Asia for its life-giving properties that eighth-century specimens are preserved in the Shōsō-in). One of these attributes is usually held in Yakushi's left hand or in both hands; if held in the left hand, his right hand almost invariably makes the gesture of freedom from fear (S: *abhaya mudrā*; J: *semui-in*).[3] This image

holds a medicine bowl cupped in both hands.

Yakushi is popularly credited with bestowing longevity, though this promise is not contained in his vows. Possibly as an extension of this belief, Edo-period lore attributed to Yakushi the poem "Kimi ga yo," which invokes longevity/immortality for the emperor (and is now the Japanese national anthem). In the *Kokin-shū*, the early tenth-century anthology in which the poem first appears, it is listed as anonymous. TS

1. These were carved toggles, usually of wood or ivory or lacquer, attached to the cords of small pouches or boxes that served Japanese

men instead of pockets. The toggles prevented the cord from slipping out from under the sash of the robe.

2. Ancient Asian mineralogy is often imprecise. The Sanskrit *vaidūrya*, here translated as "lapis," is thought by some scholars (notably Edward H. Schafer) to be the lighter-colored and more translucent beryl.

3. A full account of the historical development, doctrines, lore, and iconography of the Buddha of Healing may be found in Birnbaum, *The Healing Buddha*.

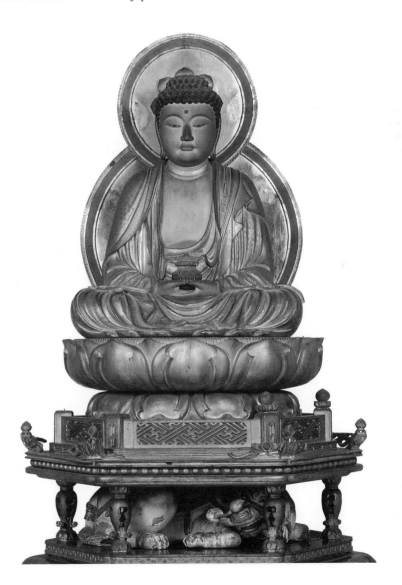

26

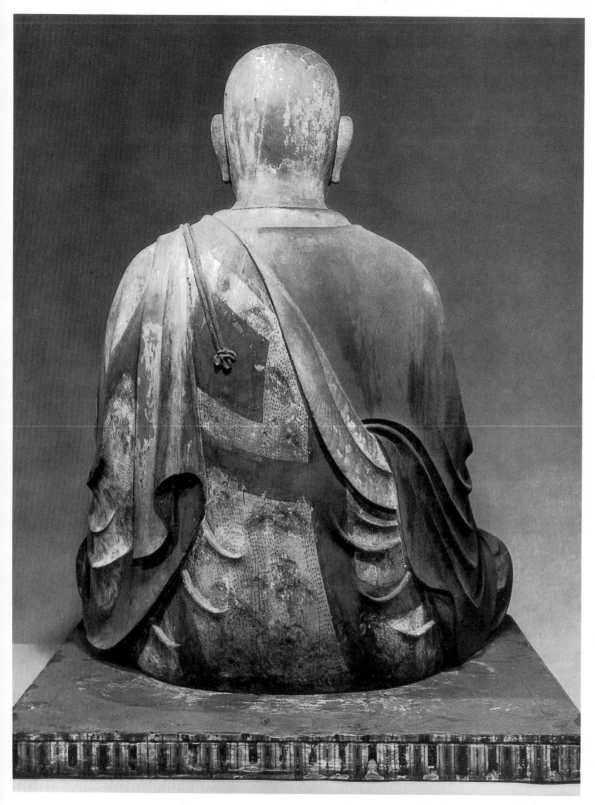

27
High Priest Rōben
Kaisan-dō
Wood
H. 92.4 cm.
Late Heian period, 10th–11th century
National Treasure

THIS imposing figure of Rōben Sōjō[1]
(689–773), slightly larger than life size, is
shown sitting in lotus position, wearing a *kesa*
(a stole-like outer garment worn over one
shoulder, symbol of the monk's calling), and
holding in the right hand a scepter of office (J:
nyoi; C: *ruyi*). Rōben is represented as elderly
but still vigorous, broad-shouldered and erect,
with strong features in a square face and open
though slightly downcast eyes. The folds of his
robe are thick and deeply carved, augmenting
the impression of monumentality.

For a portrait sculpture, this image is un-
usually large. It was made in the manner of the
single woodblock technique, with the head and
torso fashioned from one large piece of Japa-
nese cypress; additional pieces were added for
the arms, hands, and lap. The surface was
covered with a white ground and then poly-
chromed.

Rōben was of continental ancestry. He began
his Buddhist training with Gien, a monk of
mixed Hossō and proto-Esoteric beliefs whose
propagation of Buddhism in Japan became
legendary. Later Rōben turned to Kegon doc-
trines. In 733, on the slopes of Mt. Mikasa
northeast of the capital, he built a private (i.e.,
not state-commissioned) temple, Konshō-ji.
But in 741 his Konshō-ji, renamed Konkōmyō-
ji, was incorporated into the system of monas-
teries for the protection of the realm (J:
kokubun-ji) (see Introduction and no. 39). Soon
after, along with several other temples on Mt.
Mikasa, it became part of Tōdai-ji, then under
construction as the keystone of the *kokubun-ji*
system. Tōdai-ji's name first appears in the
written record in 747. Rōben, who was one of
the principal spiritual advisers of Tōdai-ji's
imperial sponsor, Emperor Shōmu, became its
first intendant and its first high priest.[2] The
inner sanctuary of Tōdai-ji's Sangatsu-dō is
thought to be on the site of the image hall (J:
kondō) of Rōben's original foundation.

This portrait-sculpture is commonly consid-

27

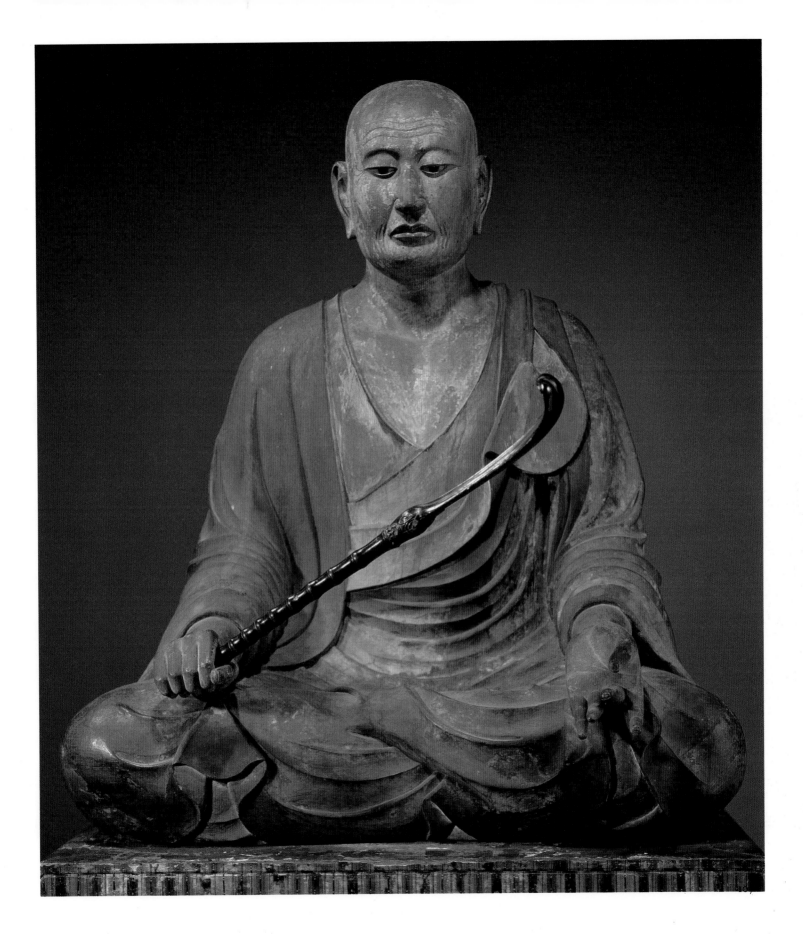

ered to have been made in 1019, the date given
in the *Tōdai-ji Yōroku* (a history of Tōdai-ji
compiled late in the Heian period) for the repair
of a statue of Rōben. Some art historians
believe that the massiveness of the statue, the
deeply cut folds, and the technique suggest a
date of the ninth century, but the arrangement
of the drapery and impassiveness of the face
reflect stylistic trends from later in the Heian
period, thus lending credence to the documen-
tary evidence. ANM

1. *Sōjō* is a Buddhist ecclesiastical title, here
rendered as "high priest." The translations
"bishop" and "abbot" are sometimes used
elsewhere.
2. The intendant (J: *bettō*) was a government
official who supervised the interrelationships of
the temple and the civil administration. The
high priest (J: *sōjō*), invariably a monk, oversaw
the spiritual and mundane internal affairs of the
temple community.

28
Monk Chōgen
Shunjō-dō
Wood
H. 82 cm.
Kamakura period, 13th century
National Treasure

THIS portrait statue in painted wood, one of
the most moving essays in realism in the entire
history of art, depicts the human condition of
great age and its infirmities. The subject is the
monk Shunjōbō Chōgen (1121–1206) (see no.
13), who undertook the restoration of Tōdai-ji
after its virtual destruction by military action in
1180. For over twenty-five years Chōgen solic-
ited funds and organized the reconstruction of
the Daibutsu-den and the Great South Gate (J:
Nandai-mon); this enterprise made him one of
the leading patrons of his day, and the present
exhibition includes several outstanding sculp-
tures that he commissioned: *Amida* (no. 13),
Jizō (no. 14), and *Hachiman* (no. 15).
 This statue is said to have been carved
immediately after the monk's death in 1206 and
used in his funeral services at Tōdai-ji. The
sculptor, who must have known Chōgen inti-
mately, shows us the bone structures and
sinews and blood vessels beneath the wrinkled

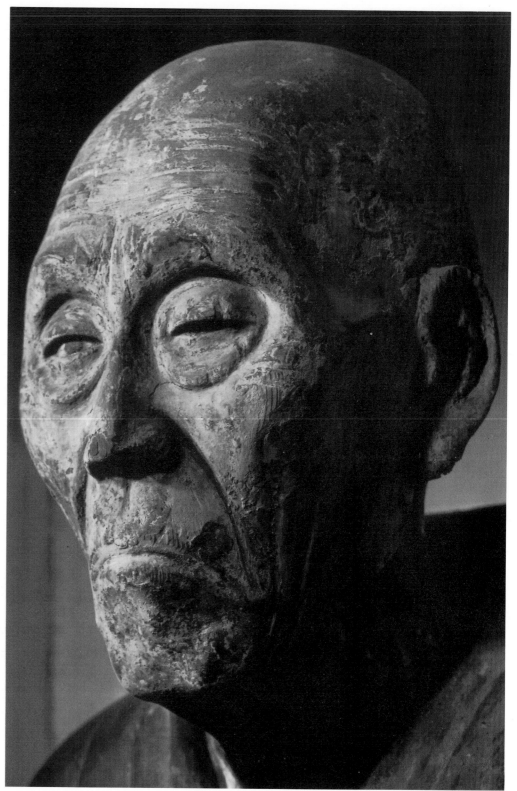

28

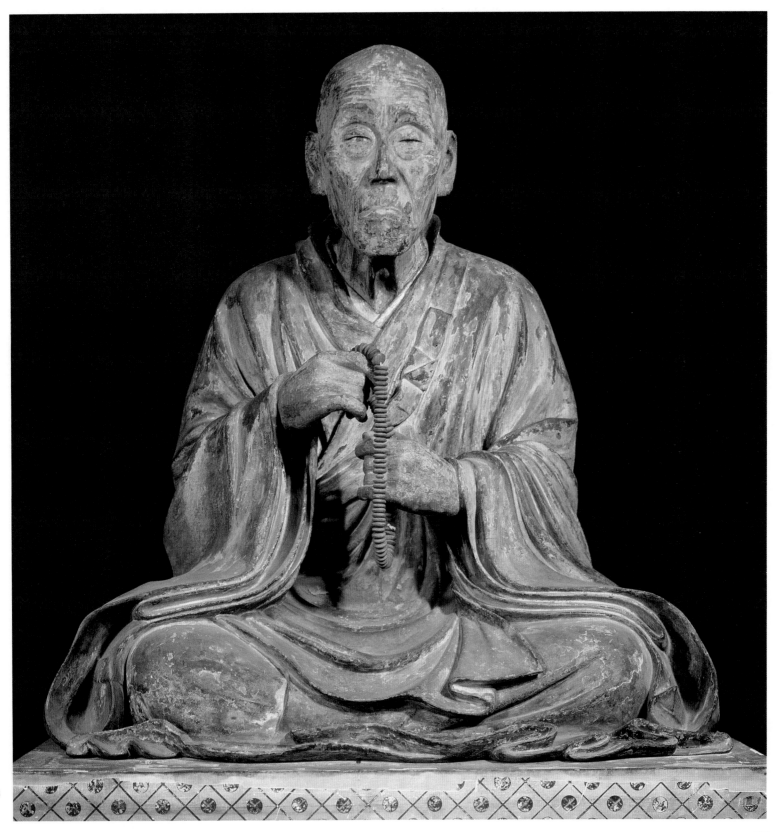

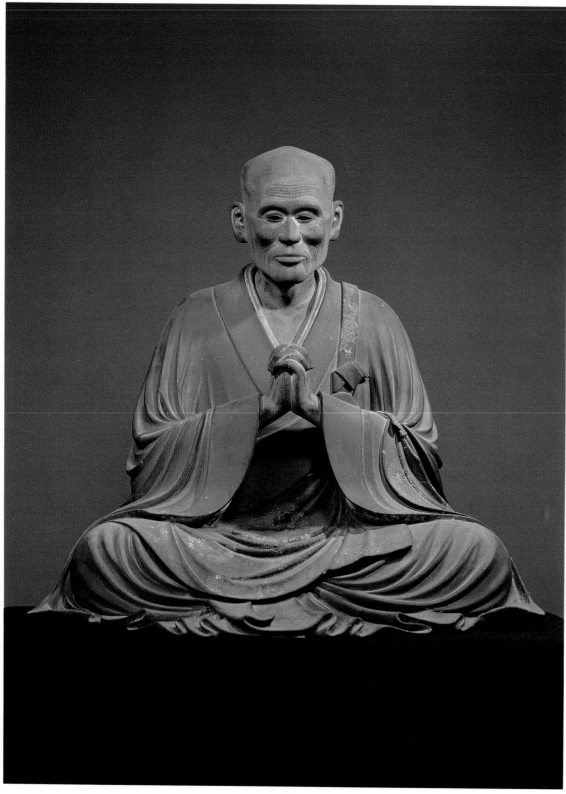

skin. Chōgen's head is thrust forward as if too heavy for his neck; his eyes are puffy and his cheeks sunken; only the large, rugged hands fingering his rosary still seem powerful. Chōgen was the most prestigious cleric of his day, but the sculptor—in keeping with Buddhist concepts of the imperfection and impermanence of the human body—made not the slightest effort to idealize his image. Depicting with unsparing fidelity the lineaments of Chōgen near death, he simultaneously managed to suggest the nature of old age and of this man who is enduring it. This statue far transcends the matter-of-fact realism of commemorative portrait statues of the mid-Kamakura period and later.

Although there exists no historical documentation for the sculptor's identity, he was probably one of the leading masters of the day; likely candidates include Unkei and Kaikei, both of whom participated in Chōgen's project for carving the attendant figures of the *Daibutsu* and the two giant Guardian Kings (J: Ni-ō) at the Great South Gate. A precedent for this portrait may be seen in the statues of the six patriarchs of the Hossō sect, carved in 1188–89 for the Nan'en-dō of the neighboring monastery of Kōfuku-ji; in them are formal qualities that came to maturity in the Chōgen image, including the garment folds, heavy and active in form, and the stable seated posture.

Not readily apparent is the craftsmanship by which the statue was made, extraordinarily sophisticated but typical for Japan of its day. The image was made in joined woodblock construction from more than fourteen pieces of well-dried cypress wood, separately carved and then carefully pegged and glued together. Head and neck together were carved from two pieces joined vertically behind the ears. The front of the body is composed of two large pieces joined vertically down the center; in addition the sculptor employed one piece for each half of the back, for the outside of each shoulder, for each leg section, each forearm, each hand, and for the hemlines of the robe. When the body was assembled, the head and neck section was inserted into it. Before final assembly the inside of the hollow figure had been coated with black lacquer.

The surface of the statue was finished in four layers of material to produce a highly realistic color scheme. Directly over the wood was glued a layer of hemp cloth; over this came a

29

coating of brown lacquer which served as a base for a layer of finely ground white clay akin to gesso. Last of all the flesh tones and garment colors were added; remarkably, however, the eyes were carved in the wood and painted, unlike other realistic sculptures of the period which employed crystal or glass set inside the eye socket. JMR

29
Monk Kōkei

By Shōkei and Sokunen
Kōkei-den of Ryūshō-in
Wood
H. 69.7 cm.
Edo period, 18th century
Important Cultural Property

KōKEI (1648–1705), a monk of the Ryūshō-in, was the driving force behind the restoration of Tōdai-ji's *Daibutsu* and the Great Buddha Hall (J: Daibutsu-den) that housed it. The colossal bronze statue of Vairocana (J: Roshana Butsu) and the hall in which it stood had both been commissioned by the devout Buddhist emperor Shōmu and were consecrated in 752. Destroyed by fire once in the civil war of 1180–85 (see Introduction and no. 15), they were burned again in 1567 during the final rounds of a general struggle for national hegemony that is aptly called "the Age of the Country at War." Peace came in 1615 and, in the generations immediately following peace, a strong impulse to revive and reconstruct. Kōkei travelled tirelessly throughout Japan, collecting donations to restore the *Great Buddha* and its hall. Their present appearance is owing to his efforts, and his title *shōnin*, a Buddhist honorific meaning "superior person," was doubtless awarded in recognition of this achievement.

Kōkei entered the priesthood at Tōdai-ji at the age of thirteen. Temple tradition holds that he vowed before the ravaged statue of the *Daibutsu* to restore it and the Daibutsu-den. The work of collecting funds began in 1684, when Kōkei was thirty-seven years old, and actual repairs commenced soon after. Once the head was recast, it took six more years to restore eighteen petals of the lotiform pedestal and the stone platform on which the image sits. In 1692 the "eye-opening ceremony" (see no. 2, n. 1)

was held. Reconstruction of the Daibutsu-den proceeded simultaneously, and its ridge pole was raised in 1705. That same year, in the seventh month, Kōkei died in Edo, aged fifty-eight.

This commemorative portrait, now enshrined in the Miei-dō of the Ryūshō-in, was commissioned by Kōkei's disciple Kōjō (d. 1724). One of the two sculptors, Sokunen, had also been a close disciple of Kōkei. The priest is shown wearing a brown *kesa* (see no. 27) over his cinnabar robe. He is seated in lotus posture, with hands folded in front of his chest and eyes slightly downcast. Although this statue was made during the Edo period, when the creative heyday of sculpture was long past (see no. 31), its evocative naturalism belies its date. The very thinness of Kōkei's face emphasizes his prominent cheekbones, deepset eyes, and firm mouth, reflecting the fervor of his commitment and the lifelong exertion of his enterprise.
ANM

30
Gyōki Bosatsu

By Kenkei and Sokunen
Gyōki-den
Wood
H. 80.9 cm.
Edo period, 1728

THE mendicant monk Gyōki (668–749) was concerned for people's physical as well as spiritual well-being. Though in 708 he had built a temple near Rōben's (see no. 27) on Mt. Mikasa, he spent much of his time wandering, preaching the Buddhist Law and supervising the building of canals and bridges, both without official sanction. So successful was he at these activities that the court lifted its initial displeasure when his popularity and his skills became necessary to the building of Tōdai-ji. For his help in soliciting contributions to that project, and for his technical assistance in the construction of the *Daibutsu* image, he was awarded the title Master of the Buddhist Law (J: *hōshi*), then raised to the rank of Senior High Priest (J: *dai sōjō*) in 745. But an even greater honor was the appellation *bosatsu* (S: *bodhisattva*), meaning an Enlightened Being who forgoes entry into nirvana in order to assist other beings along the same path. In 749 Gyōki

Bosatsu died at Sugahara-dera at the western edge of the capital. His ashes are buried at Chikurin-ji in Ikoma (between Nara and Osaka).

Inscribed on a wooden tablet behind the knees of the image are the circumstances of its carving. It was begun during the mid-1680s at the behest of Kōkei Shōnin (see no. 29) but was not completed at that time. After Kōkei's death his disciple Kōshun, in obedience to Kōkei's wish, undertook to have the statue finished. In the fourth month of 1728 he commissioned the temple sculptors Sokunen and Kenkei[1] to copy a statue of Gyōki then at Chikurin-ji (now housed at Tōshōdai-ji).

Gyōki is depicted sitting in lotus position on a high priest's chair draped with brocade. His right hand holds a Buddhist rosary;[2] his left is bent as if it once held a *nyoi* scepter. In its rendering of old age and in its treatment of the drapery folds this statue retains the realism of the Chikurin-ji portrait. ANM

1. Kenkei also sculpted the two attendant bodhisattvas now in the Great Buddha Hall of Tōdai-ji, Kokūzō (S: Ākāsagarbha) and Nyoirin Kannon (S: Cintāmanicakra Avalokitesvara).
2. The Buddhist rosary, like the Catholic, is used to keep count of the number of prayers chanted.

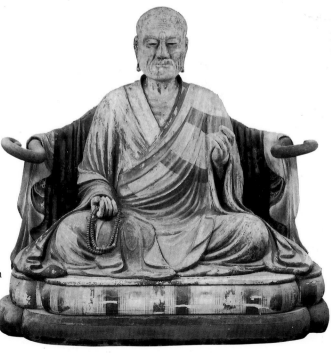

30

31
Monk Jian Zhen (J: Ganjin)
By Kōtatsu
Senju-dō of Kaidan-in
Wood
78.2 cm.
Edo period, 1733
Important Cultural Property

NOT all the dangers of the sea, nor blindness brought on by physical hardship, could deter the Chinese monk Jian Zhen (689–763) from his mission to teach the *ritsu* (S: *vinaya*), or rules of monastic life, in Japan. After five failed attempts, including shipwreck, he reached Japan with a party of Chinese disciples and an escort of Japanese envoys in 753. He arrived at Nara, the capital, in 754, too late for the dedication of the Tōdai-ji *Daibutsu* (held in 752), but he nevertheless received the warmest of official welcomes from an expectant court. Jian Zhen, better known as Ganjin (the Japanese pronunciation of his name), was one of the most prominent Chinese ecclesiastics of his generation, and to the Japanese his teachings bore the authority and legitimacy of pronouncements from the source, which to them was Tang-dynasty China. Before the year 754 was over, Ganjin had supervised the construction of a temporary ordination platform at Tōdai-ji, and there he conferred the precepts (*ritsu*) on Retired Emperor Shōmu, his empress, Kōmyō, their daughter, the reigning empress Kōken, and many leading Japanese monks. His effect on Japanese culture was enormous, for Ganjin was a master of contemporary Chinese learning, secular as well as Buddhist, and he also brought with him the latest continental styles in religious art.

Soon, however, Ganjin became disillusioned with the religious life in the capital. The emperor, for all his piety, was chiefly interested in using the Buddhist religion as a political tool, and the aristocracy was indifferent to the strict religious regulations of the Ritsu school.

Therefore in 759 Ganjin began the building of Tōshōdai-ji, his own private temple on the western edge of Nara, where he could strictly control the ordination of monks.

As was customary for monks of tremendous influence and achievement, Ganjin was memorialized at his death by a hollow dry lacquer portrait sculpture. This image is still housed in the Founder's Hall (J: Kaisan-dō) of Tōshōdai-ji, which was erected after Ganjin's death by Si To, a Chinese disciple who had accompanied the master to Japan. Other portraits of Ganjin exist, both sculpted and painted, but all of them were modelled after this original image, including the sculpture exhibited here.

The Tōdai-ji Ordination Hall (J: Kaidan-in), where this statue is enshrined, had fallen into disrepair during the mid-Edo period, and Tōdai-ji petitioned the shogunal government to send Ekō, a priest at the Reiun-in in Edo and a leading authority on Ritsu scholarship, to be the temple's chief solicitor (i.e., fund-raiser and general administrator; J: *kanjin shoku*). In 1733 Ekō came, rebuilt the Ordination Hall, and commissioned this sculpture. On the back of the statue's dais is the following inscription,

written in ink, describing the circumstances of its creation:

> This statue is a portrait of the founder of this temple, Ganjin, the master who crossed the seas. Made[1] in the second month of 1733, when Ekō, the third person to have revived the temple, was an old man. Written by the Buddhist priest Myōdō.

In the *Tōdai-ji Nenjū Gyōji Ki* (*Record of Annual Events at Tōdai-ji*), in the entry for the fifth month of 1743, there is the following passage:

> On the seventh day of the same month, same year, Kōtatsu of the Ordination Hall remade the wooden statue of Ganjin Wajō at the cost of two hundred *hiki*. . . .

This attests that in 1743 the statue was complete, even to its painting, and that the sculptor-painter was the monk Kōtatsu of the Ordination Hall. The meaning of the word "remade" is unclear; perhaps this statue *replaced* an older one in the Ordination Hall or elsewhere in Tōdai-ji.

As noted above, this statue was copied from the eighth-century founder's portrait at Tōshōdai-ji. The two works are almost identical in composition, but they were made a millennium apart, and during that millennium sculpture had ceased to be a vital mode of artistic expression; creative artists of the Edo period did not for the most part become sculptors. The image seen here is most competently carved, and the likeness is unmistakable, but the evocative power of the Tōshōdai-ji portrait—the sense of an extraordinary individual realistically depicted—is missing.
ANM

1. The ambiguity typical of Japanese grammar leaves the reader to infer whether it was the statue or the temple that was "made" in 1733. Independent evidence suggests that it is the temple that is meant.

31

32
Five Masks for *Gigaku* Performance
Important Cultural Properties

ON exhibition are five masks from the dance-drama form known as *gigaku* (literally, skill music). They were selected from a collection of thirty-nine such masks housed at Tōdai-ji, all of which date from the Nara period save two Kamakura-period replacements of Nara originals; seven, however, are in fragmentary condition. *Gigaku* is a performance art traditionally said to have originated in the southeastern Chinese kingdom of Wu (222–80). It is more likely, however, that it began in India and then adapted and developed certain aspects of Central Asian and southern Chinese dramatic traditions acquired during the process of transmission to China. One account of its introduction to Japan claims that a descendant of the king of Wu brought knowledge of various dance forms and a set of musical instruments to Japan on a diplomatic mission in the seventh century. Another account, in the early chronicle *Nihon Shoki* (compiled in 720), mentions a Korean instructor in *gigaku*, trained in Wu,[1] who resided in the Yamato area in the year 612, during the reign of Empress Suiko (r. 593–628). Whatever the case, Japanese craftsmen had seen continental masks by at least the seventh century. By this time both the performance art and the mask-making technique were fully developed in China and Korea, so the admirable quality and range of expression in the Tōdai-ji masks is not surprising. Many of them have rather un-Japanese facial features, further indication of Central Asian and Chinese influences.

Gigaku and *bugaku* (see no. 33) were extremely popular during the Nara period as features of temple and court ceremonies. Extant records do not clearly describe the original content and form of *gigaku*, but it seems to have consisted of simple musical arrangements performed by flute, drum, and gong to accompany relatively dramatic dances; exaggerated facial expressions on many masks support our inference that the dances were expressive and stirring. Some of the plots known to us are humorous; *gigaku*, which was performed mostly at temples, was undoubtedly broad in appeal and may have functioned as a comic interlude in the long and solemn Buddhist ceremonies of the time. Music and dance in Japan were classified and organized—both aesthetically and officially—with the establishment in 701 of the Bureau of Music (J: *Gakaku Ryō*). This office included official dance instructors, many of them Korean or Chinese, who trained both the professionals and the aristocratic amateur performers. *Gigaku* was one of the various music-and-dance performances offered at the elaborate "eye-opening ceremony" for the *Daibutsu* in 752. Most of the original masks at Tōdai-ji saw use in this ceremony, as did the 131 now kept in the Shōsō-in. Over time *gigaku* was supplanted by the more elaborate and courtly *bugaku* form of dance-drama; during the Heian period *gigaku* performances were infrequent. The last recorded performance took place in the Genroku reign-period (1688–1704). Vestiges survive, however, in certain folk dances, particularly the lion dance.

Over two hundred *gigaku* masks are known to exist in the Shōsō-in and in various temple and museum collections. The earliest examples (Asuka period) are of camphor wood; most Nara-period masks are of lightweight paulownia wood, some few are of dry lacquer, and rare examples employ clay mixed with hemp fiber. *Gigaku* masks are greater than life size, for they were made to cover all but the back of the head. Inevitably, they share certain traits with contemporary sculpted icons and portraits, for although the functions differed, the materials and techniques were the same. In fact, those mask makers whose identities are known were sculptors of Buddhist images as well.

In general, *gigaku* masks exaggerate human features and expressions, while *bugaku* masks are fantastically conceived as well as modelled. Because masks were worn in performance, they were necessarily subject to damage and wear: inscriptions have been lost, repairs have been frequent, alterations have been required to fit an existing mask to a new dancer. Such changes, while they irrevocably alter the pristine appearance of a mask, at the same time reveal a great deal about its construction. Details of construction and some methods of finishing the wood and creating the features are discussed in number 33, the section on *bugaku* masks.

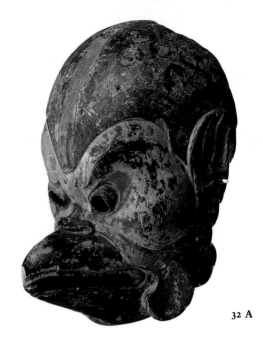

32 A

A
Karura
Paulownia wood with lacquer undercoat and pigments
H. 33.8 cm. W. 22.8 cm.
Late Nara period, 8th century

THE Karura mask represents the Indian Garuda bird, frequently described in ancient Hindu legend as the mount of the god Vishnu. The early Garuda was a mythical giant bird that preyed upon the *nāgas* (serpent divinities) (see no. 2), but he later became as much human as avian. This later form usually shows a boyish human head and torso, with the clawed feet and wings of a bird and a beak more or less transformed into a hooked nose. Garuda entered the Buddhist pantheon as one of the Eight Classes of Divine Protectors of the Buddhist Faith (J: *hachi bushū*), who attend on Sākyamuni and protect the doctrine.

The close-set eyes of this striking mask stare down toward the tip of the beak, wherein Karura grasps a round bead. A helmet-like cap hugs the pate and contours the forehead, narrowing toward the bridge of the nose. At the center of this "cap" a stripe of exposed wood indicates the place where a cock's comb was once affixed. Holes alongside the stripe secured tufts of feather-like hair. Except for simple ruffled patterns of the sides of the head where the ears would be, and comma-shaped

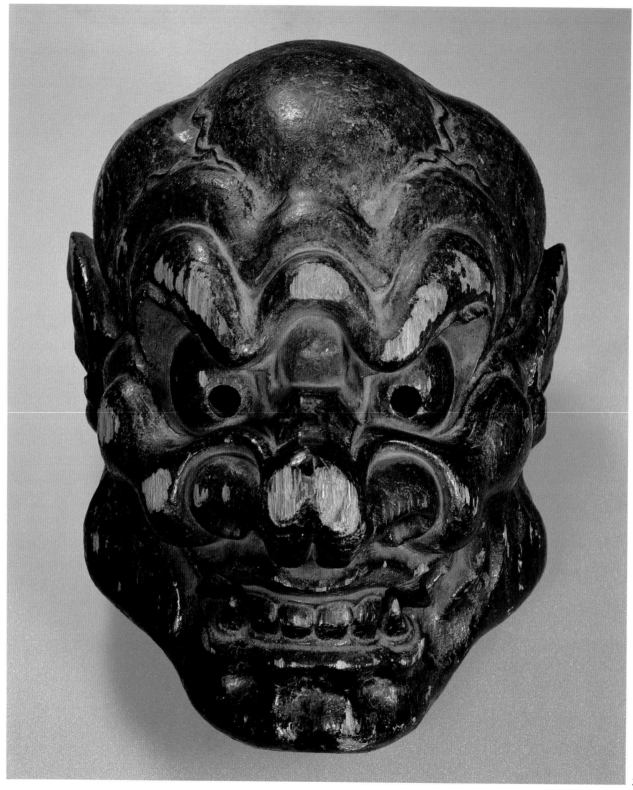

32 **B**

earlobes, the surface features are relatively smooth.

An inscription on the back of the mask reads, "Tōdai-ji——Tempyō——," followed by an indication that the mask was used in the ritual called *Kagon-e* (i.e., *Kegon-e*).[2] The precise date of this Buddhist ritual is not known, but it was held at approximately the same time as the *Daibutsu* "eye-opening ceremony," from which it differed in content. According to temple records 180 monks, accompanied by lay musicians, officiated at the early Tōdai-ji *Kegon-e*—chanting, sprinkling water, scattering flowers, carrying sacred objects in procession.

B
Konron
Paulownia wood with black lacquer finish
H. 39.2 cm. W. 27.8 cm.
Late Nara period, 8th century

ACCORDING to Chinese legend Konron (C: Kunlun) was an ancient western barbarian who became enamored of a beautiful Chinese woman. His subsequent behavior, however, was considered most lewd and inappropriate, and so the gods punished Konron by giving him the pugnacious appearance so marvelously expressed by the mask on display. His torso is said to be that of a muscle-bound wrestler, and the head—as revealed by the mask—has the pointed ears of an animal, a bulbous nose, exaggerated musculature, blood vessels threatening to burst at the forehead, bared teeth and protruding fangs, and bulging eyes. His disposition, as clearly conveyed by this large Tōdai-ji mask, is permanently enraged.

Five Konron masks remain at Tōdai-ji, but only three are in good repair. The unpainted lacquer surface often used for this type of mask is particularly susceptible to wear; although the mask on display is the best-preserved example, it is damaged on certain areas of the nose, cheeks, and arching eyebrows. Faint marks remain on the head where hair was secured, and holes are visible where the bristle-like whiskers typical of Konron once projected from the jaw. Although modelled as a human type, the mask successfully conveys the ferocity and vigor required of the Konron role in a *gigaku* performance.

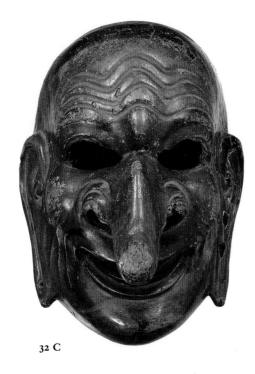

32 C

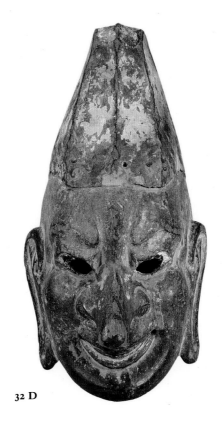

32 D

C
Baramon
Paulownia wood with lacquer undercoat and cinnabar pigment
H. 32.8 cm. W. 34.3 cm.
Late Nara period, 751

BARAMON represents an Indian Brahman (or Brahmin). The Brahman are the highest of the four Hindu castes, created, according to legend, to be teachers of humankind, and historically serving as priests. A humorously long nose and generous mouth characterize this mask, with compensating dignity provided by the black-painted moustache and chin whiskers and the thoughtfully furrowed brow and crinkled corners of the eyes. The elongated earlobes are characteristic of the nobility in Indian art (cf. Sākyamuni's elongated earlobes, signifying his princely origins), and the large open holes through which the performer's eyes were visible undoubtedly contributed to the human quality of the Baramon role.

Age has darkened the rich cinnabar-painted surface, which is otherwise well preserved, with bare wood showing only on the tip of the long nose. An inscription in ink on the back of the mask dates it to 751 and notes repairs made in 1793. Another Baramon mask housed at Tōdai-ji is quite similar in design but has a large piece of the jaw missing.

D
Suiko-ō
Paulownia wood with lacquer and clay undercoat and pigments
H. 44.6 cm. W. 23.4 cm.
Late Nara period, 8th century

THE legend of Suiko-ō, which literally means a drunken barbarian king, probably originated in China, since *tōgaku* (Tang Chinese) style works with similar titles survive in the *bugaku* repertoire: *Suiko Kokyoku* (*Short Piece About a Drunken Barbarian*), *Suiko Tōtai* (*Drunken Barbarian Advance Corps*), and *Konju*, a *bugaku* equivalent of Suiko-ō. *Suiko-ō* is performed, usually at the end of a *gigaku* performance, by eight inebriated dancers who represent gloriously drunken foreigners. These eight dancers (though not the assistants) wear tall,

crown-like headpieces supposedly of Central Asian or Near Eastern type. These too are of wood, but made separately and secured to the back of the mask with a rivet.

On this mask the lacquer undercoating was tinted with yellow ochre before the application of flesh-colored pigments. Suiko-ō is distinguished by his big ears with holes in the lobes, presumably from wearing earrings—an unusual practice to the Japanese. On the back of the mask an inscription in *sumi* ink contains the characters *Tō-dai-ji* and an illegible passage that may have been a date. This type of mask is thought to have been used in a *gigaku* work performed at the "eye-opening ceremony" for the *Daibutsu* in 752.

E
Suiko-jū
Paulownia wood
H. 28.9 cm. W. 19 cm.
Late Nara period, 752

AN inscription on the back of a mask in the Shōsō-in has provided the proper name for this mask type: Suiko-jū, or attendant to the Suiko-ō (discussed above) who is the principal character of the piece called by that name. Suiko-jū's features are not particularly distinctive; the long nose and big ears, resembling those of the king, are traits generally ascribed to foreigners. This Suiko-jū has an expressively wrinkled brow and quite stylized wrinkle patterns below the eyes and around the mouth. The mouth is open in a drunken half-smile, and the eyes are close-set.

On the back of the mask is an inscription in *sumi* ink that notes the making of the mask in 752 by Enkin, a sculptor named in various documents. Four other Suiko-jū masks remain at Tōdai-ji, including one in the rarely used dry lacquer medium. CJB

1. By literary convention the name Wu continued to be applied to southeastern China long after the Kingdom of Wu had disappeared.
2. The full name of the *Kegon-e* is *Kegon no Dai-e*, or Great Kegon Ceremony. It was a spring ritual, marked by the reading of eighty chapters of the *Kegon-kyō* followed by a vegetarian feast for the monks. (See Introduction, "Religious Art at Tōdai-ji.").

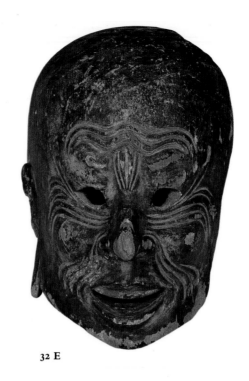

32 E

33
Five Masks for *Bugaku* Performance
Important Cultural Properties

THE masks shown here were used for *bugaku*, a performance art that entered Japan along with *gigaku* in the seventh century. It received secular aristocratic as well as temple patronage and, unlike *gigaku*, survives to the present day.

Bu-gaku, meaning literally "dance-music" or "dance-entertainment," incorporated the banquet music of the Tang Chinese court. It expressed beauty and refinement and, unlike *gigaku*, was wholly serious in intent. The term is often used interchangeably with *gagaku*, which literally means "elegant," or "correct," music and refers to the arrangements of wind, percussion, and stringed instruments that accompany *bugaku*. It is perhaps the oldest extant orchestral music in the world, having been under the patronage of the Japanese imperial (and, later, shogunal) court since the sixth century.[1]

Of course various kinds of dance, drama, and music antedated formal diplomatic contact between Japan and the continent, but it was the Bureau of Music's patronage of Tang court music, beginning in the early eighth century, and the subsequent arrival in Japan of continental and Indian dancers and musicians, that formalized the art of *bugaku* in Japan. *Bugaku* was particularly popular during the Heian period and was consciously Japanized at the beginning of that period.[2] There are records of its performance at many types of gatherings, from temple ceremonies to flower-viewing parties and poetry readings. Professionals and aristocratic amateurs both performed, although not together; the professionals, many of them of continental origin, belonged to the hereditary music guilds, the amateurs were young aristocrats who had studied with teachers from the Bureau of Music. The *Tale of Genji* contains several accounts of amateur *bugaku* performances of breathtaking beauty.

In the ensuing four centuries, however, the relative decadence of the imperial court was paralleled by a long decline in the popularity of *bugaku*; no longer a favored entertainment of the elite, it retained government sponsorship only as a part of certain temple rituals, particularly of purification and exorcism.[3] But, unlike *gigaku*, it was revived at the beginning of the Edo period under the potent patronage of the first Tokugawa shogun and thereupon enjoyed a renewed vogue among the military aristocracy. It is only natural that in the provincial temples and the castle towns of the great lords *bugaku* developed variations unknown in the capital. The Bureau of Music was reestablished during the Meiji period (1868–1912), and under its auspices *bugaku* continues to this day.

By the time it reached Japan, *bugaku* had enjoyed a long existence over wide areas of the continent and naturally comprised a large and heterogeneous repertoire of dances and accompaniments. These the Japanese attempted to categorize (see n. 2), and the classifying terms that were coined remain in use to this day, although they incorporate a certain understandable degree of overlapping and confusion. Each dance is named for its sole or principal character; since this character is embodied in the mask, the name of the mask *is* the name of the dance, as in *Sanju*, *Ryō-ō*, or *Kitoku*.[4] The musical accompaniments were classified for their supposed region of origin: Tō (Tang China), Shiragi (Silla, a kingdom in southeastern Korea), Kudara (Paekche, a kingdom in southwestern Korea), Kōrai (Koguryo, a king-

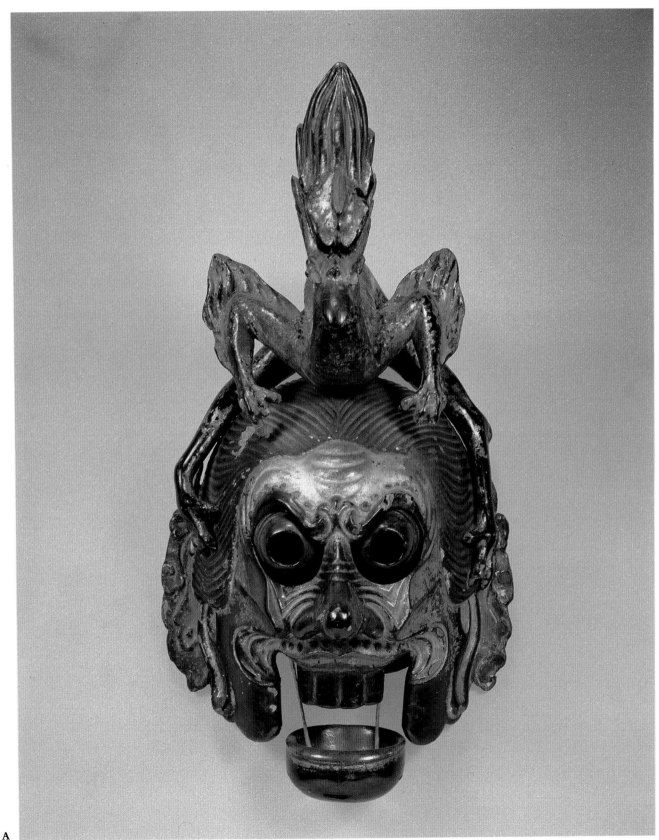

dom in northern Korea), Tora (perhaps Central Asia), Rin'yū (Champa, in Vietnam), and Bokkai (Pohai, in eastern Manchuria). The term *komagaku* (Korean music) apparently came to include some or all of the accompaniments from Shiragi, Kudara, and Kōrai. *Tōgaku* accompaniments constituted by far the largest part of the repertoire. In the mid-ninth century these various geographical categories were grouped under the rubrics "left" and "right"—a terminology probably derived from the nomenclature of court rank.[5] The "left" category comprised music (and appropriate dances) supposed to have originated in Tang China, Central Asia, and India and southeast Asia; the "right" included the music and dances composed in Japan itself as well as those brought from Korea and Pohai. Even the colors of the richly embroidered *bugaku* costumes echo ancient court practice: dances of the "left" are costumed primarily in red, those of the "right" primarily in blue or green.

Although we can assume that the nature of the music determined to a very considerable extent the type of dance performed to it, the dances were themselves further categorized. "Peaceful" or "even" dances (J: *hira mai*), which usually begin a program nowadays, are generally executed in symmetrical unison by groups of four or six dancers wearing relatively lifelike masks. These will be followed by more energetic "military" dances (J: *bu no mai*) in bold-featured masks, and the program will conclude with "running" dances (J: *hashiri mai*), rapid and exciting solo turns danced in highly expressive masks.[6] *Bugaku* dances are expressive rather than narrative, although the name and appearance of the mask, and the general "mood" of the music and the strictly prescribed choreography, usually contain at least a suggestion of myth or legend or mythologized history.

Gravel surrounding the modern *bugaku* stage reminds us that performances originally took place in the open air. *Bugaku* is performed in the round or three-quarter round; the stage is in the center of the theater, elevated about three feet and enclosed by a red railing except at upstage and downstage center, where wide stairs provide for entrances and exits. The square stage measures about twenty-six feet on a side, but the actual performing area is an eighteen-foot square in its center; this is raised about six inches above the stage itself and covered with green cloth. The musicians sit

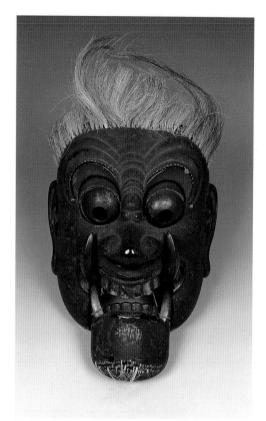

33 B

33 D

upstage before a curtain, and large drums in elaborately carved wooden frames occupy the upstage right and left corners.

Bugaku masks cover only the face and forward part of the scalp and are thus smaller than those that were used in *gigaku*. Except for one dry lacquer example in the Fujita Art Museum, Osaka, all the known masks are of wood—mostly paulownia but a few of cypress. Paulownia was poorly suited and rarely, if ever, used for statues, but its light weight made it perfect for the masks, which are usually carved from a single block.

Three steps were commonly involved in the surface preparation of both *bugaku* and *gigaku* masks. A primer coat of either *kataji no ko* (lacquer mixed with volcanic ash) or *sabi urushi* (a mixture of wheat glue, lacquer, and a pulverized fired clay called *tonoko*) was first applied to the mask, inside and out. (Before the primer was applied, the best masks might also be covered inside and out with hemp cloth soaked in lacquer as a binding agent.) Over the primer, the outside of the mask received a coat of white kaolin. Finally the outer surface was detailed and embellished, using pigments, lacquer, or gilding, or a combination of these. Buddhist statuary was made in essentially the same way during corresponding periods. On the inside surface of the masks the primer coat of *kataji no ko* or *sabi urushi* acts as a sealer, resisting damage from abrasion and perspiration. Cross-grain braces are sometimes added inside the mask to prevent warping. Despite its advantageousness, some early masks (ninth through early eleventh century), including those from Tōdai-ji and Tamukeyama Shrine dated to 1042, lack the primer coat.

Some masks have movable parts, particularly the chin or jaw sections and the eyes, to allow for variation of facial expression. The movable chin section (J: *tsuriago*) was carved separately and attached by cloth or leather cords to the back of the eyeballs. *Dōgan*, bulging movable eyes carved from a separate piece of wood and pierced by a bamboo or copper rod secured to the temple of the mask, move up and down in unison with the chin. These features move with the rhythm of the dance, lending a subtle but forceful stage presence to the mask. Hair and beards were made of animal hair or vegetable fiber, passed through small holes carved in the masks and attached with wooden pegs or affixed with lacquer.

By far the greatest number of surviving masks date from the Heian period. The masks may represent humans—many of them continental Asians—or gods, birds, or animals. Some are composite faces of no identifiable species. Nara-period examples are somewhat more naturalistic than those of the Heian period, reproducing for the most part the style of their Tang Chinese prototypes. Inscriptions much like the ones found on Buddhist statuary frequently give the name of the mask and designate the place and date of dedication, patron's name, number of dancers in the piece, and on occasion the name of the sculptor. Because all inscriptions were written on the inside forehead or cheek areas, they were often recopied when the mask was repaired or its inside surface relacquered. This makes it extremely difficult to verify the dating by the style of handwriting or the type of ink, paint, or lacquer used.

During the Meiji Restoration, when government fiat distinguished Shintoism from Buddhism and severed long-associated shrines and temples, many masks were transferred to the shrines, where *bugaku* became one of a number of nonsacral but customary activities. Tōdai-ji and Tamukeyama Shrine, Kōfuku-ji and Kasuga Shrine, are examples of institutions that originally held *bugaku* masks in common.

A
Ryō-ō

Cypress wood and cloth with pigments and gilding

H. 34.8 cm. W. 20.3 cm.

Kamakura period, 1259

Dance form: *tōgaku*, left, *hashiri mai*, one dancer; alternate names: *Raryō-ō, Ranryō-ō*

JUDGING from surviving records, the most frequently performed *bugaku* dance was *Ryō-ō*. Over sixty *Ryō-ō* masks remain in Japan, a relatively large number, and widely distributed geographically.

This dance may have originated in legends of the eight dragon kings of Buddhist iconography, or as a shamanistic invocation to the dragon, lord of the waters, for rain—an invocation that may in turn derive from an ancient Indian serpent play. Legends relating it to Chinese sources abound, too. The most fre-

33 C

quently cited is the legend of the young prince Lan Ling (J: Ranryō) from Pohai (J: Bokkai, in Manchuria), who hid his delicate good looks behind a grotesque mask such as this in order to strike fear into the enemy in battle. Cloth fragments in the Shōsō-in, dated to 752, are marked as costumes for the "old Chinese dance of *Ranryō-ō*." A document at Hōryū-ji notes the performance of the *Ryō-ō bugaku* in 1315 to break a late summer drought, and other sources record its use for the same purpose throughout the Kamakura period.

The mask exhibited, dating from a time when the art of *bugaku* was not at its height, is nevertheless an excellent example of the *Ryō-ō* type. It is signed by the sculptor Shōjun, of whom we know nothing except three surviving works. Its features are characteristic of *Ryō-ō*: a dragon bestrides the head like a helmet plume, its long nose and open, snarling mouth echoing those of the figure below; a profusion of stylized wrinkles are skillfully carved at the brow and on the cheeks; the hair—here painted green—is parted down the center; the face is painted gold; the circular chin drops open to reveal a scarlet mouth with long black upper teeth; the bulging eyes are movable; the aggressively jutting nose is painted cinnabar for emphasis. Tufts of hair once bristled from the holes along the upper edge of the eyebrows. The scaly green dragon bears down on the viewer with equal ferocity. Its hind legs grasp the head with surprising delicacy in a posture that is at once an embrace and a foothold from which to lunge. When the dancer executes the *Ryō-ō* steps, and the mask's eyes dart and its mouth gapes, Ryō-ō's warrior prowess seems truly uncontestable.

B
Nasori

H. 21.2 cm. W. 22.1 cm.
Kamakura period, 14th century
Dance form: *komagaku*, right, *hashiri mai*, usually two dancers; alternate name: *Rakuson* (when danced by one)

NASORI rivals *Ryō-ō* in popularity, with approximately the same number of extant masks distributed just as widely. References dating from the late eighth century attest to its early importation from China; during the Heian period the relatively dramatic movements of

Nasori made it a popular victory dance after various competitions. Popular belief associates the rapid and fluid movements of this dance with frolicking dragons, but little about its sources has been recorded. *Nasori*, a "running" dance of the "right," is usually paired with *Ryō-ō*, a "running" dance of the "left," and is most often performed by two dancers.

Compared with the mask of *Ryō-ō*, the Nasori mask is more grotesque than terrifying. Long fangs project upward from both the lower and upper jaw, and the nose is broad and blunt. The cheeks are smooth, but stylized, arching forehead wrinkles further emphasize the bulging, round, movable eyes and descend to distorted bumps on the bridge of the nose. Tufts of hair that once protruded from the brows are missing (as on the *Ryō-ō* mask), but clumps of real white hair are well preserved at the upper hairline and remains can be seen at the chin as well. The movable jaw differs somewhat from *Ryō-ō*'s, being three-sided rather than circular and having more restricted vertical movement. There are three *Nasori* masks in the Tōdai-ji collection, including the one on exhibition.

C
Sanju

By Inken
H. 22.5 cm. W. 16.3 cm.
Kamakura period, 1207
Dance form: *tōgaku*, left, *bu no mai*, one dancer with two–six assistants; alternate name: *Sanju Hajinraku*

THE mask for the heroic *Sanju* dance represents a king. The principal dancer, supported by two, four, or six boys, wears a helmet, carries a halberd, and wears a sword at the hip. Although this commanding face is distinctly human, its deep red color and exaggerated features lend it an abstract quality. In basic outline the face is long and rectangular, its square forehead balanced by a square chin and its high cheekbones making taut curves of the vertical sides. Inflated nostrils create a nose that is more a stylized form than an empirical description of a facial feature. The eyes are wide open and stare downward, creating an expression of heroic aloofness. Both eyes and eyebrows slant, there is a bump above the bridge of the nose, and the mouth is broad,

closed, and rather sensual. The mouth section is not movable, but the eyes once were. Though the mask is now completely hairless, we can see where eyebrows and a moustache were originally stuck on. This example represents one of two common *Sanju* types; the other has a larger and somewhat more naturalistic face, with parted lips and chin whiskers.

Various origins are claimed for the *Sanju* dance. One theory has it composed and performed in ancient times by King Shishikutsu (Japanese reading) to celebrate the birth of Sākyamuni; another makes it a celebratory dance, performed by a god of mythological times, at the defeat of the Silla (Korean) army.

On the right inside surface of the mask exhibited is an inscription in red lacquer stating, "Saishō Shitennō-in, copied from a model in the Shin Hiyoshi Shrine by Busshi Hōgen [Buddhist sculptor, rank Eye of the Law (see no. 14, n. 1)] Inken. Jōgan 1 [1207], 11th month, 15th day." Recorded commissions for the imperial court and the Fujiwara family reveal that Inken was a central figure of the In school at Shichijō Ōmiya, one of two major sculpture ateliers in Kyoto. The mask was copied from a *Sanju* at Hiyoshi Shrine as an offering to the Saishō Shitennō-in. Another mask with exactly the same inscription is found at Tamukeyama Shrine.

D
Kitoku

Cypress wood and cloth with pigments
H. 21.9 cm. W. 16.5 cm.
Kamakura period, 13th century
Dance form: *komagaku*, *bu no mai*, one dancer (some forms with attendants)

THIS early Kamakura *Kitoku* mask, like the *Sanju*, represents a ruler, and the dancers are similarly accoutered, though the *Kitoku* helmet bears a dragon crest. The name Kitoku is the Japanese pronunciation of the Chinese characters *gui de*, meaning "honorable" and "virtuous," i.e., a gentleman. There are two such masks at Tōdai-ji, one currently housed in Tamukeyama Shrine. Their features are comparatively realistic, and they have been dated to the early Kamakura period by their likeness to certain thirteenth-century Buddhist sculptures of guardian figures.

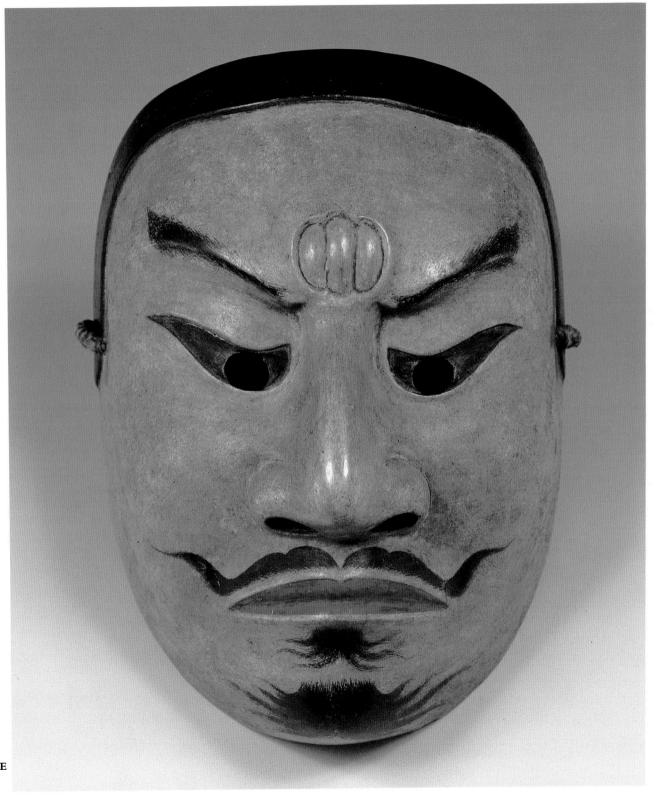

33 E

There are two types of *Kitoku* mask, one fully human, the other with a round, open mouth like a carp's. Here a broad oval face shows human lips parted and turned down at the corners, a wide, prominent nose, large, wide-open eyes staring intently downward under knit brows, and two bumps at the bridge of the nose. *Kitoku* are either green or flesh-colored, and some of them have hair. The original color of this mask is difficult to determine, as the paint has worn away, leaving only the kaolin undercoat.

E
Ōnin-tei

Paulownia wood with pigments
H. 20.8 cm. W. 15.1 cm.
Late Heian period, 1042
Dance form: *komagaku,* right, *hira mai,* four dancers; alternate name: *Ōnin*

ONE of four similar *Ōnin-tei* masks at Tōdai-ji made for the slow *hira mai* dance form, this mask does not personify a specific character but simply conveys solemnity and dignity. Only seventeen of this type survive today; the four at Tōdai-ji and one at Tamukeyama Shrine, all dated by inscription to 1042, are the earliest datable *bugaku* masks extant.

Tradition has it that the *Ōnin-tei* dance was first performed in the year 313 by the Korean scholar Wa'ni, from the Kingdom of Paekche, for the coronation of the Japanese emperor Nintoku. Thereafter it was customarily performed at the coming-of-age ceremony for the crown prince. *Ōnin-tei's* slanted eyes have a distinctive curve, "dipping" at the center and narrowing at the outer edges. His slanting brows are angled at their inner edge, like check-marks. Over the bridge of the straight nose, which is realistic in size and shape, is a medallion-like three-section bump, Otherwise the face is smooth and unwrinkled. Wide, firmly shut lips are bordered by a painted moustache and chin whiskers. The Tōdai-ji masks have recently been repainted, but the original blue-green pigment of the face is still visible on the mask at Tamukeyama Shrine. A band of black hair—characteristic of slow-dance masks—has been painted on. CJB

1. The *gigaku* music, which is approximately contemporary, no longer survives.
2. In the first half of the ninth century, under the influence of Confucian ideas about the relationship between musical and political harmony, the court undertook to regulate the musical modes in use and to codify the dance forms. Scales and instruments that did not conform to the new standards were adapted or went out of use; native *bugaku* dances and

music were composed; many dances of continental origin lost their original exotic associations and became assimilated. The terms were devised by which *bugaku* pieces have been classified ever since.
3. The oldest written treatise on *bugaku*, the *Kyōkunshō (Books of Instruction)*, may have been written in hope of preserving at least a written record of an apparently dying art. It was written in 1233 by Koma Chikazane, a *bugaku* dancer from Nara.
4. Although not every *bugaku* role wears a mask.
5. Every minister, councillor, or captain was either "of the Left" or "of the Right" (referring originally to the side of the emperor he was privileged to flank). Court pastimes included many kinds of team competitions (literary as well as athletic), in which courtiers "of the Left" were pitted against those "of the Right." When a contest was won, or even when a point was scored, the winners might call for a dance. Certain dances became associated with the Left and others with the Right. From this, the dances came to be performed in pairs (as they are to this day), a dance of the "left" being followed by a dance of the "right."
6. *Mai*, which means dance, is an alternative reading of the character *bu* in *bugaku*.

Painting and
Calligraphy

第五離癡亂
行知識師子
宮城海寶髻
長者讚

第四亓盡行
知識大興城
明智居士讚
蟹量國五諸眾生
種種所須不同欲
自從明智稱慶
一切有求守滿足

34

34

Illustrated Handscroll of Zenzai Dōji's Pilgrimage to Fifty-five Places as Described in the Kegon Sutra (J: *Kegon Gojūgo-sho Emaki*)

Handscroll; ink and light colors on paper
H. 30 cm. L. 1,287 cm.
Kamakura period, late 12th century
National Treasure

THE *Kegon Gojūgo-sho Emaki* depicts the encounters of the miraculous child Zenzai (S: Sudhana) with fifty-four spiritual teachers in his search for Ultimate Truth and Enlightenment. The title is a slight misnomer: Zenzai Dōji's pilgrimage began and ended with the bodhisattva Monju (S: Manjusrī), and he once visited two teachers at the same place, thus meeting fifty-four persons at fifty-four different places. An equally familiar title for this scroll is *Zenzai Dōji Emaki* (*Illustrated Handscroll of Zenzai Dōji*).

Unlike most illustrated handscrolls, the scenes here do not alternate with sections of text but are continuous. Inscriptions are confined to ink-bordered rectangles above each scene; these describe the stage of religious development reached in the scene below, identify the teacher and the place, and conclude with a poem summarizing the meeting and praising the teacher.[1]

Like another famous pilgrim's progress, this one is an allegory, designed to make abstruse religious doctrine more accessible to the popular mind. Zenzai Dōji's journey begins with the bodhisattva Monju's charge to seek Enlightenment and ends with the miraculous child becoming himself a bodhisattva. The stages of his progress were derived from the *Kegon Sutra* by Fa Zang (J: Kōzō Daishi) (see no. 44), a celebrated Chinese monk of the Hua-yan (J: Kegon; Flower Garland) school. Yang Jie, who wrote the poems, was also Chinese—a devoutly Buddhist scholar-official of the late eleventh century.

From the inscriptions we can see that encounters 22 to 31 and 48 to 55 are missing from the Tōdai-ji scroll. These sections left the temple after the Meiji period and are now divided among the Fujita Art Museum in Osaka, the Tokyo National Museum, and various private collections.

Compositionally, some scenes are circular, with the spiritual teacher in the center surrounded by other figures in a half-circle. In others the figures form a diagonal, with the counselor largest in scale, while yet others are frontal, centered on a palace or tower. Although each spiritual stage is an independent composition, the scenes are not demarcated but flow naturally from one to the next.

The lines in the scroll are executed in light ink with fluid, simple brushwork, giving the figures a certain liveliness of expression. Yellow, sometimes quite pale, renders the skin tones of bodhisattvas. On all the figures clothing is light green and red, with somewhat darker shades for garment necklines and pedestals. Platforms and screens are dotted with white, tree trunks are light black, branch tips and pine needles deep black. Accents of more saturated color serve to unify the compositions and to emphasize significant elements within them.

Fluent, rhythmical brushwork, harmonies of hue and shade, and clear delineation of shapes characterize this painting. The style is Japanese, but Chinese influence can be detected in the facial features of the spiritual advisors, in the presence of pedestals and portable baldachins,

and in the drawing of the trees, indicating that the prototype for this painting must have been of continental origin. Thus the end of the twelfth century, when the native Japanese handscroll tradition was coming under the influence of recent Chinese painting styles, is probably the time when this scroll was executed. ANM

1. Excellent discussions of the scroll can be ·found in Murase, *Emaki*, no. 2, and in Fontein, *Pilgrimage of Sudhana*.

35
Spiritual Teachers of the Kegon Ocean Assembly (J: *Kegon Kai-e Zenchishiki Mandara*)

By Raien (act. late 12th century)
Hanging scroll; ink and colors on silk
H. 184.5 cm. W. 118 cm.
Kamakura period, late 12th century
Important Cultural Property

WRITTEN along the upper margin of this painting, "Kegon Kai-e Zenchishiki" (Spiritual Teachers of the Kegon Ocean Assembly) refers to the individuals consulted by the boy Zenzai during his quest for Ultimate Truth (see no. 34). In a large rectangle centered beneath the inscription, a crowned, haloed Buddha sits on a white lotus pedestal; both the crown and the characters written in ink in the upper right-hand corner of the rectangle identify him as Dainichi Nyorai (S: Mahāvairocana Buddha), principal and primordial deity of the Esoteric Buddhist pantheon. Flames of red, black, blue, green, and yellow, accented with white and gold, fill the rectangle around the mandorla. Surrounding Dainichi is a grid demarcating fifty-four smaller rectangles, each containing an imaginary portrait of one of Zenzai Dōji's spiritual guides. A cartouche in the upper right-hand corner of each small rectangle identifies these preceptors; we see them in the order in which Zenzai Dōji met them by reading the scroll boustrophedon style, beginning from top left to right.

Unlike most representations of Dainichi, this painting shows his hands in teaching mudra. According to Myōe (Myōe Shōnin, 1173–1232),

35

the highly influential monk and abbot of Kōzan-ji who revived Kegon Buddhism in the Kamakura period, such depictions derived from Chinese prototypes.[1] Furthermore, Myōe's *Dream Diary* (*Yume no Ki*) contains a sketch of Dainichi in teaching mudra, and another such representation is found in the *Gosei Mandara* (S: *mandala*; a diagrammatic depiction of Buddhist deities that symbolizes their interrelationships), a painting housed at Kōzan-ji that Myōe deeply revered. That this type of image had been depicted on the continent by the beginning of the eleventh century is proved by a low-relief carving at the Fei-lai-feng cave-temple near Hangzhou, dated by inscription to 1022. Similar images considered to be from Song- and Yuan-dynasty China are found at Kenchō-ji (near Kamakura) and in the Boston Museum of Fine Arts.[2] Moreover, the color harmonies of white/blue/, white/green, and white/red, as well as the additional cinnabar and gold in the figures, the five-colored flames, the light in each register, and the clouds all reflect the influence, or even the direct model, of a Song Chinese original.

The figure of Dainichi has suffered severe damage. Though the white garments and lotus pedestal are relatively intact, the head and the mandorla surrounding the body are later restorations. An inscription recording repairs to the scroll notes that it was painted at Kōzan-ji by Raien Hokkyō[3] of Bitchū Province and inscribed by the former Senior High Priest Ryōhen, that it was entrusted to Jōkai-ji in Harima Province in 1294, and that it was transferred to Tōdai-ji in 1421.[4]　ANM

1. The teaching mudra and its derivation from Chinese prototypes is mentioned in *Kegon Bukkō Sanmai Kanhi Hōzō*.

2. The former is a painting of Shaka known (because the Shaka figure is crowned and jewelled) as "The Worldly Crowned Shaka"; the latter is called *Sākyamuni Expounding the Law of the Perfect Enlightenment to an Assembly of Bodhisattvas and Devas*.

3. *Hokkyō* means "Bridge of the Law" and is a high priestly rank awarded as an honor to lay artists.

4. This handscroll is discussed in Fontein, *Pilgrimage of Sudhana*.

36

Shaka Triad with Sixteen Rakan

Hanging scroll; ink and colors on silk
H.. 148.4 cm. W. 101.9 cm.
Kamakura period, 14th century
(Not in exhibition)

SHAKA sits cross-legged, facing the viewer, on a seven-tiered lotus throne. At the foot of Shaka's pedestalled throne, half turned toward each other, sit Fugen and Monju, also on lotus thrones, on their elephant and lion mounts. Behind Shaka in the distance rises Vulture Peak (S: Gṛdhrākūta), the hill in northeastern India where Shaka preached the *Lotus* and other sutras. Among his hearers there, say these scriptures, were five hundred Buddhist sages, called *rakan* in Japanese (S: *arhat*). These are fully Enlightened humans, who have already attained the nirvanic state and will enter into it upon their deaths. Till then, *rakan* practice and teach the Buddhist Law on earth, keeping it alive during the time between Shaka's entry into nirvana and the coming of Miroku (S: Maitreya), Buddha of the future. Sixteen of these *rakan* flank the central triad, eight on each side.

As in all traditional representations, the *rakan* have nimbuses (though not body halos) in sign of their Enlightenment. But in contrast with the idealized, otherworldly appearance of the Buddha and bodhisattvas, the *rakan* are thoroughly and individualistically human-looking. They are shown as monks, and though Buddhist tradition (borrowing probably from Daoism) makes them wonder-workers as well, their arduous progress along the Eightfold Path to Enlightenment was not aided by any miraculous powers. Some are old, some stout, some gaunt, some ugly—all are marked by the intensity of their spiritual struggle. As a group, they symbolize the practice of the earlier form of Buddhism, Theravada, which emphasizes self-discipline and the study of the Four Noble Truths as the path to Enlightenment. This austere and strenuous doctrine was never popular in China or Japan, where the later, Mahayanist, idea of salvation by faith in benevolent intercessionary bodhisattvas proved more congenial. Nevertheless, the *rakan* became an extremely popular iconic type in both countries. As emblems of an inward and solitary pursuit of Enlightenment, they ap-

pealed especially to Zen (C: Chan) Buddhists. *Rakan* images became common in Japanese religious art with the arrival of Zen Buddhism from China in the thirteenth century.

Shaka is wearing red monastic robes. Fugen and Monju are elaborately crowned and jewelled, as befits bodhisattvas, with Monju holding a *nyoi* sceptor and Fugen a three-pronged sword and wish-granting jewel. In the right and left foreground are a reclining tiger and a cloud-wreathed dragon, each looking up intently at the *rakan* who tamed him—respectively Nakora and Karika.

Stylistically the Shaka triad shows the influence of Chinese Buddhist painting of the Song dynasty, particularly in the elaborateness of Shaka's throne, in the Chinese style crowns worn by the bodhisattvas, and in the bright coloring of the robes. But Japanese traits are also present: the approachable, endearing sweetness of the deities' expressions, the lack of three-dimensionality of their figures, and the forms of clouds and gently rolling hills in the background. The sixteen *rakan*, too, reveal an admixture of Song and indigenous styles, their features, figural modelling, and draperies being typical of Song Buddhist painting but having the characteristic Japanese lack of figural volume.[1] This painting is a notable example of the work of a Buddhist painter from Nara atelier (J: Nara *ebusshi*) during the late Kamakura period.

Shaka worship, eclipsed in Japan first by the Esoteric deities and then, during the twelfth and thirteenth centuries, by Amida worship, experienced a resurgence during the later Kamakura period. This resurgence had two religious roots: it was part of a renewed interest in the code of monastic conduct (J: *ritsu*; S: *vinaya*) followed by Shaka's disciples and by the *rakan*, and it was part of the reaction against Amidism. This painting, which once belonged to the Ordination Hall, reflects the renaissance of Shaka's cult during the fourteenth century.
JDP

1. Cf. Seiryō-ji painting of *Sixteen Rakan*, imported from Song China. The painting is reproduced in *Kokka*, no. 154 (1903) and no. 754 (1955).

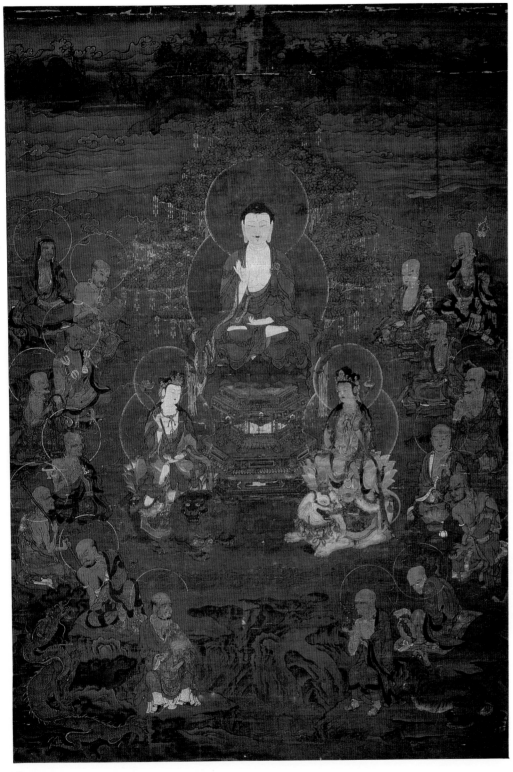

37
Shaka Triad

Three hanging scrolls; ink, colors, and cut gold leaf on silk
(Center scroll) H. 60.7 cm. W. 28.5 cm.
(Side scrolls) H. 46.5 cm. W. 28.5 cm.
Muromachi period, 15th century

SHAKA Nyorai, the historical Buddha, is
flanked in this triad of paintings by his custom-
ary attendant bodhisattvas, Monju (S: Man-
jusrī) and Fugen (S: Samantabhadra), who
embody complementary aspects of Buddha-
nature. Shaka is framed by a large halo, and the
whole image—including throne—seems to
emerge out of swirling clouds below. With his
hands in preaching mudra, he faces front,
sitting cross-legged on a lotus throne placed on
an elaborately decorated pedestal.

His bodhisattvas, shown in three-quarter
view, turn toward him, Monju (supreme
wisdom) on the right and Fugen (compassion-
ate action toward all living things) on the left,
seated on pedestalled lotus thrones atop their
respective animal vehicles. Both are icono-
graphically orthodox: Monju holds a long-
handled wish-granting jewel (J: *nyoi* or *hōju*; S:
cintāmani; see no. 14), and his Chinese style
crown symbolizes the five types of Buddhist
wisdom as his lion symbolizes the power of
that wisdom; Fugen's six-tusked white elephant
represents the purity of the six sensory and
intellectual organs, and the long-stemmed lotus
blossom in his hand alludes likewise to purity.
Lion and elephant each stand squarely on four
more lotus blossoms.

The painting is elaborately detailed, and
jewel-like in its rich coloring and lavish use of
gold paint and leaf. Light yellow—the custom-
ary hue of divine radiance—colors the flesh of
the three divinities, with cinnabar lines of
varying thickness emphasizing the contours.

Their garments are outlined and contoured
with vigorous modulated ink lines. Shaka
wears a cinnabar colored robe striped and
bordered in reddish orange, and the robes of all
three figures are adorned in gold paint with
auspicious patterns such as linked circles, key-
frets, swastikas, and bracken.[1] Individual hairs
of the lion's fur have been carefully painted in
gold, and shaded cinnabar colors the elephant.

Shaka's lotus throne and pedestal are unusually
magnificent, rendered in a manner very close to

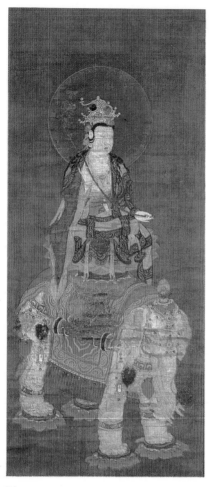

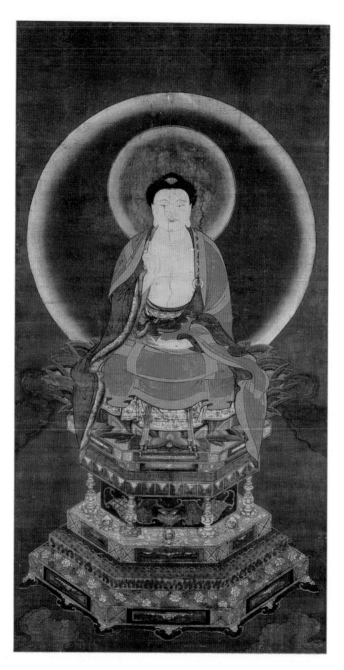

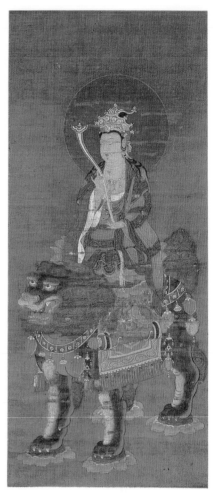

37

Chinese Buddhist painting styles of the Song and Yuan dynasties. Each step of the five-tiered hexagonal pedestal is lavishly painted and gold-leafed with lions, clouds, mountains, and peony scrolls, and decorative perforations adorn each riser. The red and blue-green lotus petals are finely veined in gold paint. But the use of cut gold leaf on the mandorlas and nimbuses and on Shaka's throne, and the thickly applied gold paint used to represent jewelry and metal religious paraphernalia, suggest that these paintings are not Chinese but were executed in Japan, based on Chinese models, about the turn of the fourteenth century. JDP

1. There is almost no decorative motif in Japanese art—and especially in Buddhist art—without auspicious significance. For the meaning of many of these motifs, see Mizoguchi, *Design Motifs*, and the sections on Buddhist art in Hansford, *Glossary of Chinese Art and Archaeology*, and Medley, *Handbook of Chinese Art*.

38
Four Saintly Persons (Eiwa version)
By Kanjō
Hanging scroll; ink and colors on silk
H. 201.5 cm. W. 153 cm.
Nambokuchō period, 1377
Important Cultural Property

THE four saintly persons depicted in this painting were key figures in the creation of Tōdai-ji and its *Daibutsu*. In the center and larger than the others is Emperor Shōmu (701–56; r. 724–49), in court dress. On the left, holding a *nyoi* scepter, is High Priest Rōben (689–773); at right rear, with clasped hands, is the Indian monk Bodhisena (704–60); and at right front is Gyōki Bosatsu (668–749) (see no. 30). Emperor Shōmu first conceived the project and put it into operation. Rōben was Tōdai-ji's first high priest (J: *sōjō*). The monk Bodhisena, of Indian origin, came to Japan from China in 736 and officiated at the "eye-opening ceremony" of the *Daibutsu* in 752. Gyōki was instrumental in the actual construction of the statue.

The Eiwa version is dated by inscription to 1377 and is named for the era, or reign-period

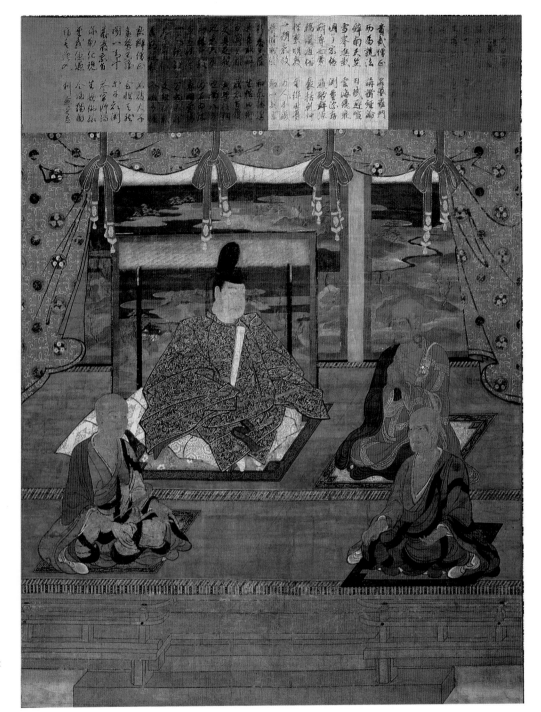

38

39

(J: *nengō*; C: *nian hao*), of its execution.[1] It is a faithful copy of another scroll of the Four Saintly Persons painted in 1256 and now housed at Tōdai-ji. According to the dedicatory inscription on the back of the mounting the painting in this exhibition was executed by Hokkyō Kanjō from Mino Province, and the person who wrote the inscription and directed the ceremony dedicating the painting was the imperial prince Shōchin (religious name: Tōnan-in Miyanibon). This scroll originally belonged to Miken-ji, a subtemple of Tōdai-ji which was disbanded in 1868.

In Japan revered persons were often commemorated in "portraits" painted after their deaths. Some of these were made soon after the death of the subject, by artists who might well have known how he looked in life. But others were generations or even centuries posthumous, and these portray ideal types—of royal majesty, spiritual or worldly power, scholarly acuity, and so on. Even those portraits that seem intensely individual, both physically and psychologically, are depicting the subject as he might have been expected to look—they were never intended as portraits in the Western sense. ANM

1. In Japan events were traditionally dated according to the reign-period in which they had occurred (e.g., "the third year of Keichō" [1598]). These reign-periods were declared by the emperor and given auspicious names. A new reign-period would be promulgated if the previous one had not fulfilled its auspices or if some remarkable portent had occurred. The idea had come from China.

39
Emperor Shōmu

Hanging scroll; colors on silk
H. 87.5 cm. W. 46.5 cm.
Muromachi period, 15th century

INSCRIPTIONS written on a long slip of paper on the back of the mounting, on another slip of paper under the strings that tie up the scroll, and on the upper left corner of the painting reveal that this portrait of Emperor Shōmu (701–56; r.724–49), which is usually called *Shōmu Tennō Kagami no Miei* (*The Mirror Reflection of Emperor Shōmu*), belonged to the Tōdai-ji subtemple Miken-ji, which was disbanded in 1868 (see no. 38).

Emperor Shōmu was a fervent Buddhist, a zealous patron of Buddhist images, temples, ceremonies, and scholarship. Tōdai-ji, though he died before it could be completed, is a monument to his aspirations. The inspiration and precedents for his Buddhist activities came from Tang-dynasty China, whose political and cultural effulgence were the cynosure of the Japanese court and whose emperors were (till the ninth century) devout and demonstrative Buddhists. But Shōmu had certain political incentives as well, and these were purely native. A national system of monasteries and nunneries (proposed before but never successfully implemented), with Tōdai-ji as capstone and the emperor as Tōdai-ji's chief patron, might effectively extend and reinforce the still circumscribed authority of the central government. And a project that enlisted the support of every subject in a common enterprise might well be a unifying force in a faction-ridden court, helping to bring about that "peace under Heaven" that the reign-name Tempyō so hopefully invoked.

In this rare portrait the emperor is facing right, framed by a swagged curtain and seated on a tatami mat decorated with contrasting bands of color. To his right is a stand with an octagonal mirror leaning on it. He is wearing court dress identical to his costume in *Four Saintly Persons* (no. 38). In his right hand he holds a cord, and his left rests palm upward on his knee. The facial features show greater detail than in number 38, but the left eye, the nose, and the mouth are restorations.

Vivid hues of cinnabar red, lead red, green, blue, and brown are laid on in thick, fluid strokes. In technique this painting is very close to other Buddhist paintings from Miken-ji. The brilliance of the colors and lack of modelling suggests a date at the beginning of the Muromachi period. ANM

40
High Priest Rōben

Hanging scroll; ink and colors on silk
H. 95.5 cm. W. 38.5 cm.
Kamakura period, 14th century

RŌBEN (689–773), first high priest (J: *sōjō*) of Tōdai-ji, is shown seated on a tatami mat with a border of contrasting colors. He faces left, grasping a *nyoi* scepter in his right hand and

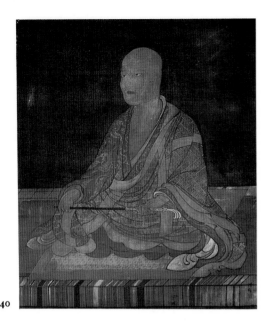

40

resting it in his left palm. The man we see has elongated eyebrows; wrinkles along the bridge of his nose; sharp, glistening eyes; and protruding ribs that make him look emaciated.

At the top of the painting is a nine-line inscription ending with the phrase "Monk Shoku Wa'nan, early fall of hinoto mi." The cyclical designation *hinoto mi* corresponds to either 1317 or 1377, but the pigments on the painting do not appear to be that old and may have been applied during a restoration. ANM

41
Monk Ji Zang (J: Kashō Daishi)
Hanging scroll; ink and colors on silk
H. 141.2 cm. W. 64.4 cm.
Kamakura period, 13th century
Important Cultural Property

THE monk Ji Zang (549–623) was the son of a Parthian father and a Chinese mother, but his education was wholly Chinese. His Japanese name, Kashō, derives from the Jia-xiang Si (J: Kashō-ji) in China, where he spent much of his life; *daishi* is a Buddhist honorific meaning "great teacher." Ji Zang was a patriarch of the San-lun school (J: Sanron) and the doyen of San-lun scholarship in China. Thousands attended his lectures on doctrine, and his influence continued strong for some two centuries

after his death. Though he never visited Japan, his image was particularly revered at Tōdai-ji since the revival of Sanron teaching during the Kamakura period. This painting is thought to have been hung during annual ceremonies held in his honor on the fifth day of the fifth month, and during annual sermons, begun in 1249, at Tōdai-ji's Shin-in subtemple.

Here Ji Zang is shown standing, holding a censer; he turns to his right and looks up slightly. The painting is softly outlined, and its clear colors emphasize contrasts of cinnabar and green, a stylistic trait typical of Buddhist paintings from Nara. Furthermore, the standing pose and the implication of movement conveyed by the direction of the glance call to mind the portrait of the San-lun monk Hui Yuan (no. 42), so this painting may well date from the period when the monk Shōshu (1219–91) of the Shingon-in, an Esoteric subtemple of Tōdai-ji, revived Sanron teaching in Japan. ANM

42
Monk Hui Yuan (J: Jōei Daishi)
Hanging scroll; ink and colors on silk
H. 146.2 cm. W. 64.6 cm.
Kamakura period, 13th century
Important Cultural Property

HUI Yuan (523–92) lived in the monastic and commercial outpost of Dunhuang on China's northwest frontier. His Japanese name, Jōei, was derived from the name of his temple, Qing-ying Si (J: Jōei-ji). He was known in Japan as the "Commentator Priest." At the Shin-in, which had become the center of Sanron scholarship at Tōdai-ji during the Kamakura period, sermons were based on one of his commentaries. Like Ji Zang (see no. 41), Hui Yuan was revered in Japan as a patriarch of the Sanron sect and was called "Daishi."

In this portrait Hui Yuan stands with his arms folded beneath his robes and his head slightly bowed. The artist was one of the Nara temple painters, and the portrait was made for ceremonies commemorating the anniversary of Hui Yuan's death. In the style of its painting and calligraphy this portrait resembles the one of Ji Zang, though the painters were not the same. It dates to the period when the monk Shōshu (see no. 41) was reviving Sanron scholarship and the portrait of Ji Zang was completed. ANM

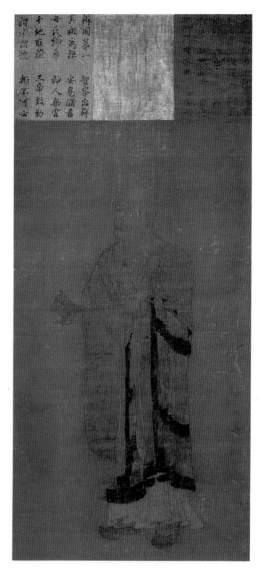

41

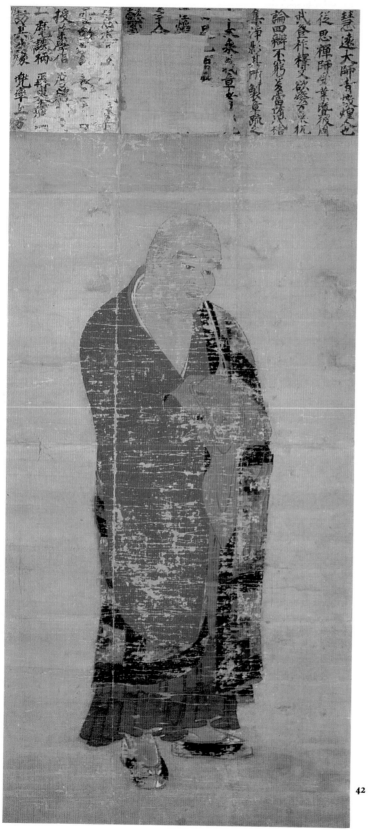

42

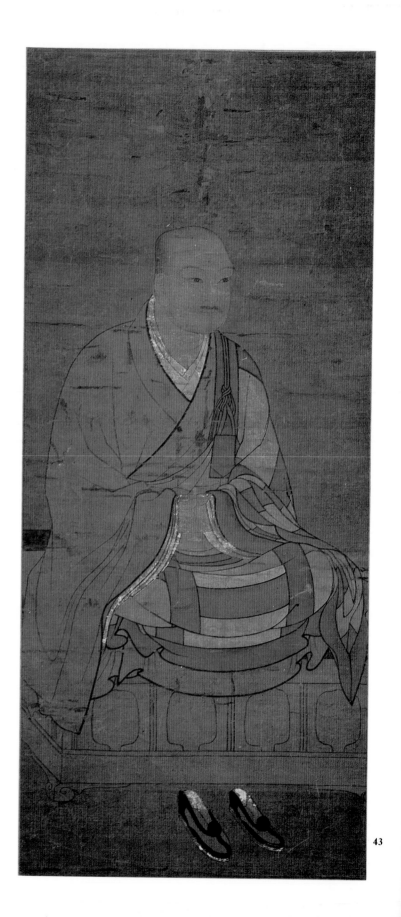

43

43
Monk Zhi Yan (J: Shisō Daishi)

Hanging scroll; ink and colors on silk
H. 96.2 cm. W. 41.3 cm.
Muromachi period, 14th century

Zнı Yan (602–68), second patriarch of the Hua-yan (J: Kegon) school, was the disciple of Du Shun and the master of Fa Zang (J: Kōzō Daishi or Genjū Bosatsu) (see no. 44). The name Shisō is the Japanese pronunciation of Jin-xiang, the name of the Chinese temple where Zhi Yan lived and preached.

Zhi Yan is shown in three-quarter view, seated cross-legged on a dais. As in many commemorative portraits of revered patriarchs and teachers, his slippers stand before the dais.

The Kegon school, whose principal temple was Tōdai-ji, had been virtually the established church of Japan during the Nara period, but the arrival of Esoteric Buddhism in the ninth century had greatly diminished its appeal. In the Kamakura period, however, many of the Nara-period schools were revived. This portrait, probably one of a set depicting the five Kegon patriarchs, exemplifies the revival. Its clear colors and strong brushwork are distinctive traits of the Nara ateliers during the Kamakura and Muromachi periods. ANM

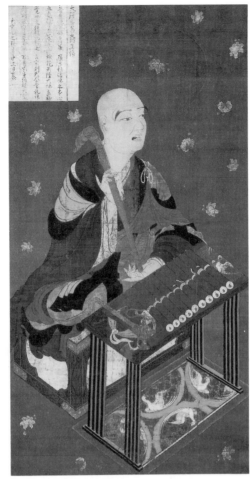

44

44
Monk Fa Zang (J: Kōzō Daishi)

Hanging scroll; ink and colors on silk
H. 152.5 cm. W. 81.4 cm.
Kamakura period, 13th century
Important Cultural Property

FA Zang (J: Kōzō Daishi or Genjū Bosatsu; 643–712) was the third of the five patriarchs of the Hua-yan (J: Kegon) school. His father was a Central Asian from Samarkand, but Fa Zang was born in Changan, the capital of Tang China. He entered the priesthood only in his middle years, after hearing a discourse on the *Hua-yan Sutra* by Zhi Yan, the second patriarch of the school (see no. 43). Under the guidance of the illustrious Chinese pilgrim-monks Xuan Zang and Yi Jing and of the Khotanese scholar Sikṣānanda, he translated sutras newly brought from India. His commentaries on Hua-yan doctrine gained the attention of the throne: Fa Zang served as preceptor to several Tang-dynasty rulers. Though he was particularly honored by Empress Wu Zetian, who usurped the Tang throne in 690, he did not fall into disrepute when Tang rulers returned to power. For systematizing Hua-yan teachings and for creating a hierarchy of Buddhist doctrines with Hua-yan at its apex, Fa Zang became the patriarch of that sect.

In this portrait Fa Zang is shown lecturing on a sutra. Holding a *nyoi* scepter, he sits on a dais; before him a sutra table stands on a rug bearing designs of fantastic birds in roundels. On the table lie ten rolled-up sutra scrolls and a gilt-bronze censer. Apart from the two items of furniture, there is no suggestion of three-dimensional space. Figure and furniture seem suspended before a flat background of scattered peony-like blossoms. These flowers, which appear to be drifting down from above, illustrate a line inscribed in the cartouche at upper left: "The auspicious cloud becomes a canopy of unusual flowers which fall to earth from heaven directly." Looking carefully at the painting, one sees that there is indeed an "auspicious cloud" rising heavenward from Fa Zang's mouth as he speaks.

The strong color accents of cinnabar, vermillion, and white are not found in other portraits, nor is the slightly slanted bird's-eye-view composition. The date inscribed in the cartouche corresponds to 1185 (twenty-fifth year of the reign-period Da Ding of the Jin dynasty then ruling northern China). Some scholars think that this painting is an original Chinese work or a copy executed in Korea during the Koryō period, but certain Japanese stylistic traits are apparent. The stylization, particularly, suggests that it is a copy of a continental original, painted in Japan during the Kegon revival of the mid-Kamakura period. ANM

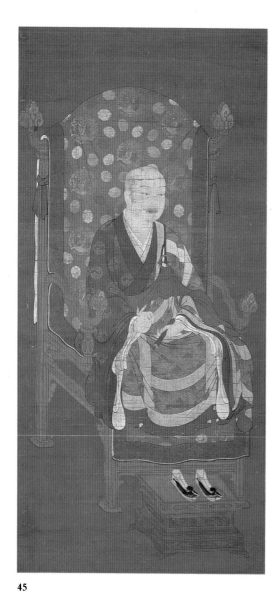

45

45

Patriarchs of the Kegon Sect: Cheng Guan (J: Seiryō), and Zong Mi (J: Shūmitsu)

Two hanging scrolls; ink and colors on silk

(Each scroll) H. 109.5 cm. W. 51.5 cm.

Muromachi period, 15th century

THESE scrolls probably belonged originally to a set of paintings depicting the five patriarchs of the Kegon sect. Today the portraits of the first three patriarchs—Du Shun (558–640), Zhi Yan (602–68), and Fa Zang (643–712)—are missing, but those of the fourth patriarch, Cheng Guan (738–c. 820 or 838), and the fifth, Zong Mi (780–841), have survived. The latter two men also excelled in Tian-tai and Chan teachings and advocated that teaching and meditation are one.

Buddhist legend has transfigured Cheng Guan (J: Seiryō) into a giant with glowing eyes, but he was remarkable even without these attributes. He began Buddhist studies early and left secular life by the age of eleven, though he was not ordained till twenty. Then he became a wandering scholar, studying Indian languages, secular literature, and sutras—particularly the *Hua-yan Sutra*—under many masters throughout northern China. His translations, commentaries, and oral teachings were enormously influential, and honors came to him in abundance from a succession of emperors. To later generations of Hua-yan devotees, he was an incarnation of Monju (see no. 22) or "the Hua-yan Bodhisattva."

Zong Mi (J: Shūmitsu) was pursuing secular studies toward a career in government when a meeting with a Chan (J: Zen) master led him to abandon secular for Chan monastic life. A later meeting with Cheng Guan caused him to become that master's disciple. His mature teachings advocated an amalgamation of Chan and Hua-yan teachings and practice. Like his master Cheng Guan, he was celebrated in his own time. Many of his commentaries are used in monastic training to this day.

In both paintings the subjects are seen in three-quarter view, sitting in the high-backed, throne-like chairs draped with brocade that seem to have been the customary perogative of eminent monks. Their slippers rest on

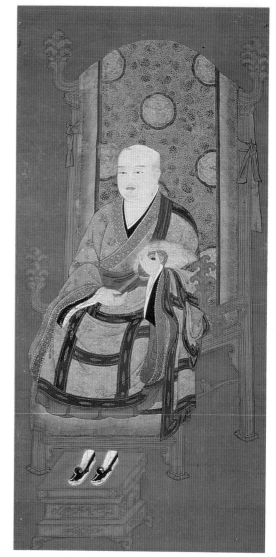

45

134

footstools before them. Cheng Guan holds a
rolled-up scroll and Zong Mi a fly whisk;
otherwise, the two portraits are closely similar.
The paintings have been executed with a sure
hand but display a remarkable degree of styliza-
tion, which can be seen particularly in the lack
of volume in both the chairs and the faces.
Consequently they can be dated to the mid-
Muromachi period, when this type of conven-
tionalized, flat rendering characterized paintings
produced by the Nara painting ateliers.
ANM

46
Legends of Tōdai-ji (J: Tōdai-ji Engi)

**Pair of hanging scrolls; ink and colors on
silk**

(Each scroll) H. 153.8 cm. W. 83.3 cm.

Nambokuchō period, 14th century

LEGENDS OF TŌDAI-JI is typical of narrative
paintings commissioned by temples and shrines
to familiarize lay audiences with their sacred
history. They were hung in temple halls during
special ceremonies or carried about by itinerant
monks for use in fund-raising (see nos. 47, 49).
Because these picture scrolls did not always
depict events in clear or logical sequence,
monks relied on the small labels that dot the
scrolls to help locate and identify each scene.

 Prior to its acquisition by Tōdai-ji, this pair of
hanging scrolls belonged to Miken-ji, a temple
dedicated to Emperor Shōmu (see nos. 27, 31,
39). In style and subject matter these scrolls
resemble a hanging scroll triptych at Iehara-
dera, a temple in Izumi Province (modern
Osaka Prefecture). That triptych is entitled
Illustrated Biography of Gyōki (J: *Gyōki E-den*). Its
first scroll depicts the previous incarnations of
the famous monk Gyōki (see no. 30), its second
and third treat Gyōki's great deeds and the
construction of Tōdai-ji, in which he partici-
pated. Similarities in subject matter lead us to
assume that the *Legends of Tōdai-ji* scrolls were
also originally intended as a biography of
Gyōki, and that the whole work, like the *Gyōki
E-den*, in fact comprised three scrolls. It is now
thought that one scroll of the Tōdai-ji set is in
the collection of The Art Institute of Chicago,
under the title *Illustrated Legends of Tenchi-in* (J:
Tenchi-in Engi-zu). Tenchi-in was Gyōki's own
temple, founded by him in 708 on Mt. Mikasa

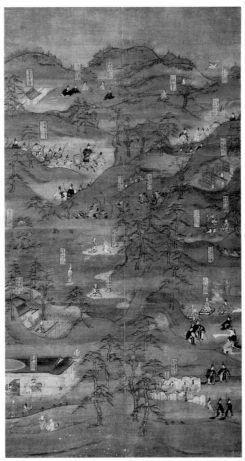 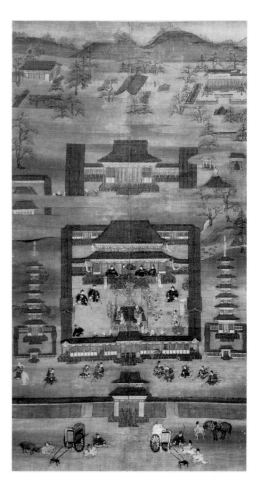

46

near Nara and later absorbed into the Tōdai-ji complex. The Art Institute scroll, which treats legends relating to the "prehistory" of Tōdai-ji, would be the first scroll in the *Legends of Tōdai-ji* triptych.

Of the two scrolls remaining at Tōdai-ji, the first, entitled *Illustrated Legends of Tōdai-ji* (J: *Tōdai-ji E-engi*), comprises legends concerning the temple's actual founding. The scenes are distributed among horizontal bands of gently rolling, verdant hills typical of *Yamato-e* style landscape.[1] Each scene is labelled in an accompanying rectangular cartouche, allowing the viewer to follow the story. The viewing sequence begins at upper right, where the infant Rōben (see nos. 4, 27) is being abducted by an eagle and carried to the faraway eastern mountains. We then see the works of Rōben, Gyōki, and Emperor Shōmu (all moving spirits in the foundation of Tōdai-ji), the beneficent power of the Thunderbolt Deity (see no. 50), the journey of the Usa Hachiman to Nara (see no. 49), the monk Jitchū performing the *Omizutori* ceremony (see Introduction, "*Omizutori*") before the Eleven-Headed Kannon of the Nigatsu-dō, and the conferring of the Buddhist precepts by the monk Ganjin on Retired Emperor Shōmu and Retired Empress Kōmyō (see no. 31). The scroll continues in boustrophedon fashion to the lower left, where Empress Kōmyō is seen ministering to outcasts. The accompanying cartouche states that she spent a thousand days in this good work.

The second scroll shows the major buildings of Tōdai-ji in a map-like layout resembling the mandala format, and for this reason it is called the *Mandala Tōdai-ji* (J: *Tōdai-ji Mandara-zu*). In fact this is a misnomer, because the scroll actually depicts the "eye-opening ceremony" for the original *Daibutsu*, held in 752 (see nos. 2, 47). We know this because Emperor Shōmu's grand procession to the temple with his courtiers and advisors has been included in the painting, as has the "Old Mackerel Peddler" (*Saba-uri no okina*). All that this pious old man had to offer the *Daibutsu* was mackerel, says the legend, and the mackerel was promptly transformed into the *Flower Garland Sutra* (J: *Kegon-kyō*). The scroll also includes armored warriors crouched outside the Inner Gate (J: Chū-mon), a reference to the rededication of the Daibutsu-den in 1195, when troops of the shogun Minamoto no Yoritomo guarded the precincts.

At the center of the scroll is the Daibutsu-den, surrounded by the Lecture Hall (J: Kōdō), Monks' Three-Sided Dormitory (J: Sanmen Sōbō; a building with two wings at right angles to its main hall), Ordination Hall (J: Kaidan-in), and the East and West pagodas. On the upper third of the scroll we find the Nigatsu-dō, Sangatsu-dō, and Tamukeyama Hachiman Shrine (see no. 15). The placement of these structures roughly corresponds to their present locations.

We do not know who painted these scrolls. In their rigid, map-like rendition of the Tōdai-ji compound and their loose arrangement of vignettes within a panoramic *Yamato-e* style landscape they conform closely to the composition and style of *Kasuga Mandala* paintings. These paintings, depicting Nara's Kasuga Shrine, adjacent Kōfuku-ji, and the surrounding countryside, were especially popular during the fourteenth and fifteenth centuries. They were a specialty of Nara painters, and the *Legends of Tōdai-ji* exhibited here may also have been created in one of the Nara painting workshops.　　LEM and CMEG

1. The term *Yamato-e* has come to designate a native Japanese style of painting, lyrical and decorative, that came into use during the Heian period. It is characterized by loving attention to landscape, brilliant mineral pigments, flat and stylized forms, and perspective devices that seem arbitrary to Western eyes.

47
Illustrated Legends of the Daibutsu (J: *Daibutsu Engi Emaki*)

By Rinken (act. 1536–91)
Handscroll in three rolls; ink and colors on paper
(Roll 1) H. 35 cm.　L. 138 cm.
(Roll 2) H. 35 cm.　L. 144.2 cm.
(Roll 3) H. 35 cm.　L. 212.1 cm.
Muromachi period, 1536
Important Cultural Property

TŌDAI-JI'S Hachiman Shrine and Daibutsu-den required repairs in 1534. Emperor Go-Nara (r. 1526–57) was approached, but imperial coffers were so low that he was unable to help. To raise the necessary funds, Tōdai-ji, as so often in the past, sought contributions from the populace. The *Illustrated Legends of Hachiman* (J:

Hachiman Engi Emaki) (no. 49), completed in 1535, and *Illustrated Legends of the Daibutsu* (J: *Daibutsu Engi Emaki*), completed the following year, were commissioned by Tōdai-ji solicitor Yūzen (d. 1560) for use by him and his assistants in their fund-raising efforts. By recounting the temple's history to the accompaniment of a lively picture scroll, travelling monks were assured a large audience of potential donors. Duplicates were made so that several monks could raise funds simultaneously in various parts of Japan. A duplicate of the *Illustrated Legends of the Daibutsu* is today in the MOA Museum of Art in Atami.

Illustrated Legends of the Daibutsu, also known as *Legends of the Daibutsu-den* (J: *Daibutsu-den Engi*), treats Tōdai-ji's history with special emphasis on events pertaining to the Daibutsu-den.[1] The temple's founding, the life of Rōben, the casting and dedication of the *Daibutsu*, and the temple's reconstruction under Chōgen after the conflagration of 1180 are among its highlights. In the third scene of the third roll, illustrated here, the colorful spectacle of the "eye-opening ceremony" of 752 unfolds before the viewer. The golden-hued figure of the *Daibutsu*, disproportionately large in scale, dominates the composition. Although the Buddha was customarily represented in the more formal frontal view, he is depicted here in a three-quarter view better suited to the narrow, elongated format of the handscroll. Before an assembly of religious and secular notables a monk wearing rich brocade vestments extends a censer in the shape of a double lotus blossom toward the *Daibutsu*; behind the statue another ecclesiastic extends a pagoda-shaped censer. Lotus petals float gently down from the sky. In the interest of compositional clarity the artist has eliminated the architectural framework. Along the upper and lower edges of the scroll stylized bands of ultramarine mist outlined in black, white, and gold help to anchor the scene within its restricted pictorial space.

The colophon written at the end of the third scroll by Yūzen states that the work is an abridged reproduction of the twenty-roll *Illustrated Legends of Tōdai-ji* (J: *Tōdai-ji Engi E-kotoba*), now lost but believed to have been completed in 1337. It also informs us that Emperor Go-Nara was the calligrapher of the first scroll, Prince Sonshin (twenty-third abbot of the Shōren-in) of the second, and Nishimuro Kōjun of the third.[2] It names Rinken (act.

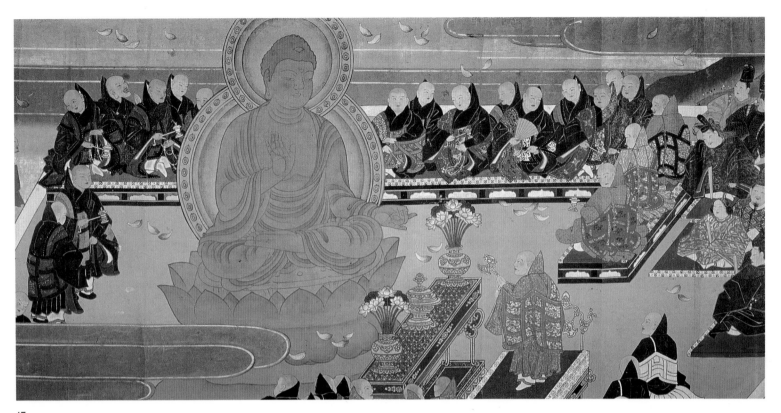

47

1536–91) as illustrator of all three scrolls.[3]

Rinken was a leading artist in Nara around the middle of the sixteenth century. Although at one point in his career he may have belonged to the Handa guild, on the Tōdai-ji scroll he is identified with the Shiba guild. Several other works by Rinken are preserved in Nara temples. He is thought to have painted portions of the *Taima-dera Engi* of 1531 (see no. 49) as well as a number of *ema*, small wooden votive plaques depicting horses and their grooms, for Kasuga Shrine. A scene of courtiers restraining a horse at the beginning of the second roll of the *Daibutsu Engi* closely resembles these *ema*.[4] Rinken's style shows a strong affinity with that of Tosa Mitsushige (1496–1559), leading exponent of the Tosa style during Rinken's lifetime. They share a predilection for rich mineral pigments, gold and silver, and profuse ornamental detail. But Rinken's static and precisely drawn figures reflect the influence of Buddhist devotional painting styles, and he is more idiosyncratic than Mitsushige in his treatment of landscape. LEM and CMEG

1. According to the title on the scroll backing the work is named *Illustrated Legends of the Daibutsu* (J: *Daibutsu Engi Emaki*), but the title *Legends of the Daibutsu-den* (J: *Daibutsu-den Engi*) is on the lid of the box in which the scrolls are kept.

2. Nishimuro Kōjun was the intendant (J: *bettō*) of Tōdai-ji from 1498 to 1502. The name Nishimuro is derived from the Tōdai-ji hall in which he lived. Kōjun was the son of Sanjōnishi Sanetaka (1455–1537), a courtier and aesthete, patron, poet, calligrapher, and connoisseur with a particularly strong interest in the illustrated handscroll (*emaki*) format.

3. According to the *Tōdai-ji E-dokoro Nikki* (*Diary of the Tōdai-ji Painting Workshop*) the third scroll was painted by Fujikatsumaro. See *Nara-shi Shi*, p. 455.

4. On this and other works by Rinken, see Kawahara, "Yūzen to Rinken," pp. 155–70.

48

Illustrated Legends of the Nigatsu-dō (J: *Nigatsu-dō Engi Emaki*)

Handscroll in two rolls; ink and colors on paper
(Roll 1) H. 34.9 cm. L. 870 cm.
(Roll 2) H. 34.9 cm. L. 1,205 cm.
Muromachi period, 16th century

OF the original *Illustrated Legends of the Nigatsu-dō*, completed in 1545, only fourteen illustrations from the second roll survive; the rest was probably lost in the fire that destroyed the Nigatsu-dō in 1667 (see no. 11, n. 1).[1] The handscroll exhibited here is a later copy of that lost original. It has no colophon or historical documentation but is conjectured to have been produced not long after the 1545 version. Its contents were inspired by the *Illustrated Legends of Tōdai-ji* (J: *Tōdai-ji Engi E-kotoba*) of 1337.

The first roll comprises six episodes and the second ten, with an illustration following the

text for each. The story begins in 751 with the heroic accomplishments of the monk Jitchū, worthy disciple and assistant to Rōben and supervisor of construction at Tōdai-ji during the last half of the eighth century. Jitchū saw both the *Daibutsu* and the Daibutsu-den to completion, took a directing hand in the architecture and statuary of other Nara tem-ples, and supervised the hydraulic, lumbering, and tile-making requirements of various Nara temples.

After recounting events of Tōdai-ji's first sixty years, the first roll ends—and the second continues—with scenes demonstrating the miraculous efficacy of the Kannon image in the Nigatsu-dō and the wonder-working qualities of the pure water of Wakasa Well (see Introduction, "*Omizutori*").

The illustration of the tenth episode, which appears to be by a different hand, relates the story of the Tōdai-ji monk Eikun, set upon by highwaymen from the village of Terada as he returned from an inspection of Tōdai-ji estates in Mino Province. Invoking the Kannon of the

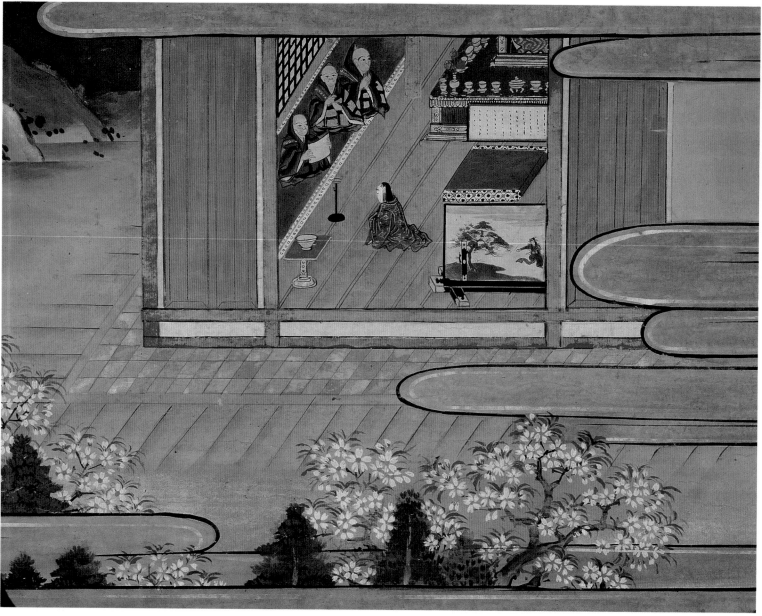

48

138

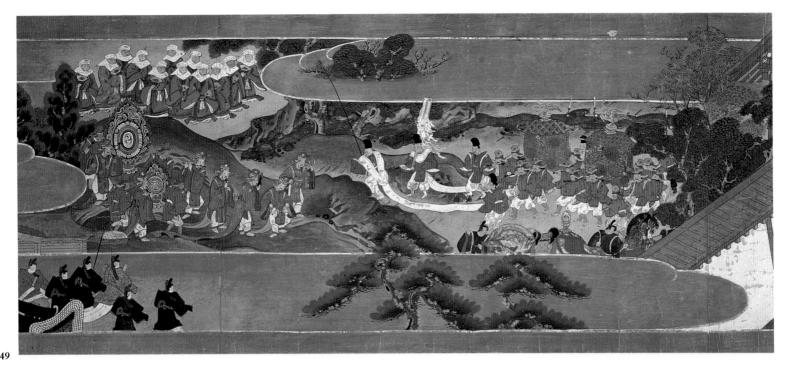

49

Nigatsu-dō, Eikun cursed Terada, and the village thereupon sank into miserable poverty. Only after a repentant pilgrimage to the Nigatsu-dō in 1546 did the villagers attain forgiveness and a return to their former standard of living.

The circumstances of the *Nigatsu-dō Engi Emaki*'s creation are not known, but it may have been commissioned as a result of the misadventures of Eikun and the villagers of Terada. The scroll's concluding passage notes that Eikun's curse was not lifted until after the completion of the scroll.

Illustrated Legends of the Nigatsu-dō makes liberal use of bright colors throughout, but its pictorial style is less decorative and ornate than that of the *Daibutsu Engi Emaki* (no. 47).

LEM and CMEG

1. As in the case of the *Daibutsu Engi Emaki*, duplicates of the original *Nigatsu-dō Engi Emaki* must have been made. The colophon of a 1545 version, now lost, was copied into a collection of texts. This copy names Emperor Go-Nara, Prince Sonshin of Shōren-in, and Sanetaka's two sons Nishimuro Kōjun and Sanjōnishi Kineda as calligraphers and Ryōjun as the painter. Nothing is known of Ryōjun, but he is thought to have been a member of the Nara painting workshops.

49
Illustrated Legends of Hachiman (J: *Hachiman Engi Emaki*)

By Sōken
Handscroll in two rolls; ink and color on paper
(Roll 1) H. 33.7 cm. L. 1,691 cm.
(Roll 2) H. 33.7 cm. L. 1,788 cm.
Muromachi period, 1535

HACHIMAN owes his enduring place in Tōdai-ji history to the role he played in the completion of the *Daibutsu*. Tradition tells that an oracle from Hachiman revealed the location of a vein of gold needed for gilding the statue. This underlay Hachiman's enshrinement at Tōdai-ji in 749 and his transformation from a minor Shinto deity of the Usa region to a protector of Buddhism and the state.

Within a few years of his installation at Tōdai-ji Hachiman issued a second oracle that prevented the monk Dōkyō, confidant of Empress Kōken (r. 749–58 and 664–70), from assuming the imperial throne. This in turn contributed to his identification as a guardian of imperial legitimacy. Still later developments led to the belief that he was an incarnation of the legend-

ary emperor Ōjin, born to Empress Jingū after a successful military campaign in Korea. In time he became Japan's war god par excellence.[1] According to popular etymology Hachiman, literally "eight banners," refers either to the banners that floated down from heaven at his birth or to the banners carried into battle by warriors. This complex of beliefs informs the events recounted in the *Illustrated Legends of Hachiman* (J: *Hachiman Engi Emaki*).

The *Illustrated Legends of Hachiman* derives from a group of scrolls produced in 1433 by order of the shogun Ashikaga Yoshimasa and dedicated to the Usa, Konda, and Otokoyama Hachiman Shrines. Of the three works, only the Konda version survives. The handscroll exhibited here resembles the Konda version in its depiction of Empress Jingū's invasion of Korea and the founding of the shrine at Usa. Their final episodes differ, however, with the Tōdai-ji scroll, appropriately, representing Hachiman's progress from Usa Shrine to Tōdai-ji. This culminating episode is the scene reproduced here. The five episodes of the first roll show Jingū being blessed for safe passage to Korea by the sea-god Sumiyoshi Myōjin, and receiving from an incarnation of the deity Kashima Myōjin "high and low tide gems" that contributed to her victory by enabling her to

control the tides. The second roll, in six episodes, shows Jingū returning to Kyushu and giving birth, after a miraculous twelve-month gestation, to the future emperor Ōjin; eight banners falling from heaven; the construction of Usa Hachiman Shrine, the courtier Wake no Kiyomaro escaping from his political opponent Dōkyō through the intercession of the Usa Hachiman; and the Usa Hachiman approaching Tōdai-ji.

From the colophon by Sanjōnishi Sanetaka (see Essay 3 and no. 47, n. 2) at the end of this handscroll we know that the scroll was dedicated to the Treasure Hall (J: Hōden) of the Tōdai-ji Hachiman Shrine on the fifteenth day of the eighth month of 1535. The painter was Sōken and the calligrapher Sanetaka's son, Nishimuro Kōjun. Patronage for the work was organized by Tōdai-ji's solicitor, Yūzen.

Yūzen, who also commissioned the *Illustrated Legends of the Daibutsu* (no. 47), was a dedicated and highly successor fund-raiser for Tōdai-ji and other Nara temples. Little is known of his background, but like Chōgen, the most famous of the Tōdai-ji solicitors, he is believed to have been affiliated with the Pure Land school of Buddhism. Inscriptions by his followers within his portrait statue in Saihō-ji, dedicated in 1556, four years before his death, confirm that he was a devotee of Amida.[2] Yūzen's efforts brought together Emperor Go-Nara, Sanetaka, and Nishimuro Kōjun as patrons not only of calligraphers of the Tōdai-ji scrolls illustrated here but also of the *Taima-dera Engi*, a twenty-roll handscroll of temple legends completed in 1531. This lengthy work was painted under the direction of Tosa Mitsushige by Sōken and other members of the Nara painting ateliers.

Nothing is known of Sōken other than his work on the *Taima-dera Engi* and the present scroll. Like his contemporary, Rinken, who apparently collaborated on this scroll, he was unquestionably influenced by the Tosa painting style, whose courtly values he incorporated into explicit, readily comprehensible narrative compositions. The colorful pageantry and attention to anecdotal detail in the processional scene illustrated here are characteristic of both rolls of this handscroll. LEM and CMEG

1. For a fuller account of the development of the Hachiman cult, see Kanda, *Shinzō: Hachiman Imagery and Its Development*, pp. 35–46.
2. For a reproduction of this statue and discussion of Yūzen's activities, see Kawahara, "Yūzen to Rinken," pp. 150–54.

50

Illustrated Legends of the Thunderbolt Deity (J: *Shūkongō-jin Engi Emaki*)

Handscroll in three rolls; ink and colors on paper
(Roll 1) H. 33.9 cm. L. 133.9 cm.
(Roll 2) H. 33.9 cm. L. 92.5 cm.
(Roll 3) H. 33.9 cm. L. 113.1 cm.
Muromachi period, late fifteenth century

Sʜūᴋᴏɴɢō-ᴊɪɴ (S: Vajradhara or Vajrapāni; Thunderbolt Bearer) was High Priest Rōben's personal deity. A painted clay statue of this fierce divinity, thought to have been made in 733 for Rōben, is still kept in a closed cabinet in Tōdai-ji's Sangatsu-dō. During the tenth-century Taira Rebellion the statue is said to have come to life and fought alongside imperial guards. A ribbon from his headdress, miraculously transformed into a swarm of angry bees, attacked the insurgents and spoiled their aim, insuring imperial victory. Afterward, astonished monks discovered the statue in its customary place in the Sangatsu-dō—sweating, wounded by arrows, and missing part of its headdress. Thus the statue acquired its popular name of Hachi no Miya, the Bee Prince. *Illustrated Legends of the Thunderbolt Deity* depicts this dramatic tale, along with other scenes in which the deity's exploits abet the monk Rōben's accomplishments.

The section reproduced here, from the first scroll, shows distinct episodes of Rōben's life against a common background. From right to left we see the infant Rōben in the shelter of a hollow tree, guarded by the eagle who raised him in the wilderness; his lifelong protector, the Thunderbolt Deity, standing beside a table that holds rolled sutras; and Rōben as a young man kneeling in prayer, with beams of light emanating from his clasped hands. In the succeeding portion of the scroll these beams are shown reaching the imperial palace, where they attract the attention of Emperor Shōmu and his court (roll 1, scenes 2 and 3).

In style the *Illustrated Legends of the Thunderbolt Deity* is more gentle and harmonious than the later *Daibutsu* and *Hachiman* scrolls (nos. 47, 49). Landscape is described in loose, sweeping brushstrokes, with broad, fluid contour lines

defining hills and river banks. In sharp contrast to the saturated pigments of the Tosa style, colors here are much diluted and applied with a light touch. These characteristics foreshadow the refreshing blend of courtly and popular painting styles perfected in the early seventeenth century by Tawaraya Sōtatsu (act. c. 1600–1640) and his followers. *Illustrated Legends of the Thunderbolt Deity* shows a particularly strong resemblance to Sōtatsu's *Illustrated Tale of the Poet-Monk Saigyō* (J: *Saigyō Monogatari Emaki*) of 1630.[1] Sōtatsu copied that work after a scroll that was roughly contemporary with the *Illustrated Legends of the Thunderbolt Deity* and also painted by an artist working outside the orthodox mainstream.

Sōtatsu and his followers were in fact familiar with this or another version of the *Illustrated Legends of the Thunderbolt Deity*. Whole scenes, clusters of figures, and even architectural details in these scrolls served as models for fan and screen paintings by Sōtatsu and his workshop and even by Ogata Kōrin (1658–1716).[2] The dramatic first scene of roll 1, showing previous incarnations of Emperor Shōmu and Rōben in a small boat tossed by stormy waters, was especially appealing to these seventeenth-century painters.

A sheet of paper attached to the third roll records that restoration work was done on the scroll in 1682, but there is no direct evidence for its original date of execution or for the artist's identity. It must, however, postdate an *Illustrated Legends of Tōdai-ji* (J: *Tōdai-ji Engi Ekotoba*, in twenty rolls) produced in 1337, since many of its scenes were copied directly from this work. Additionally, a Tōdai-ji Shūkongō-jin picture scroll is mentioned in two court diary entries for the eighth month of 1491: the senior high priest Jinson (Jinson Dai Sōjō of Kōfuku-ji, Nara) and the courtier Sanjōnishi Sanetaka (see no. 47) both record that Emperor Go-Tsuchimikado looked at a Tōdai-ji Shūkongō-jin picture scroll in three rolls and that he had Sanetaka read him the texts. Assuming, as is likely, that the scroll exhibited here is the one mentioned in these diaries, its execution must antedate the year 1491. It is believed that the scroll was produced in the latter half of the fifteenth century to aid monks in fund-raising on behalf of Tōdai-ji and that the painter was a member of a Nara Buddhist atelier.
LEM and CMEG

1. For reproduction of the *Saigyō Monogatari Emaki*, see *Nihon Emaki Taisei*, vol. 26.
2. These scenes are discussed and reproduced in Yamane, "Shūkongō-jin-e Yori Toritsuke Shita Mono," pp. 81–85.

51

Hauling the Rainbow Beams for the Daibutsu-den

By Kokan (1652–1717)
Handscroll; ink and light colors on paper
H. 29 cm. L. 956.5 cm.
Edo period, 18th century

Tʜᴇ pair of folding screens showing the *Consecration of the Daibutsu and Daibutsu-den* (no. 52) record in frozen tableau and with appropriately rich color and glitter the pomp of official ceremonies. Here, however, the painter-monk Kokan gives us people stripped to the waist and straining, inching the huge timbers for the hall toward the construction site. It is in all ways a very different kind of picture.

The two rainbow beams (so called for their slight arch; J: *kōryō*) run north-south through the Daibutsu-den, providing its main horizontal support. They are gigantic pines, each measuring 13 *ken* (about 23.5 meters) in length and together weighing 1,600 *kan* (6,000 kilograms). Even in the eighteenth century the Home Provinces afforded no such timbers; these trees were felled on Mt. Shiratori in distant Hyūga Province on the island of Kyushu (in what is now Kirishima Park in Miyazaki Prefecture).

In the sixth month of 1704 the timbers left Kagoshima Bay in southern Kyushu for Osaka, the port nearest to Nara. The Kyushu shipper, one Shibushi Yagorō, had a formidable task to secure such gigantic logs to the deck of his ship. At Osaka the pines were offloaded and hauled up the Yodo River by trackers to the town of Kizu, then pulled overland across Hannya-ji Slope, finally to arrive at Tōdai-ji in the ninth month of 1704. It is said that two to three thousand laborers were mobilized daily for the overland leg of the trip. In addition, volunteers came from all over the surrounding countryside to help pull, inspired by religious sentiments much like those that motivated

51

medieval Parisians to harness themselves to the giant building blocks of Notre Dame.

Kokan's handscroll has no text; it captures the intensity, excitement, and exertion of the event with fluid, unconstrained brushwork. There is obvious humor, even caricature, in his rendering of the toiling pullers, excited bystanders, and elderly men venerating the great timbers. A delightful rhythm of alternating dark and light brushstrokes emphasizes the dynamism of the scenes.

Kokan (*gō* Koshū, *azana* Myōyo)[1] was a monk of the Pure Land (Jōdo) sect of Buddhism and is also known by his religious name, Chōrensha. He lived first at Saigan-ji in what is now Nara Prefecture, then became abbot of Hō-on-ji in Kyoto, and died in 1717 at sixty-five, leaving a considerable body of painting. His mastery of the brush is attested by his inclusion among the three great Jōdo-sect calligraphers of the Edo period. Thematically and formally, the hauling of the rainbow beams was a subject made to order for the painter-monk Kokan.　　LEM

1. Every person of consequence in traditional Japan acquired several names besides his surname and given name. These alluded to his qualities, interests, or accomplishments, and might be chosen by himself or bestowed by associates. One man might have many *gō* (studio names), and an artist might have an *azana* (artist name) as well. In addition, Buddhist clergy took religious names. Which name was used on a particular occasion depended on the social context.

52
Consecration of the Reconstructed *Daibutsu* and Daibutsu-den

Pair of six-fold screens; colors and gold leaf on paper
(Each screen) H. 159 cm. W. 362 cm.
Edo period, 18th century

IN 1567, during the "Age of the Country at War," Tōdai-ji was put to the torch for the second time in its history by vengeful warlords; over a century later the *Daibutsu* had still been only partly restored and stood forlornly open to the elements.

In 1684, the Tōdai-ji monk Kōkei (see no. 29) received the shogun's permission to solicit funds for reconstruction of the image and its hall. Immediately Kōkei set off for the provinces—on foot, with monk's staff, alms bowl, and a supply of printed solicitation leaflets in hand. Before he was done he had quartered Japan from northern Honshu to southern Kyushu, and his donors ranged from the shogunal family to the humblest in the realm. People called him "the Chōgen of the Edo period," and the appellation was well earned (see nos. 13, 28).

Work on the *Daibutsu* began in 1688, and in 1692 a temporary wooden roof was built over the image and a grand "eye-opening ceremony" (J: *kaigen*) (see no. 2) was held. Reconstruction of the hall proceeded apace, continuing after Kōkei's death in 1705 under the supervision of his disciples Kōsei and Kōshun. Finally, in 1709, the new Daibutsu-den was dedicated.

The screen illustrated at the top depicts the "eye opening" and the screen below the dedication of the Daibutsu-den. Monuments of Tōdai-ji's early modern history, the screens are most artfully composed. The "eye-opening" screen enhances the prominence of the *Daibutsu* by showing it centered and from an aerial perspective, the focus of everything around it, while the Daibutsu-den screen shows the hall from a greater distance, securely and spaciously enfolded within surrounding verdant countryside. The screens, which show the surrounding cloister, the Inner Gate (J: Chū-mon) and the east and west "Music Gates" (J: Gaku-mon), built in 1716, 1717, and 1722, respectively, appear to have been executed after 1722.[1]
LEM

1. The appearance of the Music Gates establishes a terminus post quem; the style of the dress suggests a terminus ad quem.

53
Sutra of Wise Men and Fools
(J: *Kengu-kyō*), Chapter 15
Handscroll; ink on paper
H. 27.8 cm.　L. 1,203 cm.
Nara period, 8th century
National Treasure

THIS sutra expounds the Buddhist teaching through parables of wise men and fools. Translated from Sanskrit into Chinese by the monk Hui Jue in the third century, it reached Japan via Korea in a version of sixty-two

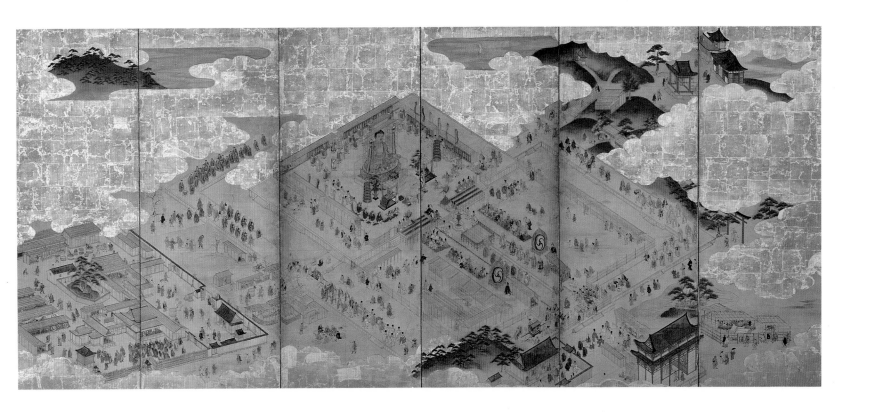

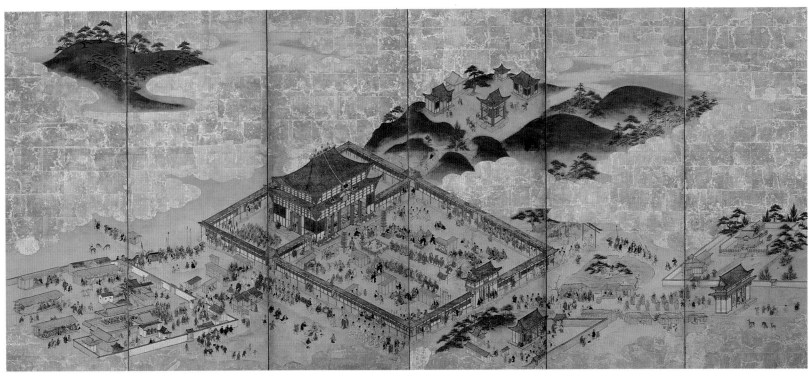

52

chapters. Another version in sixty-nine chapters, current in China between the tenth and seventeenth centuries, was probably a later (Sui–Tang period) recension.

The calligraphy is in the regular mode (J: *kaisho*; C: *kai shu*) mandatory for Buddhist scriptures during the Nara period. It is not, however, written in a precise copybook hand with emphasis on meticulous uniformity and grace. Rather, the large, heavily inked, emphatic characters show considerable vigor, individuality, and rough freedom. Emperor Shōmu, whose Buddhist zeal greatly shaped Japanese life in the mid-eighth century, is traditionally credited as its calligrapher: this handscroll is popularly called "the Great Shōmu." In fact, the scroll may have been imported from China, or it may have been produced in Japan by immigrant Chinese scribes working in a scriptorium attached to the palace or to one of the great temples. Whichever the case, this relaxed version of the regular mode had appeared in Japan by midcentury. There it exerted a major influence on subsequent calligraphy, displacing as a model the more delicate and uniform style credited to the Chinese patron saints of calligraphy, Wang Xizhi and his son Wang Xianzhi (both of the fourth century).

We see this same generous scale and sense of informal ease in scriptures copied during the late eighth century, such as the *Dainichi-kyō* (S: *Mahāvairocana-sūtra*) at Saidai-ji (Nara) and the *Greater Sutra of the Perfection of Wisdom* (J: *Daihannya-kyō*; S: *Prajñā-pāramitā-sūtra*) at Yakushi-ji (Nara). It is an indication of the dominance of this style that the Yakushi-ji scroll is traditionally called the *Gyoyō-kyō*, after Asano no Gyoyō, a minor official to whom much of the finest calligraphy of the later eighth century is popularly attributed.

To preserve the sutra from insect damage, particles of some aromatic wood were mixed into the white hemp (J: *haka mashi*) of which this paper was made. This scroll is said to have belonged originally to the Ordination Hall of Tōdai-ji.

54
Flower Garland Sutra (J: *Kegon-kyō*)
(Known as the Burned Scripture of the Nigatsu-dō)
Two fragments of a handscroll; silver ink on dark blue paper
H. 25.8 cm. L. 54.7 cm. and 55 cm.
Nara period, 8th century

LEGEND has it that the first hearers of the *Flower Garland Sutra*, preached by Shaka immediately after his Enlightenment, received its formidably abstruse subtleties with blank-faced incomprehension. It is historical fact that no Flower Garland school grew up in India. In China, however, the *Flower Garland Sutra* was

translated three times (see no. 56), and in Japan it became the doctrinal heart of Emperor Shōmu's Tōdai-ji.

The two fragments exhibited here come from the sixty-chapter version translated into Chinese in 418–20 by Buddhabhadra. Their calligraphy, in the regular mode (see no. 53), shows great precision, elegance, and verve; together with the sumptuousness of the ink and paper it suggests the work of an experienced scribe at a temple or palace scriptorium. No date has been ascertained for this copy, but it may have been commissioned as an offering for the *Kegon no Dai-e* (see Introduction, "Ceremonies and Art") first performed at Tōdai-ji by order of Emperor Shōmu in 744, or for the "eye-opening ceremony" (see no. 2) for the *Daibutsu* in 752.

On the thirteenth day of the second month of 1667 a fire broke out during the *Omizutori*, an annual purification ceremony held at the Nigatsu-dō to mark the end of the winter retreat. The Nigatsu-dō was destroyed and the copy of the *Flower Garland Sutra* that was kept there badly scorched, particularly the top and bottom edges of the rolls—hence the popular name "burned scripture of the Nigatsu-dō." In 1678 some restoration was done on the scroll, but it was later cut up and parts of it dispersed

among many private collections. Of the twenty rolls remaining in Tōdai-ji, all but two were once pasted to screens, but in recent years they have been designated Important Cultural Properties and restored to their original handscroll formats. The fragments exhibited here were never mounted on screens.

55
Precepts for Monks and Nuns
(J: *Mishasoku Komma Bon*)
Handscroll; ink on paper
H. 27.6 cm. L. 2,465 cm.
Nara period, 8th century
Important Cultural Property

As used in the title of this book, the word *komma* (S: *karma*; literally, deeds, actions) means the forms of everyday conduct proper for religiouses; in this sense it is the equivalent of *ritsu* (S: *vinaya*) (see no. 31). *Vinaya* codes of various Indian sects were translated into Chinese, among them the *Five-Part Vinaya* of the Mahāsāsakah school, translated into Chinese in 424 by the monk Buddhajiva. The *Mishasoku Komma Bon* (S: *Mahāsāsakah Karma Eva*) comprises extracts from the *Five-Part Vinaya*, plus extracts from various Indian commentaries (S: *sastra*) on the sutras, and explanatory notes added by the compiler, a Chinese monk of the Tang dynasty named Ai Tong.

In the copy exhibited here the extracts are written in large characters and the explanatory notes in small, a standard method of distinguishing text from gloss in premodern East Asia. There is a title and a subtitle, both reading "*Mishasoku Komma Bon*," and under the main title, written in black, "Recorded by the monk Ai Tong of Da-kai-ye Temple." The brushstrokes differ in quality between the first half of the scroll and second, going from stiff and hard to somewhat more relaxed. The tint of the yellow hemp paper, too, changes between sheets thirty and thirty-one. The present scroll, along with another *Komma Bon* in two rolls, is kept in a box made of paulownia wood. An inscription in black ink inside the box states that it was repaired and lined in 1811.

The scroll exhibited here is the oldest surviving manuscript of the *Mishasoku Komma Bon* and a valuable early source for the contents of the *Five-Part Vinaya*.

55

56
Flower Garland Sutra (J: *Kegon-kyō*)
Handscroll; ink on paper
H. 27.9 cm. L. 1,160 cm.
China, Tang dynasty, 9th century
Important Cultural Property

The *Flower Garland Sutra* was translated three times into Chinese by monks from India and Central Asia: in 418–20 by Buddhabhadra in a sixty-chapter version, in 695–704 by Siksānanda in an eighty-chapter version, and in 785–804 by Prajnā in a forty-chapter version which consists mostly of the story of Zenzai Dōji's search for Enlightenment (see no. 34). This section of the *Flower Garland Sutra*, formally called the *Gandhavyūha* in Sanskrit

and the *Dai Hōkō Butsu Kegon-kyō Nyūhōkai Bon* in Japanese, is popularly known by two shorter titles: the *Flower Garland Sutra of the Zhen Yuan Era* (C: *Zhen Yuan Hua-yan*, Zhen Yuan being the name of the Tang-dynasty reign-period in which it was translated), or the *Vows of Fugen* (S: *Samantabhadra*).

The roll exhibited here is the first of six remaining from a Tōdai-ji copy of the forty-chapter version. Judging from the calligraphic style, this roll and four of the others were produced in Tang-dynasty China. At the end of the first roll seventeen columns of text record the process of transmission of this forty-chapter version from India to China. This is followed by nineteen columns listing the names of those monks of the Chong-fu Temple in the Tang capital of Changan who assisted Prajnā in the work of translation. The final ten columns record the vow of Yuan Zhao, the scribe. Few sutra manuscripts have come down to us so thoroughly documented in all aspects.

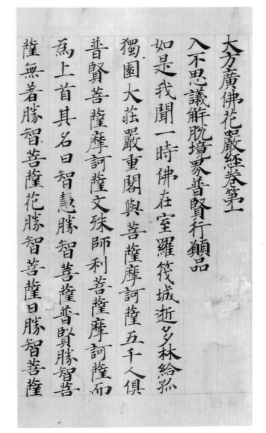

56

57

Flower Garland Sutra (J: *Kegon-kyō*)

Handscroll; gold ink on dark blue paper

H. 25.5 cm. L. 733 cm.

Kamakura period, 12th century

Important Cultural Property

THIS scroll is apparently the product of an imperial vow: in the third month of 1195, at the dedication ceremonies for the rebuilt Daibutsu-den,[1] Emperor Go-Toba (1180–1239; r. 1184–98) vowed to commemorate the event by "faithfully copy[ing] out in gold characters on dark blue paper the *Mahāvaipulya-avatamsaka-sūtra*."[2] The scroll exhibited here appears to be the first roll of that copy.

From China in the eighth century had come the custom of writing scriptures in gold or silver ink on dark blue or purple paper, and of ornamenting these handscrolls with frontispieces of deities and disciples similarly painted in metallic ink. Gradually the number and sumptuousness of such works increased, and the twelfth century saw many thousands of such lavish sutras commissioned, of which a fair number survive.

Painted on the outside cover in gold and silver ink is a decorative pattern of Chinese derivation: scrolling vines (J: *karakusa*) of imaginary flowers called *hōsōge* that are peculiar to Buddhist art. At the upper left on this cover are cartouches containing titles in Chinese, including "*Mahāvaipulya-Buddha-avatamsaka-sūtra*, chapter 1."

Directly preceding the text is a frontispiece, also in gold and silver. It shows Shaka on a pedestalled lotus throne, flanked by two bodhisattvas also on lotuses, preaching the Law to two monks and three aristocratic laymen. A background is barely suggested: bands of mist and clouds for the deities, tiny tree-clad hillocks for the mortals. Other illustrations in the same style ornament later sections of the sutra. Compared with many sutra illustrations of this period, which were often mass-produced and therefore stiff and lifeless, the illustrations to this chapter show strong brushwork and a vital calligraphic style.

The text of this copy is the eighty-chapter version of the *Flower Garland Sutra*, translated into Chinese from Sanskrit at the very end of the seventh century by the Khotanese scholar-monk Siksānanda. It expanded upon a sixty-chapter version translated by the monk Buddhabhadra in the fifth century, and for that reason was often called the "new *Kegon-kyō*."

In this copy the sutra itself is preceded by the *Preface to Sage Teaching*, composed by the Chinese empress Wu Zetian (r. 690–705).[3] At the end of the forty-eighth chapter, written in the same hand as the text, are the words "edited and presented by the sutra master Faqiao Liangyan."[4] Seventy-two of the chapters bear "proofreader's" notations, such as "corrected" or "corrected and completed," also in gold ink but in a different hand.

1. Erected under the supervision of the monk Chōgen to replace the original, burned in 1180 by Taira forces (see nos. 13, 28).

2. Although Go-Toba undoubtedly referred to the sutra by its Japanese or Chinese title, the more familiar Sanskrit is given here.

3. The only woman in Chinese history to seize the throne and declare a new dynasty (which she maintained against all comers till the age of eighty), Wu Zetian was also an ardent patron of various forms of Buddhism, including Hua-yan (J: Kegon).

4. The sutra master's Chinese name would seem to indicate that the supervisor of the scriptorium, who was also the copyist, was an immigrant Chinese monk.

58

Manuscripts in the Tōdai-ji Archives

A. Handscroll 15: Letter donating land to Tōdai-ji

Ink on paper

Kamakura period, 1250

B. Handscroll 43: Copy of the Kanzeon-ji charter incorporating references to its status as branch temple of Tōdai-ji

Ink on paper

Kamakura period (?)

Important Cultural Properties

IN 1886 Tōdai-ji's existing documents were mounted into ninety-six handscrolls collectively entitled the *Tōdai-ji Seikan Monjo* (*Tōdai-ji Archives*). Though numbering only ninety-six scrolls, the collection was commonly called the Hundred-Scroll Tōdai-ji Document Collection. In 1953 one scroll was removed from the collection and five others added, for a veritable total of one hundred scrolls, and the collection was given Important Cultural Property status in 1961.[1]

The hundred scrolls comprise 1,026 documents, ranging in date from the Nara through the Muromachi periods. Some of these are public documents pertaining to Tōdai-ji, such as official decrees (J: *kansenji*) or imperial instructions (J: *migyōsho*); some record private transactions, such as personal contracts or grants or commendations of land to the temple; some are documents pertaining (and originally belonging) to other temples, such as the Tendai temple Kanzeon-ji (Fukuoka Prefecture, Kyushu) and the Sanron temple Gangō-ji (Nara). Together with two other document collections at Tōdai-ji, the *Seikan Monjo* offers a wealth of data to historians.[2]

Scroll number 15, dated to 1250, commends to Tōdai-ji one *chō* (2.5 acres) of irrigated land in Yamato Province to pay for an eternal lamp to stand near the Kannon image adjacent to the *Daibutsu*. Though the donor, Utsunomiya Yoritsuna, with conventional humility styles himself "the *sramana* (J: *shami*; novice or devotee) Lotus Born," he was in fact one of the powerful vassals of the military government; his grandfather had donated the Kannon image.

Scroll number 43 came originally from Kanzeon-ji, built near government headquarters in Kyushu under auspices of Emperor Tenji (r. 668–71). After functioning for many decades almost as a branch temple of Tōdai-ji, it formally assumed that status in 1120. At that time its ancient charter was rewritten to incorporate references to Kanzeon-ji's new status, and a copy of this amended charter was placed in Tōdai-ji's archives. We do not know the exact date when this copy was made nor when it entered the Tōdai-ji collection, but presumably it was not long after 1120. The odd calligraphy, with its reversed slant, may reflect a provincial scribe.

1. The scroll that was removed from the collection is a Nara-period register of slaves belonging to Tōdai-ji. This scroll enjoys independent Important Cultural Property status.

2. The two other collections are a group of incomplete documents and the documents of

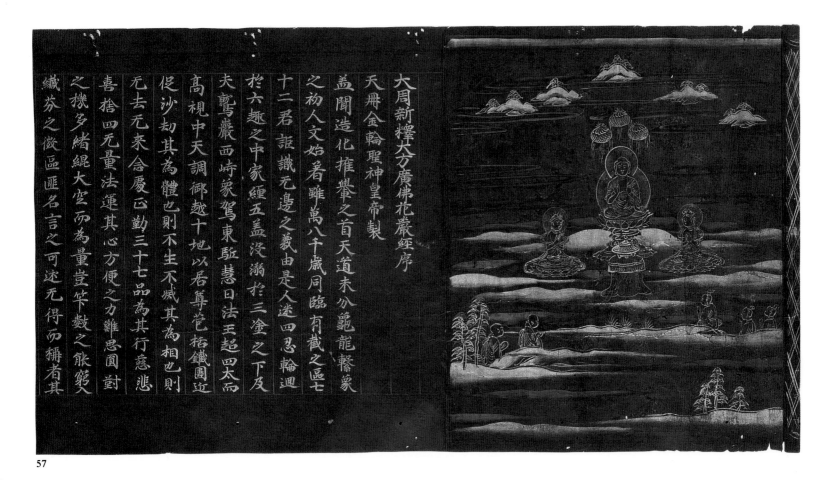

57

the Tōnan-in subtemple of Tōdai-ji. These two collections were donated to the Imperial Family in 1874 and are now stored in the Shōsō-in.

59
Registry of Deceased Persons Commemorated at the Nigatsu-dō Shunigatsu-e Ceremony (J: *Nigatsu-dō Shūchū Kako-chō*)

Handscroll; ink on paper
H. 28 cm. L. 3,436 cm.
Muromachi period–Edo period, early 16th–end of 17th century

THE Nigatsu-dō *Shunigatsu-e* is a group of prayers and rituals soliciting peace and prosperity for the nation and well-being for all sentient creatures; it includes the offering to Kannon known as *Omizutori* (see Introduction,

"*Omizutori*"). Tradition has it that the *Shunigatsu-e* was instituted by the monk Jitchū, Rōben's leading disciple, in 752, the year in which the *Daibutsu* and Daibutsu-den were consecrated and in which the Nigatsu-dō is said to been completed. Every year, on the fifth and twelfth days of the second month, as part of the *Shunigatsu-e*, the names of deceased monks and lay persons significant in Tōdai-ji's history are read aloud and prayers are offered for them.

We know that such a necrology existed at least from the beginning of the twelfth century, because from that time the *Daily Record of the Congregation of the Nigatsu-dō Shunigatsu-e* names the monks who read it aloud each year. But the *Registry of Deceased Persons* currently used for the ceremony is about a century and a half later, from the reign of Emperor Go-Saga (r. 1242–46), and doubtless it differs somewhat from the earlier and no longer extant registry. The registry in current use at Tōdai-ji bears

58

59

cantorial notations, so that the text can be chanted aloud up to the words "Hail to Master Kanjin [sic; this is *not* the monk Ganjin] founder of Tōdai-ji! Hail to Amida Buddha!" The remainder of the text is recited at speed. It has always been customary for devotees making a five-year retreat to recite the *Registry* aloud during the *Shunigatsu-e*.

Physically, the handscroll exhibited here consists of ninety-one sheets. The first fifty are thick mulberry (J: *kōzo*) paper, bearing fourteen columns of text per page; these are considered to date to the early sixteenth century. The remainder of the pages are a more lustrous paper called *torinoko*, with seventeen columns of text per page, and are thought to date to the very end of the seventeenth or beginning of the eighteenth century.

This handscroll lacks cantorial notations but is said to include the earliest names that were chanted aloud during the Nigatsu-dō *Shunigatsu-e*. Beginning with Emperor Shōmu and his mother, the recorded names span almost a millennium—from the founding of Tōdai-ji in 752 to the year 1694. They offer a rich lode of information to historians of Tōdai-ji and of Japan.

Decorative Arts

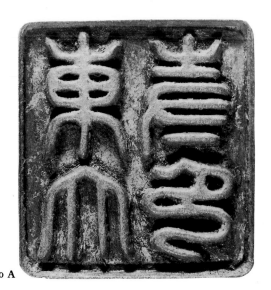

60 A

some scriptures imported from China; and a third type on various secular documents pertaining to the administration of Tōdai-ji. These imprints differ not only from each other but from that of the seal exhibited here. The seals that made them were probably destroyed in the conflagration of 1180 (see nos. 13, 28).

The "Tōdai-ji" seal with pierced, flange-shaped handle is of copper, with its inscription cast in relief. The handle is pierced for hanging from a cord. Like the lost seals whose imprints appear on the documents mentioned above, its inscription is square and its casting of high quality.

B
"Sonshō-in" seal

Sonshō-in

Copper

H. 6.2 cm. Seal face 5.5 cm.

Late Heian period, 12th century

TŌDAI-JI'S Sonshō-in was founded in the tenth month of 956 by the temple steward and became Tōdai-ji's leading subtemple under the patronage of Emperor Go-Murakami (r. 1339–68). The "Sonshō-in" seal, like the "Tōdai-ji" seal, is finely cast of copper, with the characters in relief. Its knob is also flange-shaped but is unpierced, with the word "top" incised onto its base. It is older than the "Tōdai-ji" seal, probably dating from the Heian period.

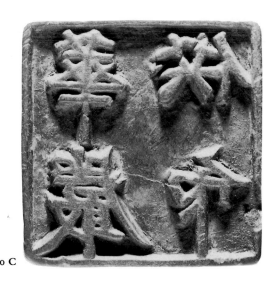

60 C

60
Official Seals of Tōdai-ji

A
"Tōdai-ji" seal

Copper

H. 5.5 cm. Seal face 5.9 cm.

Kamakura period, 12th or 13th century

THE characters carved in relief on the "Tōdai-ji" and "Sonshō-in" seals are in the archaic "small seal" script, so called precisely because it has continued in general use for seals even to the present day. Standardized in China during the Qin dynasty (221–207 B.C.), it has not been used for ordinary writing or even printing for nearly two millennia, but its somewhat ponderous, archaic look is considered to enhance the dignity of the person or institution on whose seal it appears. The use of seals and of the seal script as insignia of persons or institutions of consequence came to Japan from China by the sixth century.

Temple seals are first mentioned in the *Shoku Nihongi*, an official chronicle of the years 700–90. There an entry for the eighth month of 771 says that temple seals were distributed to twelve major temples, including Tōdai-ji and Daian-ji. Three different "Tōdai-ji" imprints are extant on Tōdai-ji documents of the Late Nara period: one on a scripture vowed by Empress Kōmyō (701–60) (see no. 31) in the twelfth year of the Tempyō reign-period (729–49); one on

C
"Kegon-ku" seal

Sonshō-in

Wood

H. 5 cm. Seal face 4.5 cm.

Kamakura period, 12th or 13th century

THE "Kegon-ku" seal, also handed down in the Sonshō-in, is much different from the other two. It is thicker bodied and made of wood, and instead of archaistic small seal characters uses a contemporary script style. Its inscription is also in relief but much shallower than on the two copper seals. The knob handle bears a carved ladder pattern with the world *top* in relief on the front and the name *Rōben* (see no. 27) incised on the back. A Late Nara-period text preserved at Tōdai-ji (the *Kegon Ryakuso Kanjo Ki*) bears a vermilion "Kegon-ku" seal, but the imprint differs from that of the seal exhibited here, which was probably made during the reconstruction following the 1180 fire.

The *Kegon-ku* was a Buddhist ceremonial gathering for the study of the *Kegon Sutra*, founded in 740 with monk Rōben as its chief sponsor and continued at the Sonshō-in after that subtemple was founded in 956.

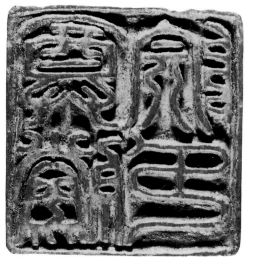

60 B

61
Ritual Objects Buried at the Building Site of the Daibutsu-den

Nara period, 8th century
National Treasures

IN Japan, as elsewhere, the practice of sanctifying a structure by burying offerings at the site is of ancient date. The traditional Japanese offering comprised the five grains (a category of Chinese origin that included rice, wheat, soybeans, and two kinds of millet) and the "seven treasures" (J: *shippō*, an auspicious emblem of Buddhist origin, including gold, silver, pearl, lapis lazuli, agate, coral, and either rock crystal, amber, or carnelian).

The objects pictured here are thought to have been part of a set of *chindan-gu*, literally, "instruments to charm the spirits of the dais." In other words, these were apotropaic offerings, interred in the earthen platform beneath the altar during the consecration ceremony of

the original Diabutsu-den in 752 to appease the spirits that may have been disturbed during the building of the hall. They were excavated from points north, south, and southwest of the building during its 1907 and 1908 restorations. Included among the finds were a small silver and parcel-gilt jar with a design of a hunting scene; a six-lobed bronze mirror; a silver and parcel-gilt cicada-shaped lock; fragments of a lacquered box made from animal hide; rock crystal, amber, and glass beads; gemstones; sword mountings of different types; and fragments of armor—fifteen objects in all.

Another important assemblage, comprising over forty items, was found at the site of Kōfuku-ji's *kondō* (image hall) in the late nineteenth century, among which a mirror, beads, and three types of swords resemble the roughly contemporary items excavated at Tōdai-ji. Finds of *chindan-gu* have provided us with information about certain types of objects that might otherwise be unknown.

A
Small jar
Silver and parcel gilt
H. 4.2 cm.

THE tiny covered jar is finely made of cast silver that was finished by turning on a lathe. Its shape is that of a medicine jar. Around the body of the jar, mounted huntsmen with bows and arrows pursue three deer and a wild boar in a landscape suggested by flowering plants and rock formations. Ultimately this theme derives from Sasanian Persian silver vessels, whose influence on Chinese art of the Tang dynasty is as patent as the influence of Tang art on Nara-period Japan.

These designs have been gilded to contrast strikingly with the hammered silver ground of *nanako* circle patterns (cf. the ablution basin, no. 2). The lid is decorated with grasses, unusual rock or mountain forms, birds, and bands of beading—all gilded—with a flattened

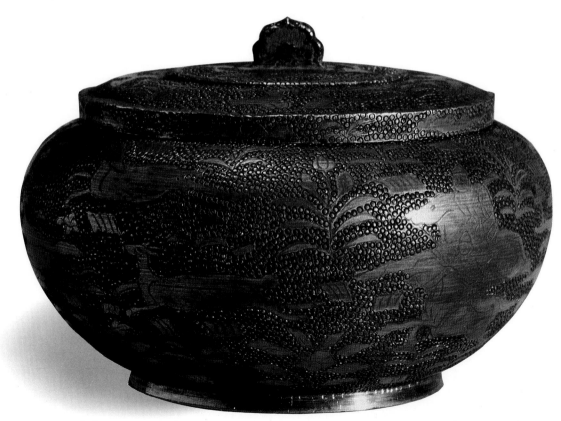

61 A

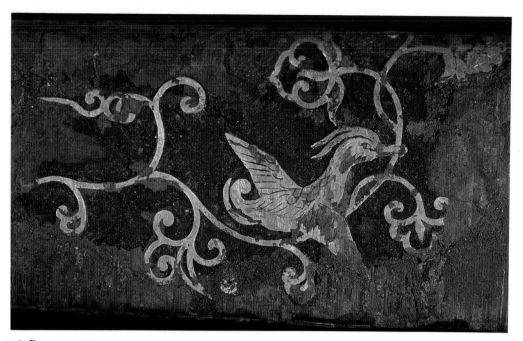

61 B

upright flame-shaped handle in the center. Pearl and crystal *tama* (jewel beads) were found in the vessel at the time of its excavation, and near it were discovered two crystal boxes with covers.

B
Sword mounting decorated with gold inlay
L. 97.8 cm.

MOUNTINGS from at least six swords were excavated from the building site, including some inlaid with gold, silver, and gilded silver. The best preserved come from two long, straight swords of the early native type (one of which is shown here) and from one so-called Tang Chinese type, a shorter and wider weapon.

The mountings for the two longer, Japanese swords were similar in design and decoration. In the example pictured, the hilt is deteriorated, but its milk-white agate pommel, surrounded by openwork metal arabesque designs, is well preserved. An unbanded cylindrical cap, made of gold openwork in the same arabesque design, forms the point of the scabbard. All that remains of the hilt are inset round glass rivet beads. The scabbard is beautifully ornamented with arabesques inlaid in low relief and

two beads of glass set in a raised pillow of scrollwork, attesting the fine workmanship and elegant design of the original weapon.

On the lower scabbard area of the Chinese style sword mounting (not exhibited), extant areas of cut gold foil inlay (J: *heidatsu*) show birds plucking at scrolling vines (J: *karakusa*), and the point of the scabbard is a finely executed openwork metal design of heart-shaped scrollwork, leaves, and flowers.

C
Cicada-shaped lock
Silver and parcel gilt
L. 3.5 cm.

AN exquisite and unusual lock in the shape of a cicada on an openwork flowering scroll was discovered during the 1907 excavation of the Daibutsu-den site. The cicada itself is made of cast silver with parcel gilt; it rests upon a silver openwork base of *hōsōge* flowers and tendril-like leaves. A newly made key, inserted between the insect's bulging eyes, can open the lock. Since the openwork base divides into two parts, with a silver pin on each, we believe that these pins attached the upper portion to the lid and the lower to the body of a box. Only when

the lock was opened and removed could the box be opened. It is thought that this lock originally pertained to the lacquered hide box with finely painted floral designs, whose remains were found adjacent.

D
Six-lobed mirror
Copper alloy
D. 9.2 cm.

MIRRORS have been made continuously in Japan from the Tumulus period, although many of the early extant examples are Chinese imports. They were imbued with religious and magical significance and were used in both Buddhist and non-Buddhist ceremonies. As elsewhere in the ancient world, they were made of cast metal, with the face polished and the back decorated with designs modelled in the surface of the clay or sand mold.

This small, six-lobed mirror from Tōdai-ji was cast in white bronze, a copper alloy high in tin which was highly reflective and therefore favored for mirrors. On the back a simple

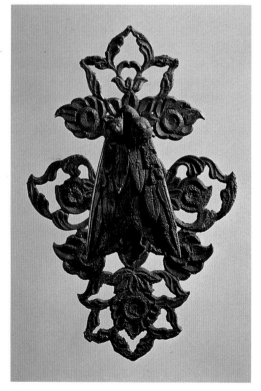

61 C

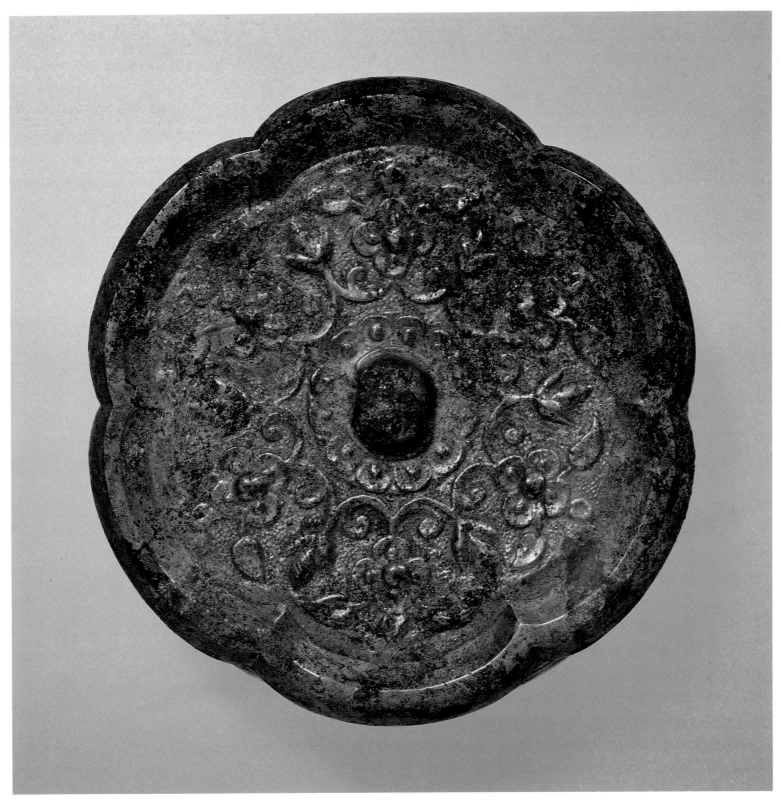

61 D

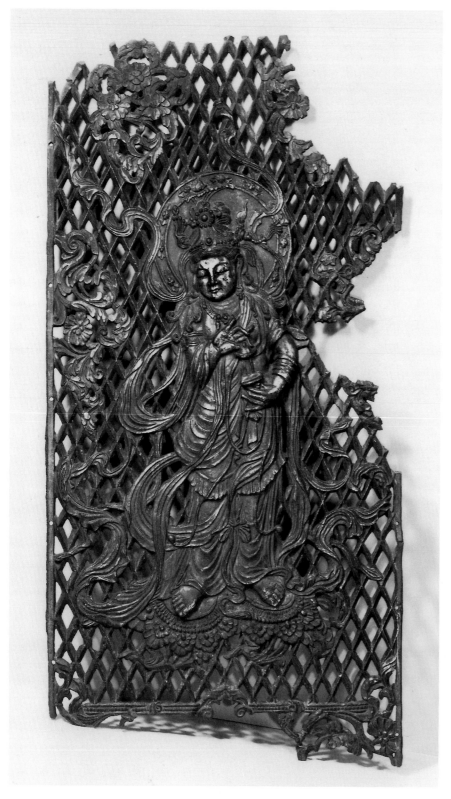

hammered knob is framed by a lotus pillow motif. This in turn is encircled by a floral arabesque — a four-petaled "auspicious flower" (J: *hōsōge*) in the center of each lobe, with a budding vine connecting the flowers. The finely dotted ground pattern was created by using an especially sandy paste for the mold. Along the edge of the mirror three bevels accent the lobed shape. Mirrors with similar designs are in the Shōsō-in and other collections. CJB

62
Panel from the Fire Chamber of an Octagonal Lantern

Daibutsu-den

Gilt bronze

H. 101.7 cm. W. 51.3 cm.

Nara period, 8th century

National Treasure

(See also frontispiece)

A magnificent octagonal lantern stands in front of the Daibutsu-den as a symbol of the Buddhist light that has been transmitted through the ages. Four celestial musicians, three playing woodwinds, occupy alternate panels of the large cast-bronze fire chamber. The fourth, shown here, is a cymbalist, who with half-closed eyes and faint, rapturous smile is about to strike a pair of hand cymbals.

The lantern was erected in the latter half of the eighth century, perhaps just after the *Daibutsu*. Despite damages sustained over the centuries, particularly during the two conflagrations of the Daibutsu-den, its four figured panels still retain traces of their original gilding and convey an accurate impression of their original style.

The four divine musicians belong to a heavenly host of "music and voice bodhisattvas" (J: *onjō bosatsu*; S: *gandharva*) who attend the Buddha. They stand with a lotus blossom under each foot, their scarves and ribbons fluttering to the sides as if the figures were in motion. For background, each has an open-work grille of bevelled diamond shapes, which allows the light of the lantern to shine through. Over the angular geometry of the grilles are superimposed scrolled cloud and lotus forms;

62

these frame the figures and are organized into scalloped bands of curving pattern at the top and bottom of each panel.

Each of the four panels without musicians is actually a pair of hinged doors, beautifully decorated at the center where they open. At the top and bottom of each door, cast in somewhat higher relief than the musicians, is a lion. Their teeth are bared, their heads project in high relief from the panel surface, and they appear to ride on arabesque clouds. Beneath each of the eight panels are lions running in various poses. Each musician panel and each door was cast as a single piece.

The lantern stands 462 centimeters high and is topped with a wish-granting gem (J: *hōju*) set against a flame-shaped openwork design. The fire chamber rests on a broad, eight-sided, bronze-plated base decorated with incised floral scrolls, "auspicious flowers" (J: *hōsōge*), music and voice bodhisattvas—all incised on a ground

of hammered circle pattern (J: *nanako*). It is surmounted by a roof with eight sloping rafters that curl up fiddlehead style at the tips. Above and below the eight-sided stone support post are lotus flowers—a single flower between the base of the fire chamber and a half-inverted double flower between the bottom of the post and the base. The post bears a lengthy inscription. The panel exhibited here is missing its lower edge, on which the word *west* is recorded to have been inscribed—undoubtedly indicating the direction in which this panel faced when the lantern first stood in front of the hall.

The divine musicians are generously modelled, with plump bodies and faces, full, sweet lips, and ingenuous expressions, rather resembling the *Shaka at Birth* (no. 2). This ideal of beauty is commonly seen in the art of eighth-century (Tang) China, which exerted a profound influence in contemporary Japan. As befits bodhisattvas, the musicians wear crowns, jewelry, and scarves. Their hair is long, and their nimbuses have floral rims. All these details have been cast with great care and skill, making this lantern one of the finest examples of metalwork from the Nara period. CJB

63

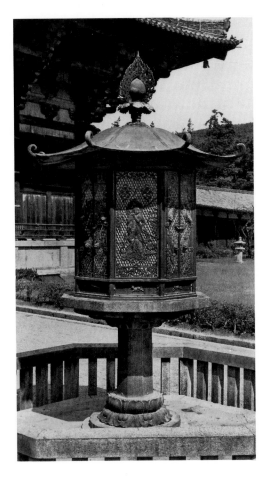

63
Mirror with Sea Creatures, Birds, and Grapes
Bronze
Diam. 13.4 cm. D. 1.2 cm.
Late Nara period, 8th century

THE decoration on the back of this cast-bronze mirror is divided into two concentric circles and an outer band. At the center is an animal-shaped knob and around it five sea creatures (perhaps fabulous, perhaps stylized otters) encircled by grape clusters and vine-scrolls. In the outer circle are seven birds with outspread wings and more grape clusters. Abbreviated cloud motifs fill the band at the rim. The same motifs, similarly disposed, adorn a splendidly cast square mirror in the Shōsō-in and are also found on a great many Chinese mirrors of Tang date.

Since the bronze of this mirror is rather thin and the design rather indistinct, and because other mirrors with this design have been

excavated at the ports of Osaka and Okayama, it is thought that this mirror was cast in Japan in a mold made locally from an imported Chinese mirror.

Originally this mirror was inlaid at the center of a lotus-flower canopy suspended from the ceiling of the inner sanctuary of the Sangatsu-dō. In 1900 it was taken out to be repaired, and since then it has been preserved separately.

64
Mirror with Celestial Beings and the Twelve Animals of the Zodiac
Bronze
Diam. 14.5 cm.
Late Nara period, 8th century

THREE concentric squares, centered on the knob handle, divide the relief decoration of this round mirror into four zones. On the inner-most square is a wave pattern, in the middle one a stylized design of sprouting seeds, and in the outermost the twelve animals of the zodiac. A celestial being of the Buddhist paradise (J: *hiten*; S: *apsarā*) occupies each of the four outer arcs. This decor is most unusual, although a Tang-dynasty mirror with the same design has been excavated in China.

The mirror exhibited here is made of thin, poor-quality bronze, and the relief pattern does

64

ground. Abrasion has destroyed parts of the design on this hide.

Three themes, each occupying two rectangular areas, make up the allover design. On the longer arm of the cross strongly geometricized arabesques (J: *karakusa*) of grape vines bearing leaves and bunches of grapes fill the two largest rectangles—a motif borrowed from Tang China and common to much Nara-period art in various mediums. Adjacent to the arabesques are narrower panels showing semi-naturalistic seascapes. Here jagged crystalline rocks, depicted in flat outline with no sense of volume, emerge from eddying waves whose swirl seems to echo the arabesque of the grape vines. Highly stylized clouds float in the sky,

and sea birds fly among the clouds and perch on the rocks. Similar scenes decorate the backs of contemporary bronze mirrors now kept in the Shōsō-in.

At each end of the shorter panel of this cruciform hide, two figures in a landscape flank a large gnarled tree. Behind each of the figures is a wooded mountain, represented in the same flat, crystalline fashion as the rocks in the seascapes. On the right a bearded hermit plays the *koto* (C: *qin*; a kind of zither) while an aristocratically dressed man sits at ease, listening. Stylized clouds like those in the seascapes float overhead, and in the disk representing the sun is the three-legged crow that (according to Daoist myth) lives in the sun. On the ground

not stand out clearly, suggesting that it was cast in Japan after a Chinese original.

Like number 63, this mirror was inlaid at the center of a canopy flower in the ceiling of the Sangatsu-dō.

65
Patterned Deer Hide
L. 76.7 cm. W. 66.7 cm.
Nara period, 8th century
National Treasure

THIS cruciform piece of leather has been cut from a single hide so as to form an envelope for a rectangular box, probably a sutra case (J: *kyō-bako*) or a container for Chinese classical texts. Small holes around six sections of the periphery suggest that cords were threaded through the hide to secure it over the box as protection and embellishment.

The technique used to pattern the hide was simple but capable of creating sophisticated designs. The hide was stretched taut, and a gum or wax resist was painted onto its surface in the pattern desired. The resisted hide was then smoked over a straw or leaf fire until the exposed areas of the leather had turned light ochre, while the areas protected by the resist retained their original color. When the resist was picked or brushed off, the reserved design showed nearly white against the ochre back-

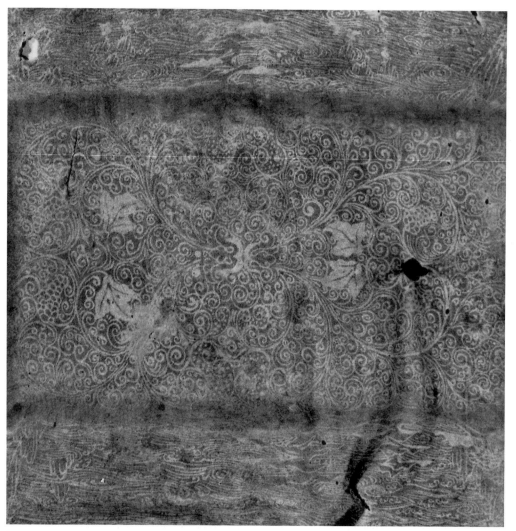

65

beside the hermit is a large ceramic jar. Playing or listening to the *qin* while appreciating the beauties of a mountainous landscape was a pleasure highly approved by the Chinese intelligentsia and repeatedly treated in Chinese painting and poetry as a form of enlightenment.

The left-hand landscape echoes the right, with the addition of flying birds. Here the figures are monks sitting cross-legged, one reading a sutra, the other listening.

Thematically the two scenes are complementary—the one Daoist-Confucian, the other Buddhist. Their juxtaposition may represent a notably early attempt to suggest a harmony among these highly different imported philosophies. Stylistically both landscapes reflect the painting style of the Period of Disunity in China. TS

66
Textile Fragments
Late Nara period, 8th century

A
Head of hanging temple banner (J: *ban*)
Weft-patterned silk *nishiki* brocade
W. (at lower edge) 33 cm.

THIS bordered triangular fragment formed the head of a hanging temple banner. It hung from its pole by the strip of light green pongee sewn to its apex; once, the green pongee was wrapped in sheer blue silk, but only traces of the blue now remain. Blue pongee forms the diagonal borders; these too, when new, were probably wrapped in sheer silk. The lower border bears a pattern called *taishi kandō* (the prince's shortcut), rendered in warp-dyed red and orange ikat (J: *kasuri*).

The most notable portion of the bannerhead, however, is the central triangle. This is a brocade of large and small floral medallions against a fine checkerboard (J: *arare*; hailstone) ground. Both the checkerboard and the flower medallions were formed by floating weft yarns over a green twill ground, using red and white yarns for the checkerboard and yellow for the flowers. (In a weft-floated brocade the weft yarns pass over two or more warp yarns at a time, thus creating the "floating" effect.) Few

float brocades survive from the Nara period; the technique came into general use, it seems, only during the succeeding Heian period. It was later, too, that the design acquired the name "nests in hail" (J: *ka ni arare*) and was reserved for imperial court textiles (J: *yūsoku moyō*). Though pattern and technique both suggest the elegant fabrics of the Heian period, this fragment is dated to Late Nara.

B
Two fragments of icon canopy (?)
Weft-patterned silk *nishiki* brocade
(Larger fragment) L. 29 cm. W. 14.6 cm.
(Smaller fragment) L. 23 cm. W. 14.6 cm.

THESE two fragments both present a typical Tang Chinese floral design on a scarlet ground. Weft-patterned brocades such as this began to be woven in China early in the Tang dynasty and were introduced into Japan in the Late Nara period. Since the colorful, intricate designs were relatively easy to weave, weft-patterned *nishiki* became the most widely used fabric among the Japanese upper class.

The design of stylized floral medallions, perfected in China in the first half of the eighth century, likewise became a favorite among Late Nara-period Japanese aristocrats. Their name for it, *karahana* (Tang flowers), reflects their emulation of things Chinese.

Karahana-patterned brocades were imported from China and also woven domestically. Since the design here is somewhat stiff and conventional, this fabric may have been a Japanese copy after a treasured Chinese import. The two fragments perhaps come from a petalled cloth that formed part of the canopy over a Buddhist icon.

C
Foot of hanging temple banner (J: *ban*)
Block-resist-dyed silk pongee
W. 26.5 cm.
(Not in exhibition)

THIS large leaf-and-flower print on roughly woven sheer silk has softly blurred edges and an effect of lightness not found in contemporary brocades. It was achieved by *kyōkechi*

dyeing, which was well suited to the large-scale floral designs popular in Tang China and Nara Japan.

The specifics of *kyōkechi* dyeing are not known, but in general it seems to have involved pressing folded cloth between wooden boards or blocks perforated with a design, then immersing the whole in dye; the dye could reach only those parts of the cloth exposed by the perforations. This was an efficient method of creating repeat patterns. Of the three resist techniques commonly used in ancient Japanese dyeing (*kyōkechi*, *rōkechi* [batik], and *kōkechi* [tie dyeing]), *kyōkechi* was the most popular, and relatively great numbers of *kyōkechi*-dyed fabrics are extant.

In the fragment exhibited here, the leaves are green and the blossoms vermilion and ochre. The ground color may have faded to its present beige from light purple. Purple gauze borders indicate that this piece was the foot of a long hanging banner. LEM

67
Painted Drum Body
Wood
H. 39.5 cm. Diam. (at widest point) 19.7 cm.
Late Heian period, 10th century
Important Cultural Property

ONE of the oldest of Japanese musical instruments, the hand drum (J: *ko-tsuzumi*) originated in India and was introduced to Japan by way of China during the Late Nara period. It was part of the ensemble that accompanied *gigaku* and *bugaku* dance-mime performances (see nos. 32, 33). The drum could be played by striking it with the palms of both hands, with drumsticks, or with both drumstick and hand. Its tone could be varied by altering the tension of the cords tied at eight places to each head. This type of drum derives its name, *saiyōko* (thin-waisted drum), from its distinctive hourglass shape.

The small drum body with painted designs (J: *sai-e kodō*) is made of a single block of paulownia wood (J: *kiri*) turned on a lathe. Paulownia was frequently used in musical instruments for its lightness and resistance to cracking and warping. The cup-shaped hollows

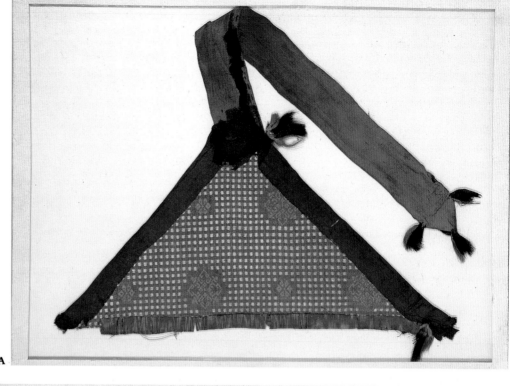

66 A

66 B

66 C

at each end were gouged out with a hammer and chisel and covered with horsehide drumheads.

Although simply constructed, this drum body is richly decorated with raised bands, painted designs, and gold foil (J: *heidatsu*). At the waist, where the drum is held, is a large band flanked by two smaller ones. A single band separates each cup from the waist. There are double bands at the mouth and the middle of each of the cups. Much of the art-historical value of this object derives from the painted designs, which were applied on a ground of fine white clay (J: *hakudo*; kaolin) over the exterior of the drum body. Despite a considerable amount of flaking, the original colors and designs are still distinguishable. On the narrow waist is a bundled lotus design, depicted with shaded (J: *ungen saishiki*) vermilion and dark blue on a red ground. Between the double bands on the cups are rows of symmetrical flower and leaf designs (J: *taiyōka mon*) painted in green and navy blue on a light red ground. Stylized and elaborately shaded *hōsōge* flower scrolls (J: *hōsōge karakusa*) on a green ground adorn the other half of the cups.

In the absence of inscriptions, drum bodies of this type are extremely difficult to date. Several eighth-century drum bodies survive, including a three-color (J: *sansai*) ceramic drum body in the Shōsō-in treasure house of Tōdai-ji and two wooden examples originally from Hōryū-ji but now housed in the Tokyo National Museum.[1] But eighth-century drum bodies were often redecorated or copied in later times. Although in shape the Tōdai-ji drum body resembles the eighth-century examples at Hōryū-ji and the Shōsō-in, its bright colors and abundant use of shading are characteristic of the Heian Period. This drum could be a Nara-period body repainted during the Heian period, or it may have been wholly made during the Heian period but copying a characteristic Nara-period shape. It is thought to date from the Late Heian period (tenth century), since it exhibits a slightly older style than another Heian-period drum body, also at Tōdai-ji, which according to inscription was repaired in 1232. Both the drumheads and the crimson-colored hemp cords were produced well after the drum body. A Muromachi-period drumstick also survives.

Though it is extremely difficult to determine the specific function of this drum, inscriptions on similar objects can provide valuable clues. Four sizes of drums, numbered one to four in order of increasing size, were used in *bugaku* performances. The inscription on the dated Tōdai-ji drum body indicates it was used as a number three drum; the inscription carved on one of the eighth-century Hōryū-ji drum bodies suggests it was a number two. The drum shown here is thought to have been either a number two or a number three, being roughly the same size as those two inscribed instruments. The hand drums used in the Nō drama, which developed in Japan during the Muromachi period, derive from this earlier form. WS

1. These are not dated by inscription, but the circumstances of their deposit in their respective temples establish their dates.

68
Inkstone in the Shape of the Character for "Wind"

Sue ware ceramic
H. 3.8 cm. W. (at base) 13.7 cm.
D. 14.6 cm.
Early Heian period, 9th century

IN East Asia ink came compressed into a hard stick; to make liquid ink this was simultaneously rubbed to powder and mixed with water on an inkstone. Early ceramic inkstones came in various shapes—"wind"-shaped (J: *Fūji ken*), circular, *hōju*-shaped, "monkey-faced" (large circle intersecting a smaller circle), and rectangular—the most common being the circular and "wind"-shaped. These two were produced in large numbers, the former being the dominant type from the first half of the seventh century into the ninth, the latter from the ninth into the eleventh. In the older "wind" shapes the sides widen toward the base, as they do here; over time the sides become progressively more parallel, and the latest stones are shaped like a Roman arch.

Sue wares have fine, grayish clay bodies fired to stoneware hardness. This produces a surface with the critical balance of porosity and smoothness for properly grinding the ink. During the Nara period Sue kilns throughout Japan produced "wind"-shaped inkstones, but the finest came from the Sanage kiln (present-day Aichi Prefecture). The inkstone exhibited here is said to have belonged to High Priest Rōben himself (see no. 27), though there is no written evidence to substantiate this claim. Its high quality, however, and the batter of its sides indicate that it is an early product of the Sanage kiln. Its surface sheen testifies to long and careful use.

The crescent-shaped protrusion near the upper end separates the part of the stone where the ink is rubbed from the smaller "pool" area where the liquefied ink collects. When ink is being made and the stone is wet, the crescent looks like the moon reflected in water. On the underside of the inkstone are two parallel

67

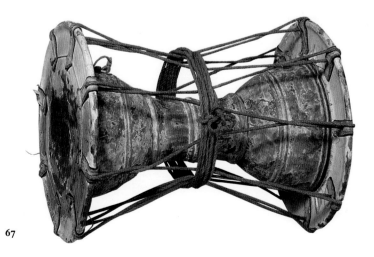

rectangular feet, and covering the entire underside is a thick layer of deep green ash glaze. The glaze was produced accidentally by particles of fuel ash falling onto this surface during firing in a reducing kiln—evidence that the piece was fired face down.

The sole inkstone in the Shōsō-in is very similar to the one exhibited here, being made out of the same ceramic and with almost identical shape and dimensions. The Shōsō-in inkstone is embedded in a hexagonal base of finely polished mottled blue stone, and the whole is mounted on an exquisite wooden stand decorated with marquetry of various woods, ivory, and horn. The inkstone exhibited here may well have been similarly adorned for use. LEM

69
Gong

Bronze

H. 27.3 cm. W. 45 cm.

Kamakura period, 13th century

Important Cultural Property

THE flat, chevron-shaped gong (J: *kei*) is one of several percussion instruments customarily used in Buddhist ceremonies. Its soft but penetrating tone served as emphasis and punctuation during sutra recitation. The gong was suspended from a stand known as a *keika* by a cord that passed through the two small rings

68

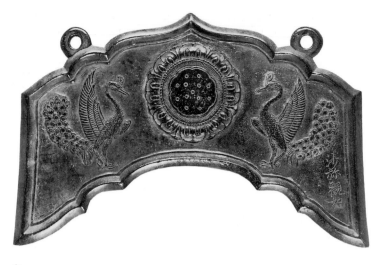

69

on its shoulders. The stand was placed atop the right armrest of the presiding priest, who struck the gong with a small weighted mallet.

This is the largest Japanese *kei* gong surviving from the early period, an appropriate size for the Daibutsu-den, where it is said to have been used originally. Until recently this gong and its black lacquer stand, which also dates from the Kamakura period, were housed in the Sangatsu-dō.

A uniformly wide and thick border surrounds the thin body on all sides, a build that improves the tone of the instrument. The vertical sides flare slightly toward the bottom. By contrast, top and bottom edges are curved, with the top forming a flattened ogee and the bottom a kind of high, shallow trefoil arch.

This *kei* bears the same decoration on both sides. In the center, where it is struck (J: *tsukiza*; striking seat), is a lotus-flower motif. Eight compound petals surround an inner circle of finely carved stamens; these in turn enclose the heart of the flower, in which thirteen small circles have been carved with a chisel to indicate seed pods. Symmetrically flanking this central motif are two peacocks shown in profile; each is standing on its far leg and holding its near leg raised with the foot curved back.[1] Their near wings are extended, the far wings folded and foreshortened. The whole design is somewhat stilted and lacks crispness, reflecting unsure carving of the clay mold in which the bronze was cast.

An itaglio inscription in the lower right corner on one side of the gong reads "Shami Kannyo," perhaps the name of the donor.[2] Although the inscription provides no date, the high arch of the lower edge, the thinness of the body, and the form of the lotus design are suggestive of the thirteenth century. WS

1. Conceivably these peacocks refer to the Peacock King of Bright Wisdom (J: Kujaku Myō-ō), an Esoteric Buddhist deity.

2. *Shami* means "novice" in Japanese, although the second syllable, *-mi*, is usually represented by a different and far more complex character. It is plausible that, for an inscription in bronze, a simpler homonym might have been chosen and that Kannyo, the donor, was in fact a Buddhist novice.

70
Ceremonial Water Ewer

Bronze

**H. 21.5 cm. Diam. of body 11.8 cm.
Diam. of base 7.8 cm.**

Kamakura period, 1305

Important Cultural Property

ONE of the most important Buddhist ritual implements, the water ewer (J: *sui-byō*) was among the eighteen basic canonical possessions of every monk. Originating in India, the water

ewer (S: *kundikā*) as a Buddhist ritual implement was introduced to Japan from China by the eighth century. There are several kinds of Japanese ewers, with names varying according to function, shape, and location. Ewers were part of numerous ceremonies, primarily to hold water for ritual hand-washing or as an offering to Buddhist deities.

Two distinguishing features of the small ewer at Tōdai-ji are its curved **S**-shaped spout and its lack of a handle. The type is known by several names, including Hōryū-ji type (J: *Hōryū-ji-gata*), after the ancient temple outside Nara where several ewers of this shape survive. More commonly, it is called *Fusatsu* type (J: *Fusatsu-gata*), for the ceremony in which it was used. During the *Fusatsu-e* (S: *Uposatha*), which was usually held on the fifteenth day of each month, an assembly of monks reviewed the ordination rites and confessed their violations of the rules. The ewer held water to wash the hands of those taking part in the ceremony. This symbolic purification of the body and mind preceded the reading and confessional. Although it appears that this ceremony had

been held since ancient times, surviving water ewers of this type do not antedate the Kamakura period.

The body, neck, and lip of this ewer are made of one piece of cast bronze finished on a lathe; the curved spout and high, flaring foot were cast separately. There are traces of tinning inside the wide mouth, which, like most such ewers, probably once had a lid. From the mouth the long neck narrows sharply, only to swell out again at the shoulder where it meets the round, bulbous body of the ewer. The mouth, foot, and shoulder are punctuated by a series of raised bands. Two other bands, around the middle of the body and the neck, emphasize the widest and narrowest parts of the vessel. The base of the spout is decorated with a chrysanthemum motif characteristic of Kamakura-period ewers.

The date of this piece is given in the inscription carved on the outside of the foot: "Property of the Kaidan-in of Tōdai-ji, third year of the Kagen era [1305]." Although numerous examples of *Fusatsu-gata sui-byō*, one of the two main types of Kamakura-period water ewers, have survived, very few are dated. This ewer and two others with dated inscriptions, one at Hōgon-ji in Shiga Prefecture (1288) and one at Hōryū-ji outside Nara (1303), are representative *Fusatsu* type water ewers of the late Kamakura period. These objects enable the art historian to establish the type of design and level of technology in use at this time; they are also valuable to the Buddhologist, since the date and function of the object and location of the ritual are known (see no. 76).

Also at Tōdai-ji is another ewer almost identical in size, shape, and design to the one illustrated here. Although this ewer lacks a dated inscription, it is thought that the two were produced at about the same time and may have been used together during the *Fusatsu* ceremony. WS

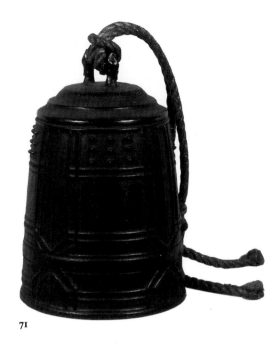

71

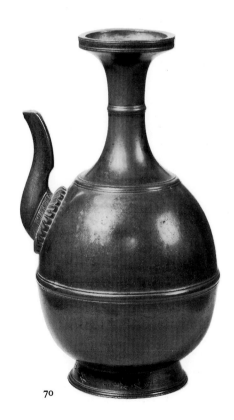

70

71
Hanging Temple Bell

Bronze
H. 30.8 cm. Diam. of mouth 20.9 cm.
Kamakura period, 1308
Important Cultural Property

SMALL bells of this type (J: *kanshō* or *yobigane*; summoning bell) were used at temples to announce meals, sutra readings, or the outbreak of a fire. This particular bell, however, had a more specialized function: it was kept in the inner sanctuary of the Nigatsu-dō and rung to signal meal and assembly times in the Worshippers' Dining Hall (J: Sanrōjo Jiki-dō) (see no. 8) of that complex during the *Shuni-gatsu-e* (see Introduction and no. 59). Also known as a *hanshō*, or half-bell, because of its size, the bell nonetheless has roughly the same form and decorative schema as the great temple bells (J: *bonshō*) that were introduced from China by the seventh century. Unlike Western bells, which have interior clappers, Japanese bells remain motionless and are sounded by striking the outside with a mallet.

This bell is suspended by a rope passed through an inverted **U**-shaped loop formed by addorsed dragon heads; the dragons appear to

72

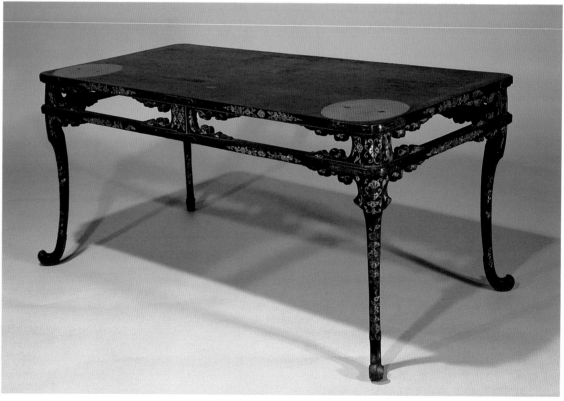

73

be gnawing on a pair of cylindrical shafts issuing from the top of the bell dome. The suspension loop is small relative to the size of the bell, and it lacks the flaming jewel (J: *hōju*) that was usually placed above the intersection of the dragon heads. The modelling of the dragons is also less crisp than on other examples, both contemporary and earlier. The two-tiered dome is called *kasa-gata* (hat-type), after the commonly worn bamboo hat of a similar shape. A small raised spot (J: *yuguchi*) marks the place at which the molten metal was poured into the mold.

The decor of this bell is organized somewhat differently from that on standard temple bells. Bells are usually divided below the dome into three horizontal fields, which in this bell are separated by raised lines. The topmost field, called the *chi no ma*, is divided into quadrants by four clusters of raised lines that form wide vertical bands (J: *jūtai*). Each quadrant contains nine low bosses arranged in columns of three. The more common arrangement was sixteen bosses—in considerably higher relief—in columns of four. The uppermost horizontal band (J: *jōtai*) that usually separates the dome from the *chi no ma* has here been replaced by a simple grooved line. A double raised line divides the *chi no ma* with its bosses from the "pond section" (J: *ike no ma*) directly below. Of the three horizontal bands usually found on temple bells, only the middle band (J: *chūtai*) has been retained and is here located *below* midpoint, a position characteristic of Kamakura-period bells and rarely seen on earlier examples. Because of this positioning, the "grass section" (J: *kusa no ma*) below the middle band here has been reduced to four narrow rectangles. The bottom band (J: *katai*) that normally wraps completely around the bell just above the mouth has here been omitted, perhaps for lack of space. The bell flares only slightly at its narrow mouth. Another idiosyncrasy is the absence of a lotus-shaped striking seat (J: *tsukiza*) (see no. 69) at the intersections of the vertical and middle horizontal bands. Instead, the bell is struck in the middle of the *chūtai*, which has been thickened for this purpose.

In one of the "pond sections" just above the middle band is the inscription "Second month of the third year of Tokuji [1308]; Akonyo [had] this repaired." Little is known about the benefactor Akonyo, although the name also appears in the great compendium of documents known as the *Tōdai-ji Seikan Monjo*. Because there are

no visible signs of repair, it is thought that this bell was newly cast to replace an older bell hitherto in use. Though it resembles earlier bells, this bell also reflects the technology and certain stylistic elements of the early fourteenth century. WS

72
Eleven Ceremonial Food Trays
Lacquered Wood
H. 1.8 cm. Diam. 43.8 cm.
Kamakura period, 1298
Important Cultural Properties

THESE trays (J: *rengyōshū-ban*), despite their simple and rather worn appearance, are important documents for Japanese art history and aesthetics. Their primary art-historical value derives from the lengthy inscriptions written in red lacquer along the circumference of the underside; these give the location of the object, its function, the number of objects in the set, the date, and the name of the artist: "Nigatsu-dō rengyōshū-ban, one of twenty-six trays; sixth year of Einin [1298], tenth month, ———— day; lacquerer: Rembutsu."

Each year during the first two weeks of the second month, the ceremony known as *Shuni-gatsu-e* (see Introduction, "*Omizutori*," and no. 59) was held in the Nigatsu-dō to ensure the prosperity of the land. The *sangyōshū* (monks who went into reclusion at the temple during this time) used the trays in the Nigatsu-dō refectory (J: *Sanrōjō Jiki-dō*) for their one meal of the day. It is thought that the number written in dark lacquer in the center of the top surface of each tray indicates the seating order of the monks. (A tray inscribed *daidōshi*, the title of the presiding head priest, is in a separate group at Tōdai-ji and provides further evidence for this theory.) Of the original twenty-six trays, only eleven have survived. Ten of these, numbers 3, 7, 8, 10, 11, 13, 15, 16, 17, and 20, bear legible numerals. Most have been extensively repaired over the centuries, but numbers 3, 7, 10, and 16 are in relatively pristine condition. On the remaining tray, unfortunately, both inscription and number are missing. A black ink inscription inside the lid of the storage box for the trays indicates that only fifteen of the original twenty-six were extant when these objects were repaired in 1841.

These simple trays, each made from a single piece of zelkova wood (J: *keyaki*) turned on a lathe, are bordered with a thin, slightly raised rim. Because it rarely warps, zelkova is ideal for these broad trays. The entire surface is covered with an undercoating of black lacquer; over this, on the top only, is a coat of the more expensive red lacquer. Before the lacquer was applied, the outer rim was reinforced with a piece of cloth (J: *nunokise*) (see no. 73), which conceals the grain of the wood. But the wood grain and initial rough carving on the bottom can still be seen, because lacquer was applied directly to the surface without the usual priming coat of lacquer mixed with sawdust or powdered clay. The circumference of the base was planed at an angle to facilitate handling and to provide a smooth surface for the inscription.

Wooden utensils simply finished with red over black lacquer (sometimes with red or black alone) were in everyday use in temples and the secular world. They were known as Negoro ware (J: *Negoro-nuri*), after Negoro-ji (Kii Province), where they are said to have first appeared in the late twelfth century. The appearance and value of Negoro ware is considered to improve with age as the upper coat of red is worn away in places through heavy use and the black lacquer shows through. Such signs of ware, and simplicity of shape and decoration, were prized by later generations, especially by practitioners of the tea ceremony. These trays are sometimes called *Einin bon* (Einin trays), after the Einin reign-period in which they were made, and sometimes *hi no maru bon* (round sun trays), for their resemblance to the red disk of the sun (as seen, for example, on the Japanese flag). WS

73
Altar Table
Lacquered wood with mother-of-pearl inlay
H. 52 cm. W. 114 cm. D. 53 cm.
Kamakura period, 13th century
Important Cultural Property

THIS large black-lacquered table (J: *shoku*) was usually placed before a Buddhist altar and is therefore also called a "front table" (J: *mae-tsukue*). In use, it would have held incense burners, flower vases, candles, and other Buddhist ritual implements.

The narrow perforated molding (J: *kōzama*) that runs along all four sides of the table is primarily a structural support for the top and the legs, but here it has been transformed into a shape of great beauty and aesthetic interest. On the long sides of the table the molding is divided by a central post into two equal sections, or bays; on each of the short sides it forms one continuous panel. Four "heron legs" (J: *sagiashi*), so called for their slenderness and graceful curvature, extend beyond the sides of the table. The upper sections of each leg reverse the curve and swell to support ornamental flower-shaped braces, which are faced with gilt-bronze fittings. The braces, legs, moldings, and indented corners enliven the shape and reduce the angularity of this simple table. Plain metal fittings protect places of high wear and stress, including the corners and center of the table top and side moldings as well as the curved feet.

To further strengthen the table top, a layer of cloth was placed directly upon its wooden surface before lacquering (a process called *nunokise*). The entire table was then painted with black lacquer. On the table top the only decorations are two large red lacquer circles in the front corners. The two rivet holes in each circle are thought to mark positions for the Buddhist ritual implements. The sides and legs are inlaid with mother-of-pearl in a technique known as *raden*. Introduced from China in the eighth century, *raden* became by the twelfth and thirteenth centuries a highly developed and frequently used method of lacquer decoration. At this time thick pieces of oyster or abalone shells were characteristically employed; thinner inlays were preferred in later periods. Here the *raden* forms a central diamond-shaped floral lozenge (J: *hanabishi*) flanked by symmetrical scrolls of the imaginary flower called *hōsōge* (see no. 24). The delicately cut patterns of iridescent shell contrast dramatically with the plain black lacquer background.

Despite the popularity of the technique, only three tables of this type and period survive. The two most notable examples, both dating from the twelfth century and designated National Treasures, are at Chūson-ji in Iwate Prefecture and at Hōryū-ji outside Nara, the eighth-century capital. These three tables share the same shape, structure, design, and decorating technique. The Tōdai-ji table, however, is lower and broader than the other two and displays by comparison a heaviness of form, rigidity of design, and excessive elaborateness of molding that suggest it was made in the following century. WS

74
Pair of Hanging Lanterns
Iron
H. 57 cm.
Kamakura period, 14th century
Important Cultural Property

PICTURED are a pair of hexagonal hanging lanterns dated to the early fourteenth century. They were forged of wrought iron and put together with rivets and clasps. The iron roof is supported by six sloping rafters with projecting fiddlehead tips (see no. 62). On the underside of these are rings from which ornaments were once suspended. At the center of each roof section, between the rafters, are six openings in trefoil shapes that the Japanese call "metamorphosed sand bars." These were cut to allow the escape of soot and smoke. At the center of the roof is a thick six-sided iron disk, surmounted by a small flame-shaped wish-granting gem at each corner. Centered on this disk, a knob in the shape of a gourd holds a trilevel lotus pedestal upon which rests a large wish-granting gem. This *hōju* is vertically trisected by three openwork flame designs—a common decorative treatment.

The panels of the fire chamber have continuous vertical struts but are visually divided into three horizontal bands by fittings attached with rivets. The top and bottom bands are narrow, the former decorated with openwork ivy scroll patterns and the latter with a foliate scroll motif in intaglio. The largest area of each finely crafted panel is the midsection, in which the iron has been wrought into an openwork fishnet pattern. Two panels on each lantern are doors that open at the side, and one panel on each interrupts the fishnet pattern with a single large wrought iron bee. The lanterns are identical except for these insects: one is shown in flight with outspread wings, the other alighting upon a twig.

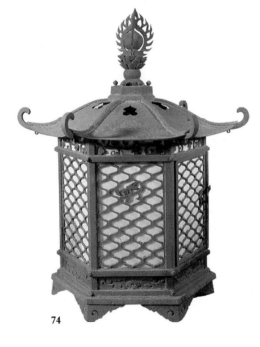

74

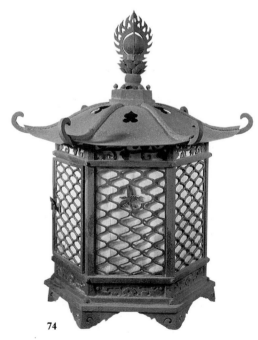

74

The bases of the lanterns are also hexagonal, and at each corner two stylized arrowroot (J: *kuzu*) leaves, each incised with a comma-shaped design, project to form stubby, non-functional legs. *In situ* each lantern is cantilevered from a pillar: a rod extends from the pillar parallel to the ground, then rises vertically, and finally divides into three prongs that fasten to three iron clasps on the underside of the lantern body.

Originally, however, the lanterns are thought to have hung from pillars flanking the miniature shrine (J: *zushi*) that houses the image of the Thunderbolt Deity (J: Shūkongō-jin) at the back of the Sangatsu-dō. Legend has it that during the tenth-century rebellion led by Taira no Masakado (?–940), the priests of the seven great Nara temples prayed for protection from attack; a swarm of enchanted bees flew from the Thunderbolt Deity's hair and stung Masakado to death (according to historical records he was killed by opposing rebel forces). The bee designs on the lanterns derive from this story, as is noted in the *Essential Records of Tōdai-ji* (J: *Tōdai-ji Yōroku*) and other documents.

Few iron lamps have survived. We are fortunate that these two from the late Kamakura period are so skillfully made and well preserved. CJB

75

75
Buddhist Scripture Chest

Lacquered wood with bronze fittings and gold leaf

H. 50.3 cm. W. 57.7 cm. D. 46.5 cm.

China, Yuan or Ming dynasty, 14th century

Important Cultural Property

THIS large, nearly cubical sutra chest (J: *kyō-bitsu*) showcases the skills of the lacquer artist, the metalworker, and the wood carver. A deep lid fits over the top of the chest and rests upon a wide, flat rim that extends around the chest. The lid is secured by a cord that passes through two bronze disks attached on the front and back of the chest. Directly below these fittings, near the base, are perforated bronze plaques in the shape of a common East Asian decorative motif, the *hanabishi*, or diamond-shaped floral

lozenge. The chest rests upon a gently curved molding that widens at each corner to form four short feet. The feet, corners, and other sections of the lid and chest most susceptible to wear are reinforced with simple bronze fittings.

Inside, the chest is coated with red lacquer. Elaborate decoration is restricted to the exterior, with a similar design on each of the four sides of the chest and on the lid. This is an eight-foil diamond-shaped lozenge framing a circle of four or five phoenixes in flight against a background of stylized clouds. Outside this frame are more cloud patterns, regularly spaced on a diagonal lattice pattern. This, in turn, is surrounded by a border of interlocking zigzag patterns, which is separated from the edges of the chest by a plain green lacquer margin.

These designs were executed over a base coat of green lacquer, using a Chinese technique known as *qiang jin* (pronounced *sokin* in Japanese). It involves incising a design into a lacquered surface with a knife or other sharp-

edged tool, then carefully packing the hairline grooves with wet lacquer and pressing gold leaf onto this adhesive. After the lacquer dries, any excess foil is brushed away, revealing a finely delineated gold design. Objects of *virtu* decorated in the *qiang jin* techniques were introduced from China during the Muromachi period, a time of expanded trade that led to a vogue for Chinese goods in Japan. Soon the Japanese were turning out *qiang jin* work themselves, but calling it *chinkin* rather than *sokin*.

At present in Japanese collections there are several Buddhist scripture boxes (smaller than chests, and called *kyō-bako*) that were made in China using the *qiang-jin/sokin* technique. Each bears an inscribed date that corresponds to the year 1315. The boxes differ, however, from the Tōdai-ji chest in design and carving and are thought to be products of another school of lacquer craftsmanship. WS

Three Hand Ablution Basins
Lacquered Wood
(Basin 1) H. 9.9 cm. Diam. 31 cm.
(Basin 2) H. 9 cm. Diam. 29.2 cm.
(Basin 3) H. 9.1 cm. Diam. 38.8 cm.
Muromachi period, (basins 1 and 2) 1427,
(basin 3) 15th century
Important Cultural Properties

AT the monthly ceremony called *Fusatsu-e* (see no. 70), a set of implements comprising a water basin, water ewer (J: *Fusatsu-gata sui-byō*), and towel rack (J: *tenugui-kake*) were used in the ritual hand-washing. Monks assembled at the *Fusatsu-e* to review and reaffirm the precepts of the order and to confess their transgressions of the preceding month against the rules. During the ritual purification performed at the beginning of the ceremony, water was poured from the ewer over the hands and was caught in the basin. The hands were then dried with the small towels hung on the towel rack reserved for this occasion.

According to the *Essential Records of Tōdai-ji* (J: *Tōdai-ji Yōroku*), compiled in 1106 and a major source of information on Tōdai-ji during the Nara and Heian periods, *Fusatsu-e* were held at the Ordination Hall four times each month, on the fourteenth and twenty-ninth for monks belonging to the Mahayana (Greater Vehicle) sects, and on the fifteenth and thirtieth for those of the older Theravada tradition. Since each monk was expected to take part in only one ceremony a month, the frequency of services probably reflects the size and diversity of Tōdai-ji's monastic community.

Preserved in Tōdai-ji are three *Fusatsu* basins (J: *Fusatsu darai*) of water-resistant Japanese cypress (J: *hinoki*). These are approximately the same in size, shape, and decoration, but they differ in the construction of the sides and in their inscriptions. The sides of basins one and two are made of four-feathered plies of wood bent into a ring around a slightly raised bottom board. The sides of the third basin, however, are assembled like the staves of a barrel, with pieces of wood of the same height fitted together side by side in a ring around the base. Each basin bears a red lacquer inscription on the underside of the base, which reads "Tōdai-ji

76

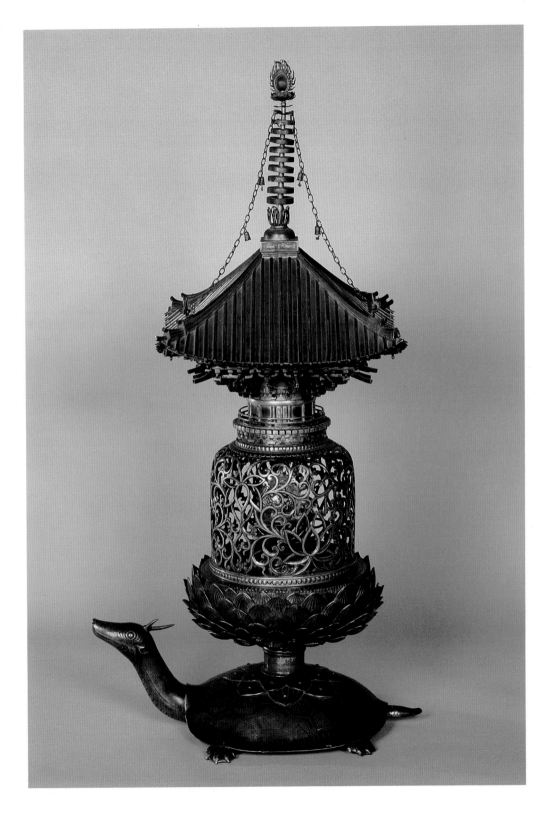

Kaidan-in fusatsu darai." In addition, basins one and two are dated: "Twenty-second day of the second month, Oei 34"; the third basin lacks a date, but is believed to be slightly older because it is more scratched and worn.

The sides of these basins are not straight as in most objects of this type but flare out noticeably toward the mouth. This, together with the two black-lacquered bands that encircle the basins near the top and bottom, imparts a sense of formal tension. The mouth and foot of each basin are also believed to be reinforced with cloth (see no. 73) beneath the lacquer surface. These basins belong to a class of lacquer ware known as Negoro ware (see no. 72), which is generally characterized by a finish of red lacquer applied over an undercoat of black lacquer.[1] On these basins the red lacquer has been left off the mouth, the two hoops, and the bottom, and the narrow black accents thus created are in pleasing contrast with the expansive, bright red basins. On the more costly red lacquer brush marks are still clearly visible.
WS

1. A small number of Negoro ware vessels are finished in black alone, or in red alone, or in translucent lacquer over the bare wood.

77
Golden Tortoise Reliquary

Gilt Bronze
H. 85 cm.
Muromachi period, 1411

THIS pagoda-shaped Buddhist reliquary (J: *sharitō*) sits on a lotus pedestal borne by a tortoise. It is a copy of the famous reliquary at Tōshōdai-ji which was said to contain three thousand grains of the Buddha's ashes, brought to Japan by Tōshōdai-ji's founder, Ganjin (see no. 31).

Miniature pagodas are commonly used as reliquaries, this being also the function of their full-sized prototypes. But the tortoise base is distinctive and unusual, a reference to the legendary golden tortoise that guarded Ganjin and the sacred relics on their sea voyage from China to Japan.

An openwork lotus arabesque forms the base of the pagoda, through which one can see the solid-walled relic container. The arabesque is

78 A

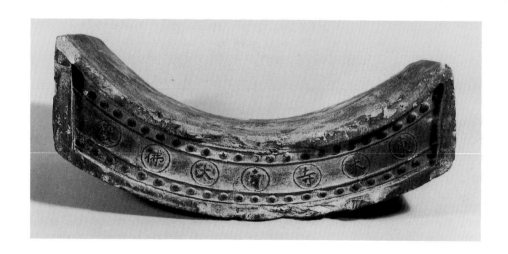

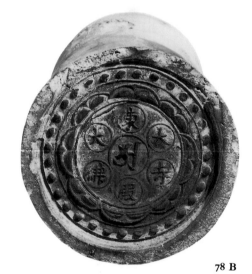

78 B

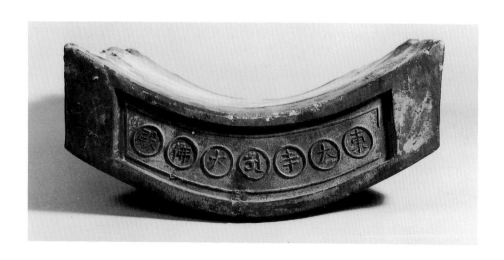

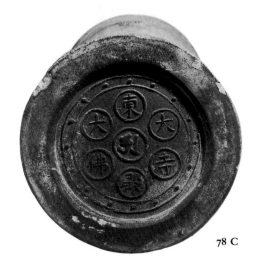

78 C

masterly in design and execution, revealing the special care that went into the making of this vessel. From documents inside the reliquary we know that it was considered one of Tōdai-ji's major treasures.

It was commissioned by the monk Sōtan and dedicated in 1411 at Tōdai-ji's Ordination Hall. An inscription reads:

Faithfully I commend this to the relic hall of the Tōdai-ji Ordination Hall. Sponsor: Monk Sōtan. The year 1411, eighth month, fifteenth day. Bronze smith, Seichō. Wife, Myōshō. Benevolent father, Saidō. Compassionate mother, Myōshin.

78
Roof Tiles

Molded earthenware

A

(Round tile) Diam. 19 cm.
(Eaves-end tile) H. (of sides) 8 cm.
W. 27.2 cm.
Late Nara period, 8th century

BOTH of the eighth-century roof tiles (J: *kogawara*) are of blue-gray clay fired to earthenware hardness. The round "stirrup" tile (so called because its cylindrical shape resembles a traditional East Asian stirrup) bears a molded design of a lotus blossom encircled with large round beads. Seven beads in the center not only represent the stamens of the flower but symbolize the seven visible heavenly bodies.[1] The raised circumference is undecorated. This design, which adorned a Tōdai-ji roof, had to be visible from a considerable distance, and for this purpose the simplicity and scale of its motifs and the crispness of their molding are well suited.

The arched eaves-end tile has as its principal motif a symmetrical floral arabesque centered on a *hōsōge* flower. As on the "stirrup" tile, the central motif is bordered by large beads. Floral arabesques, found also on the roof tiles of the Sangatsu-dō (built 746), are nearly ubiquitous in the art of the mid-eighth century. The name of the motif, *karakusa* (Tang plant), bespeaks its origin in the Tang Chinese decorative repertoire, from which the Japanese borrowed enthusiastically at this time. The example seen on this tile is relatively small and stylized compared to other extant examples from Late Nara.

B

(Round tile) Diam. 20.3 cm.
(Eaves-end tile) H. (of sides) 7.3 cm.
W. 35.8 cm.
Kamakura period, 12th century

THESE two Kamakura-period tiles are dark gray. The stirrup tile, like its Nara-period predecessor, is decorated with a lotus motif encircled with large beads, but here the petals of the lotus have shrunk and its center has greatly expanded. The central beads have also enlarged into circles, of which the outer six accommodate the characters for *Tō-dai-ji Daibutsu-den* and the inner seventh contains the Sanskrit letter *a*, symbolic of the Esoteric Buddha Dainichi (S: Mahāvairocana) of the Womb Universe (J: *Taizō-kai*). As on the Nara-period "stirrup" tile, the raised circumference is unadorned.

On the eaves-end tile the identical motifs are similarly disposed, except for a different Sanskrit letter in the center, *vam*, which symbolizes Dainichi of the Diamond Universe (J: *Kongō-kai*). The circles framing the characters and the letter are somewhat convex, like little pillows.

Tiles for the Kamakura-period reconstruction of Tōdai-ji came from the immediate vicinity and also from Bizen Province (present-day Okayama Prefecture) to the northwest and the Atsumi Peninsula of Mikawa Province (present-day Aichi Prefecture) to the southeast. The Mantomi tile kiln that produced these tiles was in Seto (Okayama Prefecture), a district notable for its tile kilns. In the Kamakura period the Mantomi locale was called Yoshioka, and reference to "tiles from Yoshioka" can be found in the writings of Chōgen (*Chōgen Monjo*), the monk who organized and supervised the rebuilding of Tōdai-ji (see no. 28). Contemporary records mention so many tile-making kilns in Bizen Province that it is reasonable to assume a general mobilization of the Bizen ceramic industry to furnish tiles for rebuilding Tōdai-ji's roofs.

C

(Round tile) Diam. 27.6 cm. D. 58 cm.
(Eaves-end tile) H. (of sides) 12 cm.
W. 55 cm. D. 46.8 cm.
Edo period, 17th–18th century

FOR the Edo-period reconstruction, the tiles were made larger than before. The two on exhibit are dark gray. On the "stirrup" tile the lotus petals (which had shrunk in the Kamakura "stirrup" tile) are now completely omitted, and the encircled characters and Sanskrit *a* make up the entire central design. The beads encircling this central design are greatly reduced in size and number. The raised outer rim remains undecorated but has grown relatively wider and thinner, as on most tiles of the period.

The eaves-end tile retains the encircled characters and Sanskrit letter but has completely lost the beaded rim of its Kamakura-period predecessor, and its raised outer rim is much broader, especially at the two ends.

These two tiles for the Edo-period reconstruction were not made in the Mantomi kilns but in Nara and Kyoto. LEM

1. These are: sun, moon, Mars, Mercury, Jupiter, Venus, and Saturn, symbolizing, respectively, the Chinese cosmic principles of *yang* and *yin* and the five elements—fire, water, wood, metal, and earth.

79
Demon-Mask Roof Tile

Molded earthenware
H. 50.8 cm. W. 44.5 cm. D. 7.5–8 cm.
Late Nara period, 8th century

THIS tile, which shows evidence of having been through a fire, was excavated from the former site of Tōdai-ji's Lecture Hall (J: *Kōdō*). Its decoration is a stylized demon (J: *oni*) face in high relief. From the semicircular opening below the teeth round tiles (now lost; see no. 78) once protruded to form the lower jaw, and from these, tooth-shaped tiles projected. The downward glare of the bulging, crossed eyes and the flaring nostrils of the snub nose suggest that this demon face may represent the *bugaku* mask Ryō-ō (see no. 33 A). At the hairline there

is a sawtooth pattern, and the whole mask is framed by a beaded border.

A mold of this design has been excavated from the site of Daian-ji (Nara), and a document from Daian-ji dated to 729 notes that the monk Dōji, having just returned from China, is employing the knowledge acquired there to supervise the building of Daian-ji. Cracks in this mold suggest that it is older than the tile exhibited here. It is also smaller. By adding an unpatterned border, the demon-mask design was adapted to make the larger tiles wanted for Tōdai-ji's Lecture Hall.

Tiles excavated from the former site of Tōdai-ji's Sai-tō (West Pagoda, southwest of the Daibutsu-den) also display this demon mask. The Sai-tō was begun in 751, the Lecture Hall in 753. The tile exhibited here is typical of demon-mask roof tiles (J: *oni-gawara*) from the height of the Late Nara period.

80
Two Sets of Carpenters' Tools
Edo period, 17th–18th century
A
(Adze) L. 82.3 cm.
(Two line markers) L. 33 cm. each
(Two carpenters' squares) L. 48.5 cm. each
Two straightedges

TōDAI-JI owns two sets of carpenters' tools (J: *kōshō-gu*), both dating from the Edo period. The first set is contained in a covered lacquer box 94 centimeters long by 33.5 centimeters wide. In this set the most striking tool is the adze, whose black-lacquered wooden handle was bound with copper strips for a striped effect; these copper strips were further decorated with incised arabesques on a hammered

fish-roe (J: *nanako*) ground. Its blade is incised with the inscription "Kyō [Kyōto], Ogawa, made by Monju Shirōtarōbei."

There are also two identical carpenters' line markers. These serve the same purpose as the modern chalk line and work on the same principle, using ink instead of powdered chalk. The base and wheel are of copper-sheathed black-lacquered wood, the base decorated with incised arabesques on a hammered fish-roe ground, the wheel with three Buddhist swastika shapes (J: *man-ji*; long-life symbols) on each side. Behind the wheel a recess in the base holds ink, and around the wheel is coiled a two-ply string seven meters long, ending in a tasselled ring. When the carpenter pulls the ring, the string passes through the inkwell and can then be used to "snap a line" on a beam or board.

The two carpenters' squares, copper plated over wood, are calibrated in 1-*sun* (about 1 inch), 5-*bu* (0.5 *sun*), and 1-*bu* units. The straightedges are likewise copper plated over wood. These are decorated with incised arabesque patterns.

This set of tools ranks with those at the Tōshō-gu¹ at Nikkō as the most superb to survive from the Edo period. The size and ornateness of the tools suggests that they were not for mundane use but for presentation at the dedication of the rebuilt Daibutsu-den in 1709.

B
(Mallet) L. 30 cm.
(Line marker) L. 19.6 cm.
(Handsaw) L. 46.5 cm.
Two chisels
Bamboo straightedge

THE second set of tools includes a mallet, line marker, handsaw, wide and narrow chisel, and a bamboo straightedge. These tools, though individually wrapped in red-and-gold brocade and kept in a white paulownia box, are themselves fairly commonplace for their time.

The inside of the box bears two inscriptions. One reads simply "Genroku 6 [1693]." The other states that one Sakura-hombō Kōgyō Nagataka, his heir Matsunobō Nagatoshi, and his younger brother Matsuda Chūbei purchased the tools in the twelfth month of Bunka 4 [1807].

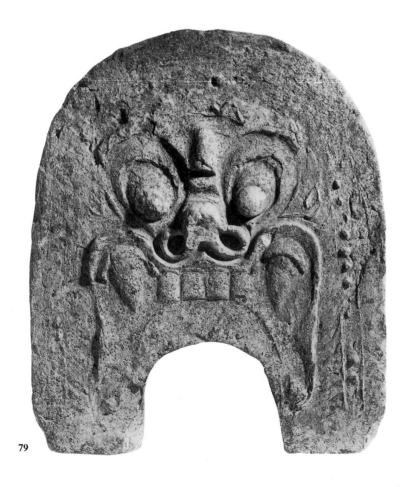

79

How these tools came into the possession of Tōdai-ji is unclear, but since the men of the Matsunobō clan were artisans affiliated with Tōdai-ji they probably donated them. From details of design and construction we may reasonably conclude that the earlier date, 1693, is when these tools were made or first used. LEM

1. Mausoleum of Tokugawa Ieyasu, first shogun of the Edo period.

81
Two Lotus Petals from *Daibutsu* Pedestal (reproduction)

(Outer petal) H. 210 cm. W. 470 cm.

(Not in exhibition)

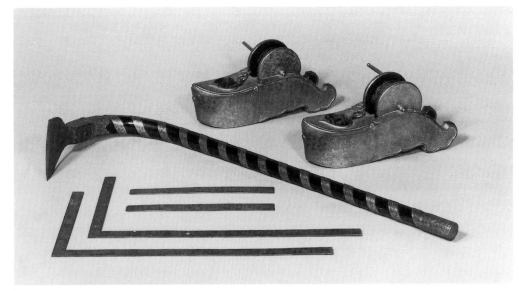

80

Of the few surviving portions of the original eighth-century *Daibutsu*, the most important to art history are several lotus petals from the massive pedestal upon which the Buddha sits (see figs. 8, 28). According to temple records the petals were completed between 756 and 757, and though they are somewhat damaged, presumably in the conflagrations of 1180 and 1567, the scenes of Buddha's paradise engraved upon them are still quite legible.

According to the *Kegon-kyō* (*Flower Garland Sutra*) and the *Bommō-kyō*,[1] the two Buddhist scriptures that served as iconographic basis for the *Daibutsu* project, the lotus throne of Vairocana Buddha consists of a thousand petals, each of which represents a universe—one of the "thousand worlds of the Buddha's paradise." Both sutras relate that in each universe dwells a manifestation of Sākyamuni, together with attendant bodhisattvas and myriads of other Buddhas. Engravings on the twenty-eight large and small (outer and inner) upturned petals directly beneath the *Daibutsu* illustrate scenes from these worlds.

On the wide outer petal the central figure is Shaka Nyorai (S: Sākyamuni Buddha), his right hand raised in the gesture of "welcoming to paradise" (J: *raigō-in*; S: *vitarka mudrā*), his left lowered in the gesture of charity (J: *segan-in*; S: *vara mudrā*). On each palm can be discerned the Wheel of the Law, representing the Buddhist teachings, and on his chest is the Buddhist *man-ji*, auspicious symbol of longevity or immor-

tality. Flaming mandorlas halo Sākyamuni's body and head, and he is flanked by a myriad bodhisattvas, each seated on a lotus with his head haloed by three concentric circles. The bodhisattvas, some of whom are illustrated here, are all seen in three-quarter view, turned toward the Buddha. Their postures, gestures, robes, and crowns are subtly varied—in interesting contrast with the rigid and frontal Buddha figure.

From above Sākyamuni descend kneeling Buddhas on swirling cloud forms, representing the "cloud realm of Buddha manifestations." Below him horizontal lines form twenty-five bands of approximately equal width; these represent the twenty-five levels of existence that make up the cosmos, as described in various Buddhist sutras. In each band are buildings, temple-like complexes, and the haloed heads of deities—alluding to the thirty-three divinities and their dwellings on Mt. Sumeru, center of the Buddhist cosmos. Beneath these twenty-five bands is a lotus in whose center Mt. Sumeru itself is represented, surrounded by schematically drawn ocean waves. Also occupying the lotus center are some roughly drawn circles, half-circles, and rectangles, more or less symmetrically arranged and possibly of symbolic significance. To right and left of the lotus that encloses Mt. Sumeru are the cresting waves of the "great cosmic ocean." Thus is the so-called Lotus Treasure

World expressed, the myriad-world cosmos with Vairocana Buddha presiding at its center.

Although the curve of the petals somewhat distorts the lines of the engraving, these scenes, along with those on the halo of the Nigatsu-dō's main image, offer rare and important clues to the style of the original *Daibutsu*. The traits of early eighth-century Chinese sculpture may be seen in the broad-shouldered, narrow-waisted Shaka Nyorai, with his round face and gracefully flowing drapery. The elegant bodhisattvas grouped around him resemble the celestial musicians on the fire chamber of the eighth-century octagonal lantern (no. 62), with round faces, full lips, and great charm and sweetness of expression. CJB

1. The *Bommō-kyō* (S: *Brahmajāla-sūtra*) was translated into Chinese by Kumārajīva in 406 and brought to Japan by the monk Ganjin in 753.

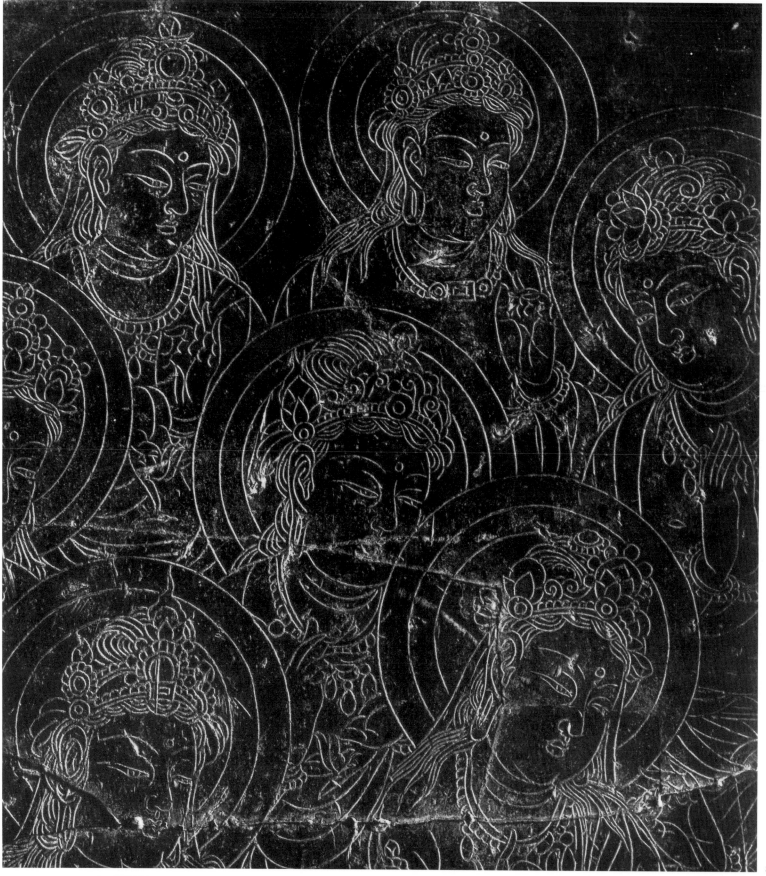

Bibliography

WORKS IN ENGLISH

Akiyama, Terukazu. *Japanese Painting*. Geneva: Skira, 1972.

Birnbaum, Raoul. *The Healing Buddha*. Boulder, Colo.: Shambhala Press, 1979.

Chang, Garma C. *The Buddhist Teaching of Totality: The Philosophy of Hwa Yen Buddhism*. University Park: Pennsylvania State University Press, 1977.

Ch'en, Kenneth. *Buddhism in China: A Historical Survey*. Princeton: Princeton University Press, 1964.

Cleary, Thomas. *Entry into the Inconceivable: An Introduction to Hua-yen Buddhism*. Honolulu: University of Hawaii Press, 1983.

Conze, Edward. *Buddhism: Its Essence and Evolution*. Oxford: Cassirer, 1951; paperback ed., New York: Harper Torchbooks, 1959.

De Bary, Wm. Theodore et al., eds. *Sources of Japanese Tradition*. New York: Columbia University Press, 1958.

Fontein, Jan. *The Pilgrimage of Sudhana*. The Hague and Paris: Mouton, 1967.

Fukuyama, Toshio. *Heian Temples: The Byōdō-in and Chūson-ji*. Tokyo: Heibonsha, 1976.

Hansford, S. Howard. *A Glossary of Chinese Art and Archaeology*. China Society Sinological Series, no. 4. London: The China Society, 1979.

Ienaga, Saburō. *Painting in the Yamato Style*. Translated by John Shields. Heibonsha Survey of Japanese Art, vol. 10. New York and Tokyo: Weatherhill and Heibonsha, 1973.

Kageyama, Haruki. *The Arts of Shinto*. Translated by Christine Guth. Arts of Japan, no. 4. New York and Tokyo: Weatherhill and Shibundo, 1973.

Kageyama, Haruki, and Kanda, Christine G. *Shinto Arts: Nature, Gods, and Man in Japan*. New York: Japan House Gallery, 1976.

Kanda, Christine G. *Shinzō: Hachiman Imagery and Its Development*. Harvard East Asian Monographs, no. 119. Cambridge, Mass.: Council on East Asian Studies, Harvard University, 1985.

_____. "The Tōdai-ji Hachiman." *Artibus Asiae* 43 (1981/82).

Kuno, Takeshi. *The Sculpture of Unkei*. Tokyo: Heibonsha, 1974.

Kurata, Bunsaku. *Hōryū-ji: Temple of the Exalted Law*. Translated by W. Chie Ishibashi. New York: Japan Society, 1981.

Lee, Sherman E. *History of Far Eastern Art*. 4th ed., rev. New York: Harry N. Abrams, 1982.

Lee, Sherman E. et al. *Reflections of Reality in Japanese Art*. Cleveland: The Cleveland Museum of Art, 1983.

Medley, Margaret. *A Handbook of Chinese Art*. New York, Evanston, San Francisco, and London: Harper and Row, Icon Editions, 1964.

Mizoguchi, Saburo. *Design Motifs*. Arts of Japan, no. 1. New York and Tokyo: Weatherhill and Shibundo, 1973.

Mori, Hisashi. *Japanese Portrait Sculpture*. Translated by W. Chie Ishibashi. Japan Arts Library, no. 2. New York and Tokyo: Kodansha and Shibundo, 1977.

_____. *Sculpture of the Kamakura Period*. Translated by Kathleen Eickmann. New York: Weatherhill/Heibonsha, 1974.

Murase, Miyeko. *Emaki: Narrative Scrolls from Japan.* New York: The Asia Society, 1983.

Nishikawa, Kyōtarō. "References to Production of Buddhist Statues Contained in Noblemen's Diaries." *CISHAAN*, section II, subsection Ia. Tokyo, September 1983.

Nishikawa, Kyōtarō, and Sano, Emily. *The Great Age of Japanese Buddhist Sculpture, A.D. 600–1300.* Fort Worth and New York: Kimbell Art Museum and Japan Society, 1982.

Pal, Pratapaditya et al. *Light of Asia: Buddha Sakyamuni in Asian Art.* Los Angeles: Los Angeles County Museum of Art, 1984.

Saunders, E. Dale. *Mudrā: A Study of Symbolic Gestures in Japanese Buddhist Sculpture.* Princeton: Princeton University Press, 1960.

Sayre, Charles F. "Japanese Court-Style Narrative Painting of the Late Middle Ages." *Archives of Asian Art* 35 (1982): 71–82.

Shimizu, Yoshiaki. "Workshop Management of the Early Kano Painters, ca. 1530–1600." *Archives of Asian Art* 34 (1981): 32–47.

Soper, Alexander C. "The Best-Known Indian Images." In *Literary Evidence of Early Buddhist Art in China*, pp. 259–65. Ascona: Artibus Asiae, 1959.

Sugiyama, Jirō. *Classic Buddhist Sculpture: The Tempyō Period.* Translated and adapted by Samuel C. Morse. Tokyo: Kodansha, 1982.

Suzuki, Daisetz T. *Outlines of Mahayana Buddhism.* London: Luzac, 1907; paperback ed., New York: Schocken, 1963.

WORKS IN JAPANESE

Andō Kosei. *Sangatsu-dō.* Tokyo: Zauhō Kankōkai, 1927.

Chūsei Jiin to Kamakura Chōkoku (Medieval Temples and Buildings of the Kamakura Period). Genshoku Nihon no Bijutsu, vol. 9. Tokyo: Shōgakukan, 1968.

Hamada Takashi. *Zuzō (Iconographic Drawings).* Nihon no Bijutsu, no. 12. Tokyo: Shibundō, 1970.

Hiraoka Jokai. *Tōdai-ji no Rekishi (History of Tōdai-ji).* Tokyo: Shibundō, 1961.

Hirata Hiroshi. "Saidai-ji Eizon no Zōzō Seikatsu ni okeru Butsuga ni Tsuite" ("Concerning Buddhist Images Commissioned by Eizon of Saidai-ji"). *Bukkyō Geijutsu*, no. 62 (October 1966), pp. 98–113.

Itō Nobuo et al., eds. *Bunkazai Kōzō Nihon no Kenchiku (Lectures on Cultural Properties).* Vol. 4: *Early Modern Period, 1.* Tokyo: Dai-ichi Hōki, 1976.

Kako Satoshi. *Nara no Daibutsusama (The Great Buddha of Nara).* Tokyo: Fukuonkan Shoten, 1985.

Kamakura no Chōkoku, Kenchiku (Sculpture and Architecture of the Kamakura Period). Nihon Bijutsu Zenshū, no. 12. Tokyo: Gakushū Kenkyūsha, 1978.

Kameda Tsutomu. *Bukkyō Setsuwa-e no Kenkyū (Studies in Buddhist Narrative Painting).* Tokyo: Tokyo Bijutsu Shuppan, 1979.

——————. *Nihon Bukkyō Bijutsu-shi Jōsetsu (Studies in the History of Japanese Buddhist Art).* Tokyo: Gakugei Shorin, 1970.

Kasuga Gongen Genki-e (Illustrated Legends of the Kasuga Gongen). Zoku Nihon Emaki Taisei, vols. 14, 15. Tokyo: Chūōkōronsha, 1982.

Kawahara Yoshio. "Yūzen to Rinken" ("Yūzen and Rinken"). *Nanto Bukkyō*, nos. 43, 44 (September 1980), pp. 149–71.

Kawamoto Atsuo. *Tempyō Geijutsu no Sozoryoku (Creativity of Tempyō Art).* Tokyo: Seimei Shobō, 1949.

Kobayashi Takeshi. *Busshi Unkei no Kenkyū (Study of Sculptor Unkei).* Nara Kokuritsu Bunkazai Kenkyū-jo Gakuho, no. 1. Nara: Yotokusha, 1954.

——————. *Koshoan Amidabutsu Kaikei (Kaikei).* Nara Kokuritsu Bunkazai Kenkyū-jo Jushu nen Kinen Gakuho, no. 12. Nara: Nara Kokuritsu Bunakazi Kenkyū-jo, 1962.

——————. *Tōdai-ji no Daibutsu (Great Buddha of Tōdai-ji).* Nihon no Bijutsu, no. 5. Tokyo: Heibonsha, 1964.

Kojima Kikuo, ed. *Tempyō Chōkoku (Sculpture of the Tempyō Period).* Tokyo: Koyama Shoten, 1948.

Machida Kōichi. *Tempyō Chōkoku no Tenkei (Characteristic Style of Tempyō Sculpture).* Tokyo: Zauhō Kankōkai, 1947.

Maruo Shōsaburō. *Dai Busshi Unkei (Unkei, Great Buddhist Sculptor)*. Nihon Seishin Sosho, no. 32. Tokyo: Monbu Shō Kyogaku Kyoku, 1930.

Maruo Shōsaburō et al., *Nihon Chōkokushi Kiso Shiryō Shusei Jūyō Sakuhin Hen*. Tokyo: Chūō Kōron Bijutsu Shuppan, 1978.

Miya Tsugio, comp. *Emaki to Shōzō-ga (Narrative Handscrolls and Portrait Paintings)*. Nihon Bijutsu Zenshū, no. 10. Tokyo: Gakken, 1979.

Mōri Hisashi. *Busshi Kaikei Ron (Study of the Buddhist Sculptor Kaikei)*. Tokyo: Yoshikawa Kōbunkan, 1961.

Morisue Yoshiaki. *Chūsei no Shaji to Geijutsu (Medieval Temples and Shrines and Their Arts)*. Tokyo: Hobō Shobōkan, 1935.

Nagashima Fukutarō. *Ichijō Kanera*. Jimbutsu Sōsho, vol. 31. Tokyo: Yoshikawa Kōbunkan, 1959.

_____. *Nara Bunka no Denryū (Traditions of Nara Culture)*. Tokyo: Chūōkōronsha, 1944.

Nakano Genzō. *Nihon Bukkyō Kaiga Kenkyū (Studies in Japanese Buddhist Painting)*. Kyoto: Hōzōkan, 1982.

Nara E-hon Kokusai Kenkyūkai, comp. *Zaigai Nara E-hon (Nara Picture Books in Foreign Collections)*. Tokyo: Kadokawa Shoten, 1981.

Nara Rokudai-ji Taikan. Vols. 9–11: *Tōdai-ji 1–3*. Tokyo: Iwanami Shoten, 1968–72.

Nara-ken Kyōiku Iinkai, ed. *Kokuhō Tōdai-ji Hokke-dō Shūri Kōji Hōkokusho (Tōdai-ji Hokke-dō Restoration Report)*. Nara: Kyodo Seipan, 1972.

_____. *Kokuhō Tōdai-ji Kaisan-dō Shūri Kōji Hōkokusho (Tōdai-ji Kaisan-dō Restoration Report)*. Nara: Meishinsha, 1971.

Nara-shi Shi Henshūban Kōkai, comp. *Nara-shi Shi, Bijutsu-hen (History of Nara City, Art Section)*. Tokyo: Yoshikawa Kōbunkan, 1960.

Neiraku Kai, ed. *Tōdai-ji no Kenkyū (Study of Tōdai-ji)*. Nara: Tomi Shobō, 1948.

Nihon Emaki Taisei (Compendium of Japanese Handscrolls), vols. 14, 16. 27 vols. Tokyo: Chūōkōronsha, 1977–79.

Nihon Emakimono Zenshū (Collected Japanese Handscrolls), vols. 16, 21. 24 vols. Tokyo: Kadokawa Shoten, 1958–69.

Nishikawa Shinji. "Kongō Rikishi Ryuzo" ("Standing Images of Kongō Rikishi"). In *Nara Rokudai-ji Taikan* (q.v.). Vol. 11: *Tōdai-ji 3*.

Noma Seiroku. *Nihon Kamen Shi (History of Japanese Masks)*. Tokyo: Gebun Shoin, 1933.

Ōta Hirōtarō. "Kodai Kenchiku no Seisan" ("The Production of Ancient Architecture"). In *Nara Rokudai-ji Taikan* (q.v.). Vol. 9: *Tōdai-ji 1*, appendix 6.

Shimada Shūjirō, ed. *Zaigai Nihon no Shihō (Further Treasures of Japanese Art in Foreign Collections)*. Vol. 1: *Bukkyō Kaiga (Buddhist Painting)*. Tokyo: Mainichi Shimbunsha, 1980.

Shirahata Yoshi. *Shōzō-ga (Portrait Painting)*. Nihon no Bijutsu, no. 8. Tokyo: Shibundō, 1966.

Sugiyama Jirō. *Daibutsu Konryu (The Making of the Great Buddha)*. Tokyo: Gakuseisha, 1968.

Suzuki Kakichi. "Daibutsu-den to Shōwa Daishūri" ("The Daibutsu-den Restoration of 1973–80"). In *Kokuhō Daibutsu-den Shōwa Daishūri Rakkei Kinen. Tōdai-ji Ten (Exhibition of Tōdai-ji Treasures)*. Edited by Tokyo Kokuritsu Hakubutsukan et al. Kyoto: Benridō, 1980.

Tamura Hiroyasu. "Nara Jidai Tōdai-ji Rushana Butsu no Ryō Wakiji ni Tsuite" ("Concerning the Two Attendant Statues to the Nara-Period Statue of Vairocana at Tōdai-ji"). *Bukkyō Geijutsu* 120 (September 1978): 70–91.

Tanabe Saburōsuke. *Unkei to Kaikei (Unkei and Kaikei)*. Nihon no Bijutsu, no. 78. Tokyo: Shibundō, 1972.

Tanaka Tan. "Chūsei Shinyōshiki ni okeru Kōzō no Kaikaku ni Kansuru Shiteki Kōsatsu" ("Observations on Structural Changes in New Architectural Styles of the Medieval Period"). In *Nihon Kenchiku Tokushitsu*. Edited by Ōta Hirōtarō Oreki Kinen Rombunshu Kankōkai. Tokyo: Chūōkōron Bijutsu Shuppansha, 1976.

Tempyō no Bijutsu (Arts of the Tempyō Period). Nihon Bijutsu Zenshū, no. 4. Tokyo: Gakushū Kenkyūsha, 1977.

Tōdai-ji. Hihō, nos. 4, 5. Tokyo: Kōdansha, 1969.

Tōdai-ji 1–3. See *Nara Rokudai-ji Taikan*.

Tōdai-ji Daibutsu-den Shōwa Daishūri Shūri Iinkai, ed. *Kokuhō Tōdai-ji Kondō [Daibutsu-den] Shūri Kōji Hōkokusho (Tōdai-ji Daibutsu-den Restoration Report)*. Nara: Meishinsha, 1980. *Nanto Judai-ji Okagami*.

Tokyo Bijutsubako, ed. *Nanto Judai-ji Okagami*. Vols. 16–18: *Tōdai-ji Okagami (Great Mirror of Tōdai-ji)*. Tokyo: Otsuka Kōgeisha, 1932–34.

Yamane Yūzō, ed. *Rimpa Kaiga Zenshū (Collected Paintings of the Rimpa School)*. 5 vols. Tokyo: Nihon Keizai Shimbunsha, 1977–78.

Index

Photo Credits: All illustrations in this book courtesy of the Asahi Shimbun except the following:

Figs. 5, 32: Asuka-en, Nara

Nos. 8, 13 (detail): *Nara Rokudai-ji Taikan*, vol. 11; courtesy of Iwanami Shoten, Publishers, Tokyo

Fig. 14: Map prepared by Julie Abrams

Figs. 15–17, 25: *Kokuhō Tōdai-ji Kondō [Daibutsu-den] Shūri Kōji Hōkokusho*, vol. 2

Figs. 18, 21, 22: William Coaldrake

Fig. 23: *Kokuhō Jūyō-bunkazai [Kenzōbutsu] Jissoku Zushū Nara-ken*

Figs. 9, 24; nos. 62 (lantern in situ), 65 (detail): *Nara Rokudai-ji Taikan*, vol. 9; courtesy of Iwanami Shoten, Publishers, Tokyo

Fig. 8, page 75, nos. 5, 7, 27 (detail): *Nara Rokudai-ji Taikan*, vol. 10; courtesy of Iwanami Shoten, Publishers, Tokyo

Fig. 28: *Kobijutsu*, no. 21 (March 1968)

Fig. 29: Maruo, *Nihon Chōkokushi Kisō Shiryo Shusei Jūyō Sakuhin Hen*, vol. 2, pl. 2

Fig. 31: *Yamato Koji Taikan*, vol. 4; courtesy of Iwanami Shoten, Publishers, Tokyo

Fig. 34: Mori, *Busshi Kaikei Ron*

Figs. 35, 36: Museum of Fine Arts, Boston

Fig. 39: The Seattle Art Museum, long-term loan, Donald F. Padelford family